the best of

LETTERHEAD AND LOGO DESIGN

ROCKPORT

the best of
LETTERHEAD AND LOGO DESIGN

GLOUCESTER MASSACHUSETTS

ROCKPORT PUBLISHERS

First published in the United States of America by
Rockport Publishers, Inc.
33 Commercial Street
Gloucester, Massachusetts 01930-5089
Telephone: (978) 282-9590
Fax: (978) 283-2742
www.rockpub.com

ISBN 1-59253-030-3

10 9 8 7 6 5 4 3 2 1

Cover Design: Debeham Design

Printed in China

INTRODUCTION

Who can deny the importance of a well designed logo and letterhead? A good brand identity will sell a product or confirm the legitimacy of any project. In designing these graphic elements for success in the global marketplace, flexibility is key. A logo must translate on paper, via a fax, and over the Internet, and be easily recognizable in every language. Color and shapes must be carefully considered to effectively cross all cultural barriers. It must be timeless in its style and not be caught up in current trends.

The logos and letterheads presented in this book are exciting and varied. Most have successfully met the requirement of a successful global design, others are in the process of doing so. We hope you enjoy this collection of wonderful work, and find inspiration for your own designs along the way.

DESIGN FIRM | WEBSTER DESIGN ASSOCIATES
ART DIRECTOR | DAVE WEBSTER
DESIGNER/ILLUSTRATOR | ANDREY NAGORNY
CLIENT | ACH, INC.
TOOLS | MACROMEDIA FREEHAND

DESIGN FIRM | SHIMOKOCHI/REEVES
ART DIRECTORS | MAMORU SHIMOKOCHI, ANNE REEVES
DESIGNER | MAMORU SHIMOKOCHI
CLIENT | X-CENTURY STUDIOS
TOOLS | ADOBE ILLUSTRATOR

[internet:press]

DESIGN FIRM | LSL INDUSTRIES
DESIGNER | ELISABETH SPITALNY
CLIENT | JP DAVIS & COMPANY, INTERNET PRESS
TOOLS | ADOBE ILLUSTRATOR

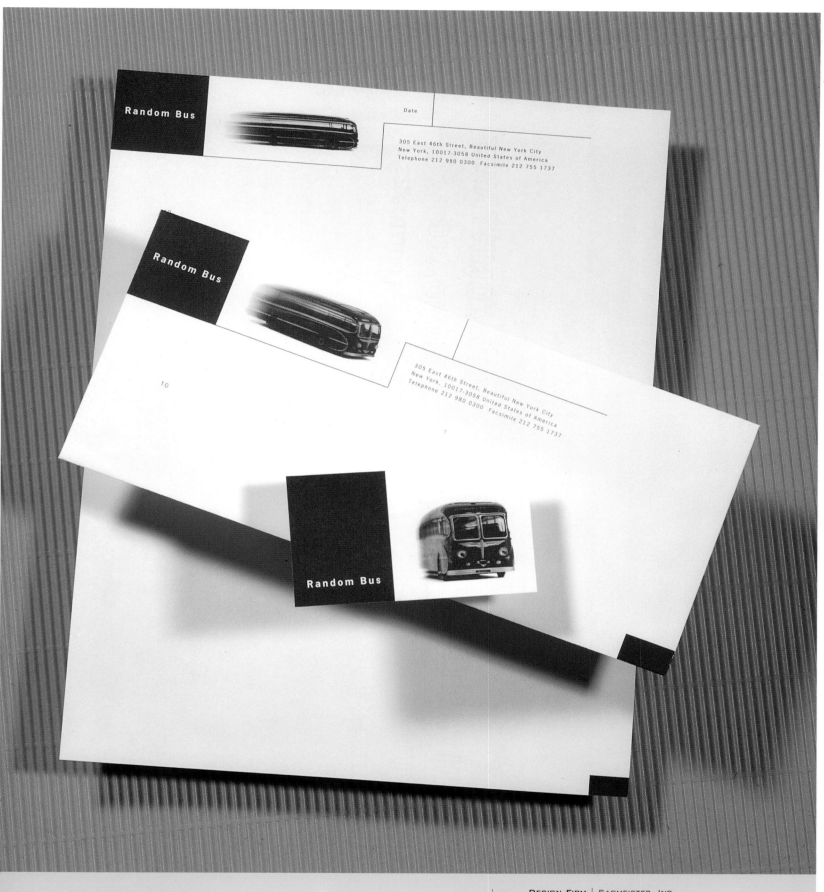

DESIGN FIRM | SAGMEISTER, INC.

ART DIRECTOR | STEFAN SAGMEISTER

DESIGNER | ERIC ZIM

PHOTOGRAPHY | TOM SCHIERLITZ

CLIENT | RANDOM BUS

TOOLS | MACINTOSH, 4 X 5 CAMERA

PAPER/PRINTING | STRATHMORE WRITING 25% COTTON

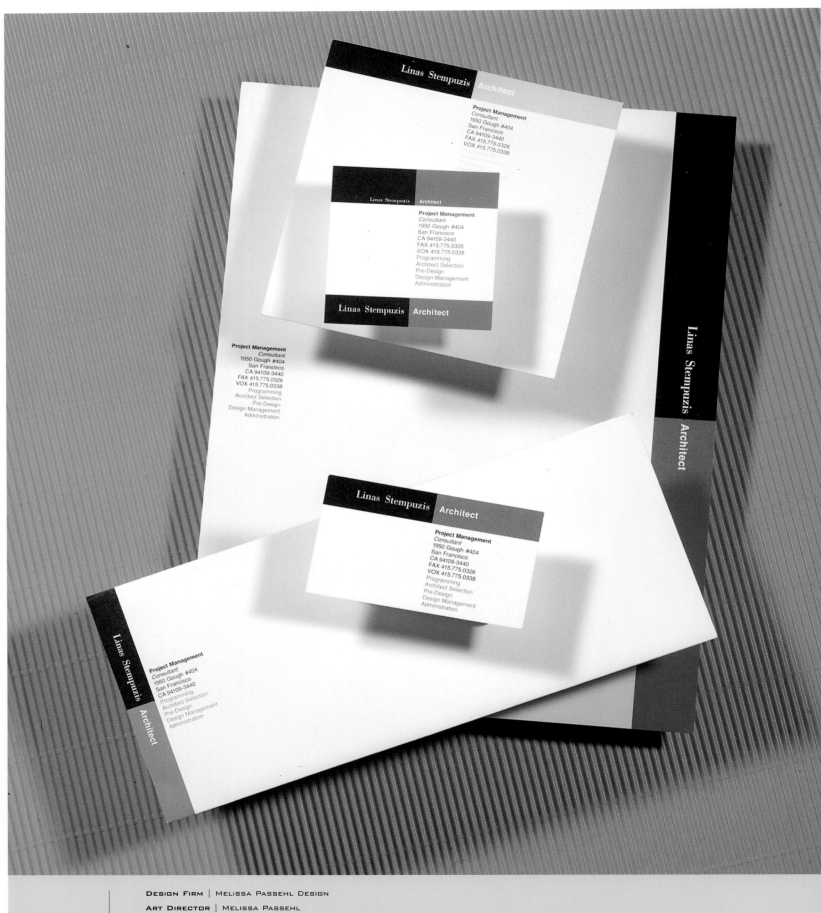

DESIGN FIRM | MELISSA PASSEHL DESIGN

ART DIRECTOR | MELISSA PASSEHL

DESIGNERS | MELISSA PASSEHL, JILL STEINFELD

CLIENT | LINAS STEMPUZIS

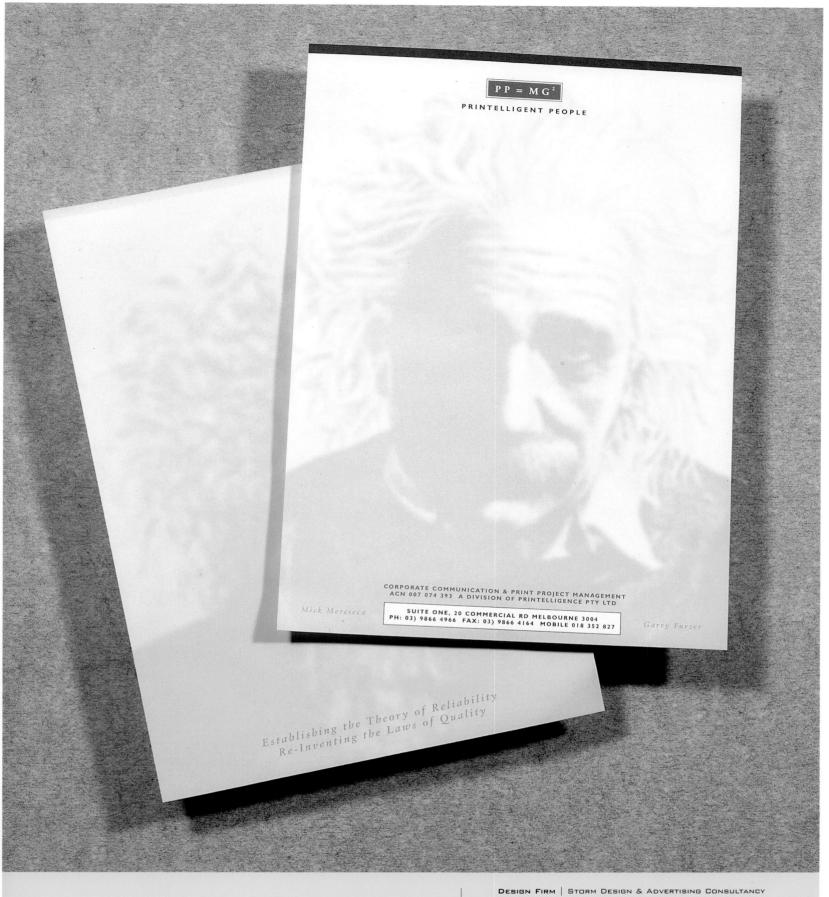

PP = MG²

PRINTELLIGENT PEOPLE

Mick Mercieca

CORPORATE COMMUNICATION & PRINT PROJECT MANAGEMENT
ACN 007 074 393 A DIVISION OF PRINTELLIGENCE PTY LTD

SUITE ONE, 20 COMMERCIAL RD MELBOURNE 3004
PH: 03) 9866 4966 FAX: 03) 9866 4164 MOBILE 018 352 827

Garry Furzer

*Establishing the Theory of Reliability
Re-Inventing the Laws of Quality*

DESIGN FIRM | STORM DESIGN & ADVERTISING CONSULTANCY

ART DIRECTORS/DESIGNERS | DAVID ANSETT, DEAN BUTLER

ILLUSTRATOR | DEAN BUTLER

CLIENT | PRINTELLIGENT PEOPLE

TOOLS | ADOBE PHOTOSHOP

PAPER/PRINTING | SAXTON SMOOTHE/THREE PMS COLORS,
SPECIAL VARNISH, EMBOSSING

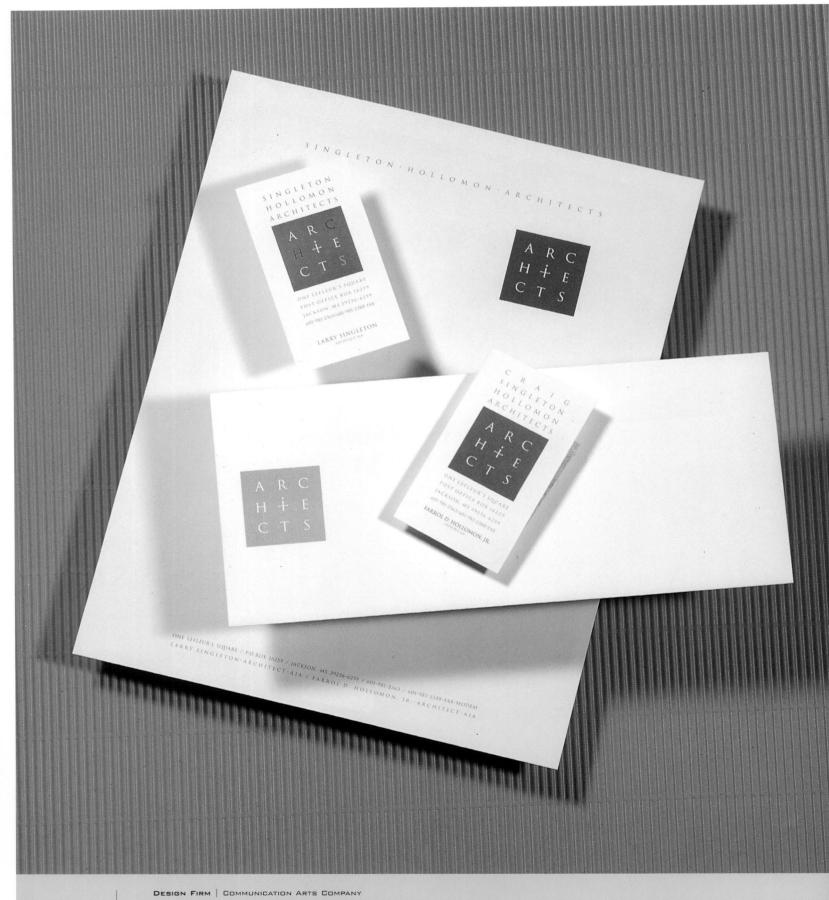

DESIGN FIRM | COMMUNICATION ARTS COMPANY

ART DIRECTOR/DESIGNER | HILDA STAUSS OWEN

CLIENT | SINGLETON-HOLLOMON-ARCHITECTS

TOOLS | MACINTOSH

PAPER/PRINTING | STRATHMORE WRITING/OFFSET LITHO

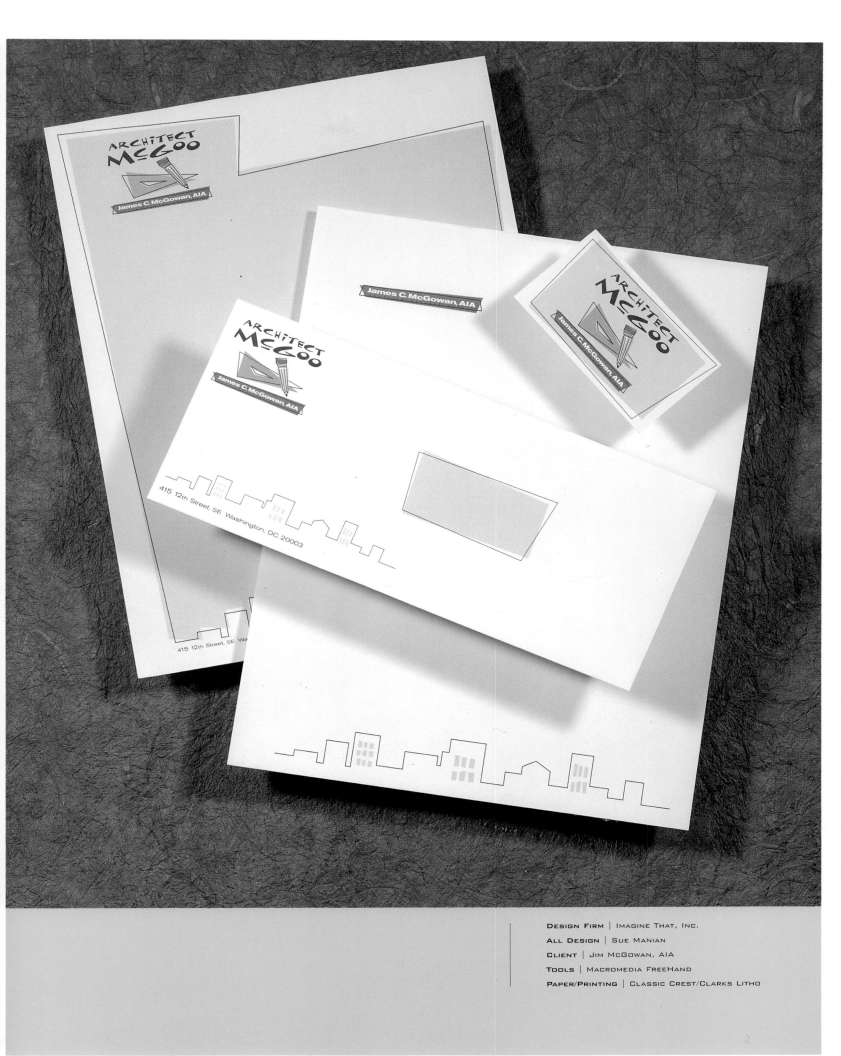

DESIGN FIRM | IMAGINE THAT, INC.

ALL DESIGN | SUE MANIAN

CLIENT | JIM MCGOWAN, AIA

TOOLS | MACROMEDIA FREEHAND

PAPER/PRINTING | CLASSIC CREST/CLARKS LITHO

13

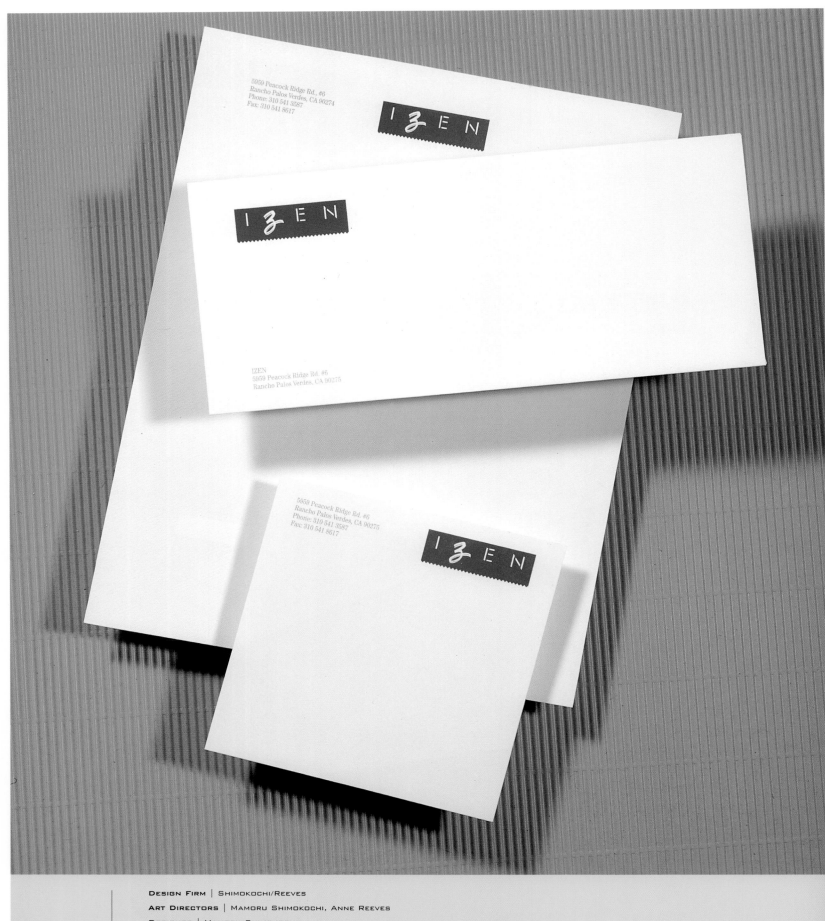

DESIGN FIRM | SHIMOKOCHI/REEVES

ART DIRECTORS | MAMORU SHIMOKOCHI, ANNE REEVES

DESIGNER | MAMORU SHIMOKOCHI

CLIENT | IZEN

TOOLS | ADOBE ILLUSTRATOR

PAPER/PRINTING | GRAPHIKA LINEAL

CENTRO INTERCULTURALE TAVOLINO ROVESCIATO

DESIGN FIRM | TANGRAM STRATEGIC DESIGN
ART DIRECTOR/DESIGNER/CREATIVE DIRECTOR | ENRICO SEMPI
CLIENT | COMPACT
TOOLS | POWER MACINTOSH

DESIGN FIRM | CATO BERRO DISEÑO
ALL DESIGN | GONZALO BERRO
CLIENT | CRESTA MAGNA/ENTERTAINMENT
TOOLS | ADOBE ILLUSTRATOR

ALL DESIGN | JOSÉ TORRES
CLIENT | TEENAGER BOUTIQUE
TOOLS | ADOBE PHOTOSHOP, MACROMEDIA FREEHAND

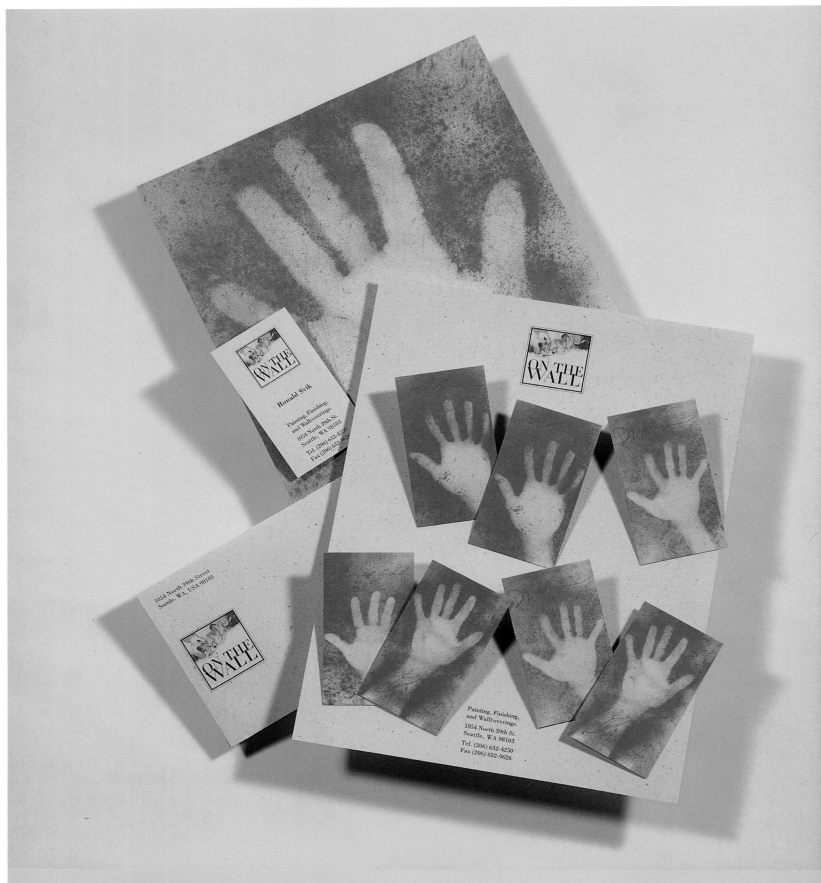

DESIGN FIRM | RICK EIBER DESIGN (RED)

ART DIRECTOR/DESIGNER | RICK EIBER

ILLUSTRATORS | DAVE D. WELLER (LOGO), GARY VOLK (HANDS)

CLIENT | ON THE WALL

PAPER/PRINTING | SPECKLETONE TWO COLOR (ONE METALLIC)
 OVER ONE COLOR

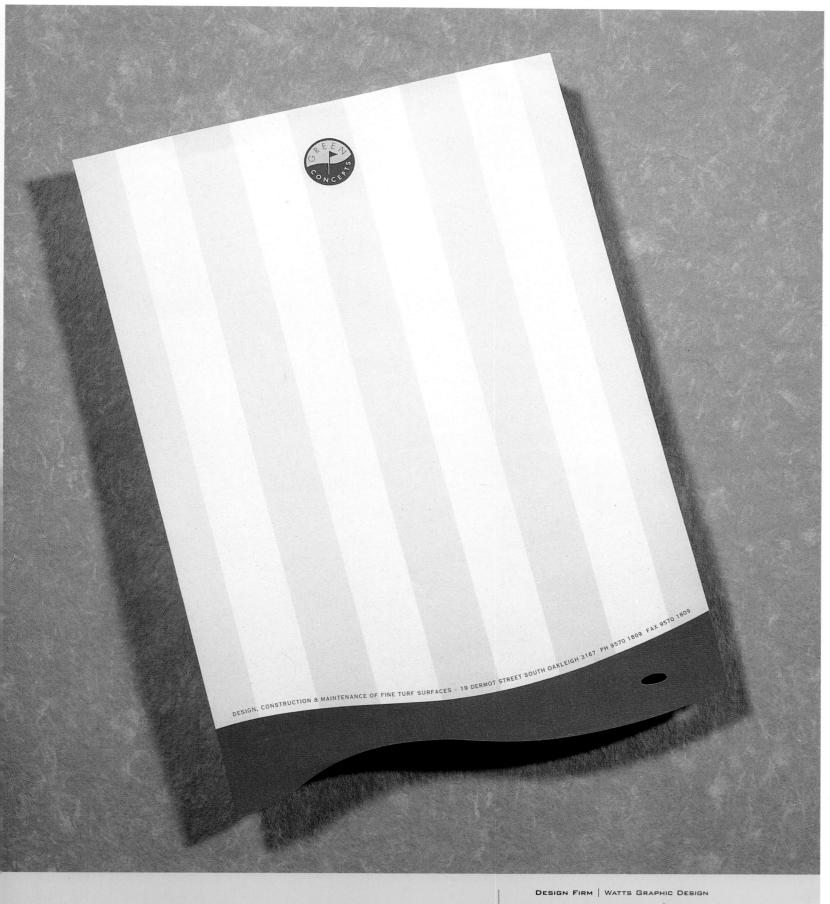

Within the image, the following text appears on the letterhead:

GREEN CONCEPTS

DESIGN, CONSTRUCTION & MAINTENANCE OF FINE TURF SURFACES - 19 DERMOT STREET SOUTH OAKLEIGH 3167 PH 9570 1809 FAX 9570 1809

DESIGN FIRM | WATTS GRAPHIC DESIGN
ART DIRECTORS/DESIGNERS | HELEN WATTS,
 PETER WATTS
CLIENT | GREEN CONCEPTS
TOOLS | MACINTOSH
PAPER/PRINTING | THREE COLOR

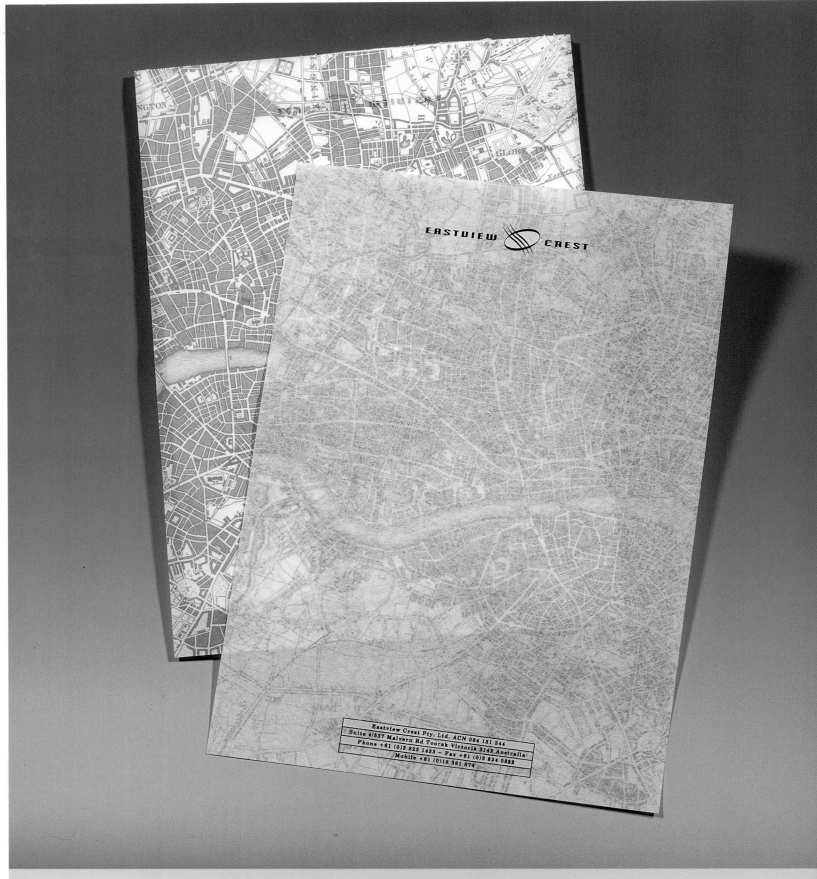

EASTVIEW CREST

Eastview Crest Pty. Ltd. ACN 064 181 344
Suite 4/537 Malvern Rd Toorak Victoria 3142 Australia
Phone +61 (0)3 823 1433 ~ Fax +61 (0)3 824 0822
Mobile +61 (0)18 381 874

DESIGN FIRM | WATTS GRAPHIC DESIGN
ART DIRECTORS/DESIGNERS | HELEN WATTS, PETER WATTS
CLIENT | EASTVIEW CREST
TOOLS | MACINTOSH
PAPER/PRINTING | PARCHMENT/ONE SIDE ONE COLOR,
ONE SIDE TWO COLOR

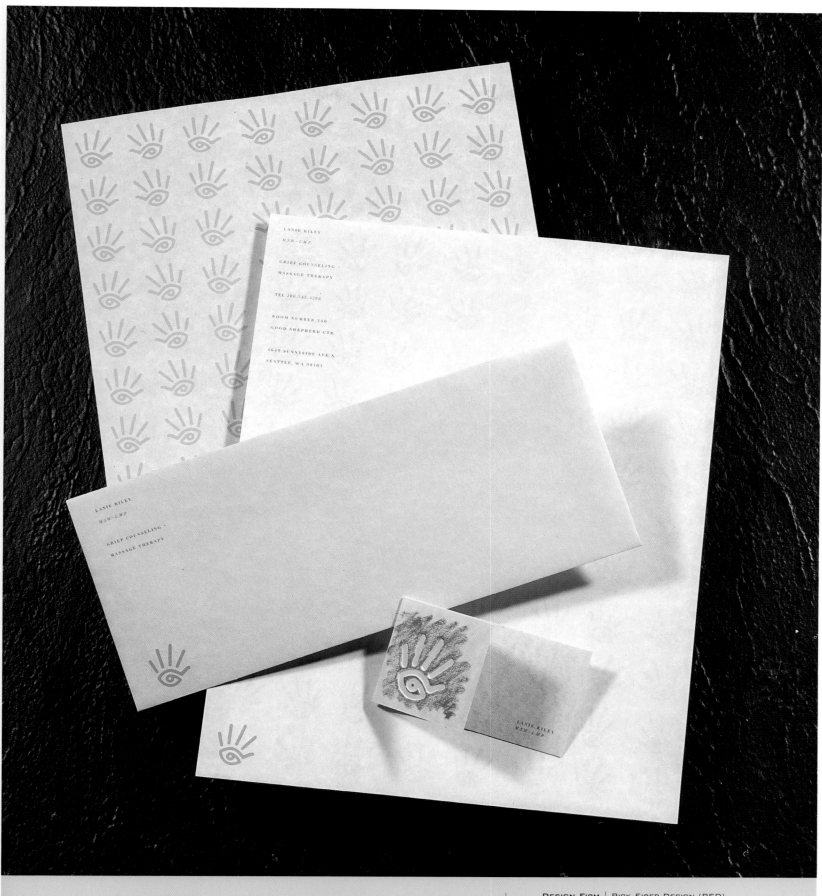

DESIGN FIRM | RICK EIBER DESIGN (RED)
ART DIRECTOR/DESIGNER | RICK EIBER
CLIENT | LANIE RILEY
PAPER/PRINTING | PARCHTONE

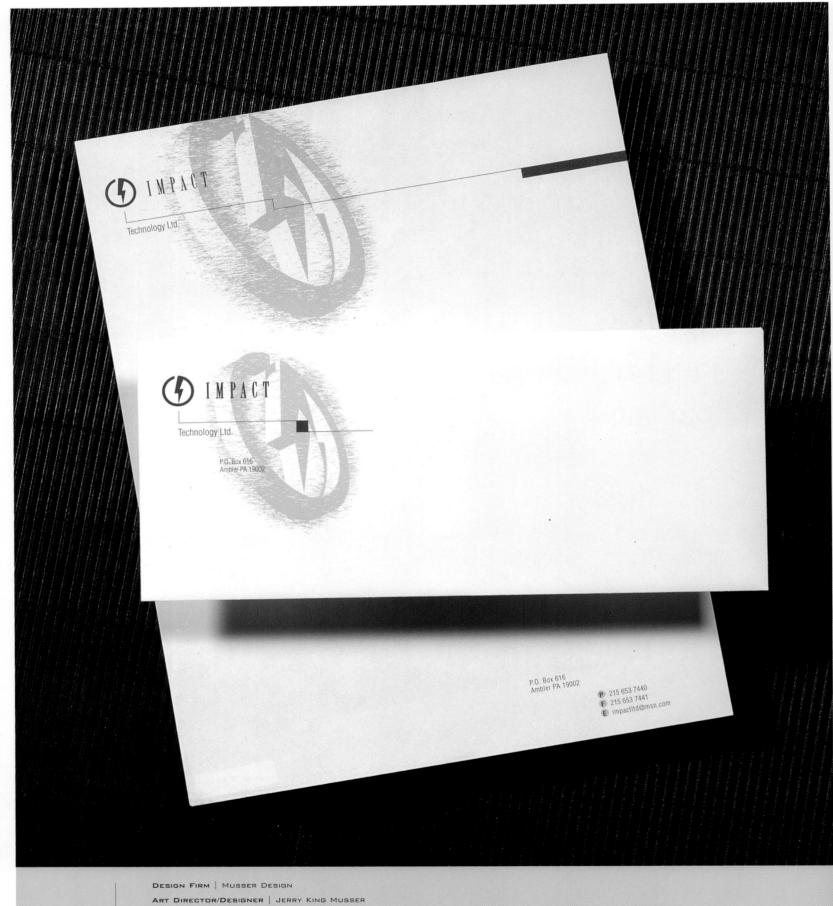

DESIGN FIRM | MUSSER DESIGN
ART DIRECTOR/DESIGNER | JERRY KING MUSSER
CLIENT | E W AND A
TOOLS | MACINTOSH QUADRA, ADOBE ILLUSTRATOR

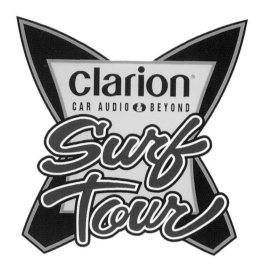

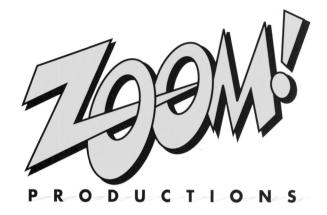

DESIGN FIRM | GILLIS & SMILER
ART DIRECTOR/DESIGNER | CHERYL GILLIS
CLIENT | CLARION SURF TOUR
TOOLS | ADOBE ILLUSTRATOR

DESIGN FIRM | PENCIL NECK PRODUCTIONS
ART DIRECTOR | GARY HAWTHORNE
CLIENT | ZOOM! PRODUCTIONS
TOOLS | ADOBE ILLUSTRATOR

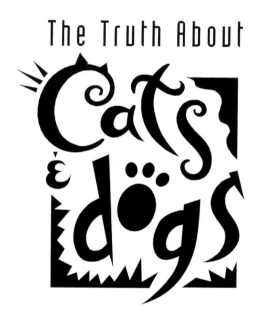

DESIGN FIRM | GILLIS & SMILER
ART DIRECTOR/DESIGNER | CHERYL GILLIS
CLIENT | NEW LINE CINEMA
TOOLS | ADOBE ILLUSTRATOR

DESIGN FIRM | ROBERT BAILEY INCORPORATED
ALL DESIGN | CONNIE LIGHTNER
CLIENT | IDEA CATALYSTS, INC.
TOOLS | ADOBE ILLUSTRATOR

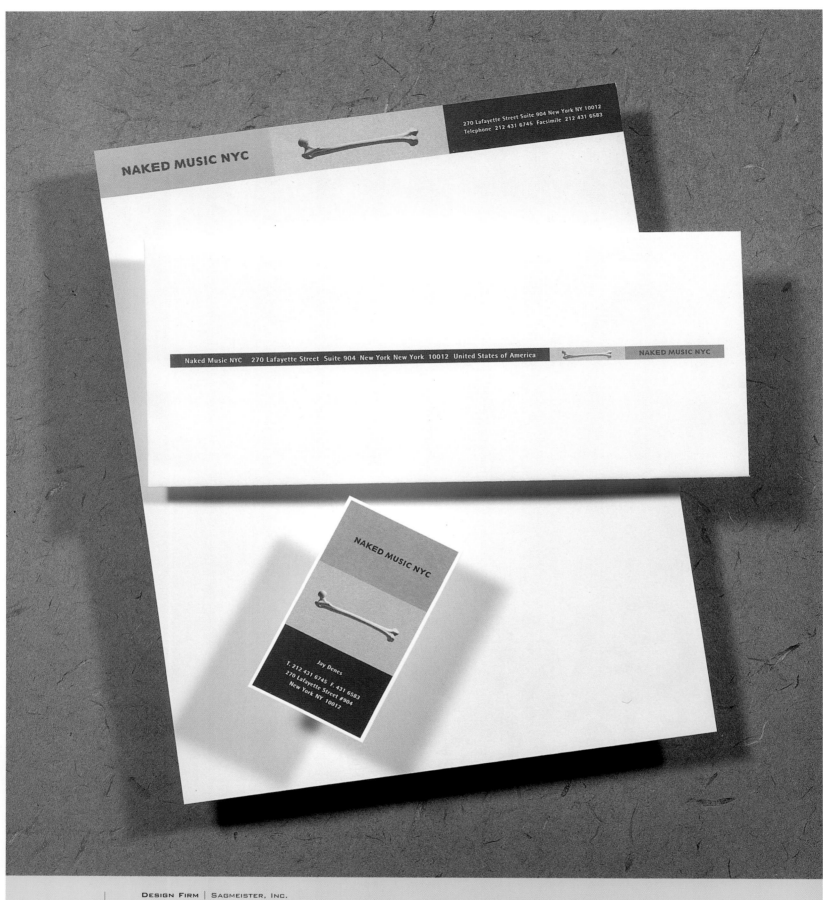

DESIGN FIRM | SAGMEISTER, INC.
ART DIRECTOR | STEFAN SAGMEISTER
DESIGNERS | STEFAN SAGMEISTER, VERONICA OH
PHOTOGRAPHY | TOM SCHIERLITZ
CLIENT | NAKED MUSIC NYC
TOOLS | MACINTOSH, 4 X 5 CAMERA
PAPER/PRINTING | STRATHMORE WRITING 25% COTTON

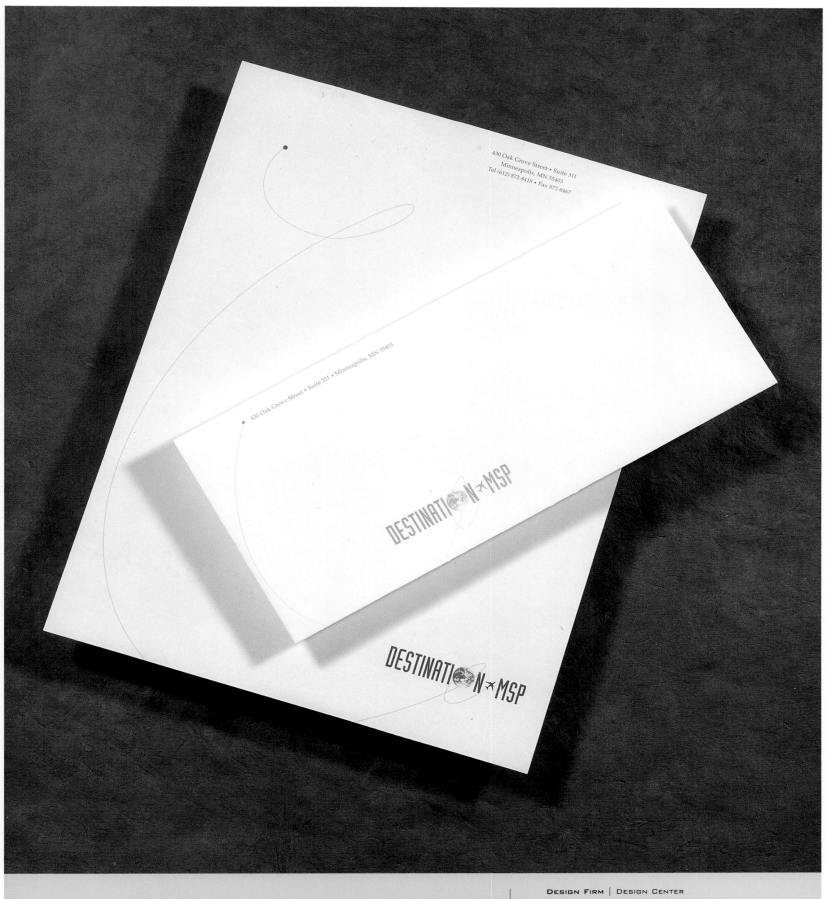

430 Oak Grove Street • Suite 311
Minneapolis, MN 55403
Tel (612) 872-8418 • Fax 872-8467

430 Oak Grove Street • Suite 311 • Minneapolis, MN 55403

DESTINATION ✈ MSP

DESTINATION ✈ MSP

DESIGN FIRM | DESIGN CENTER

ART DIRECTOR | JOHN REGER

DESIGNER | SHERWIN SWARTZROCK

CLIENT | DESTINATION MSP

TOOLS | MACINTOSH

PAPER/PRINTING | CLASSIC CREST/PRINTCRAFT

DESIGN FIRM | HORNALL ANDERSON DESIGN WORKS, INC.
ART DIRECTOR | JACK ANDERSON
DESIGNER | JACK ANDERSON, DAVID BATES
ILLUSTRATOR | DAVID BATES
CLIENT | CW GOURMET

DESIGN FIRM | XSNRG ILLUSTRATION AND DESIGN
ALL DESIGN | KEVIN BALL
CLIENT | 8 BALL MUSIC
TOOLS | CORELDRAW

DESIGN FIRM | CREATIVE COMPANY
ALL DESIGN | RICK YURK
CLIENT | LOAVES & FISHES
TOOLS | MACINTOSH

DESIGN FIRM | A1 DESIGN
DESIGNER | AMY GREGG
CLIENT | PETER BELANGER PHOTOGRAPHY
TOOLS | MACINTOSH QUADRA, ADOBE ILLUSTRATOR

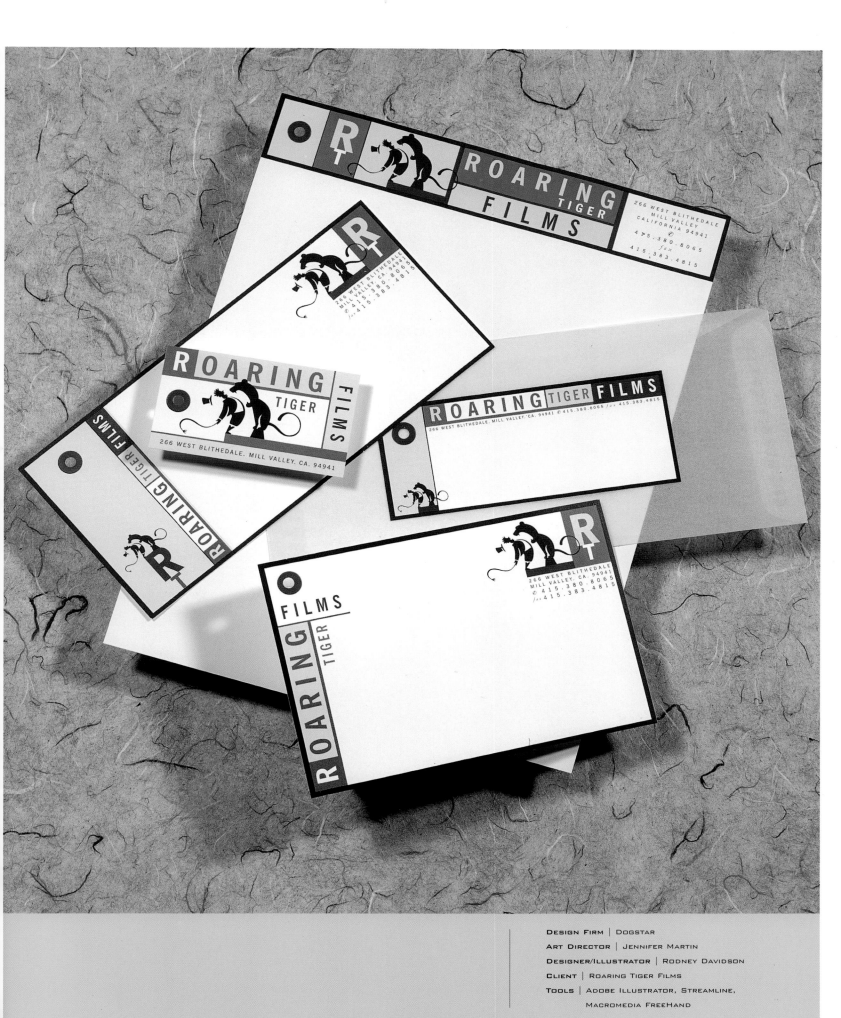

DESIGN FIRM | DOGSTAR
ART DIRECTOR | JENNIFER MARTIN
DESIGNER/ILLUSTRATOR | RODNEY DAVIDSON
CLIENT | ROARING TIGER FILMS
TOOLS | ADOBE ILLUSTRATOR, STREAMLINE,
MACROMEDIA FREEHAND

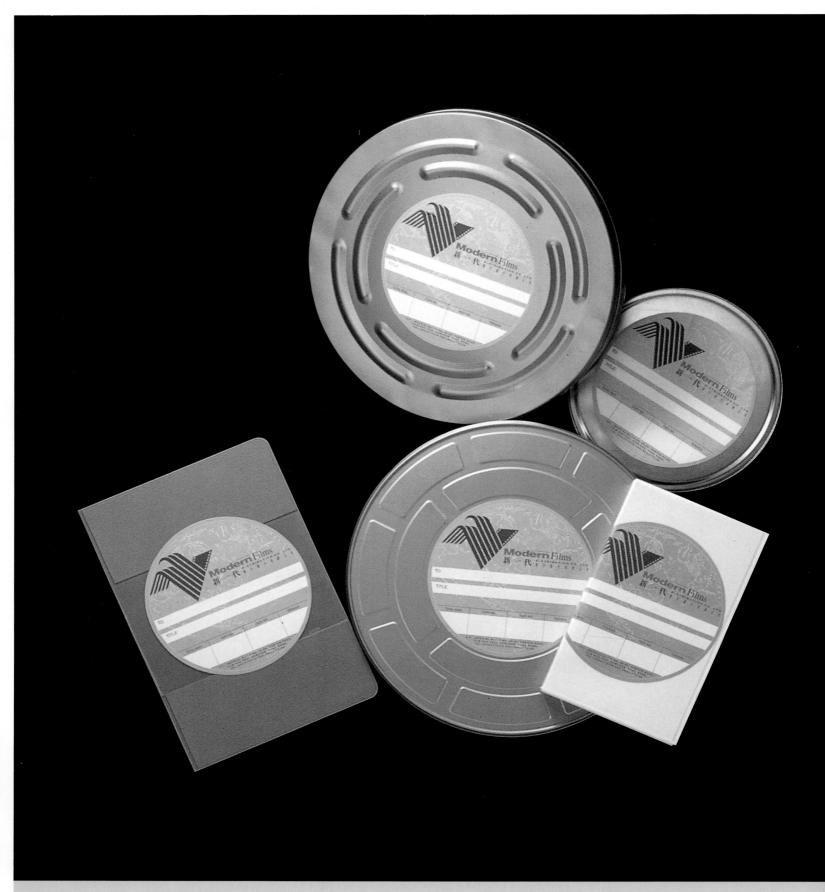

DESIGN FIRM | GRAND DESIGN COMPANY
ART DIRECTOR | GRAND SO
DESIGNER | GRAND SO, KWONG ETTI MAN
ILLUSTRATOR | KWONG ETTI MAN
CLIENT | MODERN FILMS

The Best of Letterhead and Logo Design

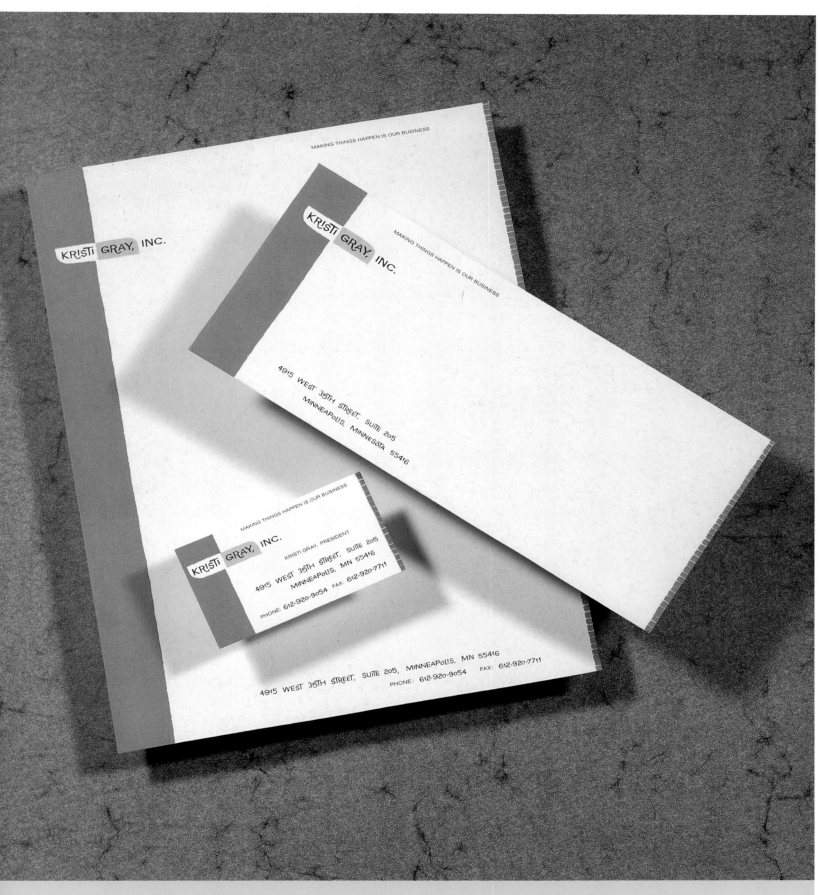

DESIGN FIRM | ZAUHAR DESIGN
ALL DESIGN | DAVID ZAUHAR
CLIENT | KRISTI GRAY, INC.

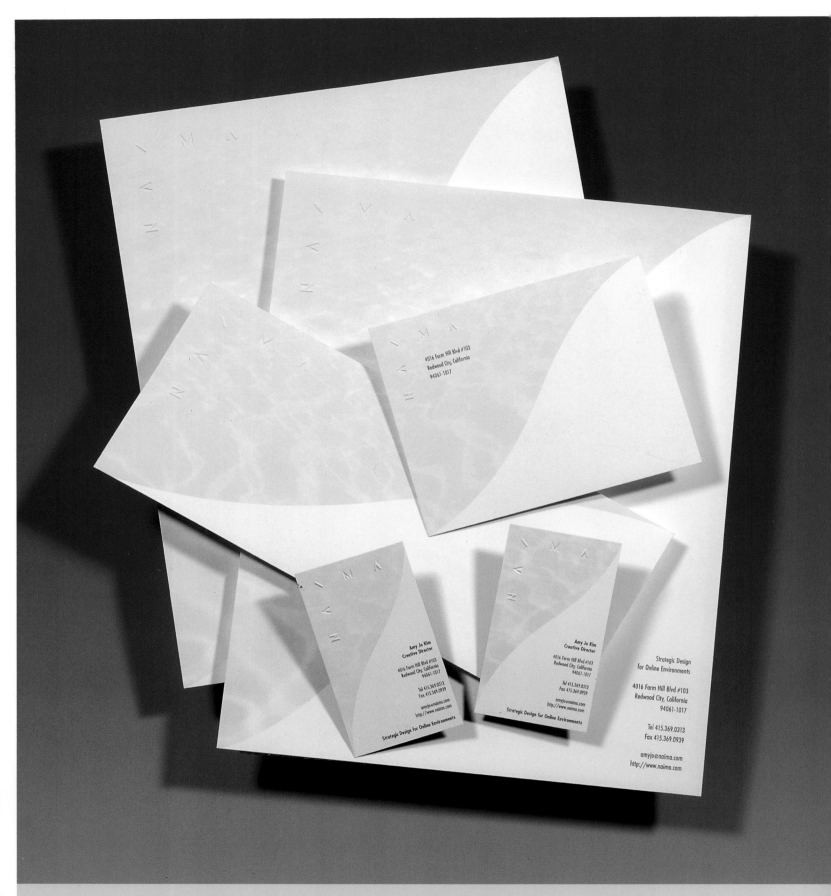

DESIGN FIRM | AERIAL

ART DIRECTOR/DESIGNER | TRACY MOON

CLIENT | AMY JO KIM/NAIMA PRODUCTIONS

TOOLS | ADOBE PHOTOSHOP, QUARKXPRESS

PAPER/PRINTING | CLASSIC CREST SOLAR WHITE 80 LB.

DESIGN FIRM | PHOENIX CREATIVE, ST. LOUIS

ALL DESIGN | ED MANTELS-SEEKER

CLIENT | ART CLASSICS LTD.

TOOLS | MACROMEDIA FREEHAND

DESIGN FIRM | MISHA DESIGN STUDIO

ART DIRECTOR | MICHAEL LENN

DESIGNER | MICHAEL LENN

CLIENT | BOSTON BALLET

TOOLS | HAND BRUSH STROKES

THIS CAPTION WAS PRINTED INCORRECTLY IN A PRIOR PRINTING

DESIGN FIRM | GRAND DESIGN COMPANY

ART DIRECTOR | GRAND SO

DESIGNER | GRAND SO, KWONG ETTI MAN

ILLUSTRATOR | KWONG ETTI MAN

CLIENT | MODERN FILMS

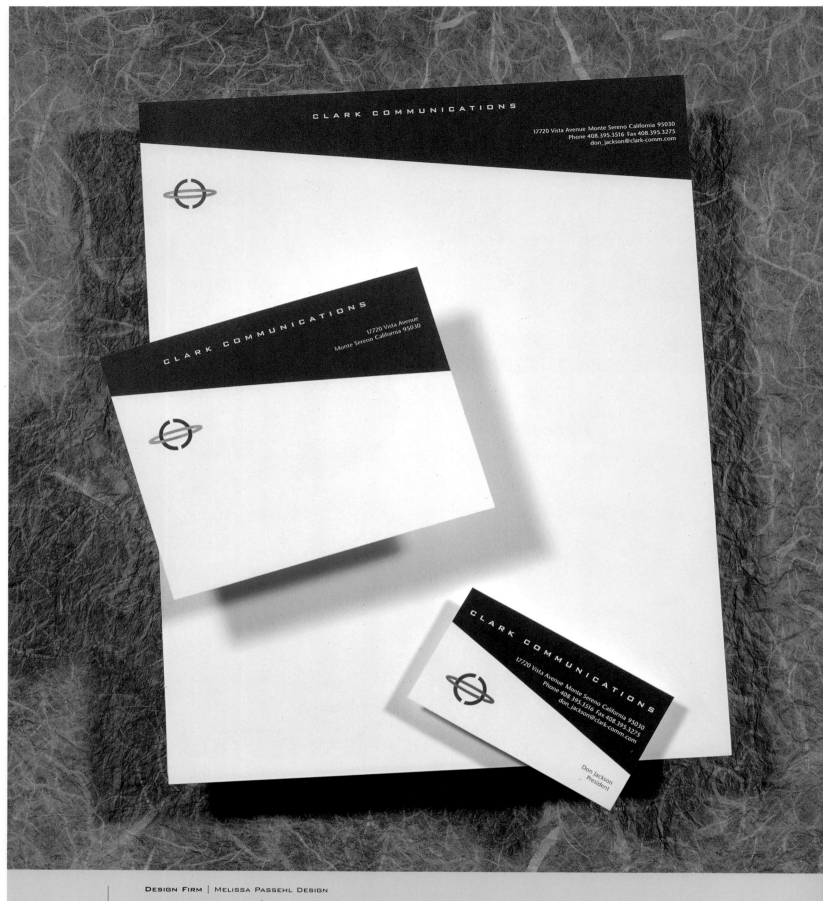

DESIGN FIRM | MELISSA PASSEHL DESIGN

ART DIRECTOR/DESIGNER | MELISSA PASSEHL

CLIENT | CLARK COMMUNICATIONS

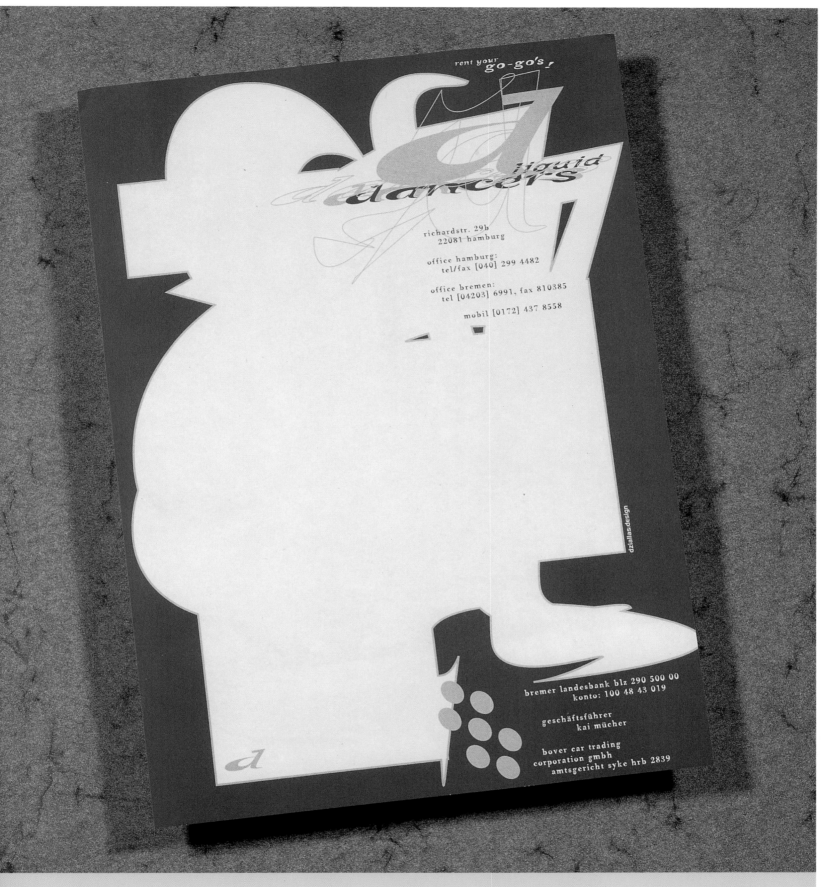

DESIGN FIRM | STEFAN DZIALLAS DESIGN

DESIGNER/ILLUSTRATOR | STEFAN DZIALLAS

CLIENT | STEFAN DZIALLAS

TOOLS | ADOBE ILLUSTRATOR, QUARKXPRESS, MACINTOSH

ALCAROTTI
CENTRO SPORTIVO

DESIGN FIRM | TANGRAM STRATEGIC DESIGN
ART DIRECTOR/DESIGNER | ANTONELLA TREVISAN
CLIENT | CENTRO SPORTIVO ALCAROTTI
TOOLS | POWER MACINTOSH

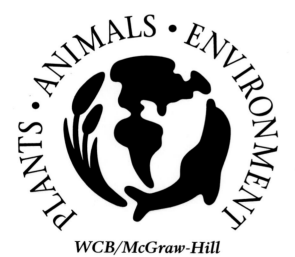

DESIGN FIRM | GET SMART DESIGN COMPANY
ART DIRECTOR | JEFF MACFARLANE
DESIGNER/ILLUSTRATOR | TOM CULBERTSON
CLIENT | WCB/MCGRAW-HILL PUBLISHERS
TOOLS | MACROMEDIA FREEHAND

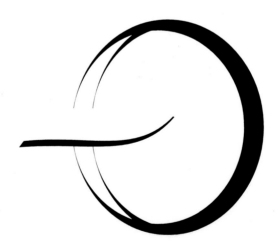

DESIGN FIRM | EYE DESIGN INCORPORATED
ALL DESIGN | ROBIN MEYERS
CLIENT | DYNAMIC DECISIONS/PEI-O
TOOLS | ADOBE ILLUSTRATOR
PAPER/PRINTING | PMS 485

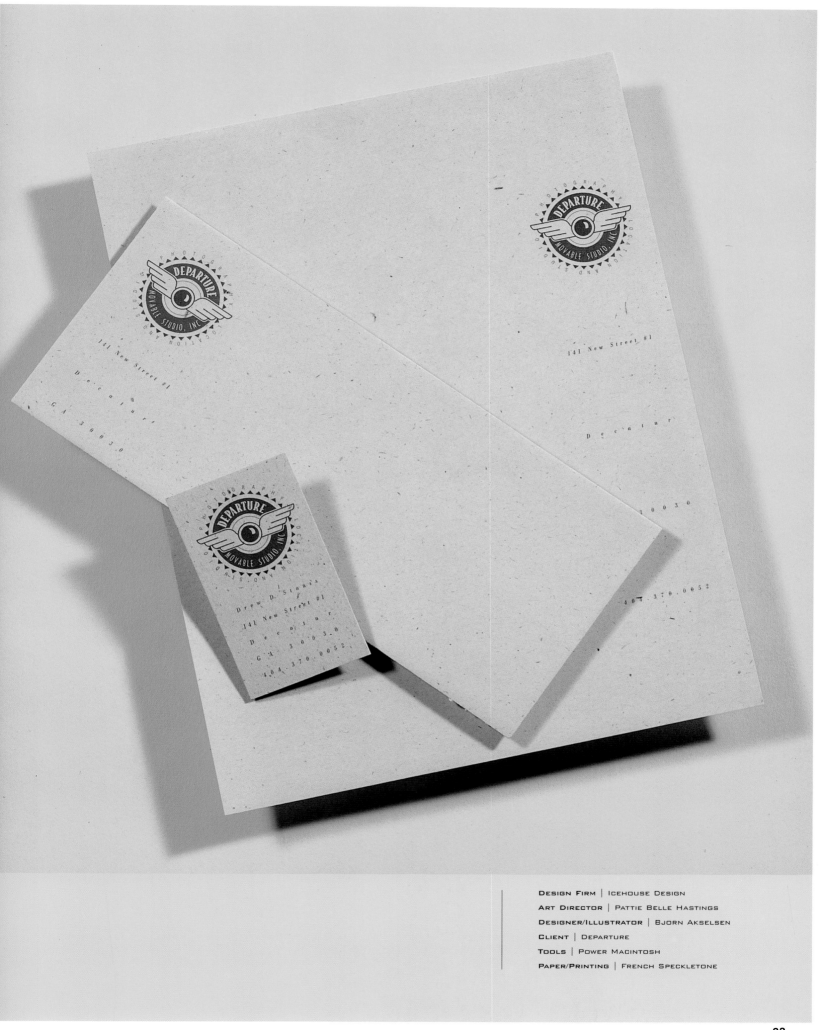

DESIGN FIRM | ICEHOUSE DESIGN
ART DIRECTOR | PATTIE BELLE HASTINGS
DESIGNER/ILLUSTRATOR | BJORN AKSELSEN
CLIENT | DEPARTURE
TOOLS | POWER MACINTOSH
PAPER/PRINTING | FRENCH SPECKLETONE

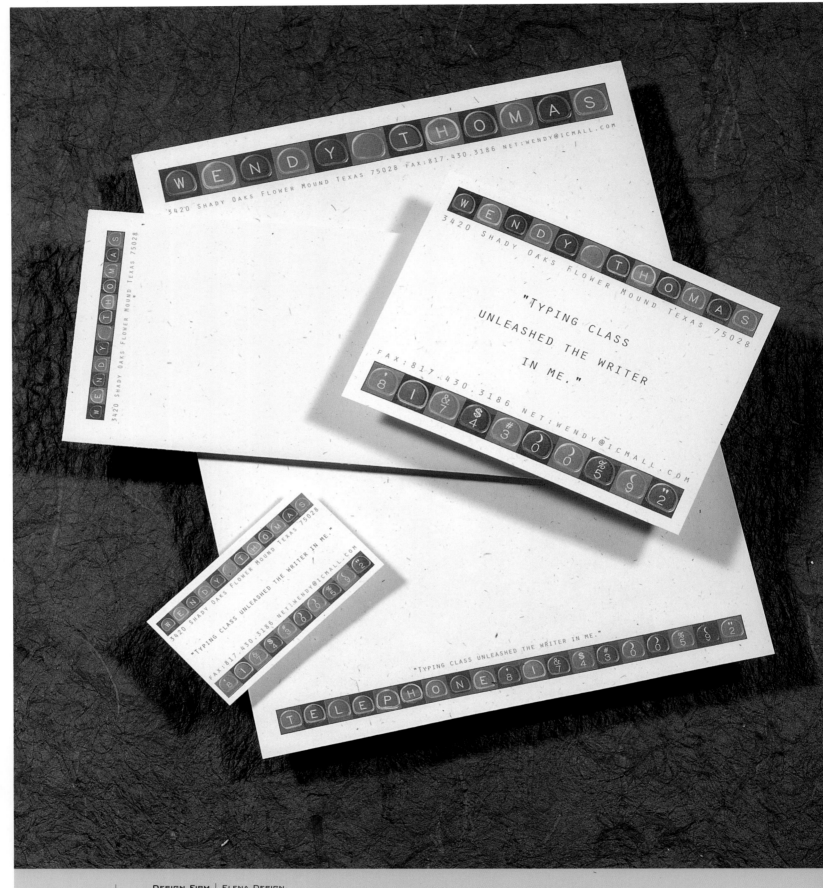

DESIGN FIRM | ELENA DESIGN

ART DIRECTOR/DESIGNER | ELENA BACA

ILLUSTRATOR | PHOTOTONE ALPHABETS

CLIENT | WENDY THOMAS

TOOLS | QuarkXPress

PAPER/PRINTING | FRENCH SPECKELTONE

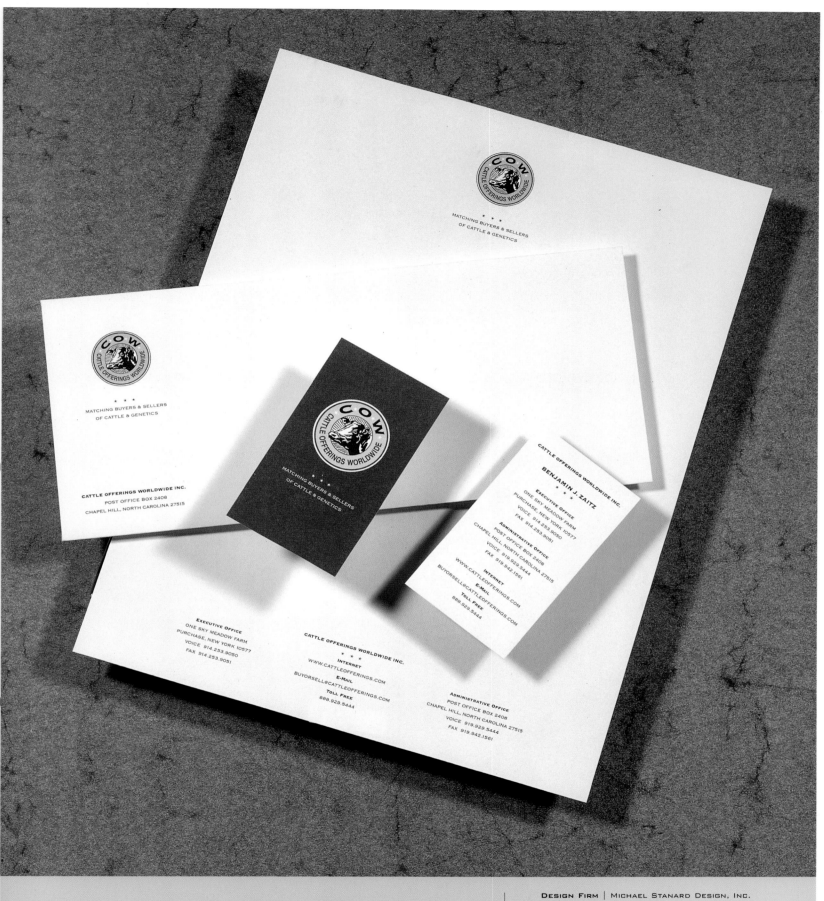

DESIGN FIRM | MICHAEL STANARD DESIGN, INC.
ART DIRECTOR | MICHAEL STANARD
DESIGNER/ILLUSTRATOR | KRISTY VANDEKERCKHOVE
CLIENT | CATTLE OFFERINGS WORLDWIDE
TOOLS | MACINTOSH, ADOBE ILLUSTRATOR
PAPER/PRINTING | STRATHMORE WRITING

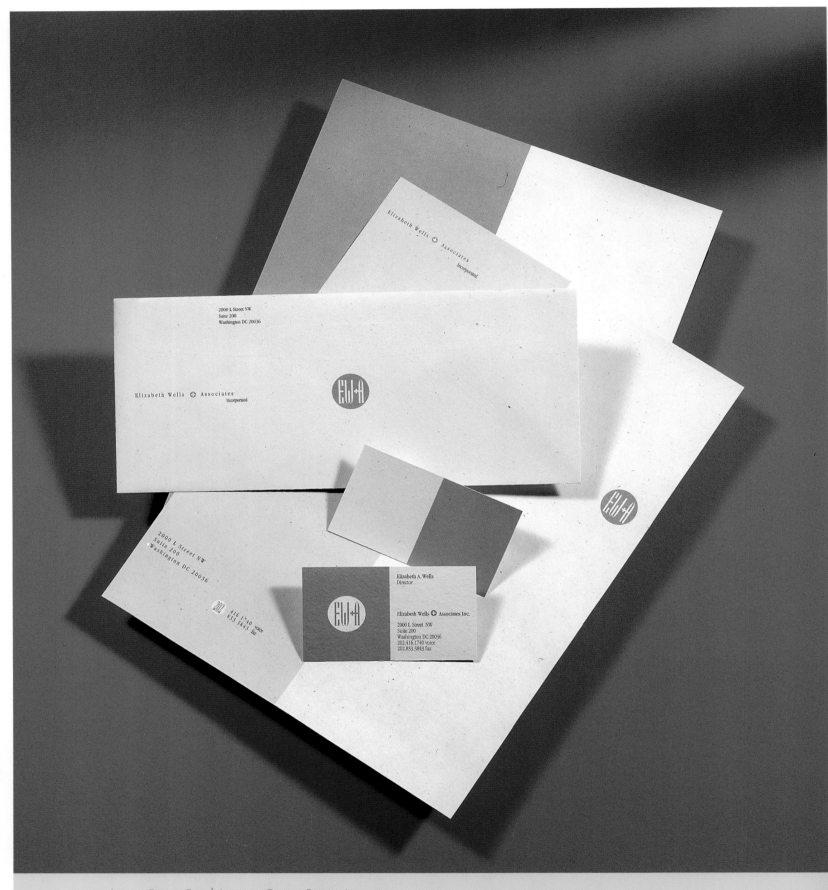

DESIGN FIRM | ANDERSON-THOMAS DESIGN, INC.

ART DIRECTOR/DESIGNER | JOEL ANDERSON

CLIENT | STAR SONG COMMUNICATIONS

TOOLS | QUARKXPRESS, ADOBE ILLUSTRATOR

PAPER/PRINTING | CLASSIC CREST/BLACK PLUS ONE PMS

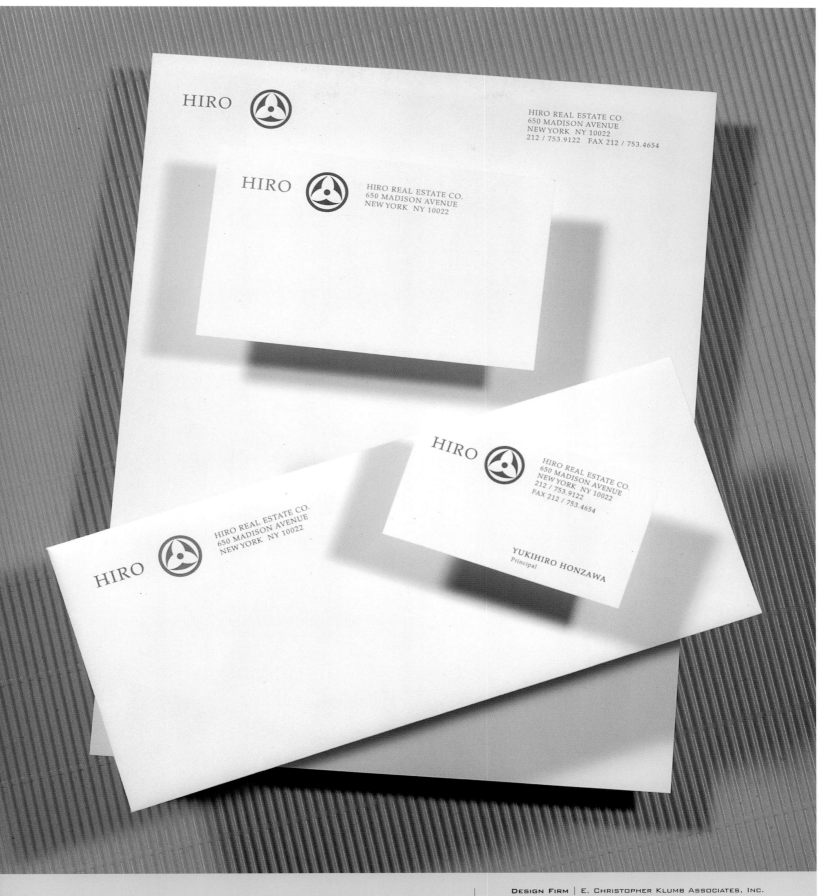

HIRO

HIRO REAL ESTATE CO.
650 MADISON AVENUE
NEW YORK NY 10022
212 / 753.9122 FAX 212 / 753.4654

HIRO

HIRO REAL ESTATE CO.
650 MADISON AVENUE
NEW YORK NY 10022

HIRO

HIRO REAL ESTATE CO.
650 MADISON AVENUE
NEW YORK NY 10022
212 / 753.9122
FAX 212 / 753.4654

YUKIHIRO HONZAWA
Principal

HIRO

HIRO REAL ESTATE CO.
650 MADISON AVENUE
NEW YORK NY 10022

DESIGN FIRM | E. CHRISTOPHER KLUMB ASSOCIATES, INC.

ALL DESIGN | CHRISTOPHER KLUMB

CLIENT | HIRO REAL ESTATE COMPANY

TOOLS | QUARKXPRESS, MACINTOSH

PAPER/PRINTING | STRATHMORE

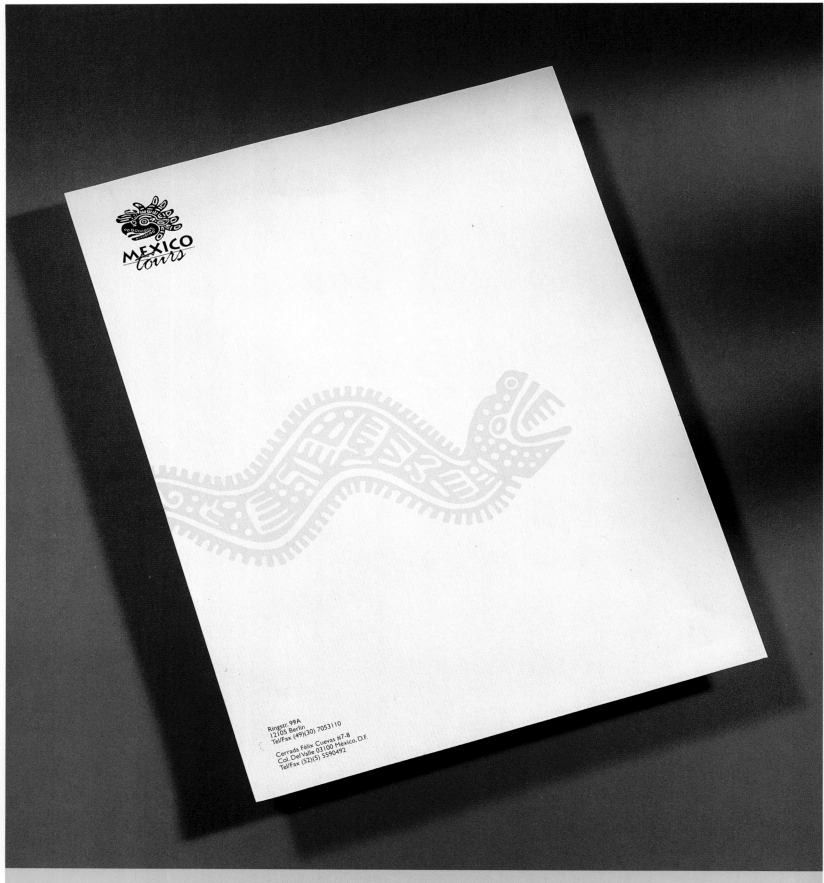

MEXICO
tours

Ringstr. 99A
12105 Berlin
Tel/Fax (49)(30) 7053110

Cerrada Félix Cuevas #7-8
Col. Del Valle 03100 México, D.F.
Tel/Fax (52)(5) 5590492

DESIGN FIRM | ZAPPATA DESIGNERS
ART DIRECTOR/DESIGNER | IBO ANGULO
CLIENT | MEXICO TOURS (TOURIST AGENCY IN GERMANY)
TOOLS | MACROMEDIA FREEHAND
PAPER/PRINTING | RECYCLED/SILKSCREEN

DESIGN FIRM | XSNRG ILLUSTRATION AND DESIGN
ALL DESIGN | KEVIN BALL
CLIENT | BARRETZ
TOOLS | CORELDRAW, PICTURE PUBLISHER

DESIGN FIRM | DOGSTAR
ART DIRECTOR | MARTIN LEEDS/CIGAR AFICIONADO
DESIGNER/ILLUSTRATOR | RODNEY DAVIDSON
CLIENT | CIGAR AFICIONADO
TOOLS | ADOBE ILLUSTRATOR, STREAMLINE, MACROMEDIA FREEHAND

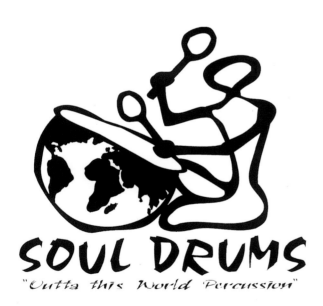

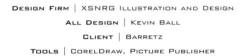

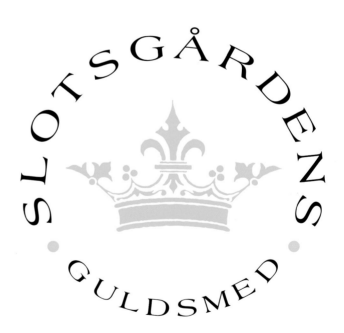

DESIGN FIRM | XSNRG ILLUSTRATION AND DESIGN
ALL DESIGN | KEVIN BALL
CLIENT | SOUL DRUMS
TOOLS | CORELDRAW

ART DIRECTOR/DESIGNER | ATHENA WINDELEV
CLIENT | SLOTSGÅRDENS GULDSMED, GOLDSMITH

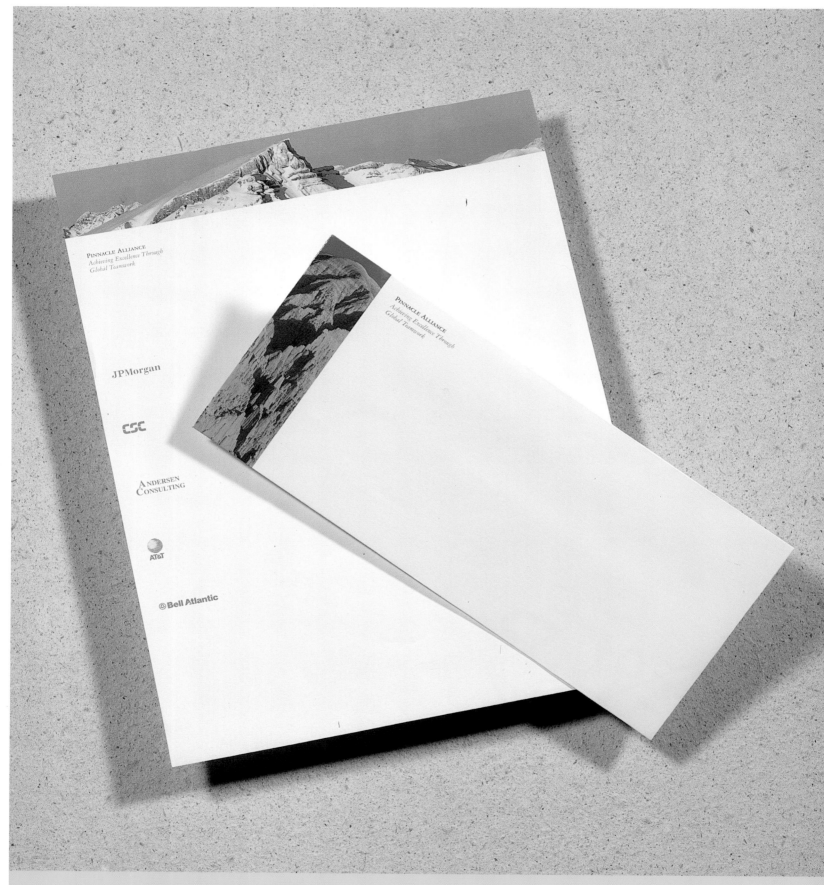

DESIGN FIRM | RAMONA HUTKO DESIGN

ART DIRECTOR/DESIGNER | RAMONA HUTKO

PHOTOGRAPHER | SHAWN HUTKO

CLIENT | PINNACLE ALLIANCE

TOOLS | ADOBE PHOTOSHOP, QUARKXPRESS

PAPER/PRINTING | MOHAWK SUPERFINE WHITE ESS SHELL
FINISH 80 LB. TEXT

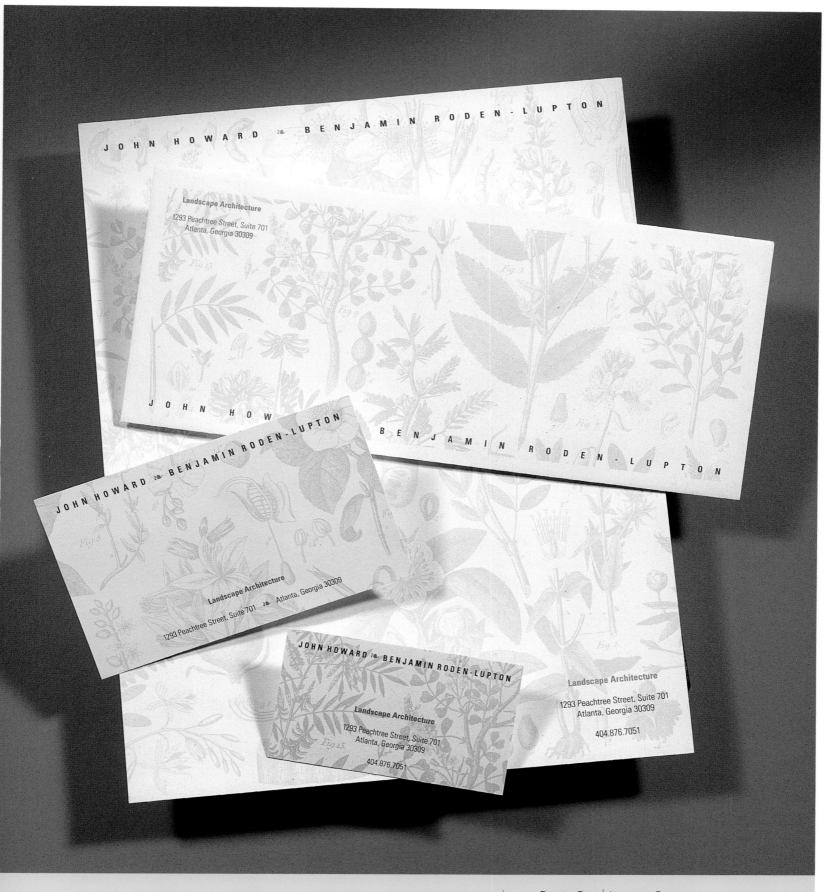

DESIGN FIRM | ICEHOUSE DESIGN
ART DIRECTOR/DESIGNER | PATTIE BELLE HASTINGS
CLIENT | JOHN HOWARD/BENJAMIN RODEN-LUPTON
TOOLS | POWER MACINTOSH
PAPER/PRINTING | CLASSIC CREST

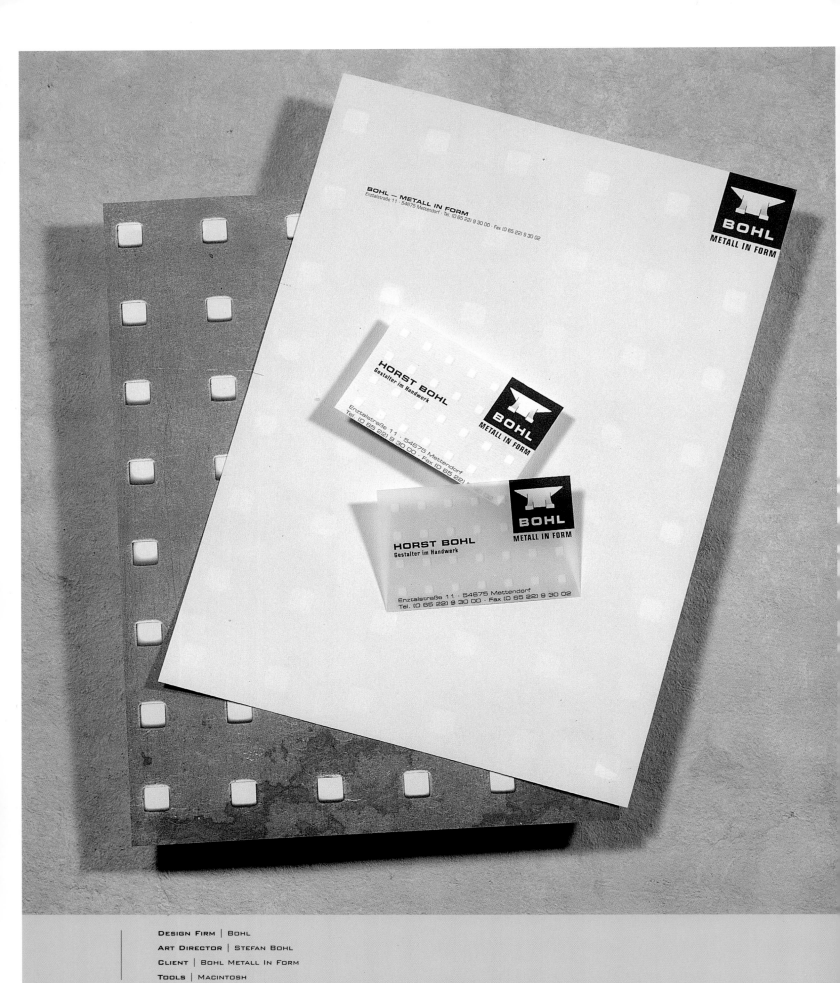

DESIGN FIRM | BOHL
ART DIRECTOR | STEFAN BOHL
CLIENT | BOHL METALL IN FORM
TOOLS | MACINTOSH

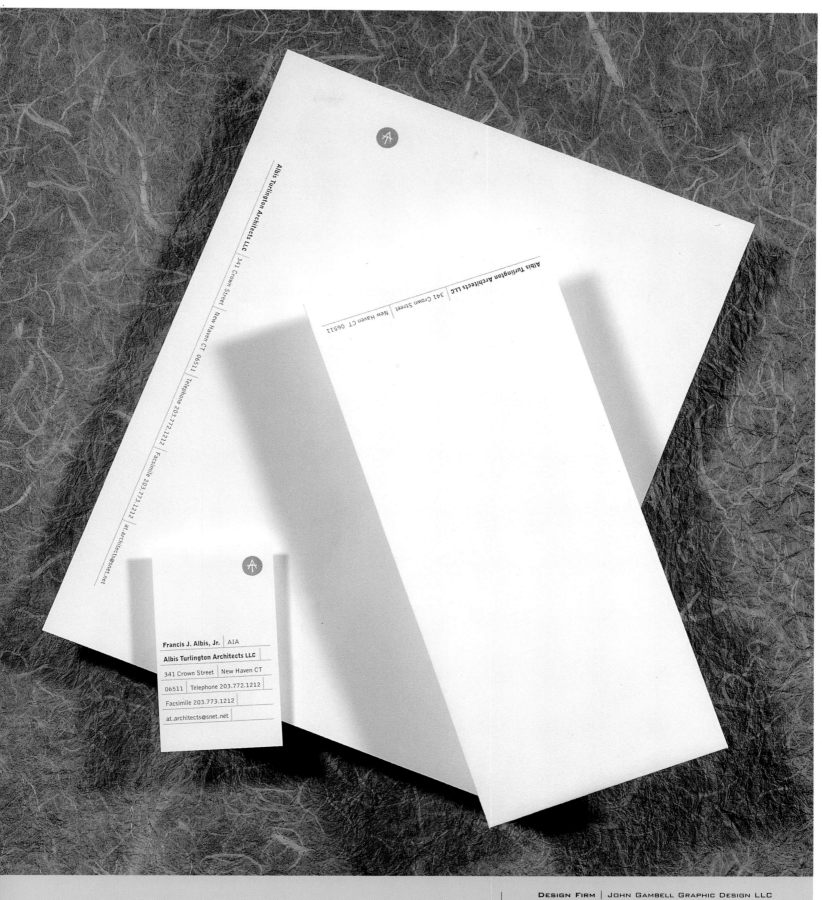

Francis J. Albis, Jr. | AIA
Albis Turlington Architects LLC
341 Crown Street | New Haven CT
06511 | Telephone 203.772.1212
Facsimile 203.773.1212
at.architects@snet.net

Albis Turlington Architects LLC | 341 Crown Street | New Haven CT 06511 | Telephone 203.772.1212 | Facsimile 203.773.1212 | at.architects@snet.net

Albis Turlington Architects LLC | 341 Crown Street | New Haven CT 06511

DESIGN FIRM | JOHN GAMBELL GRAPHIC DESIGN LLC
ART DIRECTOR | JOHN GAMBELL
DESIGNERS | JOHN GAMBELL, CHARLES ROUTHIER
CLIENT | ALBIS TURLINGTON ARCHITECTS LLC
TOOLS | QUARKXPRESS, ADOBE ILLUSTRATOR
PAPER/PRINTING | CRANES CREST 28 LB. FLOUR
WHITE/LEHAMN BROTHERS, INC., NEW HAVEN

DESIGN FIRM | VOSS DESIGN
ALL DESIGN | AXEL VOSS
CLIENT | ART 'N STUFF

DESIGN FIRM | JEFF FISHER LOGOMOTIVES
ALL DESIGN | JEFF FISHER
CLIENT | SHLEIFER MARKETING COMMUNICATIONS, AGENCY FOR
SAMUELS YOELIN KANTOR SEYMOUR AND SPINRAD
TOOLS | MACROMEDIA FREEHAND

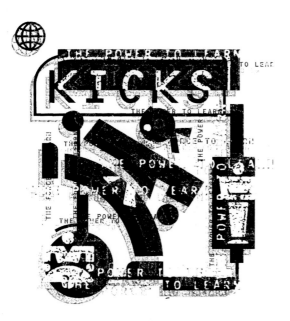

DESIGN FIRM | INSIGHT DESIGN COMMUNICATIONS
ALL DESIGNS | SHERRIE AND TRACY HOLDEMAN
CLIENT | KICKS
TOOLS | POWER MACINTOSH, MACROMEDIA FREEHAND,
ADOBE PHOTOSHOP

DESIGN FIRM | COMMONWEALTH CREATIVE ASSOCIATES
ART DIRECTOR/DESIGNER | ADAM RUDIKOFF
CLIENT | MCGOWAN EYECARE
TOOLS | MACINTOSH

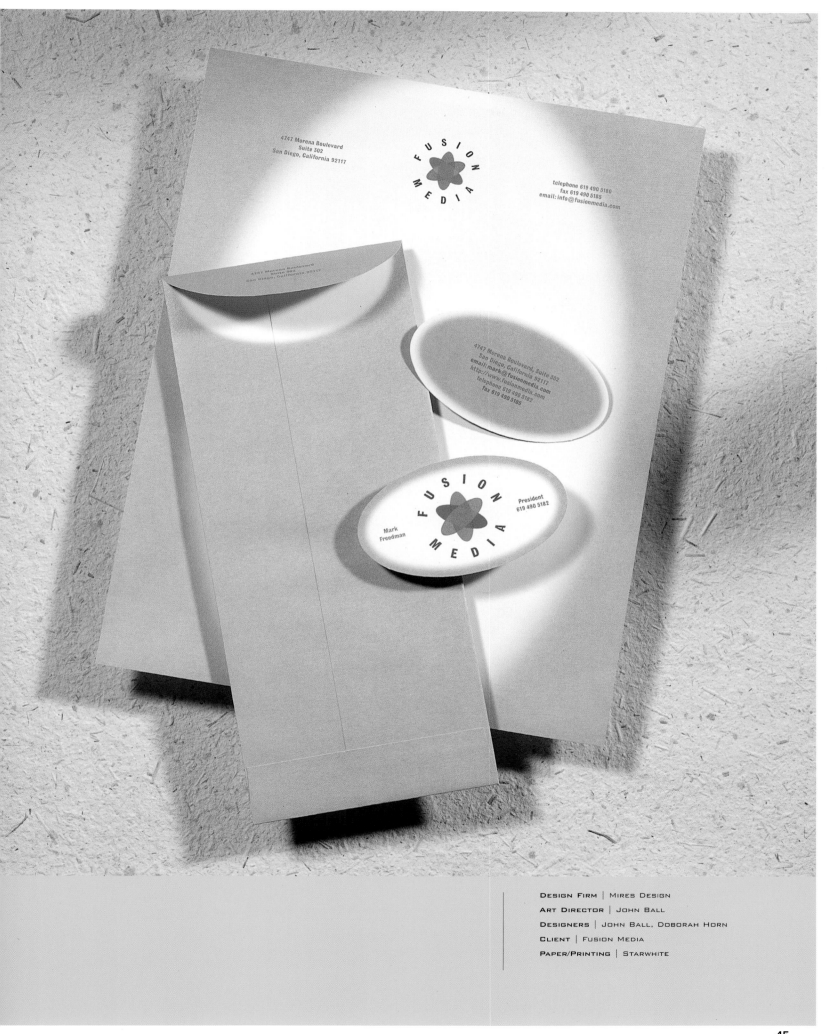

4747 Morena Boulevard
Suite 302
San Diego, California 92117

telephone 619 490 5180
fax 619 490 5185
email: info@fusionmedia.com

F U S I O N
M E D I A

4747 Morena Boulevard
Suite 302
San Diego, California 92117

4747 Morena Boulevard, Suite 302
San Diego, California 92117
email:mark@fusionmedia.com
http://www.fusionmedia.com
telephone 619 490 5182
fax 619 490 5185

Mark
Freedman

F U S I O N
M E D I A

President
619 490 5182

DESIGN FIRM | MIRES DESIGN
ART DIRECTOR | JOHN BALL
DESIGNERS | JOHN BALL, DOBORAH HORN
CLIENT | FUSION MEDIA
PAPER/PRINTING | STARWHITE

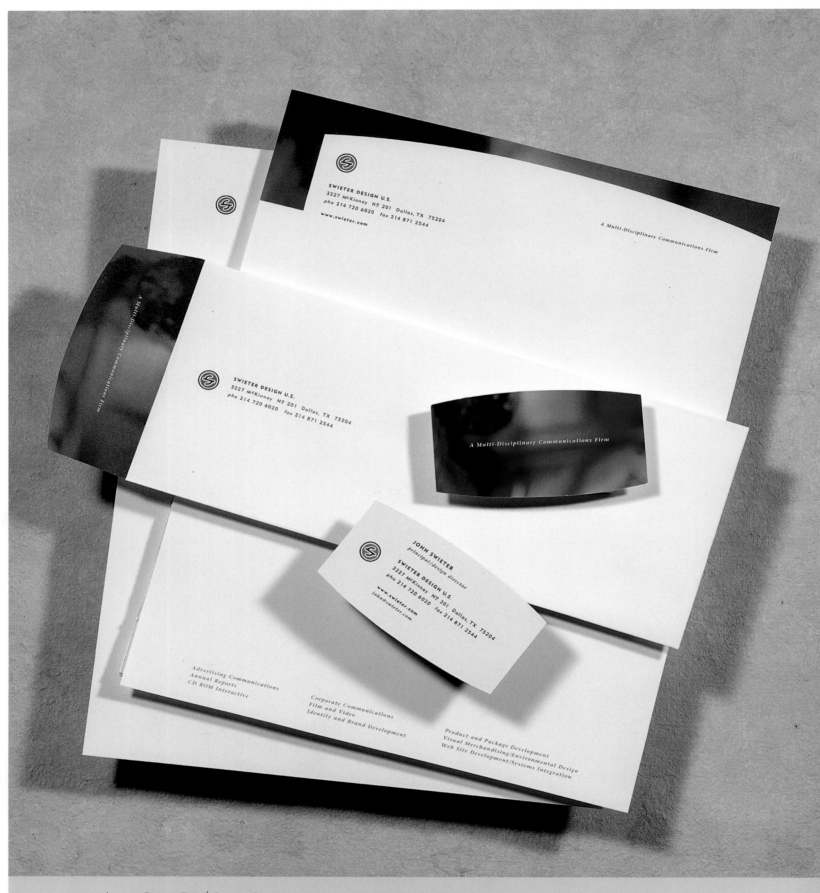

DESIGN FIRM | SWIETER DESIGN
ART DIRECTOR | JOHN SWIETER
DESIGNER | MARK FORD
CLIENT | SWIETER DESIGN
TOOLS | ADOBE PHOTOSHOP
PAPER/PRINTING | COATED/FOUR COLOR

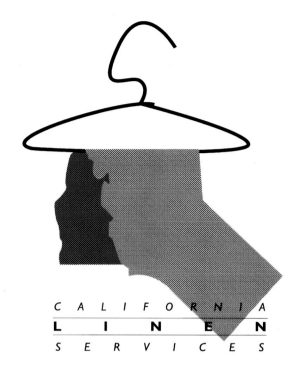

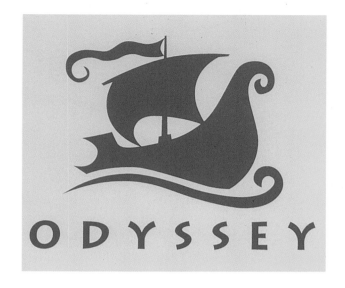

DESIGN FIRM | ADELE BASS + CO. DESIGN
ALL DESIGN | ADELE BASS
CLIENT | CALIFORNIA LINEN SERVICES
TOOLS | ADOBE ILLUSTRATOR

DESIGN FIRM | TRACY SABIN GRAPHIC DESIGN
ART DIRECTOR | ELISABETH PETERS
DESIGNER/ILLUSTRATOR | TRACY SABIN
CLIENT | HARCOURT BRACE & COMPANY/ODYSSEY
TOOLS | ADOBE ILLUSTRATOR

CHALMER ⊕ HVEDEHAVE

DESIGN FIRM | TRANSPARENT OFFICE
ART DIRECTOR/DESIGNER | VIBEKE NØDSKOV
CLIENT | CHALMER + HVEDEHAVE
TOOLS | QUARKXPRESS, ADOBE ILLUSTRATOR

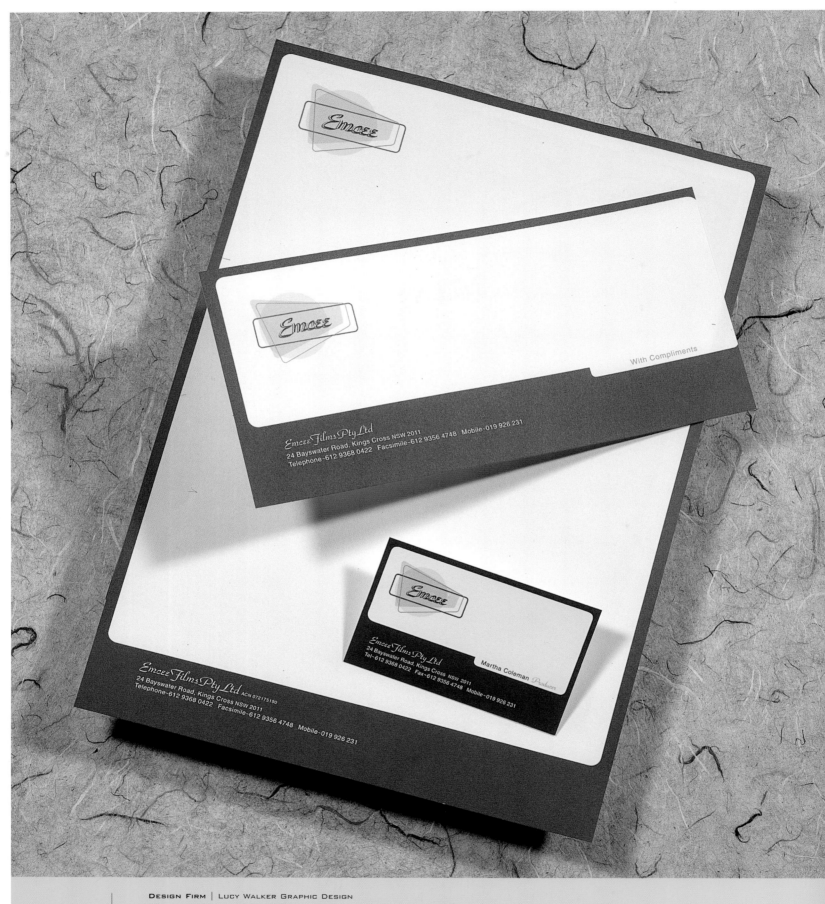

DESIGN FIRM | LUCY WALKER GRAPHIC DESIGN

ART DIRECTOR/DESIGNER | LUCY WALKER

CLIENT | EMCEE FILMS PTY. LTD.

TOOLS | ADOBE ILLUSTRATOR

PAPER/PRINTING | OCM IVORY WOVE

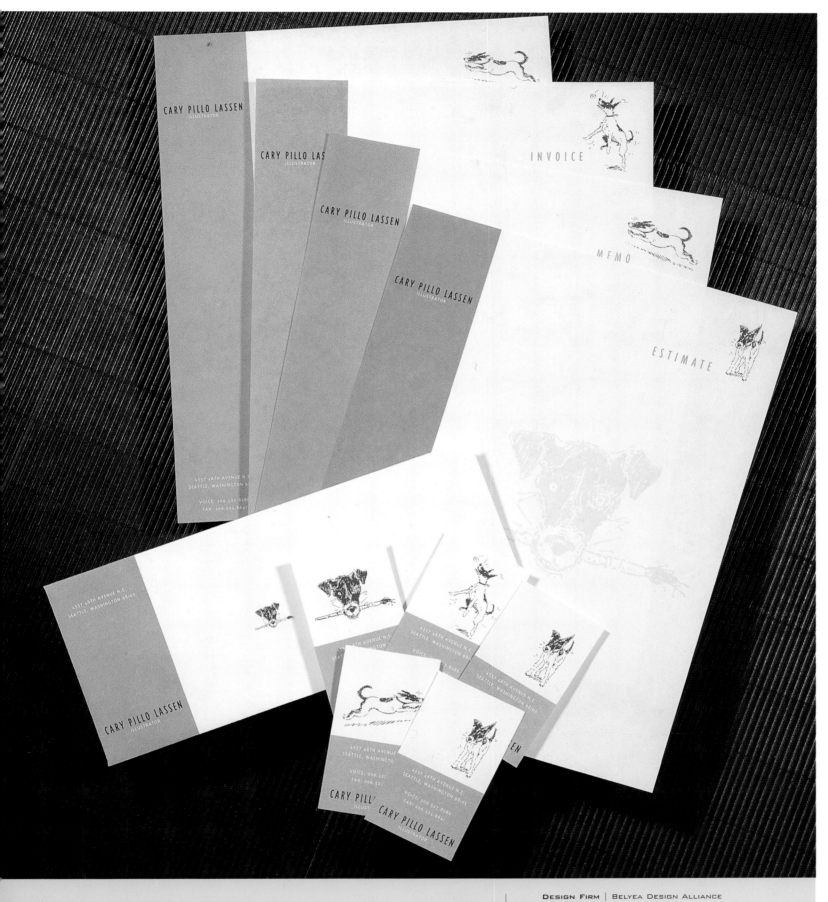

DESIGN FIRM | BELYEA DESIGN ALLIANCE
ART DIRECTOR | PATRICIA BELYEA
DESIGNER | TIM RUSZEL
ILLUSTRATOR | CARY PILLO LASSEN
CLIENT | CARY PILLO LASSEN

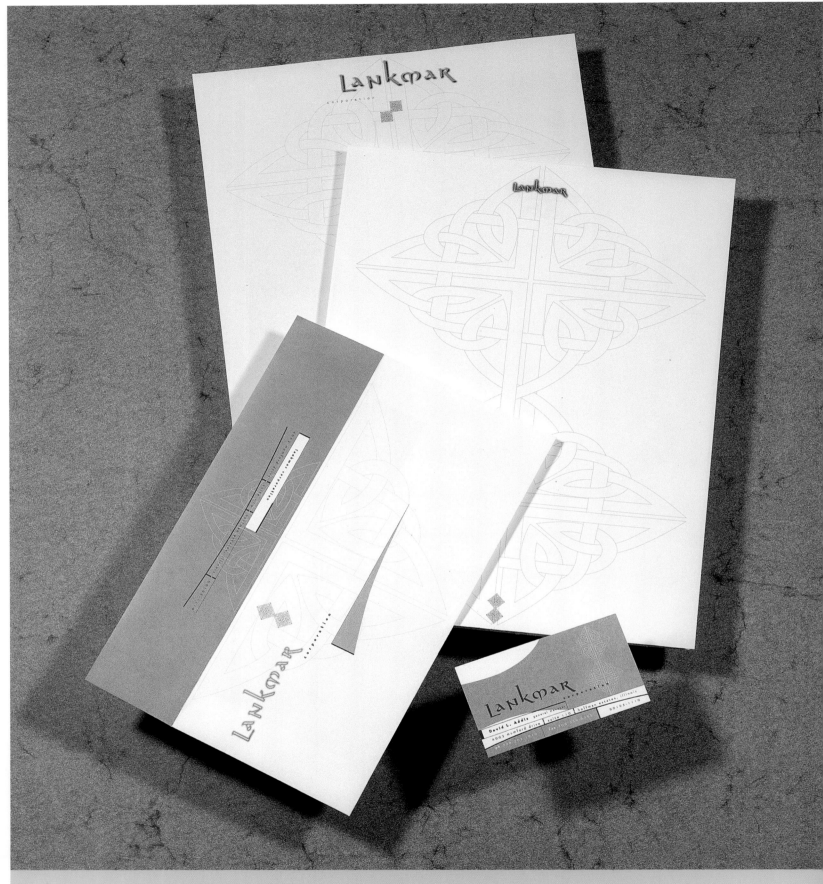

DESIGN FIRM | TANAGRAM

DESIGNER/ILLUSTRATOR | ANTHONY MA

CLIENT | LANKMAR CORPORATION

TOOLS | MACROMEDIA FREEHAND, ADOBE PHOTOSHOP

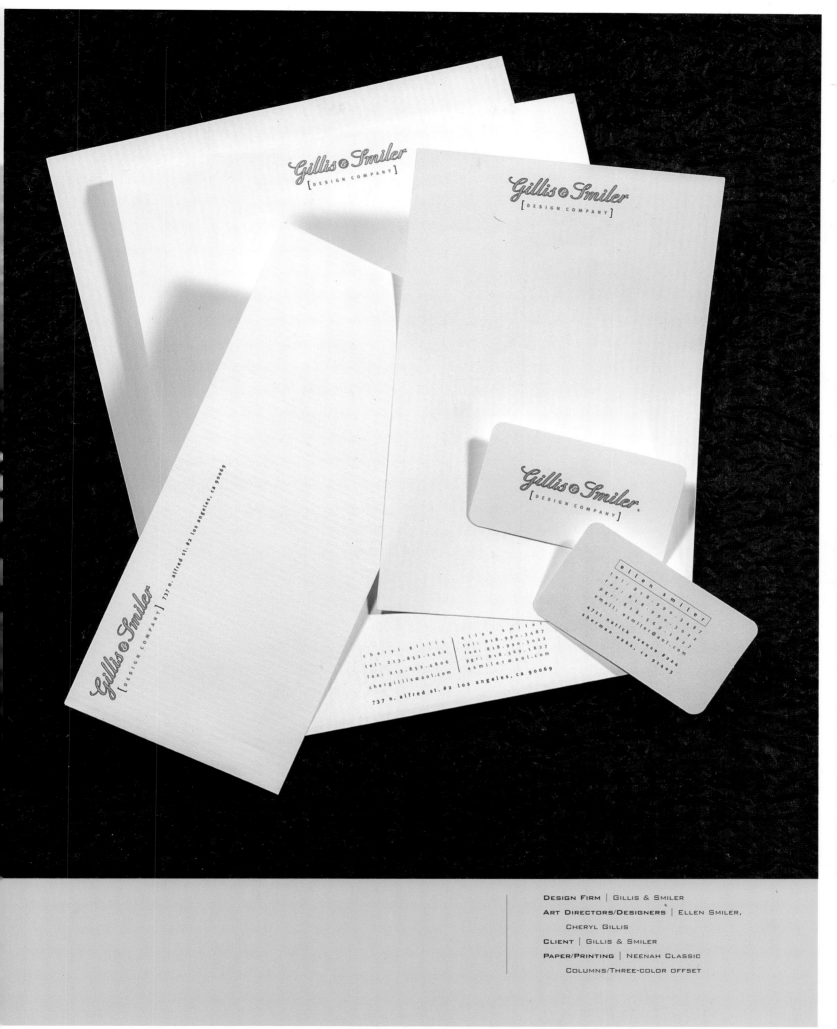

DESIGN FIRM | GILLIS & SMILER
ART DIRECTORS/DESIGNERS | ELLEN SMILER,
 CHERYL GILLIS
CLIENT | GILLIS & SMILER
PAPER/PRINTING | NEENAH CLASSIC
 COLUMNS/THREE-COLOR OFFSET

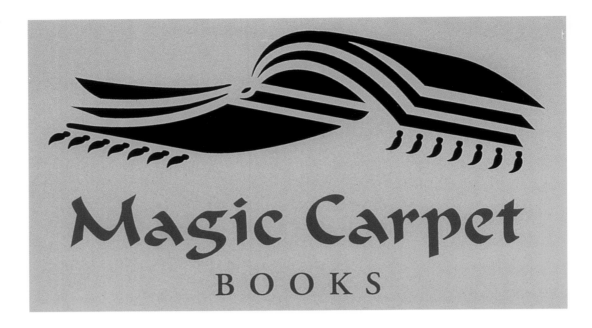

DESIGN FIRM | MIRES DESIGN
ART DIRECTOR | JOSÉ SERRANO
ILLUSTRATOR | TRACY SABIN
CLIENT | HARCOURT BRACE & COMPANY/MAGIC CARPET BOOKS
TOOLS | ADOBE ILLUSTRATOR

DESIGN FIRM | TIM NOONAN DESIGN
DESIGNER | TIM NOONAN
CLIENT | FIRSTAR BANK
TOOLS | ADOBE ILLUSTRATOR, QUARKXPRESS

DESIGN FIRM | MICHAEL STANARD DESIGN, INC.
ART DIRECTOR | MICHAEL STANARD
DESIGNERS | MICHAEL STANARD, KRISTY VANDEKERCKHOVE
ILLUSTRATOR | KRISTY VANDEKERCKHOVE
CLIENT | CITY OF EVANSTON
TOOLS | MACINTOSH, ADOBE ILLUSTRATOR

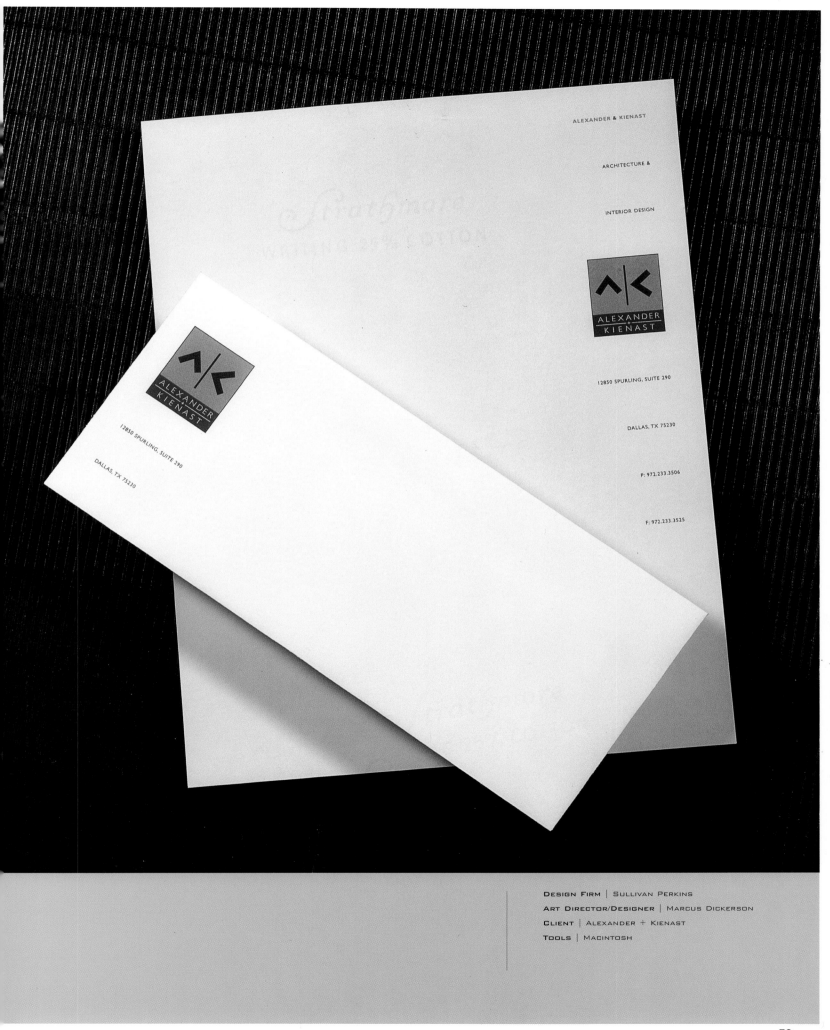

ALEXANDER & KIENAST

ARCHITECTURE &

INTERIOR DESIGN

12850 SPURLING, SUITE 290

DALLAS, TX 75230

P: 972.233.3506

F: 972.233.3525

DESIGN FIRM | SULLIVAN PERKINS
ART DIRECTOR/DESIGNER | MARCUS DICKERSON
CLIENT | ALEXANDER + KIENAST
TOOLS | MACINTOSH

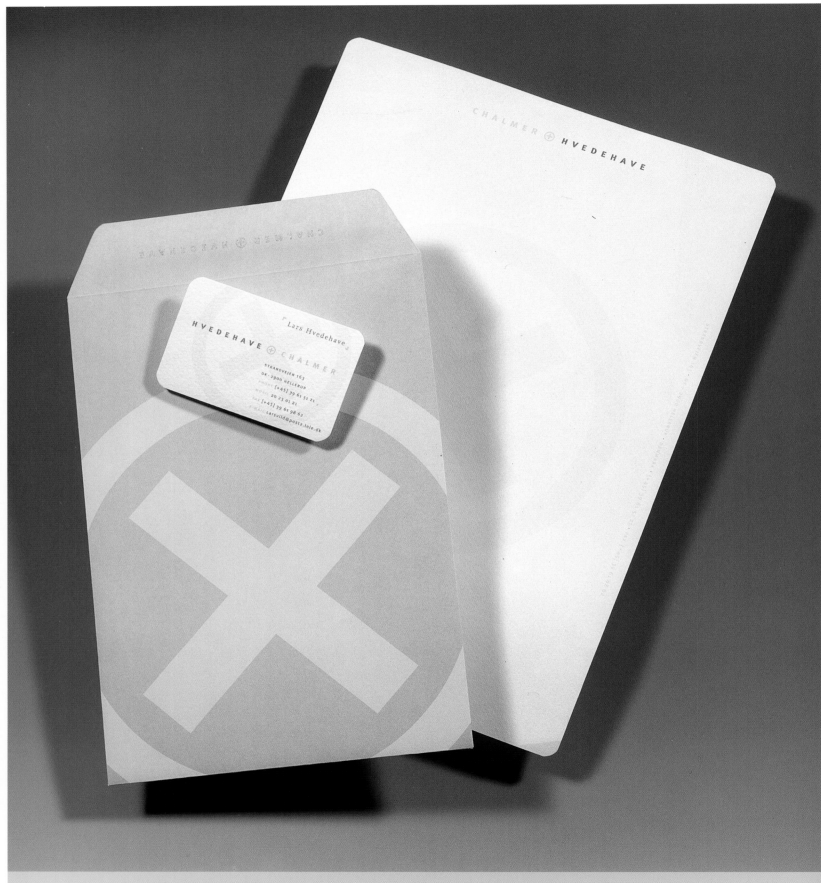

DESIGN FIRM | TRANSPARENT OFFICE

ART DIRECTOR/DESIGNER | VIBEKE NØDSKOV

CLIENT | CHALMER + HVEDEHAVE

TOOLS | QUARKXPRESS, ADOBE ILLUSTRATOR

PAPER/PRINTING | FAUNA RC 100G. IVORY/COLOR IT GREY

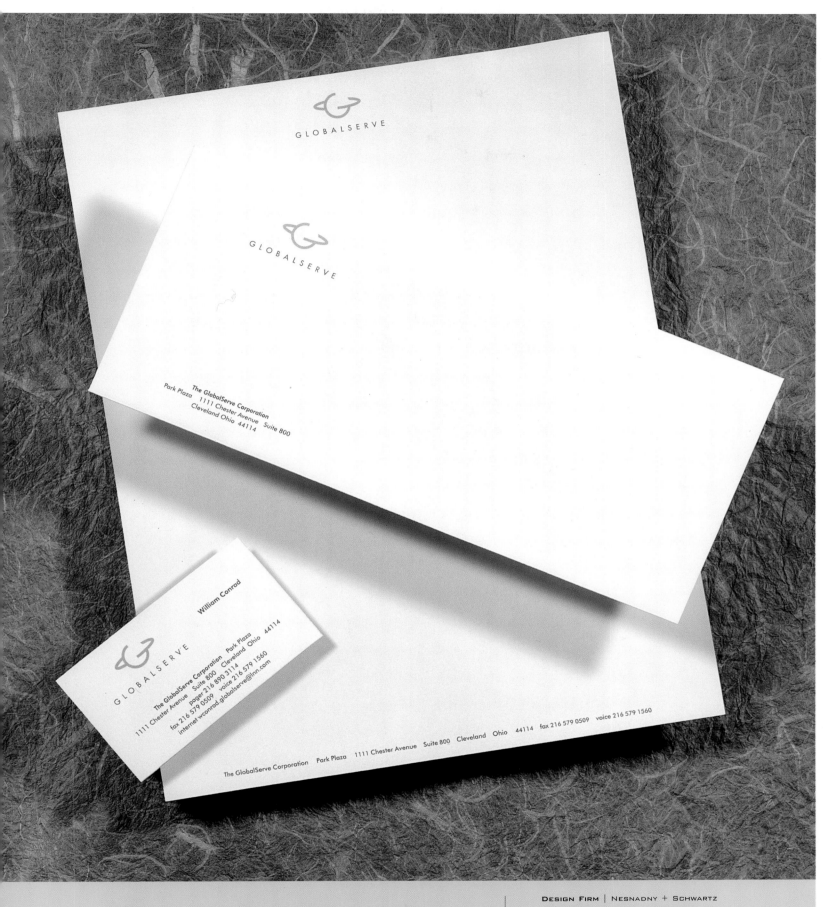

DESIGN FIRM | NESNADNY + SCHWARTZ

ALL DESIGN | GREGORY OZNOWICH

CLIENT | THE GLOBALSERVE CORPORATION

PAPER/PRINTING | MANADNOCK

STROLITE/HEXAGRAPHICS

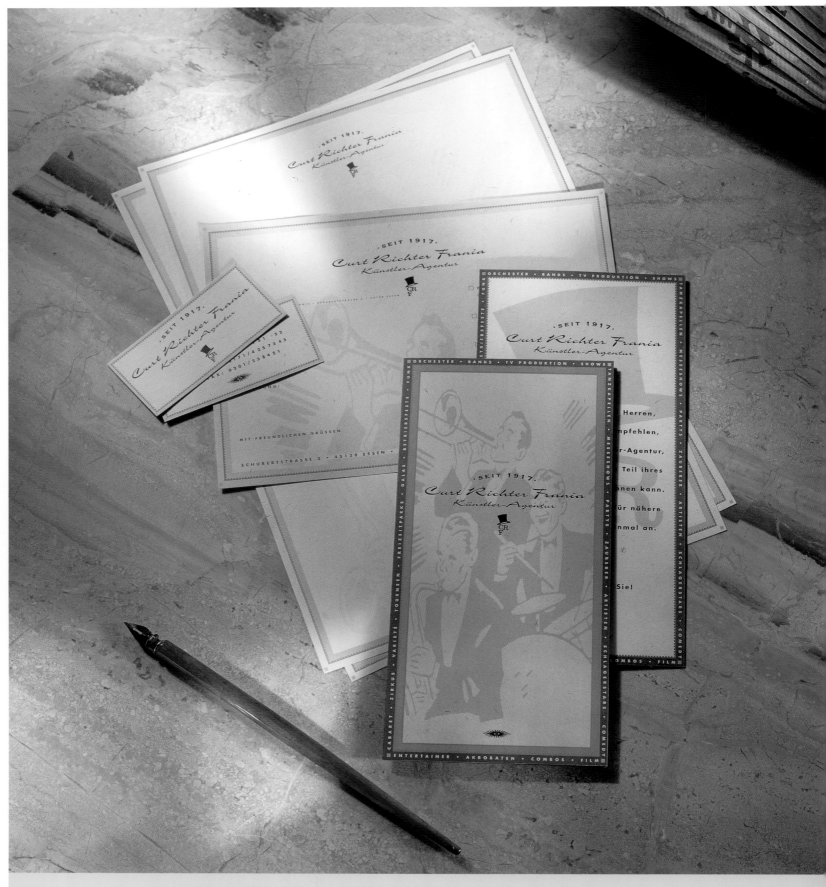

DESIGN FIRM | VOSS DESIGN
ART DIRECTOR/DESIGNER | AXEL VOSS
CLIENT | CURT RICHTER FANIA, ARTIST-AGENCY
PAPER/PRINTING | GMUND SILENCIUM

ACNielsen Day

DESIGN FIRM | WEBSTER DESIGN ASSOCIATES
ART DIRECTOR | DAVE WEBSTER
DESIGNER/ILLUSTRATOR | ANDREY NAGORNEY
CLIENT | ACNIELSEN
TOOLS | ADOBE ILLUSTRATOR

SPOT
SATELLITE

DESIGN FIRM | BARBARA BROWN MARKETING & DESIGN
ART DIRECTOR/DESIGNER | BARBARA BROWN
CLIENT | SPOT SATELLITE

DESIGN FIRM | DESIGN CENTER
ART DIRECTOR | JOHN REGER
DESIGNER | SHERWIN SCHWARTZROCK
CLIENT | MCGINLEY ASSOCIATES
TOOLS | MACINTOSH

DESIGN FIRM | DOGSTAR
DESIGNER/ILLUSTRATOR | RODNEY DAVIDSON
CLIENT | MARK GOOCH PHOTOGRAPHY
TOOLS | ADOBE ILLUSTRATOR, STREAMLINE, MACROMEDIA FREEHAND

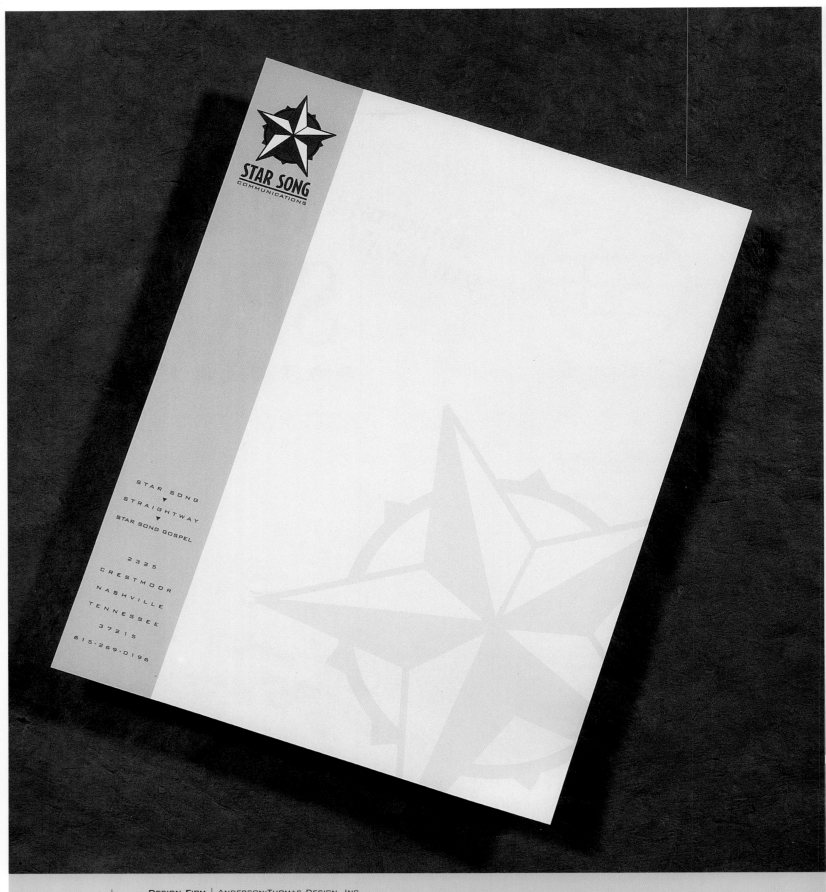

STAR SONG
▼
STRAIGHTWAY
▼
STAR SONG GOSPEL

2325
CRESTMOOR
NASHVILLE
TENNESSEE
37215
615-269-0196

DESIGN FIRM | ANDERSON-THOMAS DESIGN, INC.

ART DIRECTOR/DESIGNER | JOEL ANDERSON

CLIENT | STAR SONG COMMUNICATIONS

TOOLS | QUARKXPRESS, ADOBE ILLUSTRATOR

PAPER/PRINTING | CLASSIC CREST/BLACK AND 1 PMS

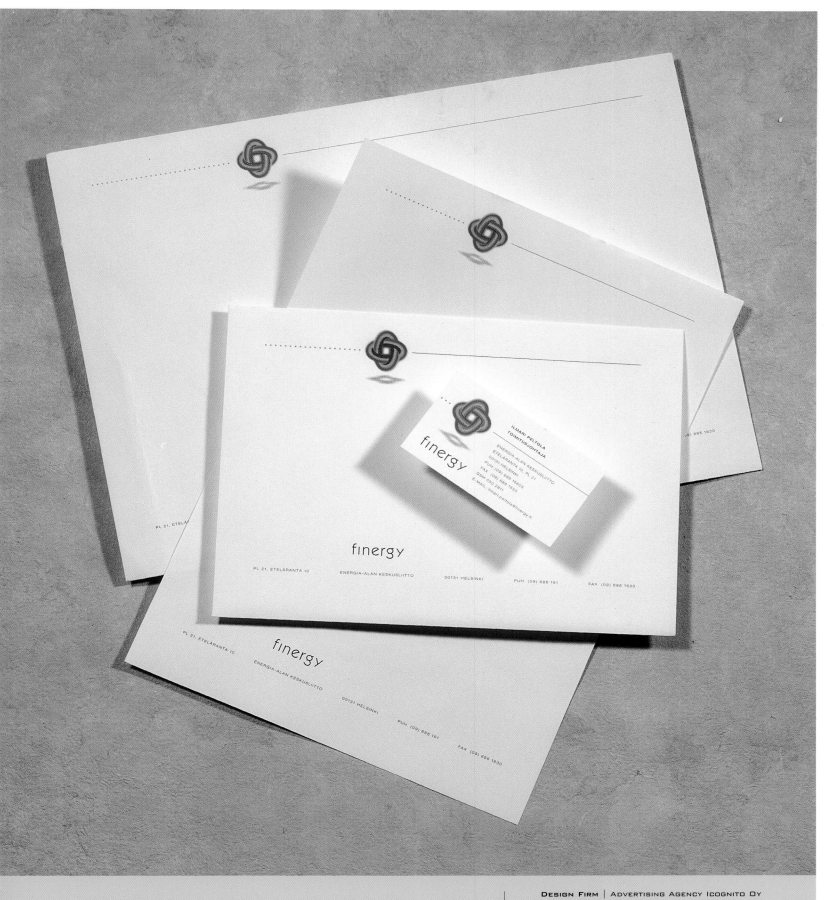

DESIGN FIRM | ADVERTISING AGENCY ICOGNITO OY

ART DIRECTOR | KEITO VUORINEN

DESIGNER | JP SILTANEN

ILLUSTRATOR | KEITO VUORINEN

CLIENT | ENERGIA-ALAN KESKUSLIITTO

TOOLS | MACROMEDIA FREEHAND, ADOBE PHOTOSHOP

PAPER/PRINTING | F. G. LÖNNBERG

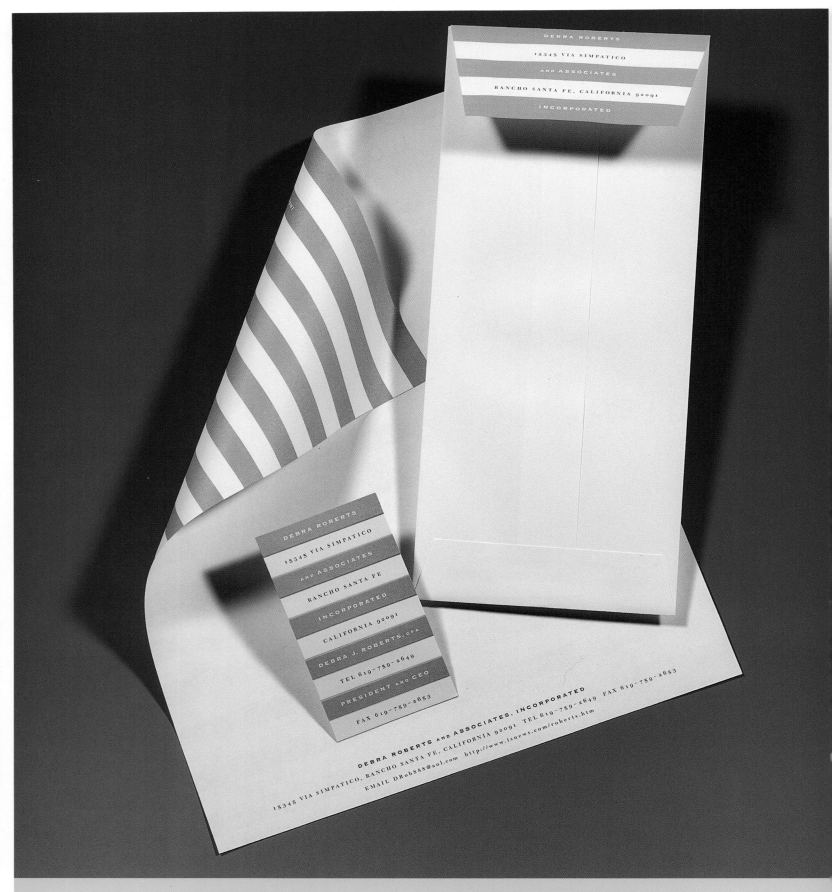

DESIGN FIRM | MIRES DESIGN
ART DIRECTOR | SCOTT MIRES
DESIGNERS | DEBORAH HORN, SCOTT MIRES
CLIENT | DEBRA ROBERTS AND ASSOCIATES

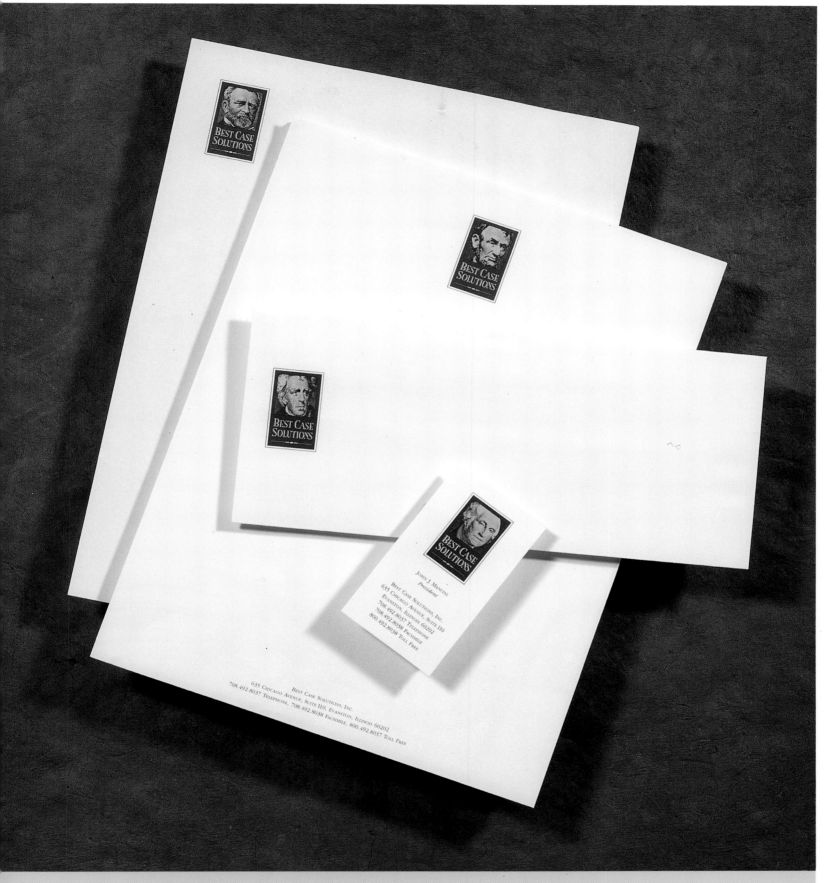

BEST CASE SOLUTIONS

Best Case Solutions, Inc.
635 Chicago Avenue, Suite 110
708.492.8037 Telephone, 708.492.8038 Facsimile, 800.492.8037 Toll Free, Evanston, Illinois 60202

John J. Mancini
President

Best Case Solutions, Inc.
635 Chicago Avenue, Suite 110
Evanston, Illinois 60202
708.492.8037 Telephone
708.492.8038 Facsimile
800.492.8038 Toll Free

DESIGN FIRM | MICHAEL STANARD DESIGN, INC.
ART DIRECTOR | MICHAEL STANARD
DESIGNER | KRISTY VANDEKERCKHOVE
CLIENT | JOHN MANCINI
TOOLS | MACINTOSH, ADOBE ILLUSTRATOR
PAPER/PRINTING | STRATHMORE WRITING

Jeff maul

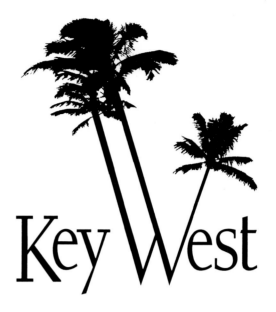

Key West

DESIGN FIRM | JEFF FISHER LOGOMOTIVES
ALL DESIGN | JEFF FISHER
CLIENT | JEFF MAUL, HAIR STYLIST
TOOLS | MACROMEDIA FREEHAND

DESIGN FIRM | MACVICAR DESIGN & COMMUNICATIONS
ALL DESIGN | WILLIAM A. GORDON
CLIENT | FEDERAL DATA CORPORATION
TOOLS | PEN, INK; ADOBE ILLUSTRATOR

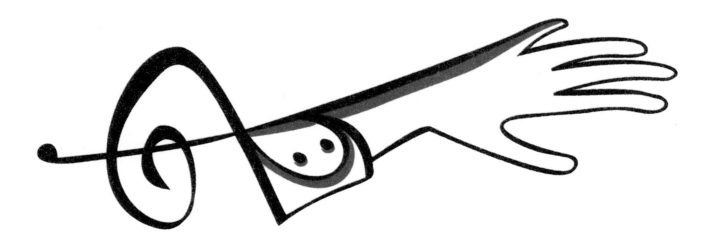

Vladimir Svoysky

DESIGN FIRM | CECILY ROBERTS DESIGN
ALL DESIGN | CECILY ROBERTS
CLIENT | VLADIMIR SVOYSKY
TOOLS | MACROMEDIA FREEHAND, QUARKXPRESS
PAPER/PRINTING | 80 LB. COVER ESSE, WHITE SMOOTH

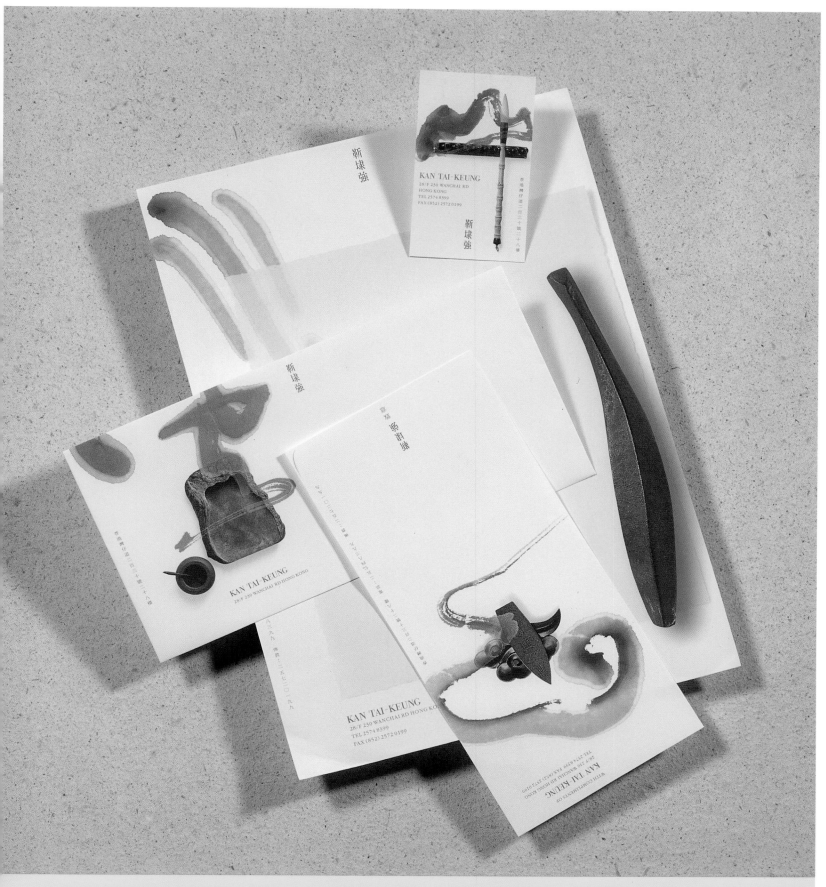

DESIGN FIRM | KAN & LAU DESIGN CONSULTANTS
ART DIRECTOR/DESIGNER | KAN TAI-KEUNG
CLIENT | KAN TAI-KEUNG
TOOLS | NAME CARD: CONQUEROR DIAMOND WHITE
CX22 250GSM; LETTERHEAD: CONQUEROR
DIAMOND WHITE CX22 100GSM; ENVELOPE:
CONQUEROR HIGHWHITE WOVE 100GSM/OFFSET

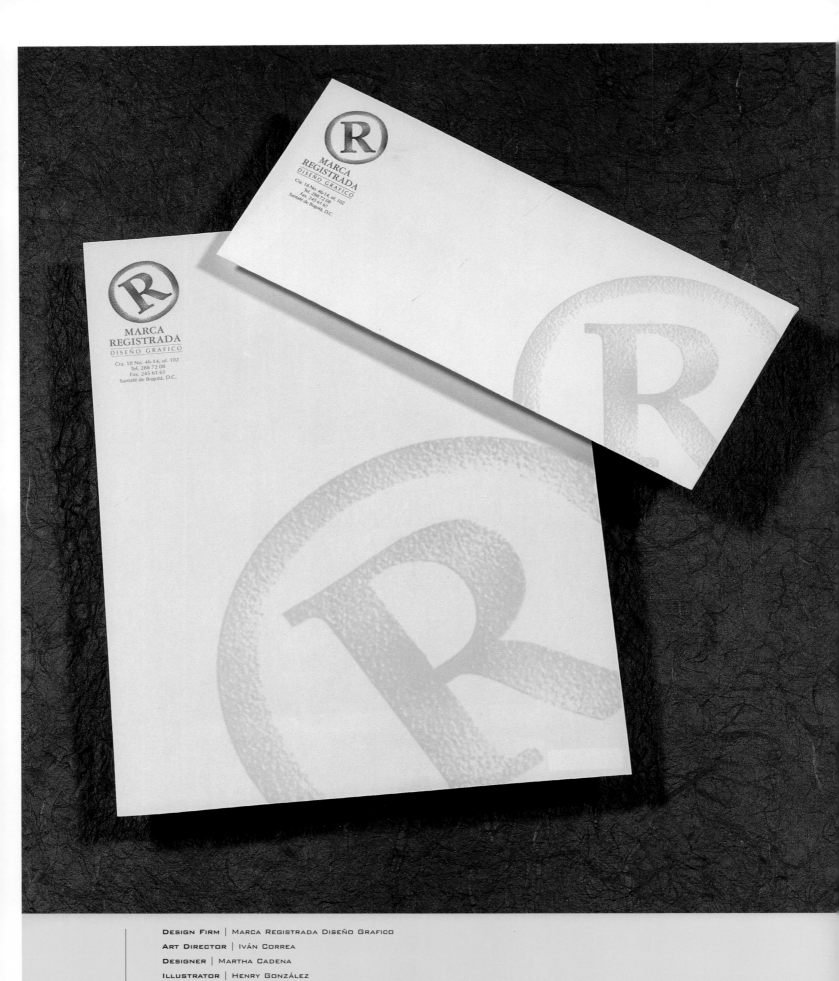

DESIGN FIRM | MARCA REGISTRADA DISEÑO GRAFICO

ART DIRECTOR | IVÁN CORREA

DESIGNER | MARTHA CADENA

ILLUSTRATOR | HENRY GONZÁLEZ

CLIENT | MARCA REGISTRADA DISEÑO GRAFICO

TOOLS | ADOBE PHOTOSHOP, MACINTOSH

PAPER/PRINTING | EDICIONES ANTROPOS (TORREÓN OFFSET)

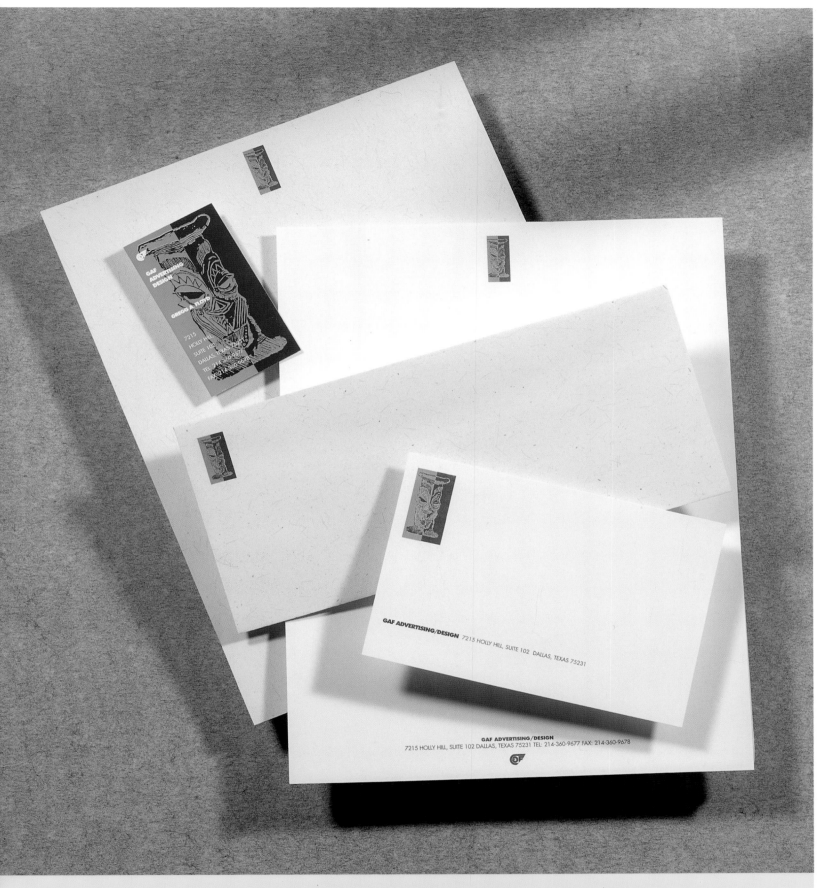

DESIGN FIRM | GAF Advertising Design

ALL DESIGN | Gregg A. Floyd

CLIENT | GAF Advertising Design

TOOLS | Woodcut, QuarkXPress

PAPER/PRINTING | Concret/Two color spot litho

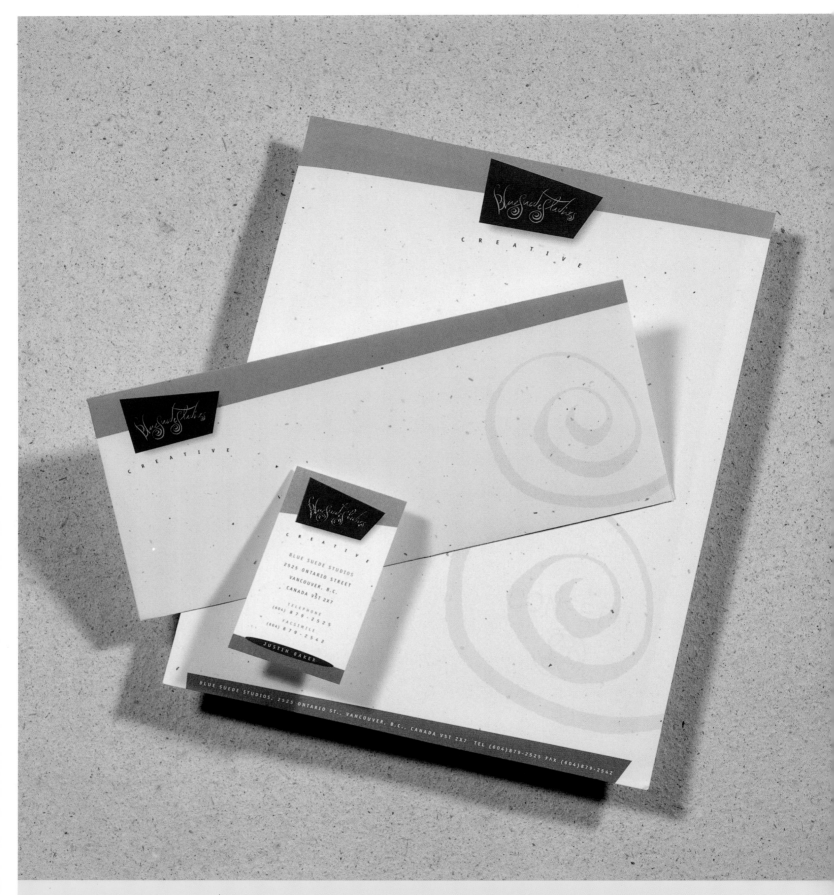

DESIGN FIRM | BLUE SUEDE STUDIOS
ART DIRECTOR | DAVE KENNEDY
DESIGNER/ILLUSTRATOR | JUSTIN BAKER
CLIENT | BLUE SUEDE STUDIOS
PAPER/PRINTING | CONFETTI/ULTRATECH PRINTERS

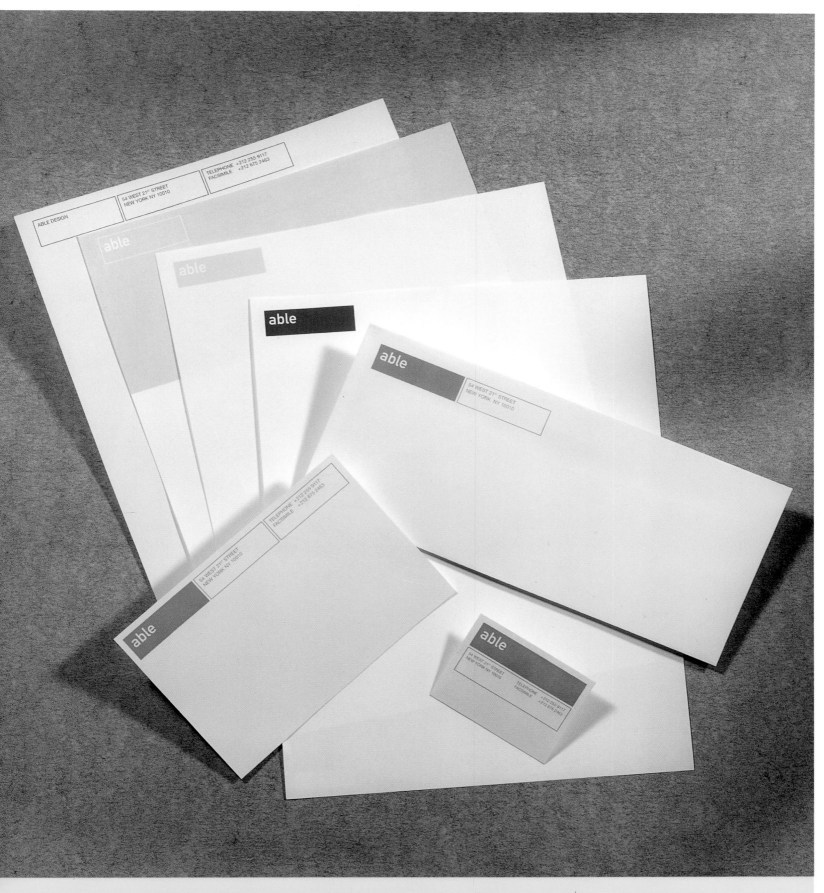

DESIGN FIRM | ABLE DESIGN, INC.

ART DIRECTORS | STUART HARVEY LEE, MARTHA DAVIS

DESIGNER | MARTIN PERRIN

CLIENT | ABLE DESIGN, INC.

TOOLS | POWER MACINTOSH, QUARKXPRESS

PAPER/PRINTING | BECKETT EXPRESSION, ICEBERG, 24 LB.

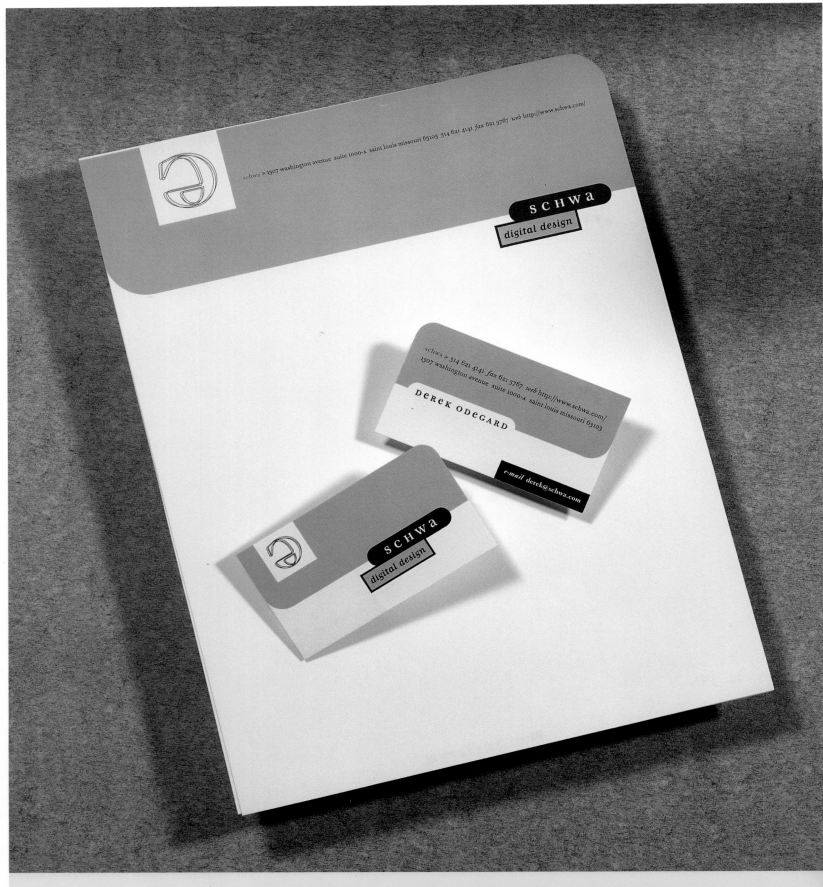

DESIGN FIRM | PHOENIX CREATIVE

ART DIRECTOR | ERIC THOELKE

DESIGNERS/ILLUSTRATORS | ERIC THOELKE, STEVE WIENKE

CLIENT | SCHWA DIGITAL DESIGN

TOOLS | ADOBE ILLUSTRATOR, QUARKXPRESS

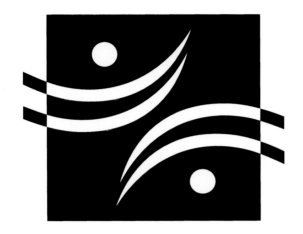

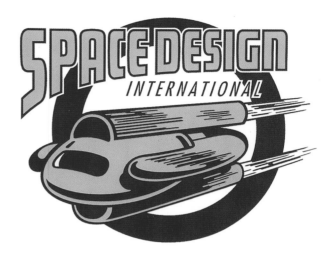

DESIGN FIRM | STEWART MONDERER DESIGN, INC.

ART DIRECTOR | STEWART MONDERER

DESIGNERS | AIME LECUSAY, STEWART MONDERER

ILLUSTRATOR | AIME LECUSAY

CLIENT | CORPORATE COMMUNICATIONS, INC.

TOOLS | ADOBE ILLUSTRATOR

DESIGN FIRM | SPACE DESIGN INTERNATIONAL

ALL DESIGN | TIM A. FRAME

CLIENT | SPACE DESIGN INTERNATIONAL

TOOLS | ADOBE ILLUSTRATOR

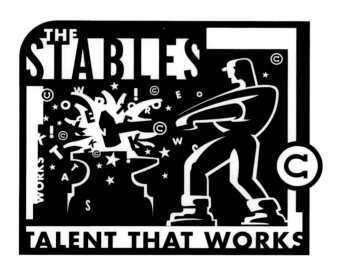

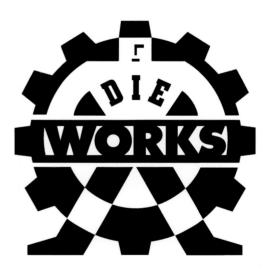

DESIGN FIRM | INSIGHT DESIGN COMMUNICATIONS

ALL DESIGN | SHERRIE HOLDEMAN, TRACY HOLDEMAN

CLIENT | THE STABLES

TOOLS | POWER MACINTOSH, MACROMEDIA FREEHAND

DESIGN FIRM | WEBSTER DESIGN ASSOCIATES

ART DIRECTOR | DAVE WEBSTER

DESIGNER/ILLUSTRATOR | ANDREY NAGORNY

CLIENT | DIE WORKS

TOOLS | MACROMEDIA FREEHAND

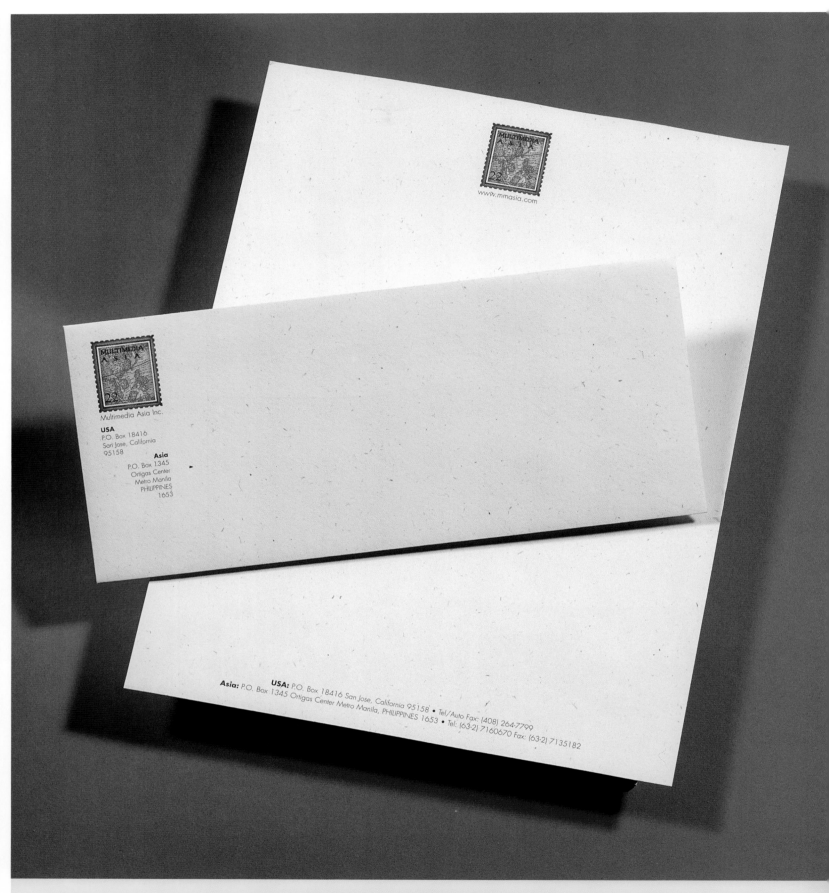

www.mmasia.com

MULTIMEDIA
A S I A
22
Multimedia Asia Inc.

USA
P.O. Box 18416
San Jose, California
95158

Asia
P.O. Box 1345
Ortigas Center
Metro Manila
PHILIPPINES
1653

Asia: P.O. Box 1345 Ortigas Center Metro Manila, PHILIPPINES 1653 • **USA:** P.O. Box 18416 San Jose, California 95158 • Tel/Auto Fax: (408) 264-7799 • Tel: (63-2) 7160670 Fax: (63-2) 7135182

DESIGN FIRM | MULTIMEDIA ASIA, INC.

ART DIRECTOR | G. LEE

CLIENT | MULTIMEDIA ASIA, INC.

TOOLS | ADOBE PAGEMAKER

PAPER/PRINTING | 80 LB. MILKWEED GENESIS

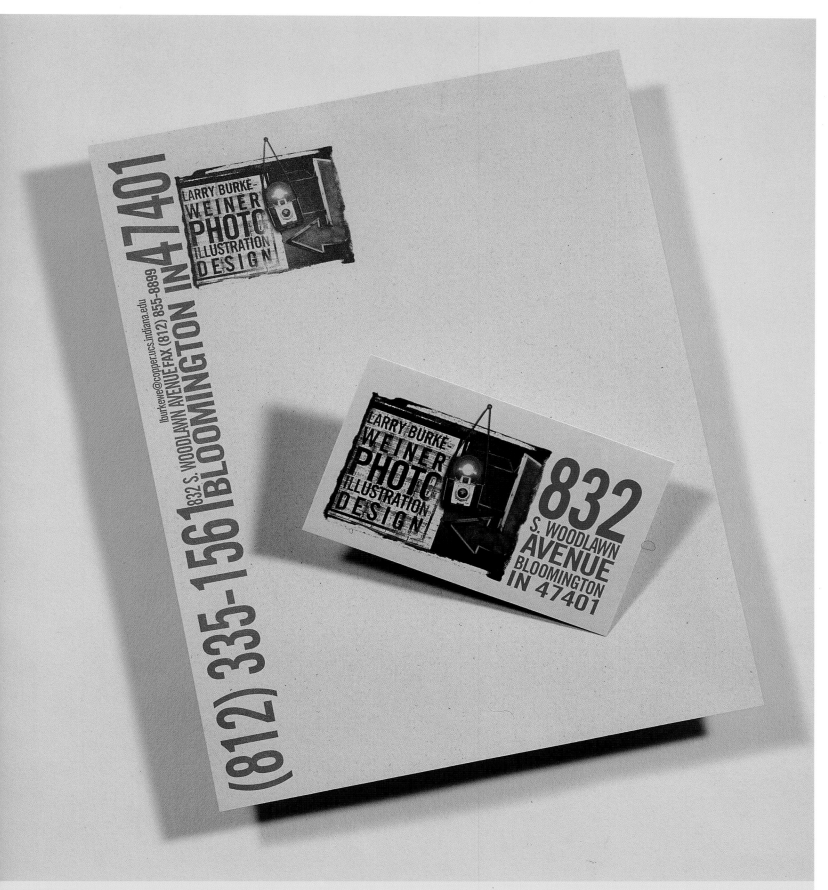

LARRY BURKE-WEINER
WEINER
PHOTO
ILLUSTRATION
DESIGN

lburkewe@copper.ucs.indiana.edu
(812) 855-8899
832 S. WOODLAWN AVENUE FAX
(812) 335-1561 BLOOMINGTON IN 47401

LARRY BURKE-WEINER
WEINER
PHOTO
ILLUSTRATION
DESIGN

832
S. WOODLAWN
AVENUE
BLOOMINGTON
IN 47401

DESIGN FIRM | LARRY BURKE-WEINER DESIGN

ALL DESIGN | LARRY BURKE-WEINER

CLIENT | LARRY BURKE-WEINER

TOOLS | ADOBE PHOTOSHOP, PAINTER,
ADOBE ILLUSTRATOR, QUARKXPRESS

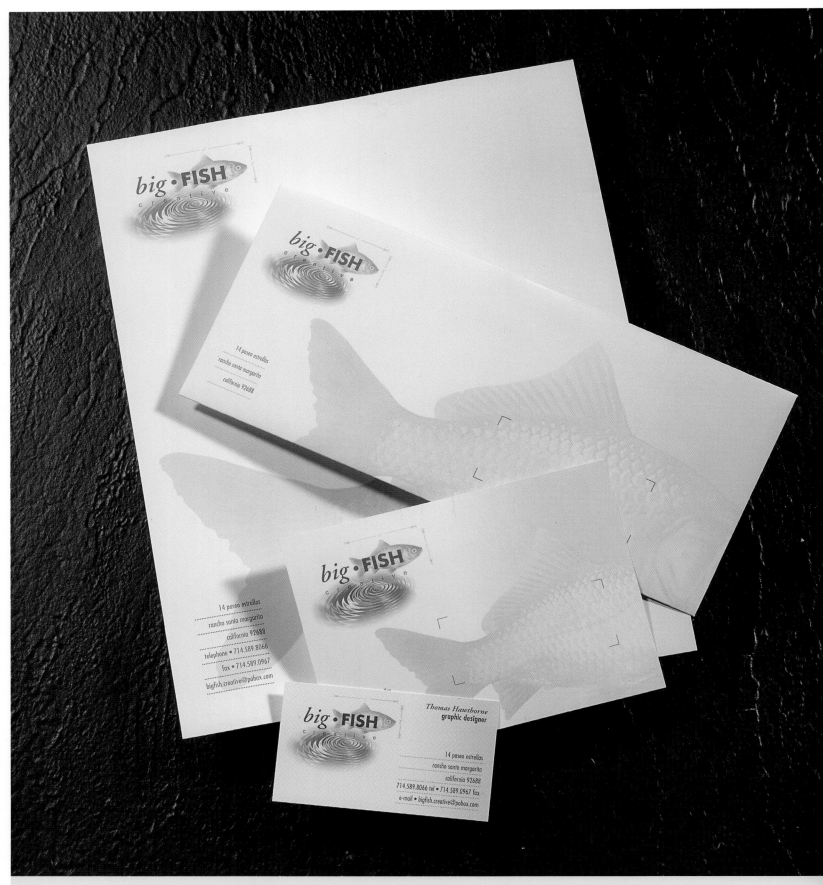

DESIGN FIRM | BIG FISH CREATIVE

ALL DESIGN | THOMAS HAWTHORNE

CLIENT | BIG FISH CREATIVE

TOOLS | QUARKXPRESS, ADOBE PHOTOSHOP, MACINTOSH

PAPER/PRINTING | STRATHMORE ELEMENTS

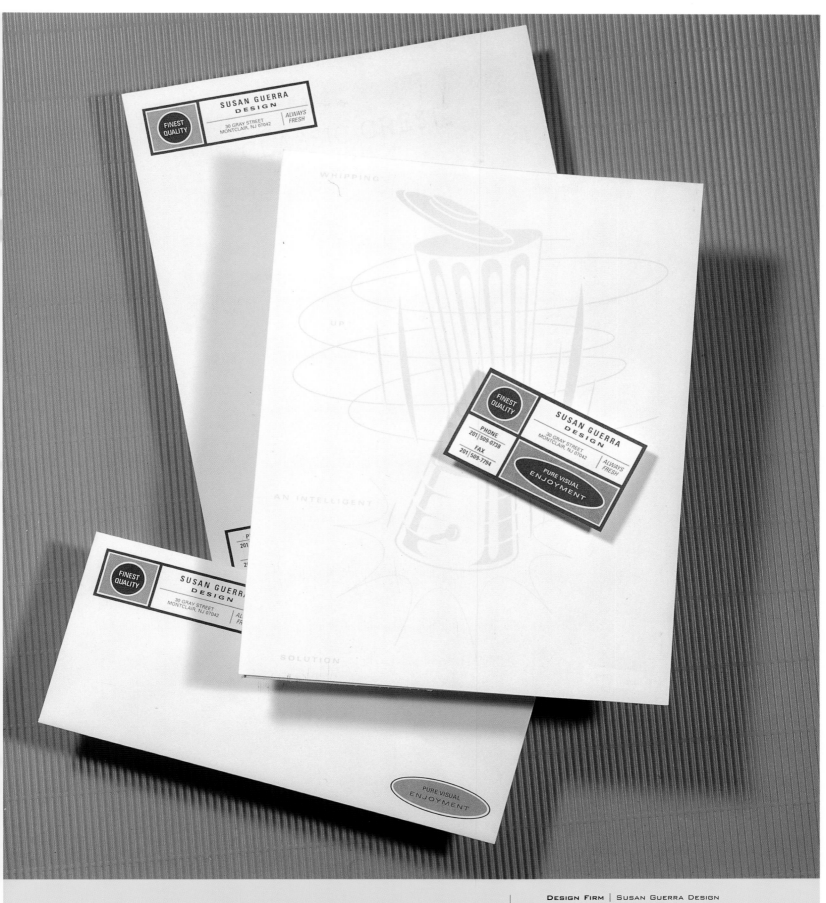

FINEST QUALITY

SUSAN GUERRA
DESIGN

30 GRAY STREET
MONTCLAIR, NJ 07042 | ALWAYS
FRESH

WHIPPING

UP

AN INTELLIGENT

SOLUTION

FINEST QUALITY

SUSAN GUERRA
DESIGN

PHONE
201 | 509-0738

FAX
201 | 509-7794

30 GRAY STREET
MONTCLAIR, NJ 07042 | ALWAYS
FRESH

PURE VISUAL
ENJOYMENT

FINEST QUALITY

SUSAN GUERRA
DESIGN

30 GRAY STREET
MONTCLAIR, NJ 07042

PURE VISUAL
ENJOYMENT

DESIGN FIRM | SUSAN GUERRA DESIGN
ART DIRECTOR/DESIGNER | SUSAN GUERRA
ILLUSTRATOR | METAL STUDIOS CLIP ART
CLIENT | SUSAN GUERRA DESIGN
TOOLS | QuarkXPress, ADOBE ILLUSTRATOR
PAPER/PRINTING | CLASSIC CREST/TWO COLOR

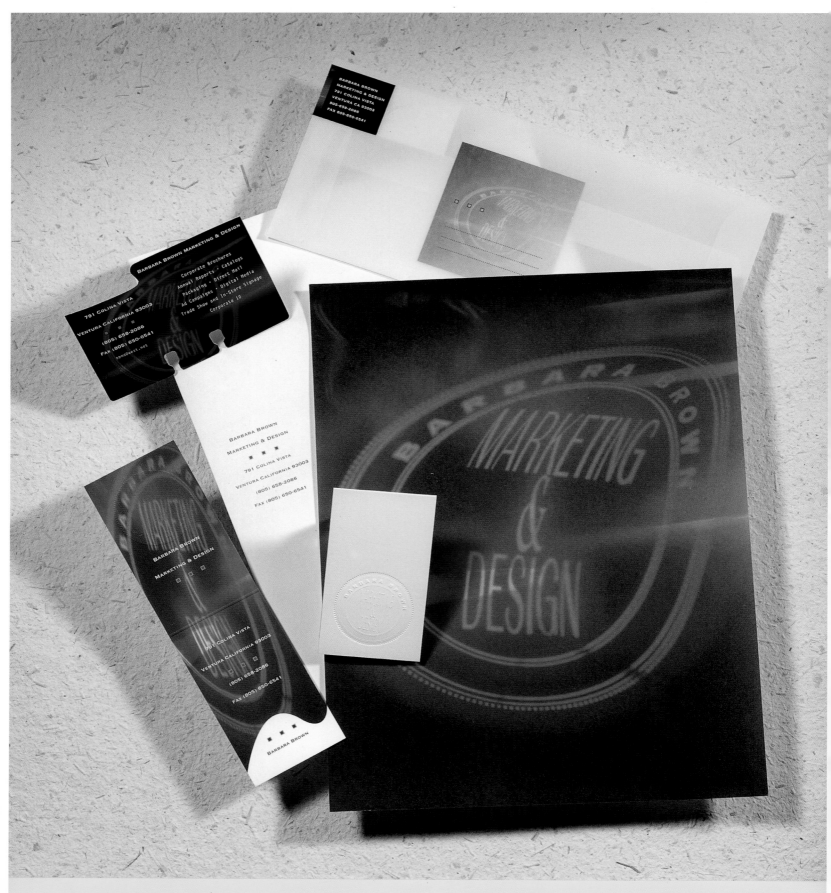

DESIGN FIRM | BARBARA BROWN MARKETING & DESIGN
ART DIRECTOR | BARBARA BROWN
DESIGNER | LANA CURTIN, PRODUCTION ARTIST
PHOTOGRAPHER | SCHAF PHOTO
CLIENT | BARBARA BROWN MARKETING & DESIGN

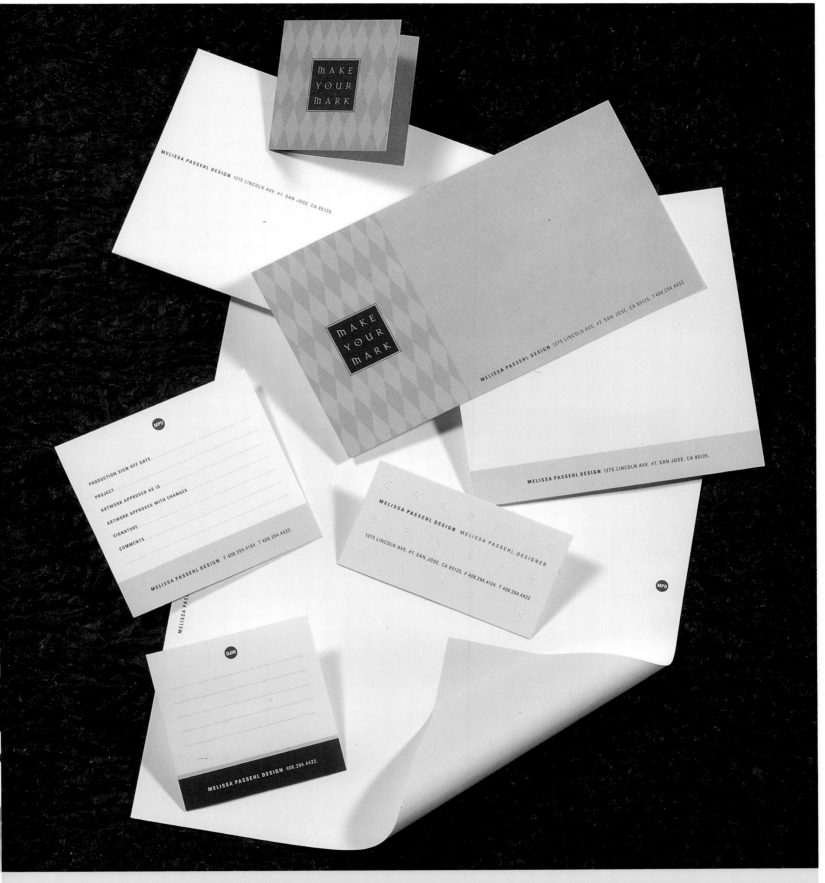

MAKE
YOUR
MARK

MELISSA PASSEHL DESIGN 1275 LINCOLN AVE. #7, SAN JOSE, CA 95125.

MAKE YOUR MARK

MELISSA PASSEHL DESIGN 1275 LINCOLN AVE. #7, SAN JOSE, CA 95125. T 408.294.4422.

MELISSA PASSEHL DESIGN 1275 LINCOLN AVE. #7, SAN JOSE, CA 95125.

MPD

PRODUCTION SIGN-OFF DATE
PROJECT
ARTWORK APPROVED AS IS
ARTWORK APPROVED WITH CHANGES
SIGNATURE
COMMENTS

MELISSA PASSEHL DESIGN F 408.294.4104. T 408.294.4422.

GRAPHIC DESIGN WORKS

MELISSA PASSEHL DESIGN MELISSA PASSEHL, DESIGNER
1275 LINCOLN AVE. #7, SAN JOSE, CA 95125, F 408.294.4104, T 408.294.4422.

MPD

MPD

MELISSA PASSEHL DESIGN 408.294.4422.

DESIGN FIRM | MELISSA PASSEHL DESIGN
ART DIRECTOR | MELISSA PASSEHL
DESIGNERS | MELISSA PASSEHL, CHARLOTTE LAMBRECHTS
CLIENT | MELISSA PASSEHL DESIGN

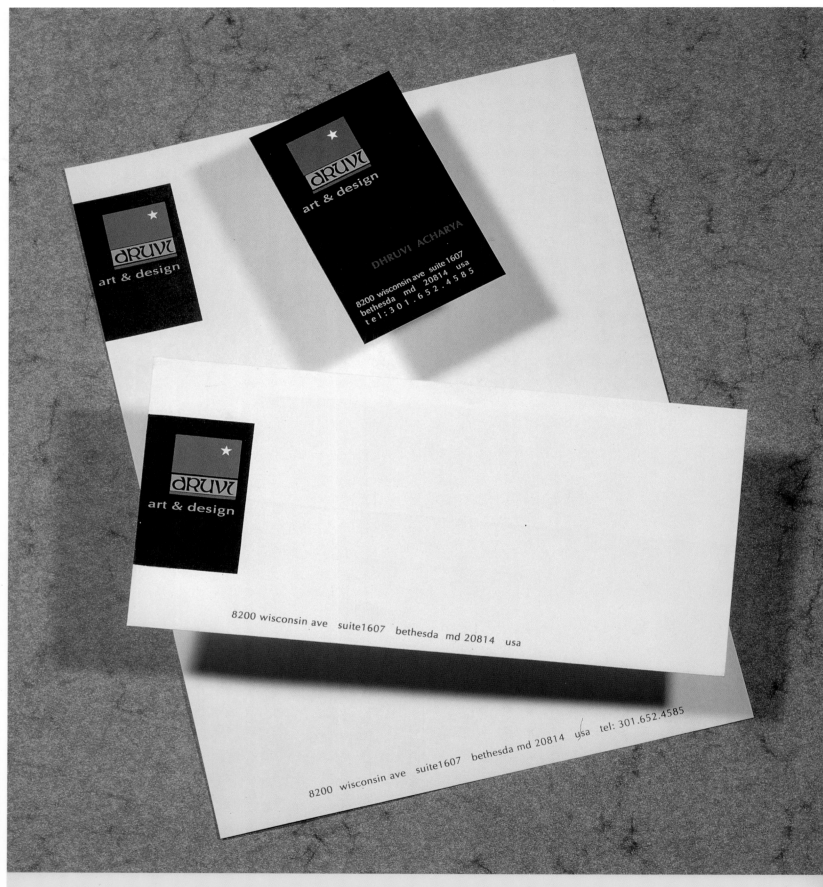

DESIGN FIRM | DRUVI ART AND DESIGN

ALL DESIGN | DRUVI ACHARYA

CLIENT | DRUVI ART AND DESIGN

PAPER/PRINTING | 80/100 LBS. CARD STOCK,
 BOND PAPER/SCREENPRINTING

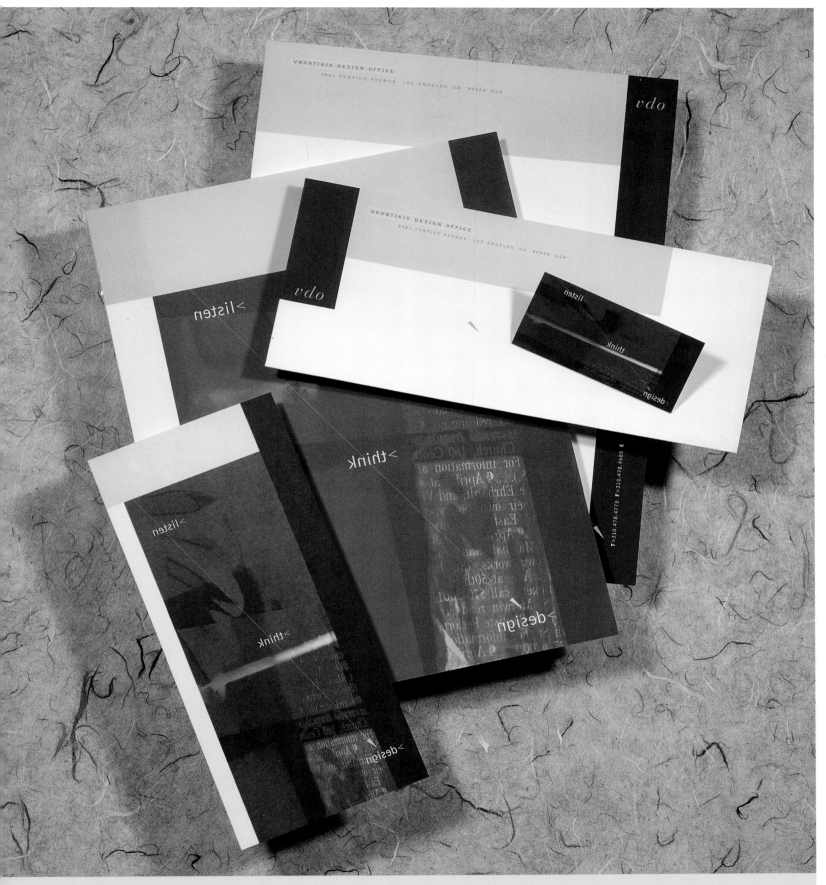

DESIGN FIRM | VRONTIKIS DESIGN OFFICE
ART DIRECTOR/DESIGNER | PETRULA VRONTIKIS
CLIENT | VRONTIKIS DESIGN OFFICE
TOOLS | QUARKXPRESS, ADOBE PHOTOSHOP
PAPER/PRINTING | NEENAH CLASSIC CREST/LOGIN PRINTING

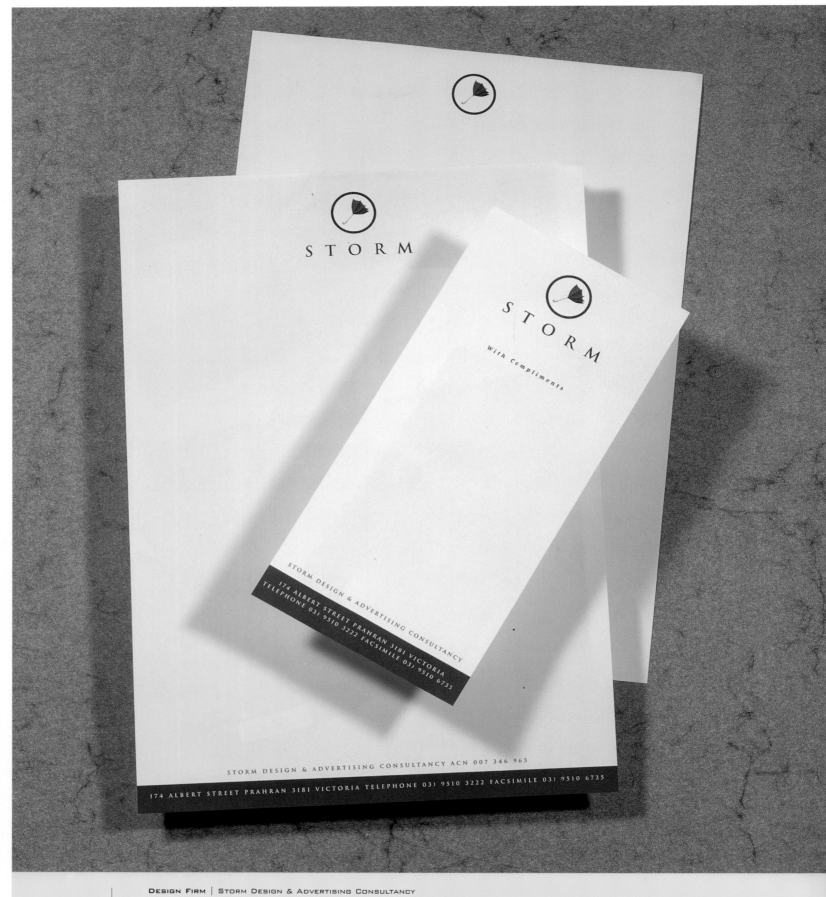

DESIGN FIRM | STORM DESIGN & ADVERTISING CONSULTANCY

ART DIRECTORS/DESIGNERS | DAVID ANSETT, DEAN BUTLER, JULIA JARVIS

PHOTOGRAPHER | MARCUS STRUZINA

CLIENT | STORM DESIGN & ADVERTISING CONSULTANCY

TOOLS | ADOBE PHOTOSHOP

PAPER/PRINTING | SAXTON SMOOTHE/FOUR COLOR PROCESS PLUS ONE

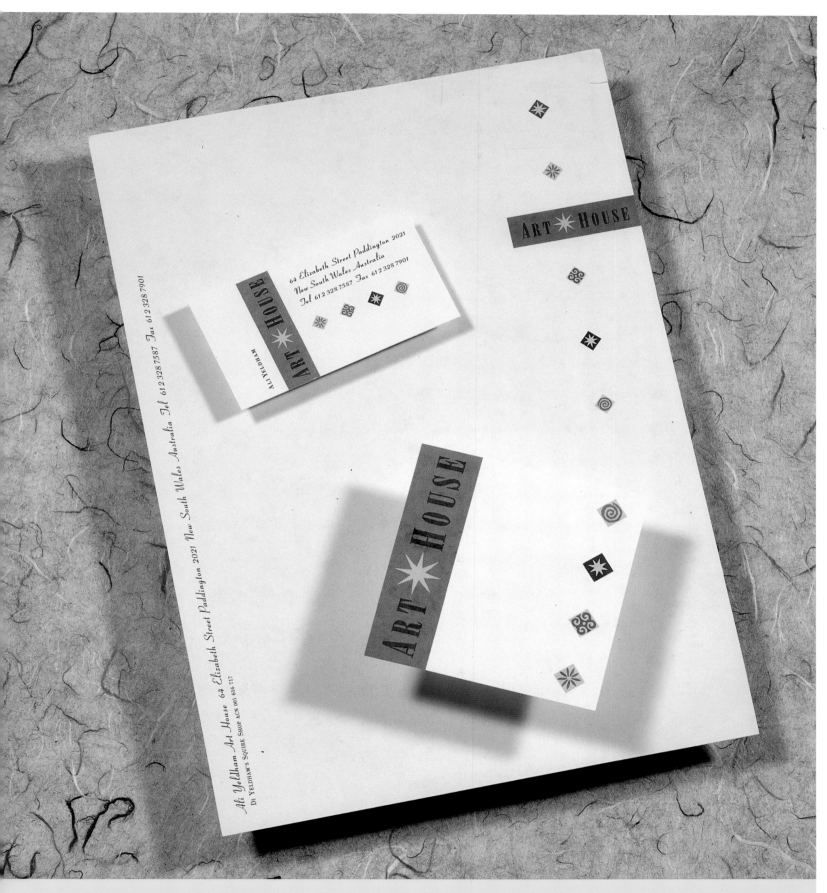

DESIGN FIRM | MOTHER GRAPHIC DESIGN

ALL DESIGN | KRISTIN THIEME

CLIENT | ART HOUSE

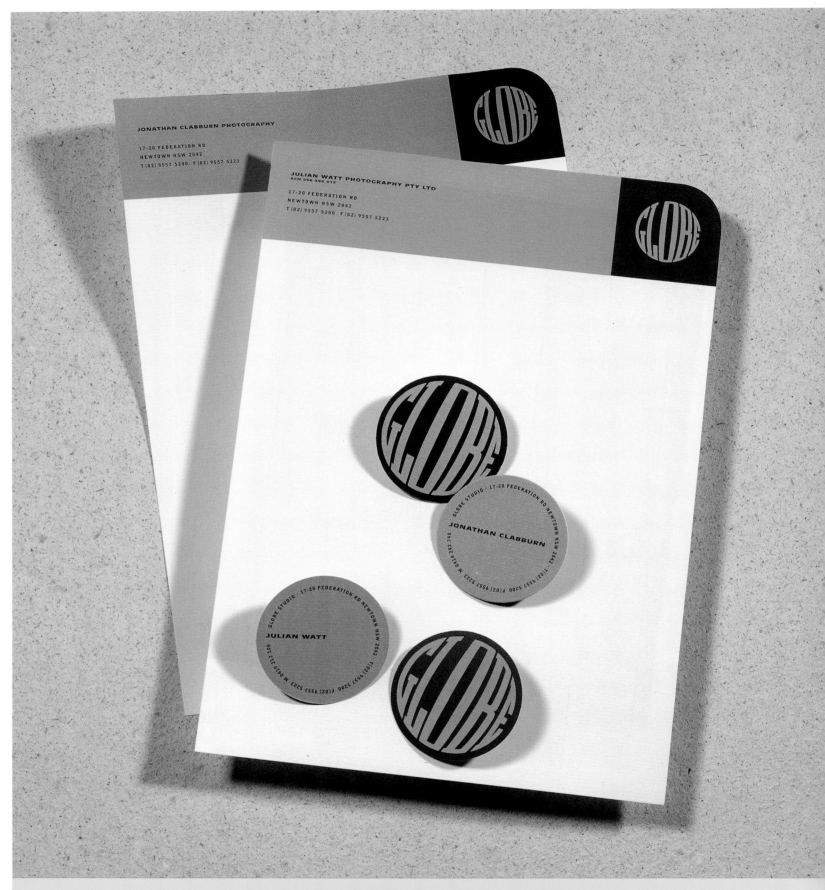

JONATHAN CLABBURN PHOTOGRAPHY

17-20 FEDERATION RD
NEWTOWN NSW 2042
T (02) 9557 5200 F (02) 9557 5223

GLOBE

JULIAN WATT PHOTOGRAPHY PTY LTD
ACN 056 396 813

17-20 FEDERATION RD
NEWTOWN NSW 2042
T (02) 9557 5200 F (02) 9557 5223

GLOBE

GLOBE STUDIO · 17-20 FEDERATION RD NEWTOWN NSW 2042 · T (02) 9557 5200 F (02) 9557 5223 M 0419 292 740

JONATHAN CLABBURN

GLOBE STUDIO · 17-20 FEDERATION RD NEWTOWN NSW 2042 · T (02) 9557 5200 F (02) 9557 5223 M 0419 212 906

JULIAN WATT

DESIGN FIRM | MOTHER GRAPHIC DESIGN
ART DIRECTOR/DESIGNER | KRISTIN THIEME
CLIENT | GLOBE STUDIO

DESIGN FIRM | GRAY CAT DESIGN
DESIGNER | LISA SCALISE
CLIENT | GRAY CAT DESIGN
PAPER/PRINTING | MOHAWK SUPERFINE/LAKE PRINTERS

DESIGN FIRM | OAKLEY DESIGN STUDIOS
ALL DESIGN | TIM OAKLEY
CLIENT | OAKLEY DESIGN STUDIOS
TOOLS | ADOBE ILLUSTRATOR

JUICE

DESIGN FIRM | JUICE DESIGN
ART DIRECTOR | BRETT M. CRITCHLOW
DESIGNERS | BRETT M. CRITCHLOW, MATT SMIALEK, MIMI PAJO
CLIENT | JUICE DESIGN

DESIGN FIRM | MALIK DESIGN
ALL DESIGN | DONNA MALIK
CLIENT | MALIK DESIGN
TOOLS | MACROMEDIA FREEHAND
PAPER/PRINTING | STRATHMORE RENEWAL

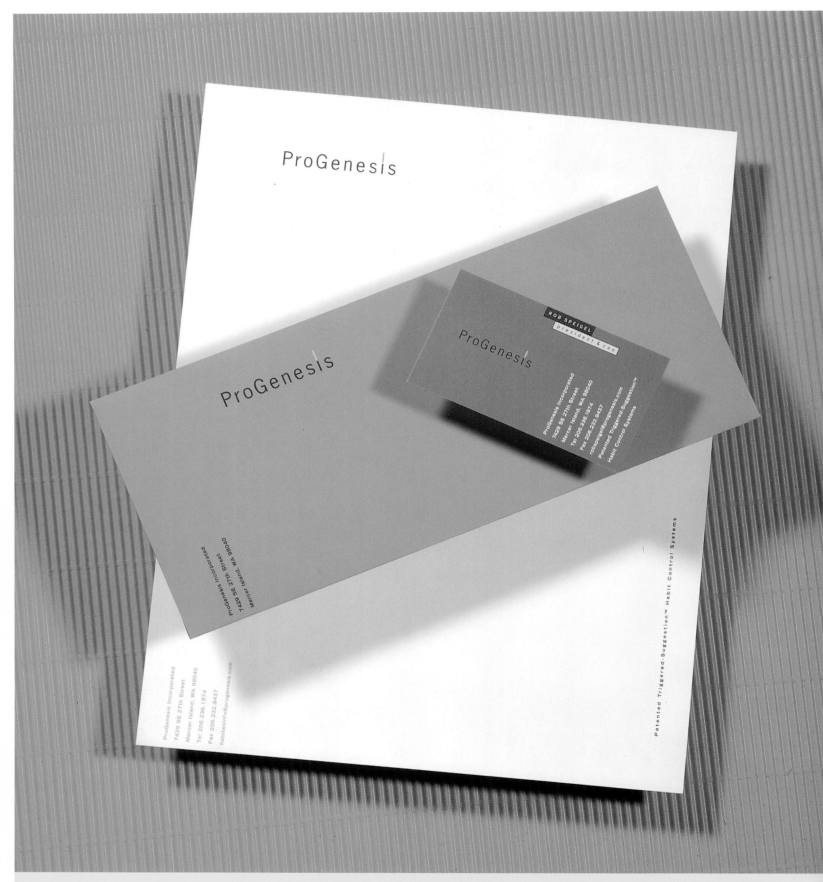

DESIGN FIRM | WIDMEYER DESIGN

ART DIRECTORS | KEN WIDMEYER, DALE HART

DESIGNER | DALE HART

CLIENT | PROGENESIS

TOOLS | POWER MACINTOSH, MACROMEDIA FREEHAND

PAPER/PRINTING | ENVIRONMENT/OFFSET

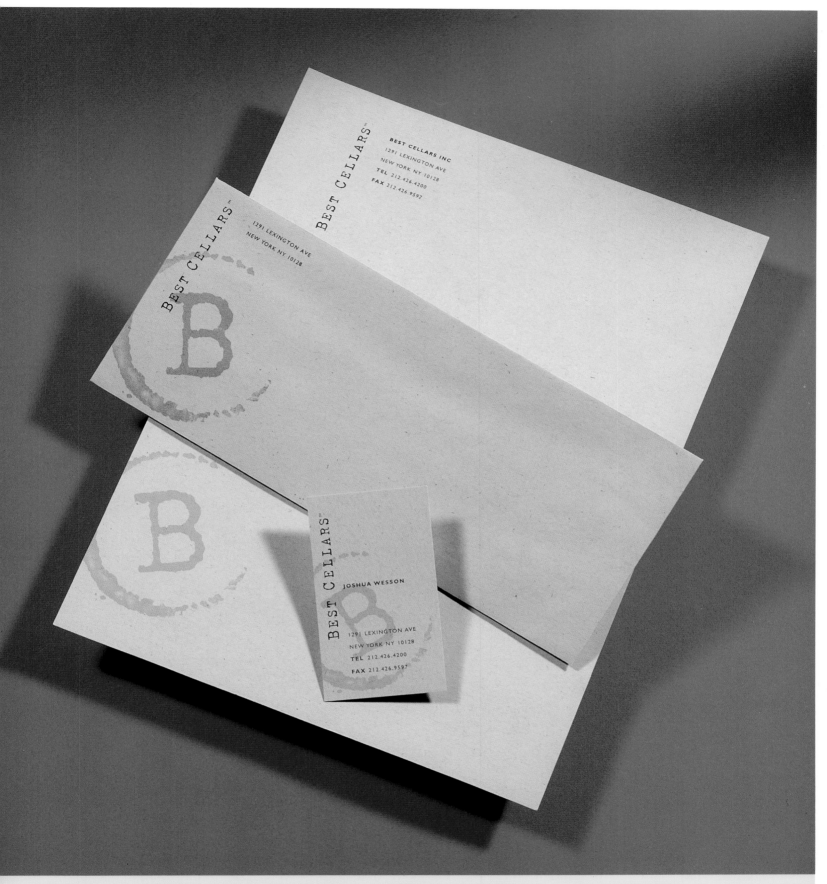

BEST CELLARS™

BEST CELLARS INC
1291 LEXINGTON AVE
NEW YORK NY 10128
TEL 212.426.4200
FAX 212.426.9597

BEST CELLARS™

1291 LEXINGTON AVE
NEW YORK NY 10128

BEST CELLARS™

JOSHUA WESSON

1291 LEXINGTON AVE
NEW YORK NY 10128
TEL 212.426.4200
FAX 212.426.9597

DESIGN FIRM | HORNALL ANDERSON DESIGN WORKS, INC.

ART DIRECTOR | JACK ANDERSON

DESIGNERS | JACK ANDERSON, LISA CERVENY,
JANA WILSON, DAVID BATES

CLIENT | BEST CELLARS

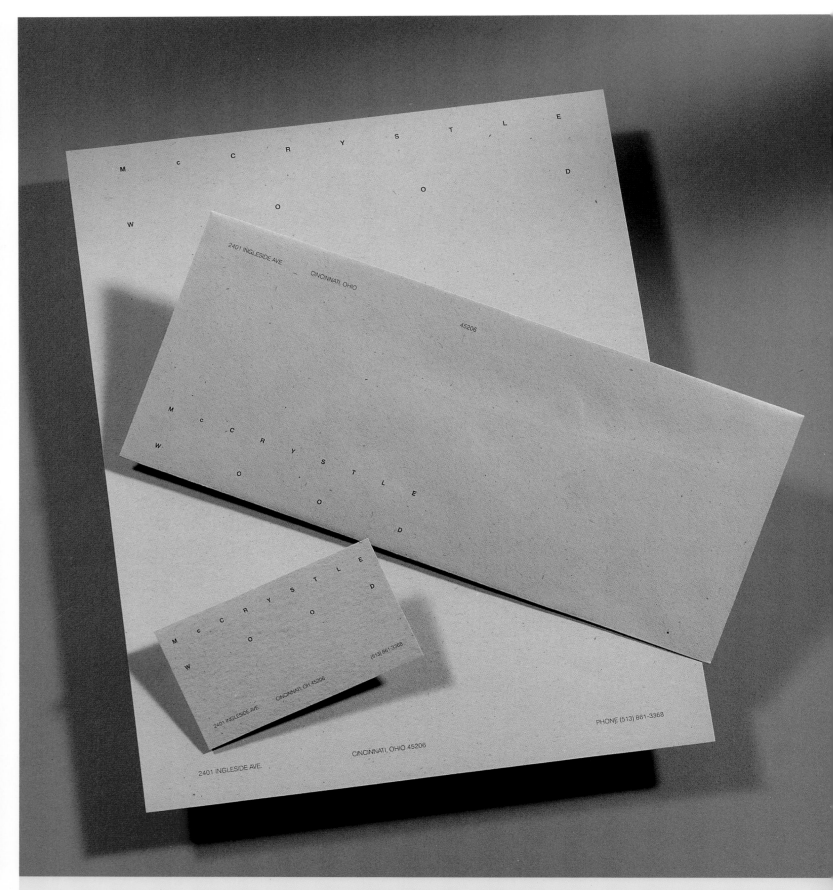

DESIGN FIRM | WOOD/BROD DESIGN

ART DIRECTOR/DESIGNER | STAN BROD

CLIENT | STAN BROD, McCRYSTLE WOOD

TOOLS | ADOBE ILLUSTRATOR

PAPER/PRINTING | SPECKLETONE/BERMAN PRINTING COMPANY

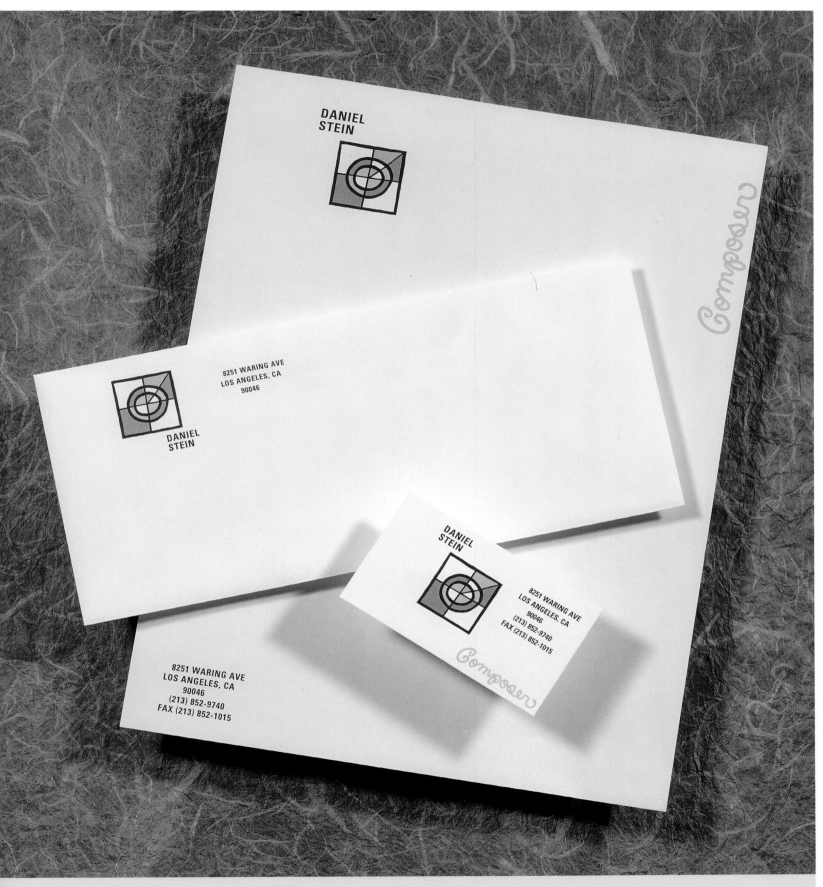

DESIGN FIRM | SUSAN GUERRA DESIGN

ALL DESIGN | SUSAN GUERRA DESIGN

CLIENT | DANIEL STEIN

TOOLS | ADOBE ILLUSTRATOR

PAPER/PRINTING | CLASSIC CREST/TWO COLOR

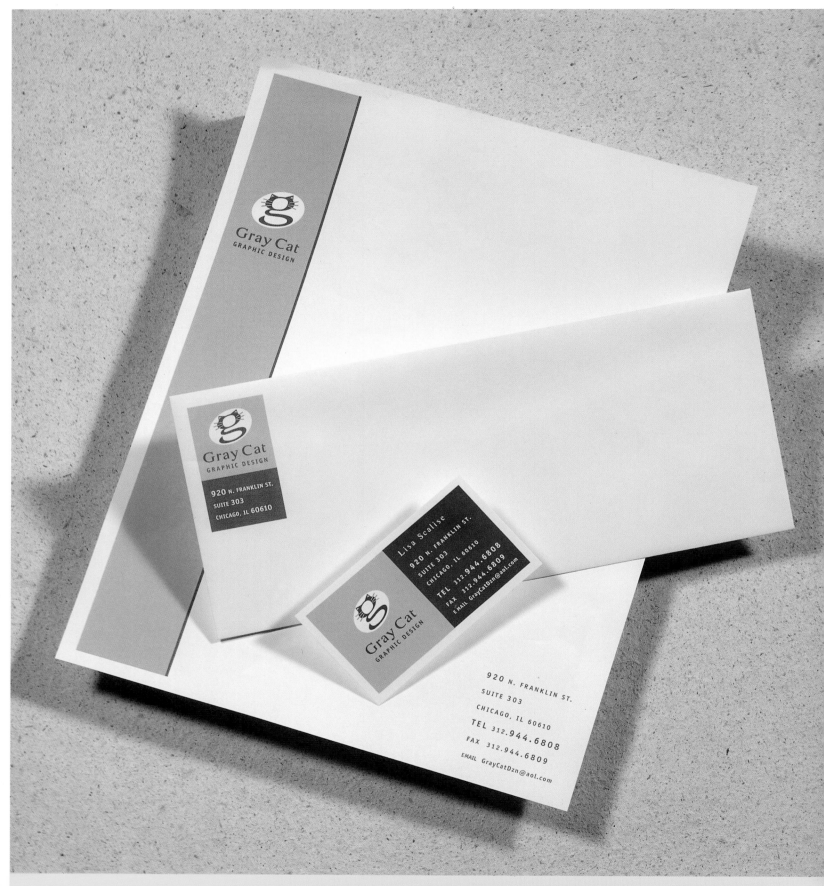

DESIGN FIRM | GRAY CAT DESIGN
DESIGNER | LISA SCALISE
CLIENT | GRAY CAT DESIGN
PAPER/PRINTING | MOHAWK SUPERFINE/LAKE PRINTERS

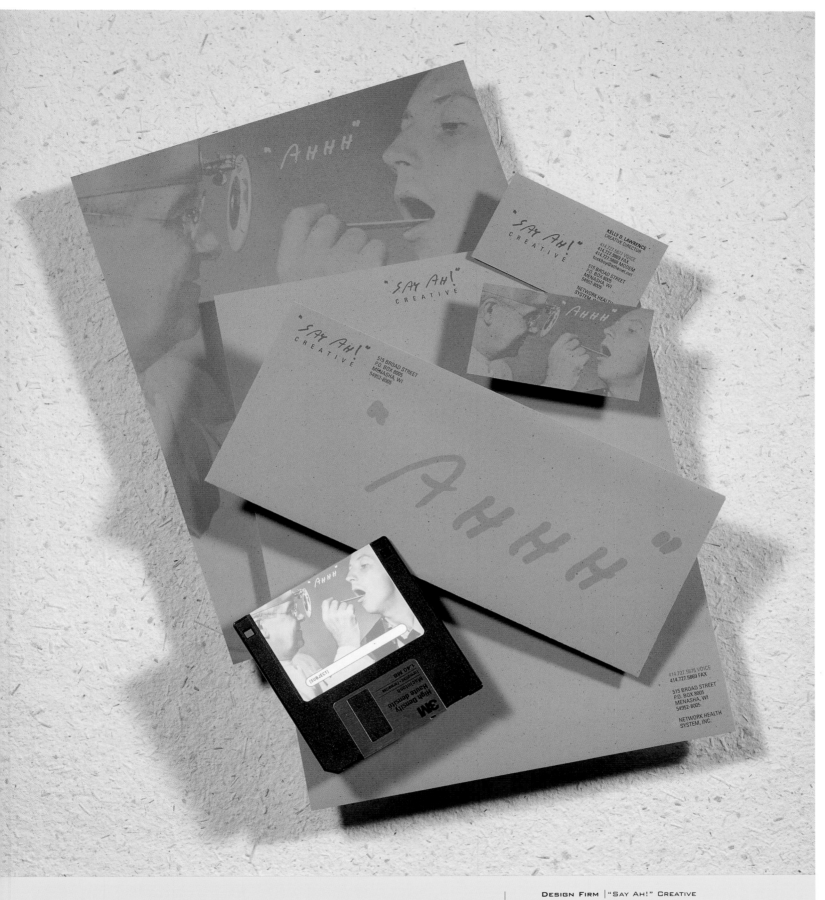

DESIGN FIRM | "SAY AH!" CREATIVE

ART DIRECTOR/DESIGNER | KELLY D. LAWRENCE

PHOTOGRAPHY | SUPERSTOCK

PRODUCTION | JON EMPEY, VICKIE MARTIN

CLIENT | "SAY AH!" CREATIVE

TOOLS | QUARKXPRESS, ADOBE PHOTOSHOP,
ADOBE ILLUSTRATOR

PAPER/PRINTING | SIMPSON QUEST-BRONZE/OFFSET

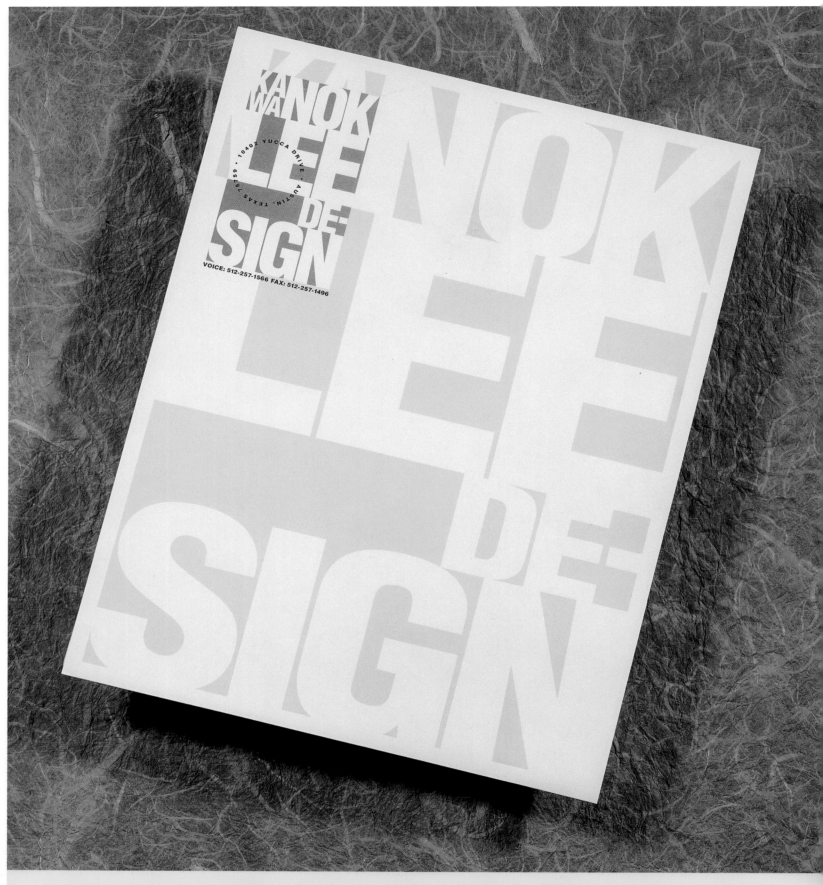

DESIGN FIRM | KANOKWALEE DESIGN
ART DIRECTOR/DESIGNER | KANOKWALEE LEE
CLIENT | KANOKWALEE DESIGN
TOOLS | ADOBE ILLUSTRATOR, QUARKXPRESS
PAPER/PRINTING | STRATHMORE KRAFT/OFFSET

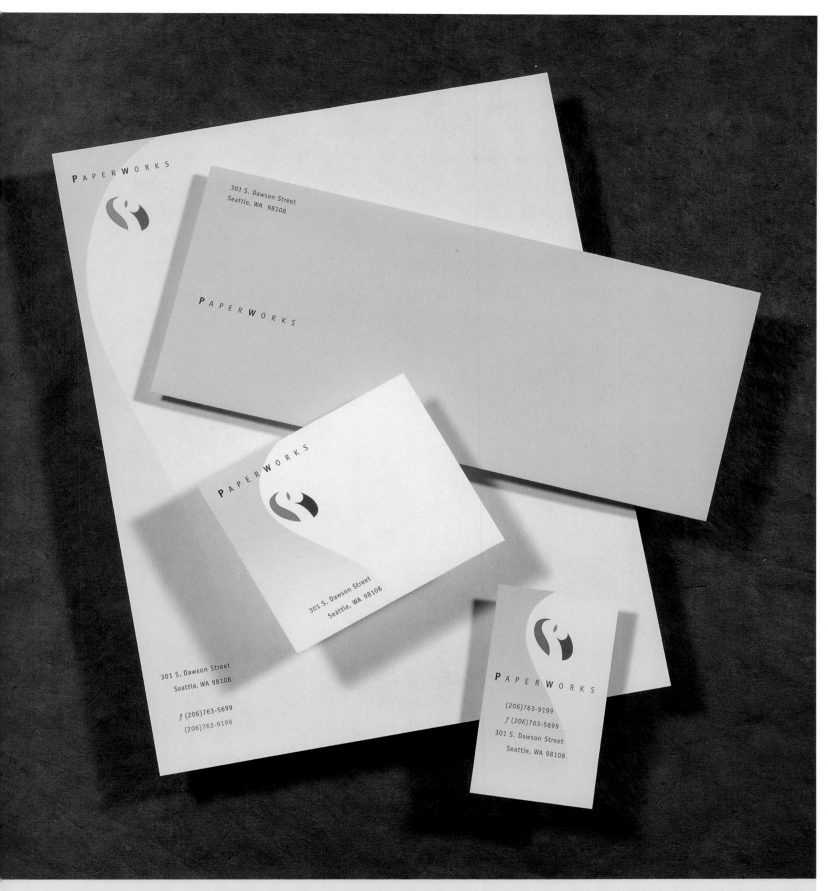

DESIGN FIRM | BELYEA DESIGN ALLIANCE
ART DIRECTOR | PATRICIA BELYEA
DESIGNER | CHRISTIAN SALAS
CLIENT | PAPERWORKS

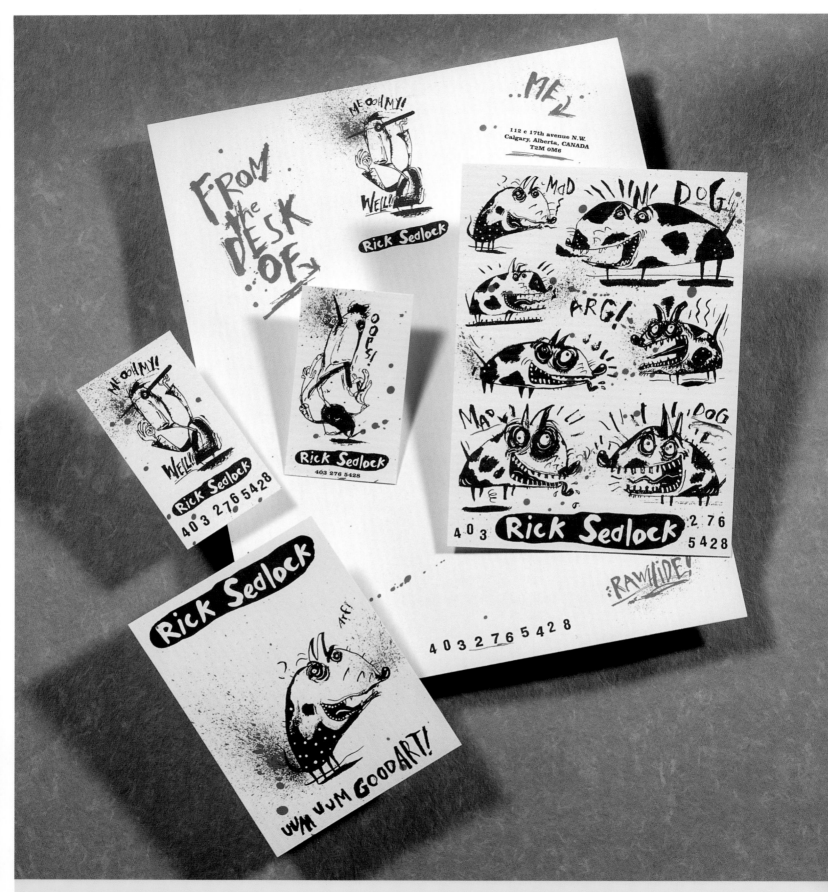

DESIGN FIRM | RICK SEALOCK ILLUSTRATION

ALL DESIGN | RICK SEALOCK

CLIENT | RICK SEALOCK

TOOLS | FOUND TYPE/PHOTOCOPIER

PAPER/PRINTING | CLASSIC COLUMN/OFFSET

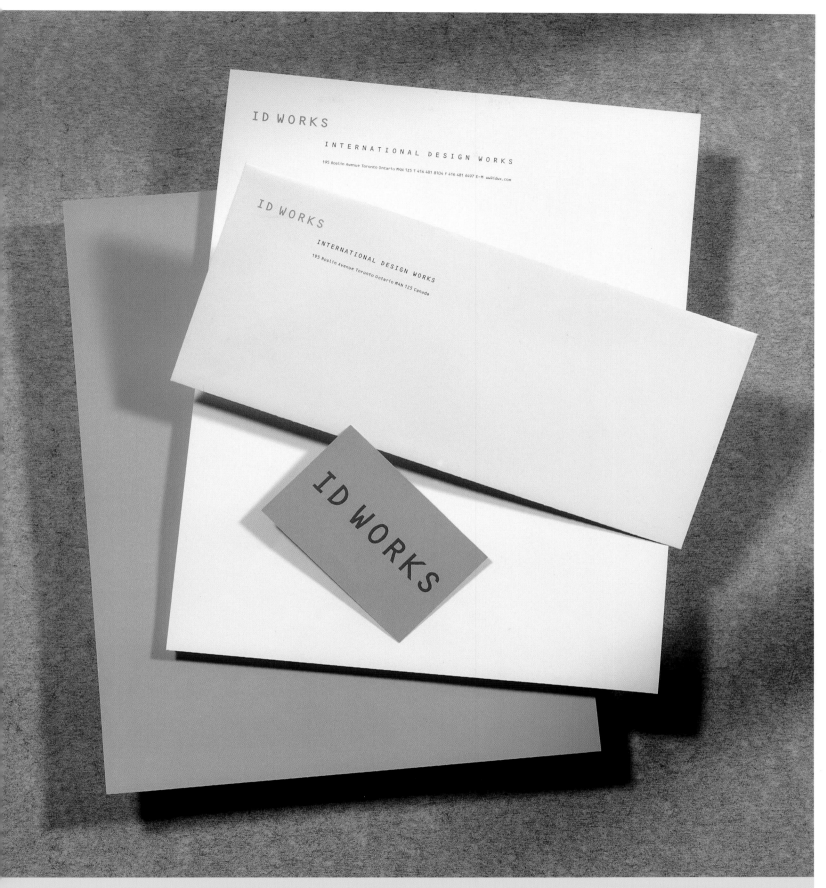

ID WORKS

INTERNATIONAL DESIGN WORKS

195 Roslin Avenue Toronto Ontario M4N 1Z5 T 416 481 8104 F 416 481 6497 E-M ww@idwx.com

ID WORKS

INTERNATIONAL DESIGN WORKS

195 Roslin Avenue Toronto Ontario M4N 1Z5 Canada

ID WORKS

DESIGN FIRM | TEIKNA

ART DIRECTOR/DESIGNER | CLAUDIA NERI

CLIENT | ID WORKS

TOOLS | QUARKXPRESS

PAPER/PRINTING | MOHAWK OPTIONS/TWO COLOR

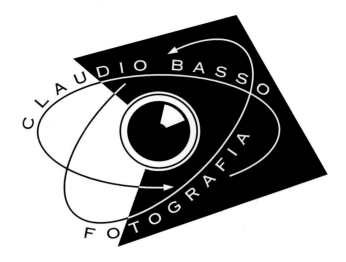

DESIGN FIRM | SIBLEY/PETEET DESIGN

DESIGNER | TOM KIRSCH

CLIENT | MIKE KING

DESIGN FIRM | VOSS DESIGN

ART DIRECTOR/DESIGNER | AXEL VOSS

CLIENT | CLAUDIO BASSO

DESIGN FIRM | TRACY SABIN GRAPHIC DESIGN

ART DIRECTOR | RUSSELL SABIN

ILLUSTRATOR | TRACY SABIN

CLIENT | MONKEY STUDIOS

TOOLS | ADOBE ILLUSTRATOR

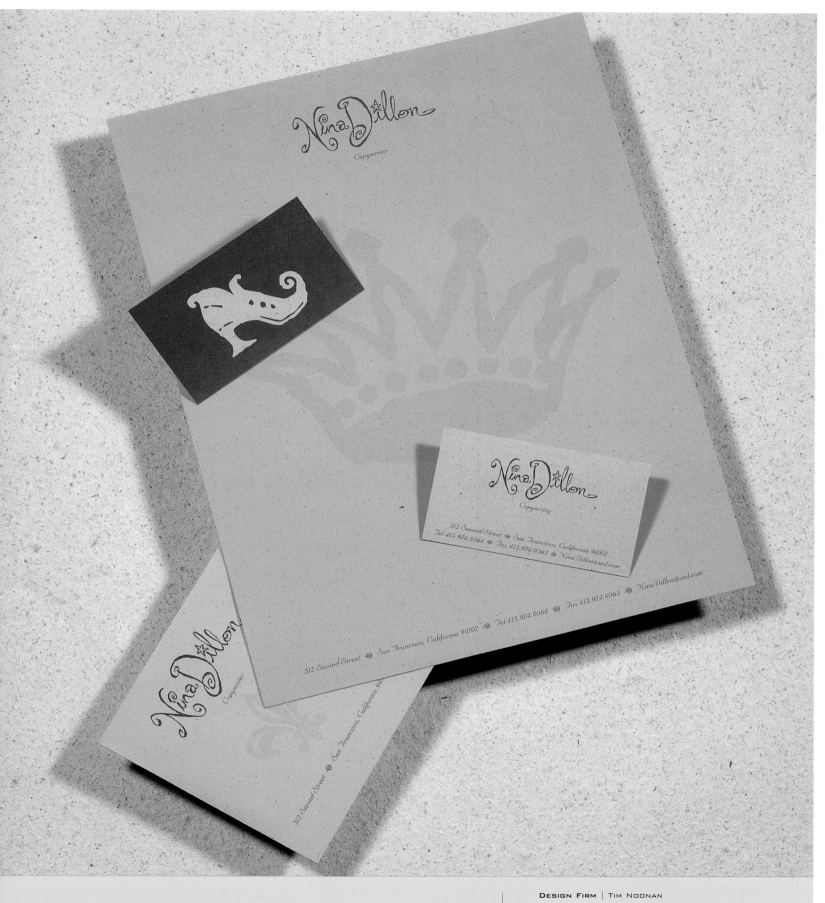

DESIGN FIRM | TIM NOONAN

DESIGNER | TIM NOONAN

CLIENT | NINA DILLON

TOOLS | QUARKXPRESS, HAND LETTERING

PAPER/PRINTING | SIMPSON QUEST/ONE PMS

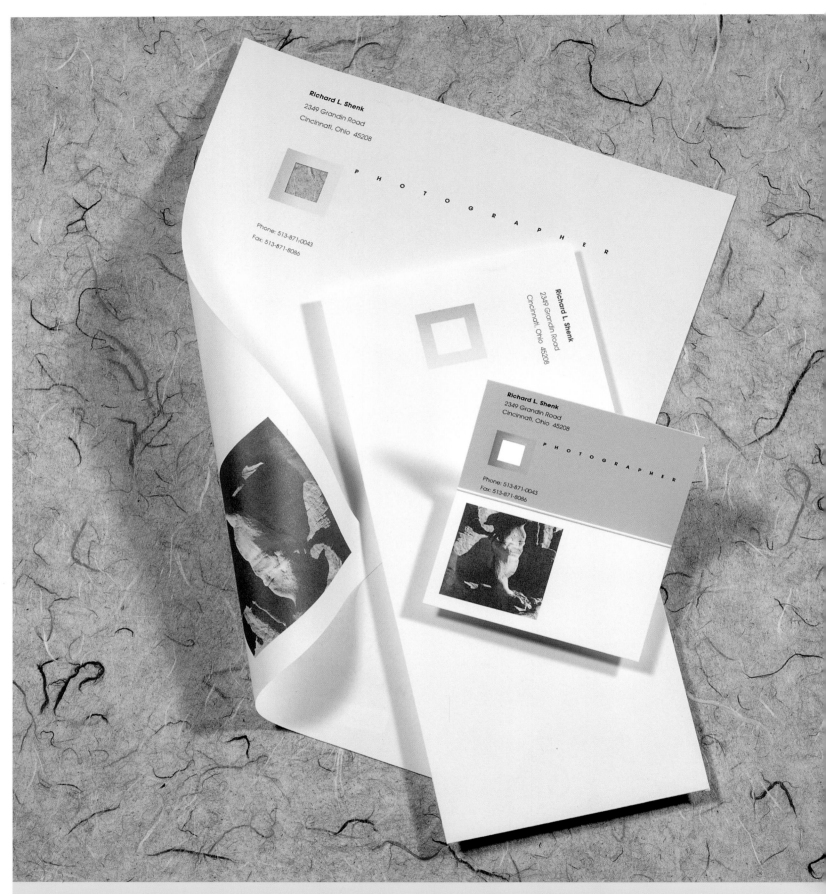

DESIGN FIRM | WOOD/BROD DESIGN

ALL DESIGN | STAN BROD

CLIENT | RICHARD L. SHENK

TOOLS | ADOBE ILLUSTRATOR

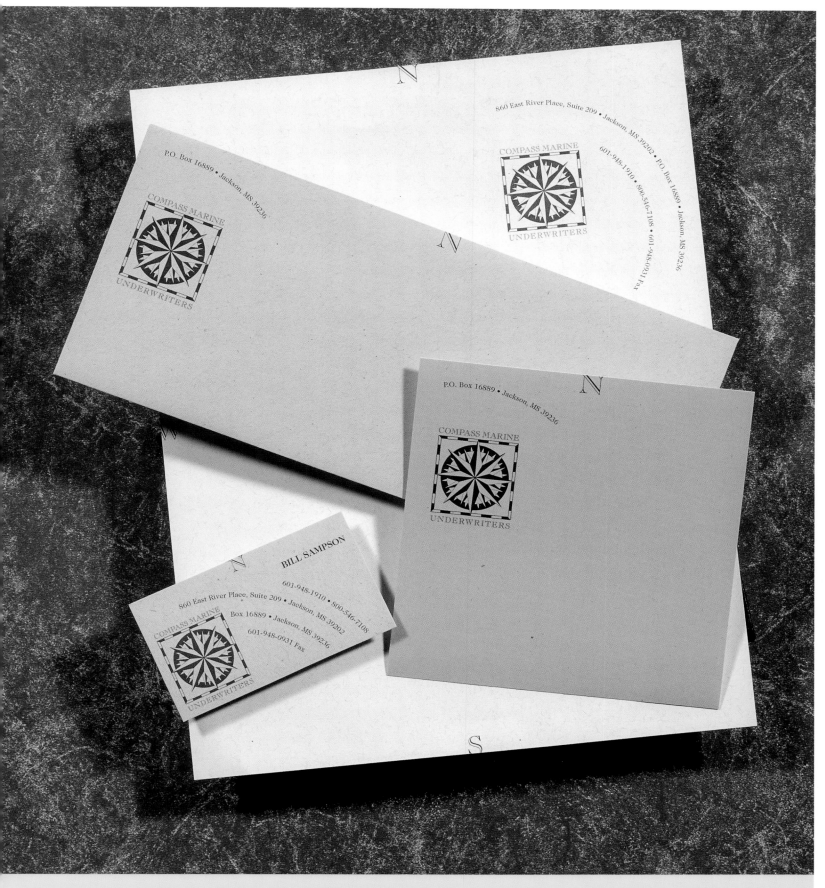

DESIGN FIRM | COMMUNICATION ARTS COMPANY

ART DIRECTOR | HAP OWEN

DESIGNER | ANNE-MARIE OTVOS

CLIENT | COMPASS MARINE UNDERWRITERS

TOOLS | MACINTOSH

PAPER/PRINTING | PROTERRA PARCHMENT &
STUCO, KRAFT/OFFSET LITHOGRAPHY

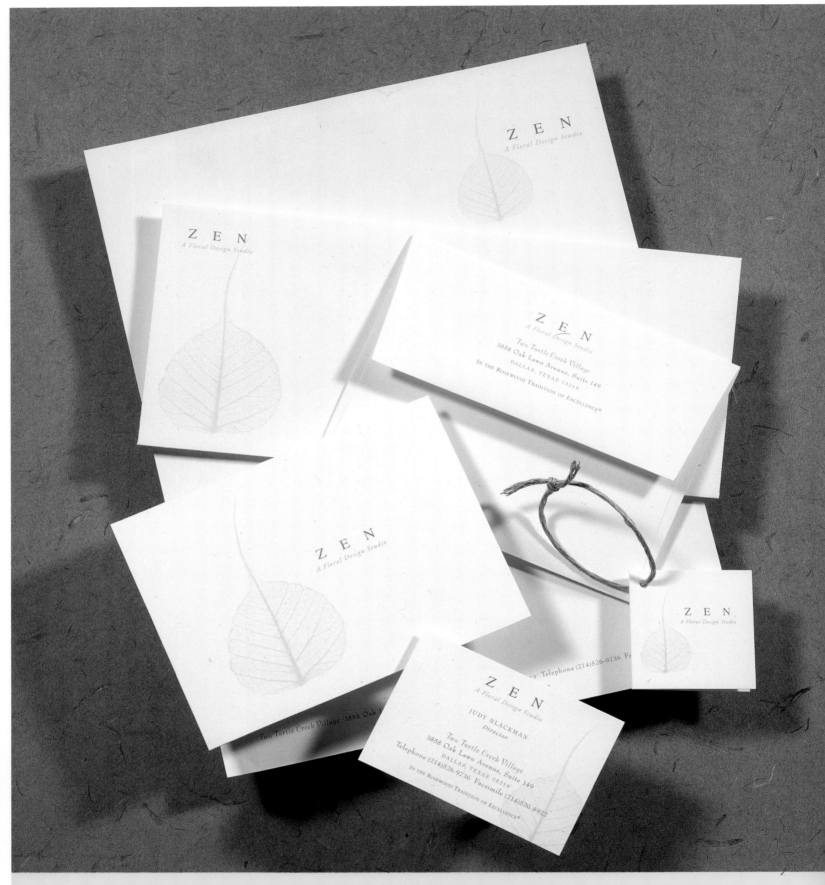

DESIGN FIRM | DAVID CARTER DESIGN

ART DIRECTORS | SHARON LEJEUNE, LORI B. WILSON

CLIENT | ZEN FLORAL DESIGN STUDIO

PAPER/PRINTING | SIMPSON EVERGREEN BIRCH/JARVIS PRESS

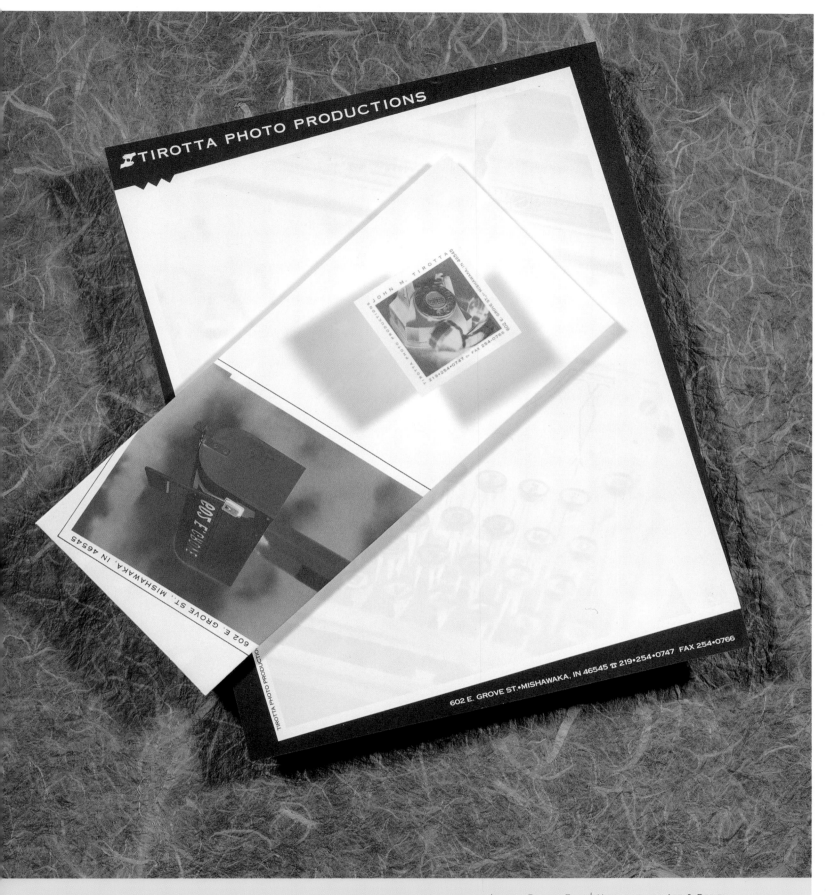

DESIGN FIRM | HIEROGLYPHICS ART & DESIGN

DESIGNER | CHRISTINE OSBORN TIROTTA

PHOTOGRAPHER | JOHN TIROTTA

CLIENT | TIROTTA PHOTO PRODUCTIONS

PAPER/PRINTING | STARWHITE VICKSBURG, UV ULTRA II

Pesona Pictures Sdn Bhd
159A Jalan Aminuddin Baki
Taman Tun Dr Ismail
60000 Kuala Lumpur *Malaysia*
Tel 603 719 1602 ✦ 718 2316
Fax 603 719 1586

Studio
24 Jalan Kemajuan 12/18
46200 Petaling Jaya
Selangor Darul Ehsan *Malaysia*
Tel 603 754 2334 ✦ 754 2276
Fax 603 754 2335

Pesona Pictures Sdn Bhd
159A Jalan Aminuddin Baki
Taman Tun Dr Ismail
60000 Kuala Lumpur *Malaysia*
Tel 603 719 1602 ✦ 718 2316
Fax 603 719 1586

Studio
24 Jalan Kemajuan 12/18
46200 Petaling Jaya
Selangor Darul Ehsan *Malaysia*
Tel 603 754 2334 ✦ 754 2276
Fax 603 754 2335

DESIGN FIRM | WERK-HAUS

ART DIRECTOR | EZRAH RAHIM

DESIGNERS | ELRAH RAHIM, WAI MING, WEE

CLIENT | PESONA PICTURES

PAPER/PRINTING | CONCEPT WAVE SAND/ONE
COLOR, COPPER HOT STAMPING, EMBOSSING

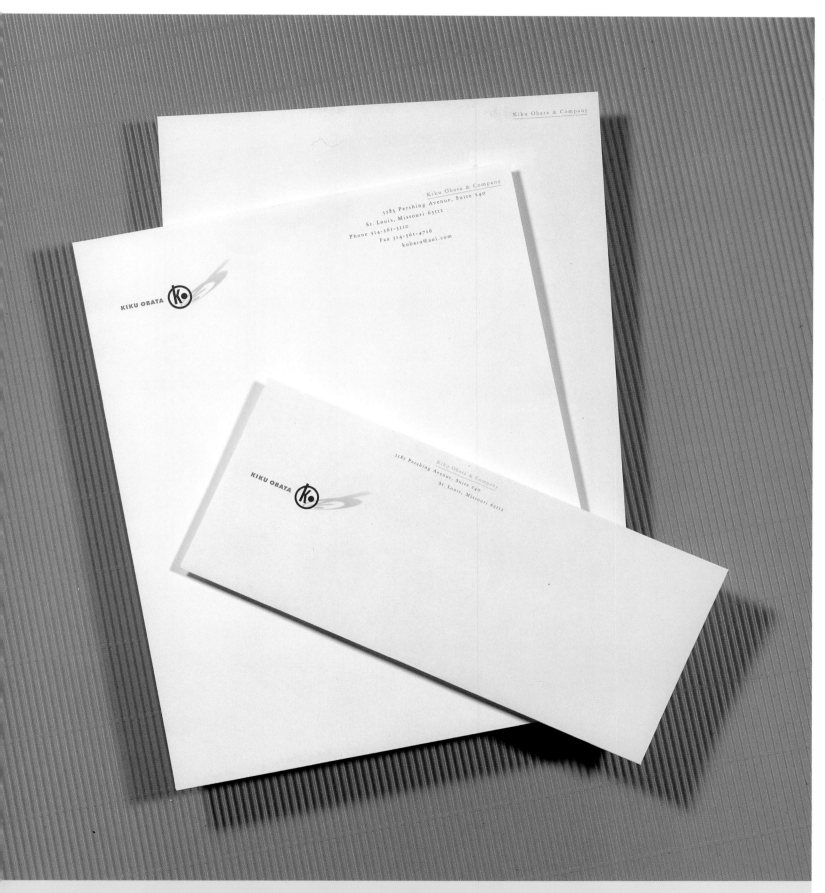

Kiku Obata & Company

KIKU OBATA

Kiku Obata & Company
5585 Pershing Avenue, Suite 240
St. Louis, Missouri 63112
Phone 314-361-3110
Fax 314-361-4716
kobata@aol.com

KIKU OBATA

Kiku Obata & Company
5585 Pershing Avenue, Suite 240
St. Louis, Missouri 63112

DESIGN FIRM | KIKU OBATA & COMPANY
ART DIRECTOR/DESIGNER | RICH NELSON
CLIENT | KIKU OBATA & COMPANY
PAPER/PRINTING | REPROX

TOWER OF BABEL

DESIGN FIRM | SIBLEY/PETEET DESIGN
DESIGNER | TOM HOUGH
CLIENT | MERCURY MESSENGER

DESIGN FIRM | TOWER OF BABEL
DESIGNER | ERIC STEVENS
CLIENT | TOWER OF BABEL

DESIGN FIRM | KIRBY STEPHENS DESIGN, INC.
ART DIRECTOR/DESIGNER | KIRBY STEPHENS
ILLUSTRATORS | DANIEL DUTTON, WILLIAM V. COX
CLIENT | KENTUCKY TOURISM COUNCIL
TOOLS | PENCIL, MACINTOSH PPC, SCANNER

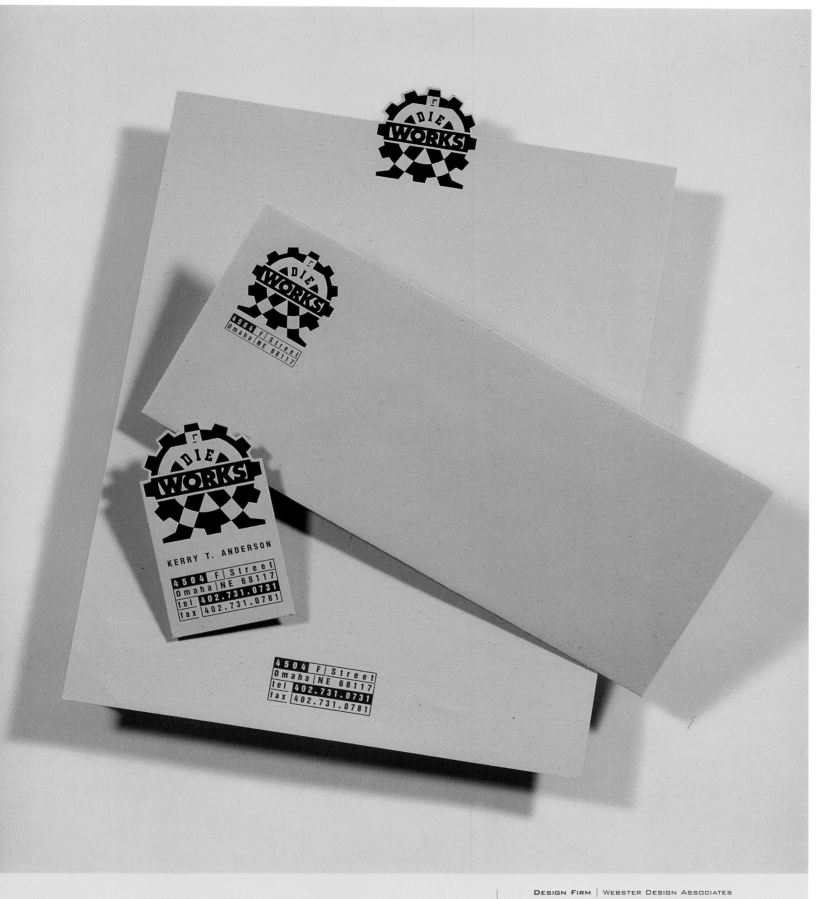

DESIGN FIRM | WEBSTER DESIGN ASSOCIATES

ART DIRECTOR | DAVE WEBSTER

DESIGNER/ILLUSTRATOR | ANDREY NAGORNY

CLIENT | DIE WORKS

TOOLS | MACROMEDIA FREEHAND

PAPER/PRINTING | CROSS POINTE GENESIS FOSSIL,
 FOIL STAMPED

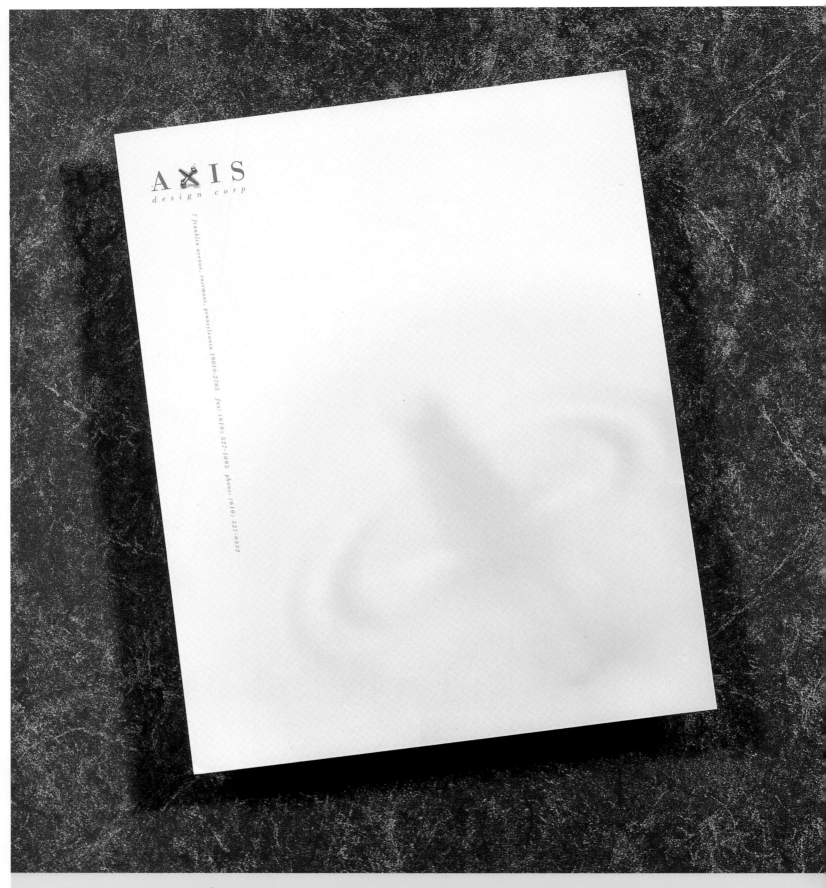

AXIS
design corp

7 franklin avenue, rosemont, pennsylvania 19010-2705 fax: (610) 527-1095 phone: (610) 527-0332

DESIGN FIRM | AXIS DESIGN

ART DIRECTOR/DESIGNER | WILLIAM MILNAZIK

CLIENT | AXIS DESIGN

PAPER/PRINTING | STRATHMORE ELEMENTS

DESIGN FIRM | DOGSTAR
DESIGNER/ILLUSTRATOR | RODNEY DAVIDSON
CLIENT | DOGSTAR
TOOLS | ADOBE ILLUSTRATOR, STREAMLINE, MACROMEDIA FREEHAND

DESIGN FIRM | STORM DESIGN & ADVERTISING CONSULTANCY
ART DIRECTORS/DESIGNERS | DAVID ANSETT, DEAN BUTLER
ILLUSTRATORS | DEAN BUTLER, DAVID ANSETT
CLIENT | PAUL WEST PHOTOGRAPHY
TOOLS | ADOBE PHOTOSHOP

DESIGN FIRM | "SAY AH!" CREATIVE
ART DIRECTOR/DESIGNER | KELLY D. LAWRENCE
PHOTOGRAPHY | SUPERSTOCK
PRODUCTION | JON EMPEY, VICKIE MARTIN
CLIENT | "SAY AH!" CREATIVE
TOOLS | QUARKXPRESS, ADOBE PHOTOSHOP, ADOBE ILLUSTRATOR

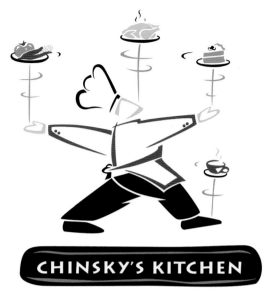

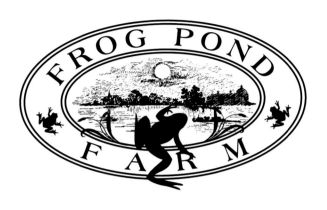

DESIGN FIRM | KIKU OBATA & COMPANY
ART DIRECTOR/DESIGNER JOE FLORESCA
CLIENT | CHINSKY'S KITCHEN

DESIGN FIRM | TURNER DESIGN
ALL DESIGN | BERT TURNER
CLIENT | FROG POND FARM

DESIGN FIRM | THARP DID IT
ART DIRECTOR | RICK THARP
DESIGNERS | RICK THARP, KIM TOMLINSON
CLIENT | CASA DE FRUTA
TOOLS | INK

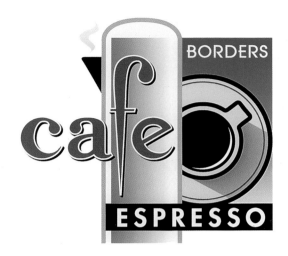

LENOX ROOM

TIP WELL AND PROSPER

DESIGN FIRM | FRCH DESIGN WORLDWIDE
ART DIRECTOR | JOAN DONNELLY
DESIGNER/ILLUSTRATOR | TIM A. FRAME
CLIENT | BORDERS BOOKS AND MUSIC
TOOLS | ADOBE ILLUSTRATOR

DESIGN FIRM | AERIAL
ART DIRECTOR/DESIGNER | TRACY MOON
PHOTOGRAPHY | R. J. MUNA
CLIENT | LENOX ROOM RESTAURANT
TOOLS | ADOBE PHOTOSHOP, QUARKXPRESS

DESIGN FIRM | FLAHERTY ART & DESIGN
ALL DESIGN | MARIE FLAHERTY
CLIENT | THE O BAR OF EATING UP THE COAST
TOOLS | ADOBE ILLUSTRATOR

DESIGN FIRM | JEFF FISHER LOGOMOTIVES
ALL DESIGN | JEFF FISHER
CLIENT | TRIAD (AD AGENCY FOR GINA'S ITALY)
TOOLS | MACROMEDIA FREEHAND

DESIGN FIRM | VRONTIKIS DESIGN OFFICE
ART DIRECTOR | PETRULA VRONTIKIS
DESIGNER | LISA CRITCHFIELD
CLIENT | HASEGAWA ENTERPRISES
TOOLS | QUARKXPRESS, ADOBE PHOTOSHOP

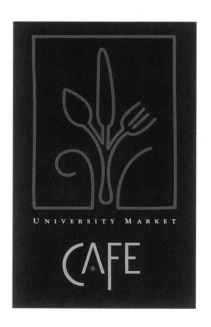

DESIGN FIRM | SAYLES GRAPHIC DESIGN
ALL DESIGN | JOHN SAYLES
CLIENT | ALPHABET SOUP

DESIGN FIRM | CORNOYER-HEDRICK, INC.
ART DIRECTOR | JIM BOLEK
DESIGNER/ILLUSTRATOR | LANIE GOTCHER
CLIENT | MOTOROLA
TOOLS | ADOBE ILLUSTRATOR

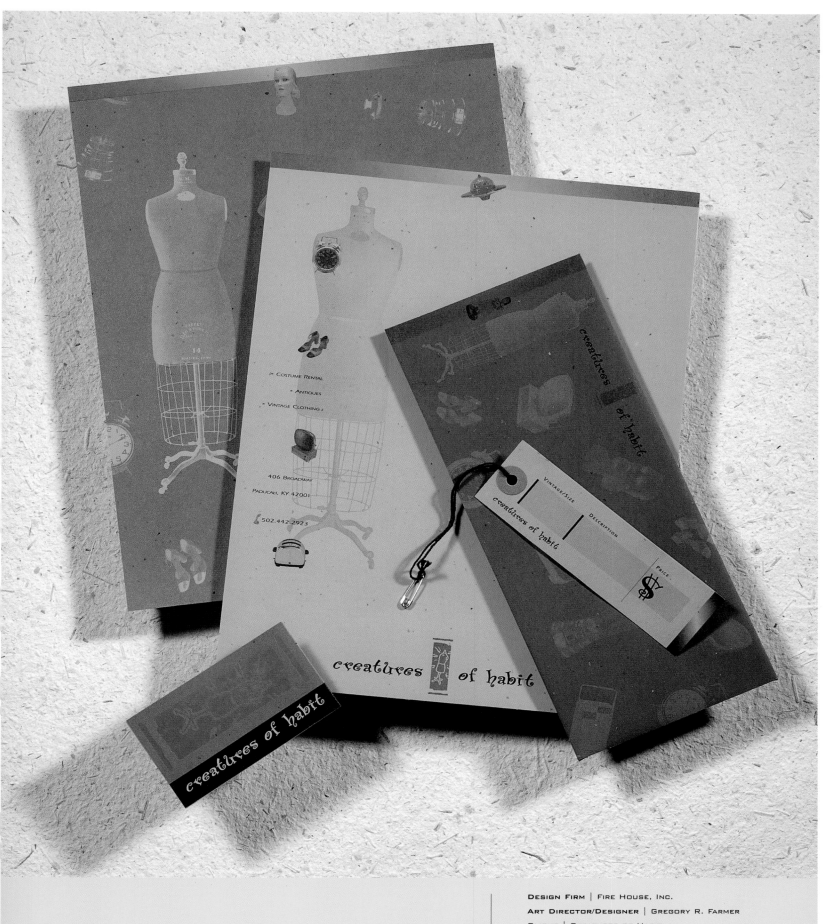

DESIGN FIRM | FIRE HOUSE, INC.

ART DIRECTOR/DESIGNER | GREGORY R. FARMER

CLIENT | CREATURES OF HABIT

TOOLS | QUARKXPRESS, ADOBE PHOTOSHOP

PAPER/PRINTING | FOX RIVER CONFETTI, MOORE-LANGEN
PRINTING COMPANY, KENNY GRAPHICS

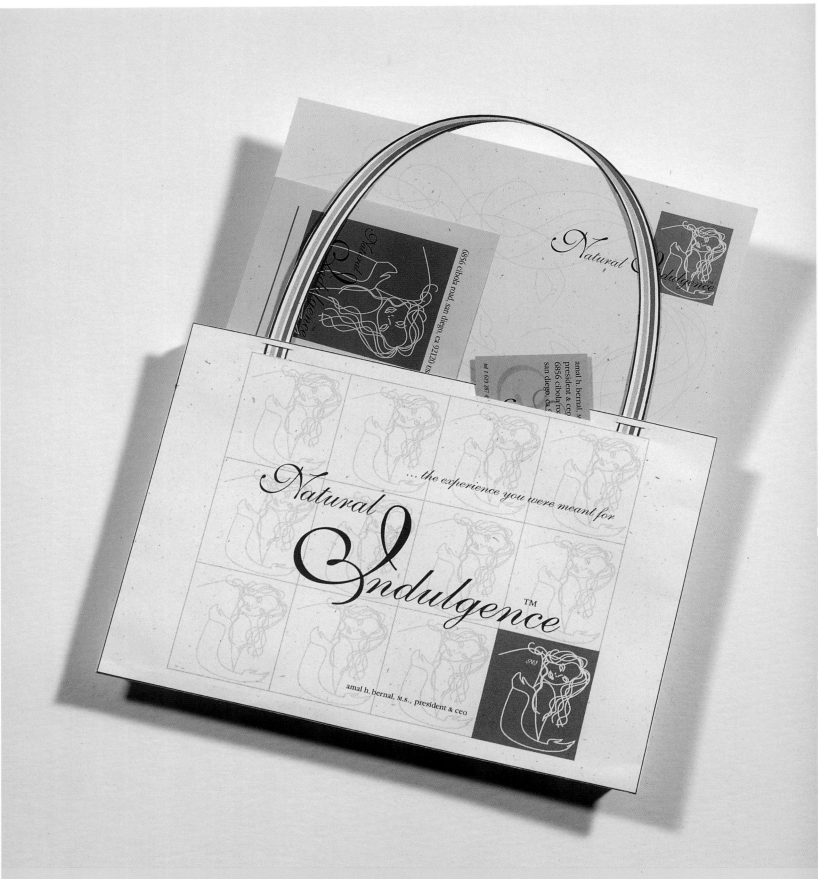

DESIGN FIRM | THE PROVEN EDGE

ALL DESIGN | RITA GOLD

CLIENT | NATURAL INDULGENCE

TOOLS | ADOBE ILLUSTRATOR

PAPER/PRINTING | CROSS POINTE/FRASER AND HOPPER, PRIORITY
PRINTERS AND EPSON STYLUS PRO WITH BINARY POWER RIP

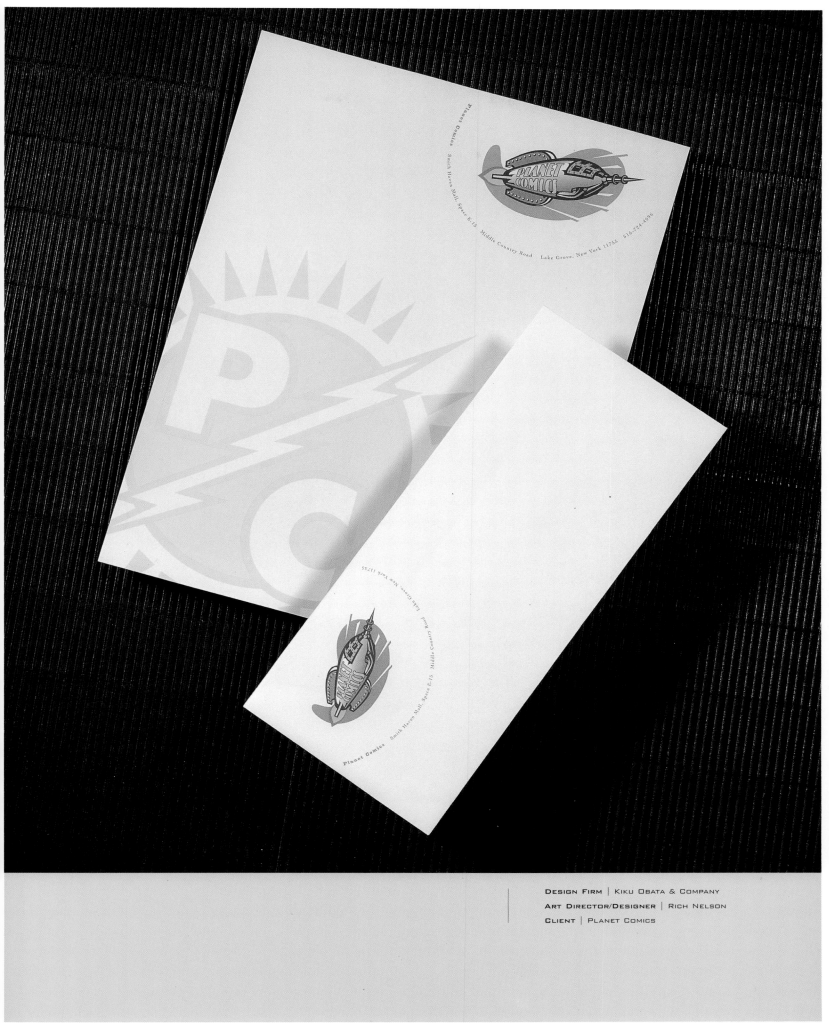

DESIGN FIRM | KIKU OBATA & COMPANY
ART DIRECTOR/DESIGNER | RICH NELSON
CLIENT | PLANET COMICS

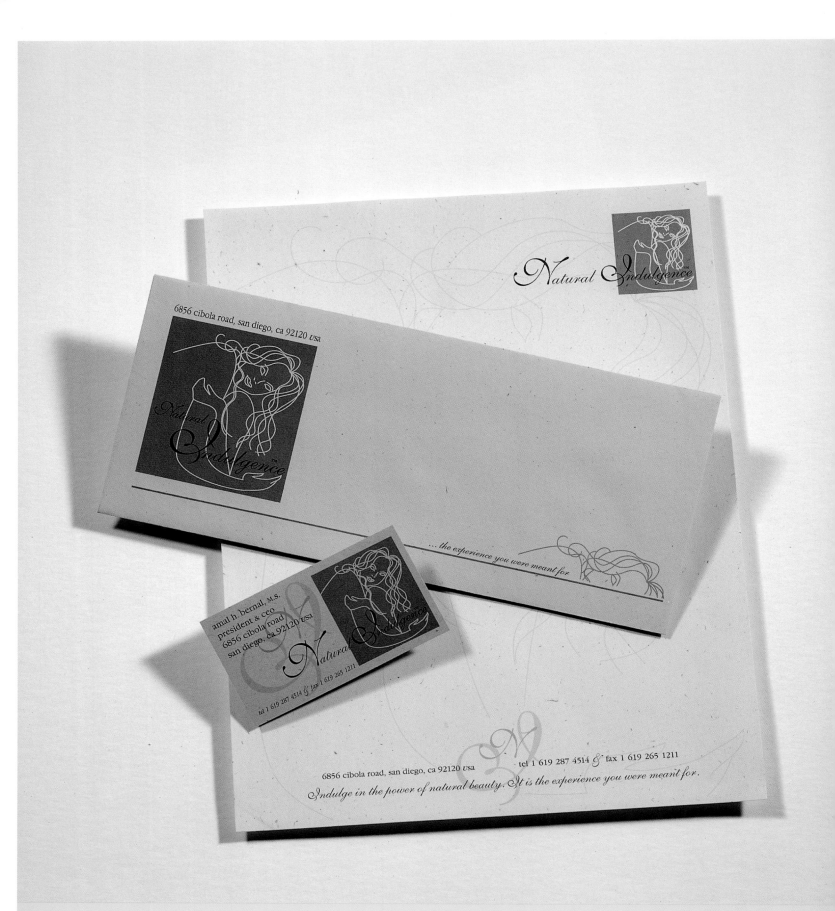

DESIGN FIRM | THE PROVEN EDGE

ALL DESIGN | RITA GOLD

CLIENT | NATURAL INDULGENCE

TOOLS | ADOBE ILLUSTRATOR

PAPER/PRINTING | CROSS POINTE/FRASER AND HOPPER, PRIORITY
 PRINTERS AND EPSON STYLUS PRO WITH BINARY POWER RIP

MISAKI ICHIBA

DESIGN FIRM | KIKU OBATA & COMPANY
ART DIRECTOR | JOE FLORESCA
DESIGNERS | JOE FLORESCA, JEFF RIFKIN, ELEANOR SAFE
CLIENT | R.I.C. DESIGN

dog lips

DESIGN FIRM | JUICE DESIGN
ART DIRECTOR/DESIGNER | BRETT M. CRITCHCHLOW
CLIENT | DOGLIPS

DESIGN FIRM | KIKU OBATA & COMPANY
ART DIRECTOR/DESIGNER | RICH NELSON
CLIENT | R.I.C. DESIGN

La Bodega

Company Store & Deli

DESIGN FIRM | FLAHERTY ART & DESIGN
ALL DESIGN | MARIE FLAHERTY
CLIENT | LA BODEGA OF EATING UP THE COAST
TOOLS | ADOBE ILLUSTRATOR

DESIGN FIRM | S&N DESIGN
ALL DESIGN | CRAIG GOODMAN
CLIENT | EXOTIC AQUATICS
TOOLS | ADOBE ILLUSTRATOR

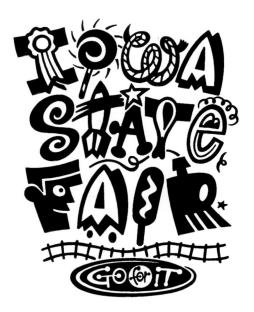

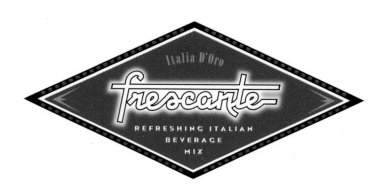

DESIGN FIRM | SAYLES GRAPHIC DESIGN
ART DIRECTOR/ILLUSTRATOR | JOHN SAYLES
DESIGNER | JOHN SAYLES, JENNIFER ELLIOTT
CLIENT | IOWA STATE FAIR

DESIGN FIRM | MIRES DESIGN
ART DIRECTORS | SCOTT MIRES, MIKE BROWER
DESIGNERS | MIKE BROWER, SCOTT MIRES
ILLUSTRATOR | TRACY SABIN
COPYWRITER | JOHN KURAOKA
CLIENT | FOOD GROUP/BOYDS COFFEE

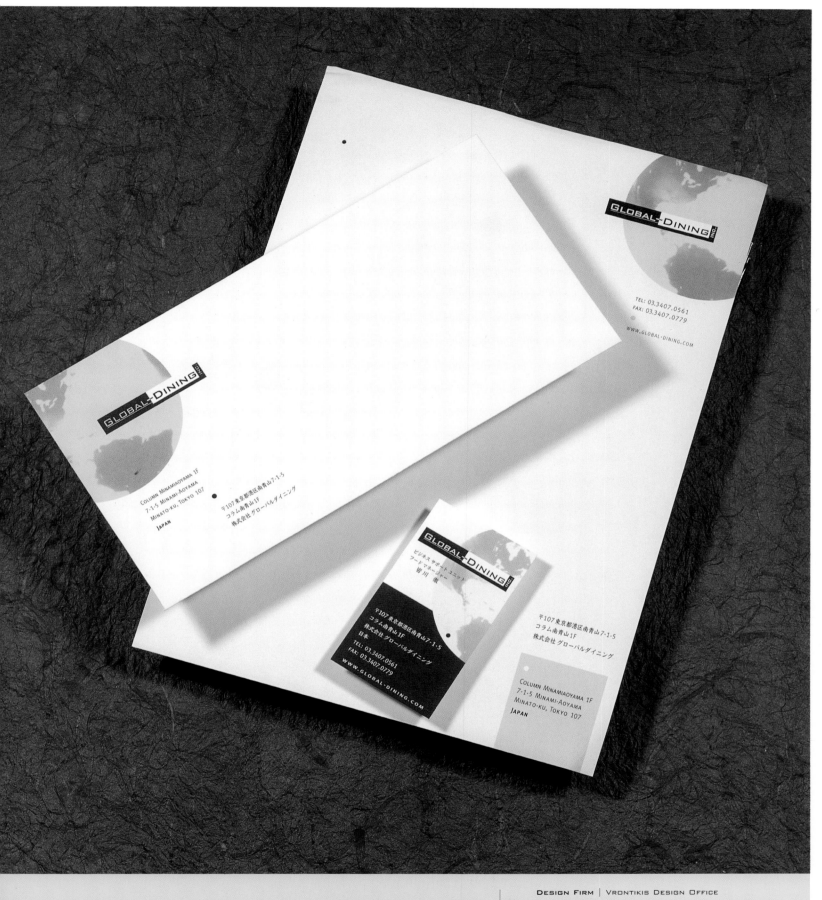

DESIGN FIRM | VRONTIKIS DESIGN OFFICE

ART DIRECTOR/DESIGNER | PETRULA VRONTIKIS

CLIENT | GLOBAL-DINING, INC.

TOOLS | QUARKXPRESS, ADOBE PHOTOSHOP

PAPER/PRINTING | NEENAH CLASSIC

CREST/DONAHUE PRINTING

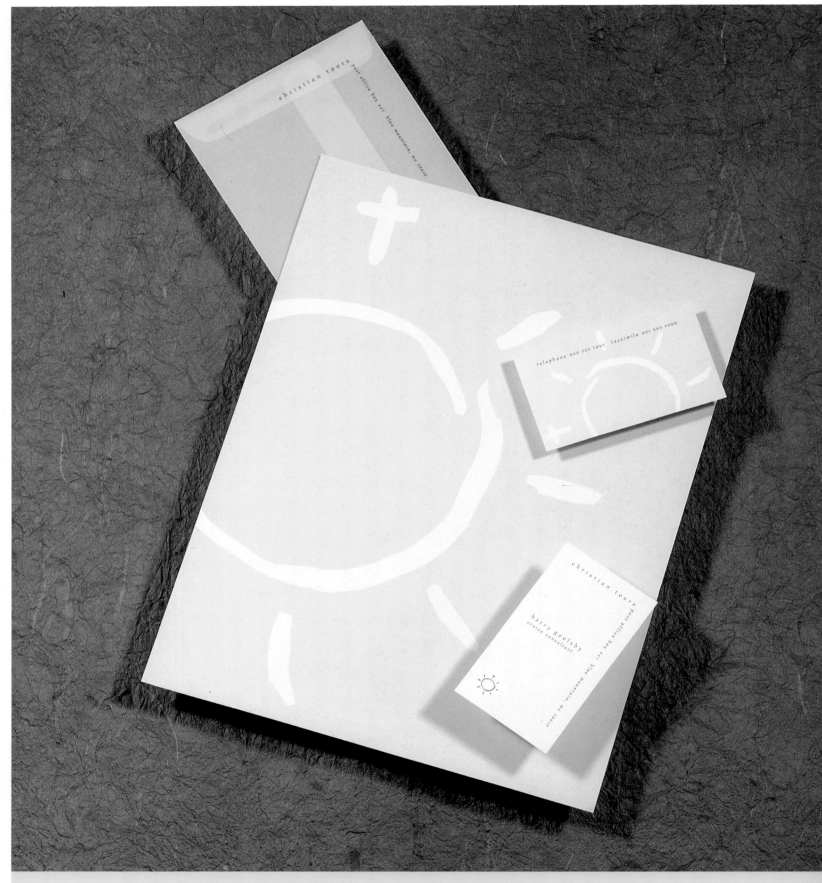

DESIGN FIRM | DAVID CARTER DESIGN

ART DIRECTOR | LORI B. WILSON, GARY LOBUE, JR.

DESIGNER/ILLUSTRATOR | TRACY HUCK

CLIENT | CHRISTIAN TOURS

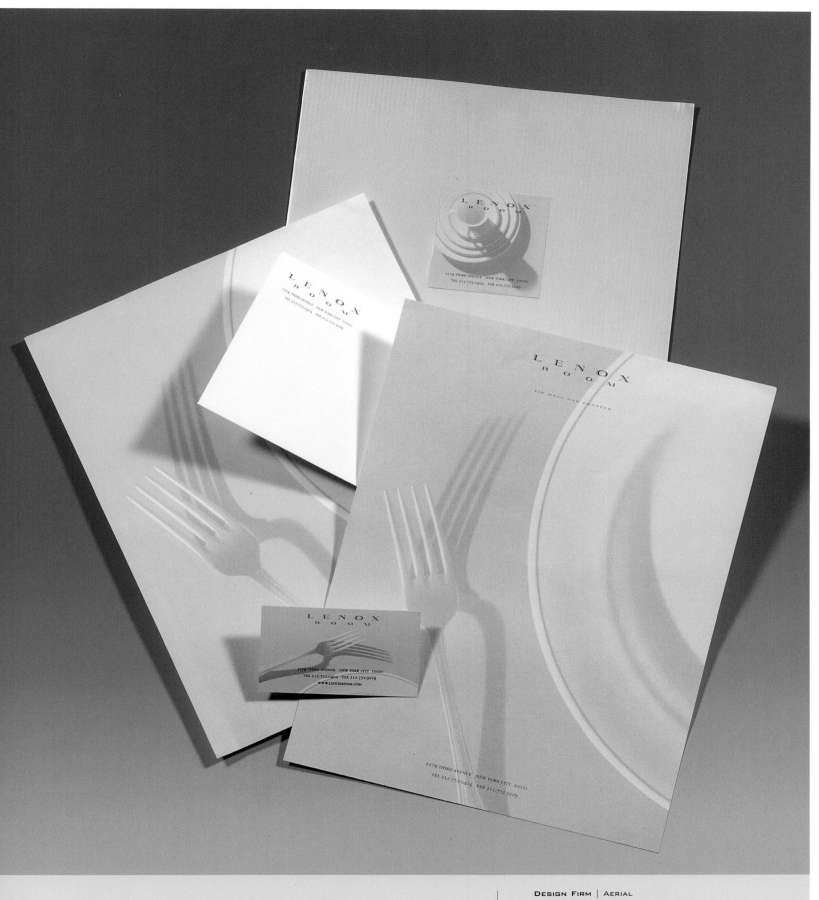

DESIGN FIRM | AERIAL

ART DIRECTOR/DESIGNER | TRACY MOON

PHOTOGRAPHY | R. J. MUNA

CLIENT | LENOX ROOM RESTAURANT

TOOLS | ADOBE PHOTOSHOP, QUARKXPRESS

PAPER/PRINTING | 24 LB. EVERGREEN IVORY

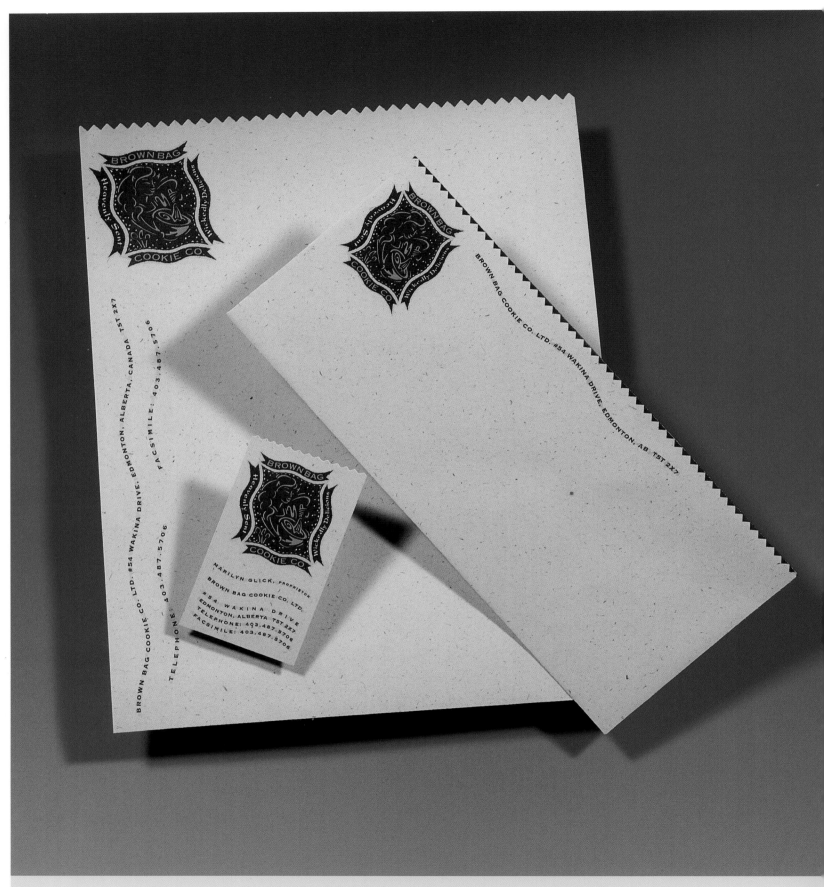

DESIGN FIRM | DUCK SOUP GRAPHICS

ALL DESIGN | WILLIAM DOUCETTE

CLIENT | BROWN BAG COOKIE COMPANY

TOOLS | ADOBE ILLUSTRATOR, QUARKXPRESS

PAPER/PRINTING | FRENCH SPECKLETONE/2 MATCH COLORS

GLOBAL-DINING INC.

DESIGN FIRM | VRONTIKIS DESIGN OFFICE
ART DIRECTOR/DESIGNER | PETRULA VRONTIKIS
CLIENT | GLOBAL-DINING, INC.
TOOLS | QUARKXPRESS, ADOBE PHOTOSHOP
PAPER/PRINTING | NEENAH CLASSIC CREST/DONAHUE PRINTING

DESIGN FIRM | SOMMESE DESIGN
ART DIRECTOR/ILLUSTRATOR | LANNY SOMMESE
DESIGNER | LANNY SOMMESE, DEVIN PEDSWATER
CLIENT | PENNSYLVANIA STATE UNIVERSITY
TOOLS | ADOBE ILLUSTRATOR

Beach House

DESIGN FIRM | AERIAL
ART DIRECTOR/DESIGNER | TRACY MOON
CLIENT | BEACH HOUSE HOTEL
TOOLS | ADOBE ILLUSTRATOR
PAPER/PRINTING | LEEWOOD PRESS/SF

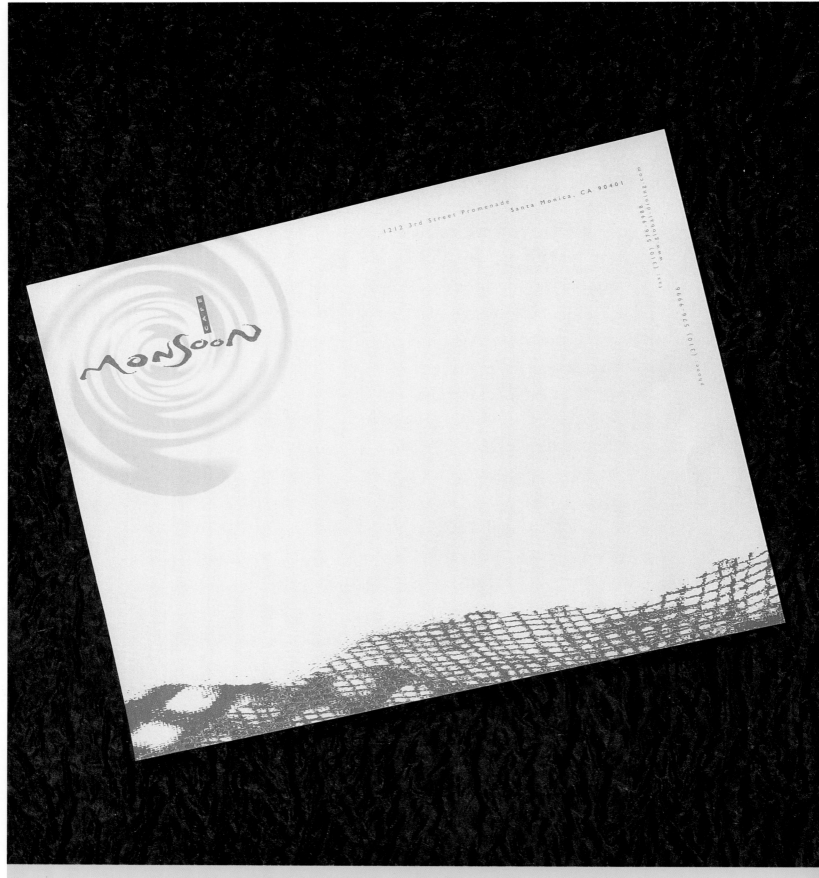

1212 3rd Street Promenade Santa Monica, CA 90401

www.globaldining.com
fax (310) 576-9988
phone (310) 576-9996

DESIGN FIRM | VRONTIKIS DESIGN OFFICE

ART DIRECTOR | PETRULA VRONTIKIS

DESIGNER | LISA CRITCHFIELD

CLIENT | HASEGAWA ENTERPRISES

TOOLS | QUARKXPRESS, ADOBE PHOTOSHOP

PAPER/PRINTING | CROSSPOINTE SYNERGY/LOGIN PRINTING

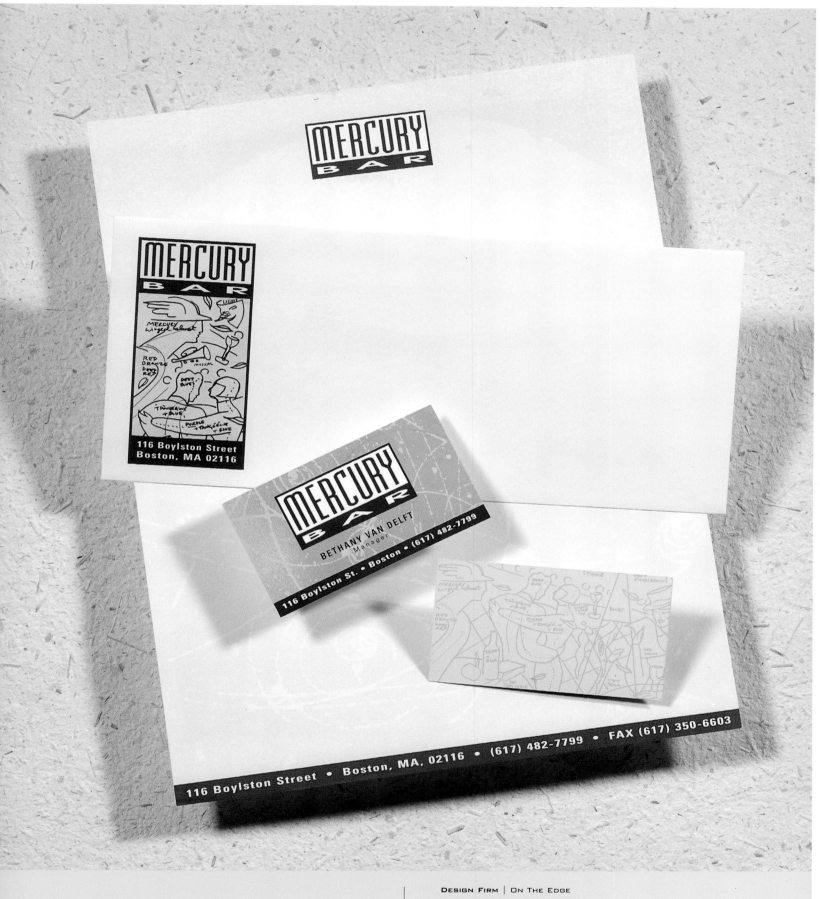

DESIGN FIRM | ON THE EDGE
ART DIRECTOR | JEFF GASPER
DESIGNER | GINA MIMS
ILLUSTRATOR | ANN FIELD
CLIENT | MERCURY BAR
TOOLS | ADOBE PHOTOSHOP, QUARKXPRESS, ADOBE ILLUSTRATOR
PAPER/PRINTING | CLASSIC CREST WHITE, LUNA WHITE COVER/FOUR COLOR

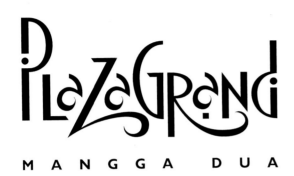

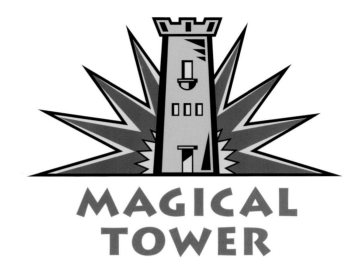

DESIGN FIRM | THAT'S CADIZ! ORIGINALS
ART DIRECTOR/DESIGNER | MINELEO CADIZ
CLIENT | PT MANGGA DUA TOWER
TOOLS | MACROMEDIA FREEHAND

DESIGN FIRM | KIKU OBATA & COMPANY
ART DIRECTOR | JOE FLORESCA
DESIGNERS | JOE FLORESCA, JEFF RIFKIN
CLIENT | R.I.C. DESIGN

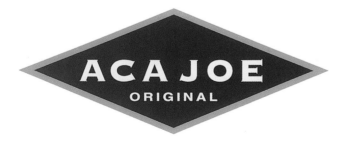

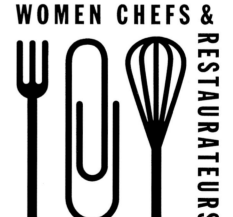

DESIGN FIRM | FRCH DESIGN WORLD WIDE
ART DIRECTOR | JOAN DONNELLY
DESIGNER | TIM A. FRAME
CLIENT | ACA JOE
TOOLS | ADOBE ILLUSTRATOR

DESIGN FIRM | TONI SCHOWALTER DESIGN
ALL DESIGN | TONI SCHOWALTER
CLIENT | WOMEN CHEFS & RESTAURATEURS
TOOLS | QUARKXPRESS, ADOBE ILLUSTRATOR

DESIGN FIRM | CLIFFORD SELBERT DESIGN COLLABORATIVE

ART DIRECTOR | ROBIN PERKINS

DESIGNER | ROBIN PERKINS, HEATHER WATSON

CLIENT | ATMOSPHERICS

TOOLS | ADOBE ILLUSTRATOR

PAPER/PRINTING | GENESIS CROSS POINT 80 LB. TEXT/CHALLENGE GRAPHICS

DESIGN FIRM | INSIGHT DESIGN COMMUNICATIONS
ALL DESIGN | SHERRIE AND TRACY HOLDEMAN
CLIENT | THE HAYES COMPANY
TOOLS | POWER MACINTOSH, MACROMEDIA FREEHAND

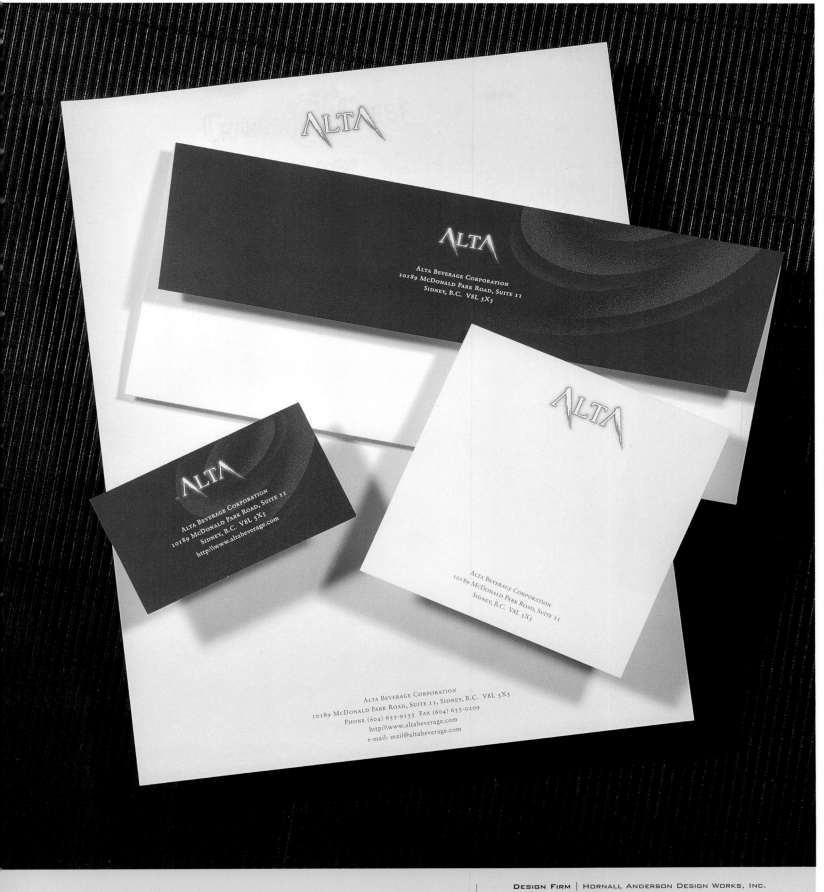

ALTA

ALTA

ALTA BEVERAGE CORPORATION
10189 McDONALD PARK ROAD, SUITE 11
SIDNEY, B.C. V8L 5X5

ALTA

ALTA BEVERAGE CORPORATION
10189 McDONALD PARK ROAD, SUITE 11
SIDNEY, B.C. V8L 5X5
http:\\www.altabeverage.com

ALTA

ALTA BEVERAGE CORPORATION
10189 McDONALD PARK ROAD, SUITE 11
SIDNEY, B.C. V8L 5X5

ALTA BEVERAGE CORPORATION
10189 McDONALD PARK ROAD, SUITE 11, SIDNEY, B.C. V8L 5X5
PHONE (604) 655-9235 FAX (604) 655-0209
http:\\www.altabeverage.com
e-mail: mail@altabeverage.com

DESIGN FIRM | HORNALL ANDERSON DESIGN WORKS, INC.
ART DIRECTOR | JACK ANDERSON
DESIGNERS | JACK ANDERSON, LARRY ANDERSON,
JULIE KEENAN
CLIENT | ALTA BEVERAGE COMPANY

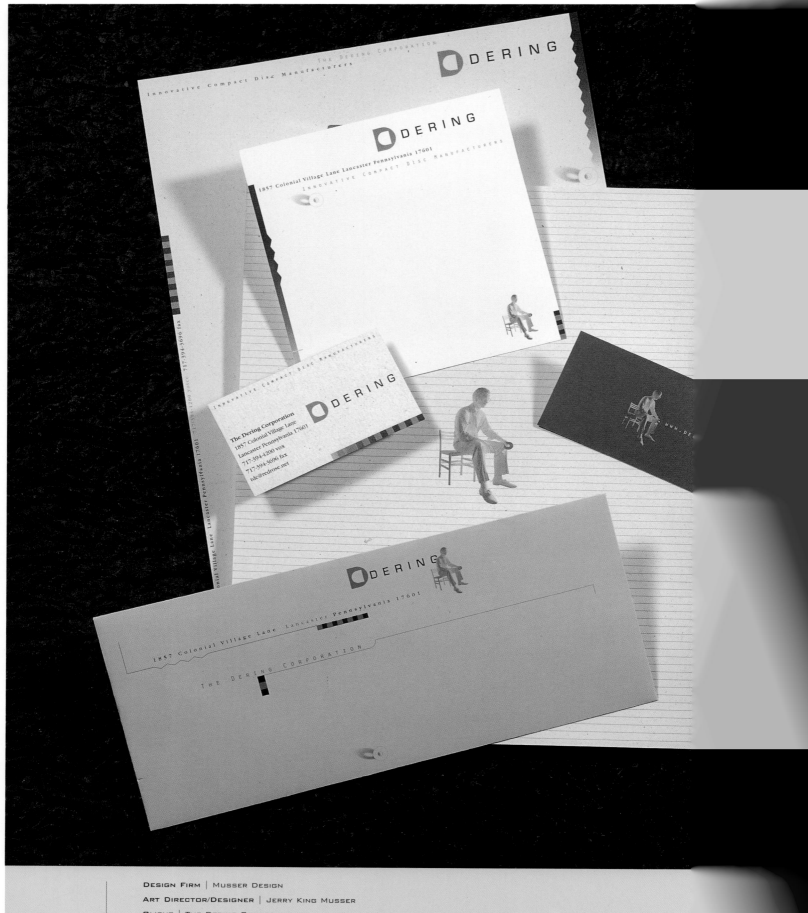

DESIGN FIRM | MUSSER DESIGN
ART DIRECTOR/DESIGNER | JERRY KING MUSSER
CLIENT | THE DERING CORPORATION
TOOLS | MACINTOSH, ADOBE ILLUSTRATOR

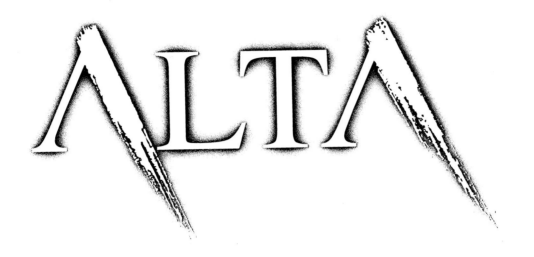

DESIGN FIRM | HORNALL ANDERSON DESIGN WORKS, INC.

ART DIRECTOR | JACK ANDERSON

DESIGNERS | JACK ANDERSON, LARRY ANDERSON, JULIE KEENAN

CLIENT | ALTA BEVERAGE COMPANY

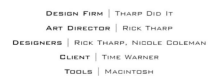

Virtual Garden

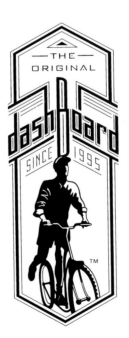

DESIGN FIRM | THARP DID IT

ART DIRECTOR | RICK THARP

DESIGNERS | RICK THARP, NICOLE COLEMAN

CLIENT | TIME WARNER

TOOLS | MACINTOSH

DESIGN FIRM | THARP DID IT

ART DIRECTORS | RICK THARP, CHARLES DRUMMOND

DESIGNER | RICK THARP

ILLUSTRATOR | NICOLE COLEMAN

CLIENT | THE DASHBOARD COMPANY

TOOLS | INK, MACINTOSH

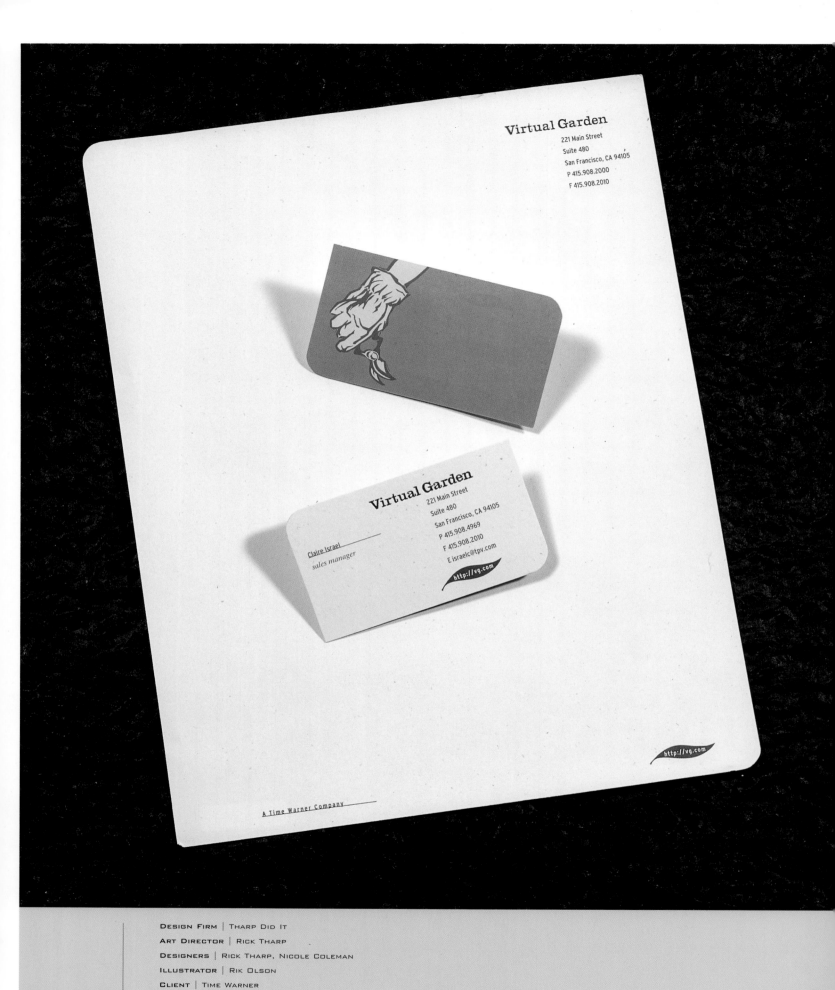

Virtual Garden
221 Main Street
Suite 480
San Francisco, CA 94105
P 415.908.2000
F 415.908.2010

Virtual Garden
221 Main Street
Suite 480
San Francisco, CA 94105
P 415.908.4969
F 415.908.2010
E israelc@tpv.com
http://vg.com

Claire Israel
sales manager

http://vg.com

A Time Warner Company

DESIGN FIRM | THARP DID IT

ART DIRECTOR | RICK THARP

DESIGNERS | RICK THARP, NICOLE COLEMAN

ILLUSTRATOR | RIK OLSON

CLIENT | TIME WARNER

TOOLS | INK, MACINTOSH

PAPER/PRINTING | SIMPSON EVERGREEN/SIMON PRINTING

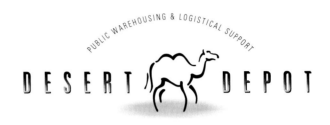

PUBLIC WAREHOUSING & LOGISTICAL SUPPORT

DESIGN FIRM | INSIGHT DESIGN COMMUNICATIONS

ALL DESIGN | SHERRIE AND TRACY HOLDEMAN

CLIENT | CLOTIA WOOD + METAL WORKS

TOOLS | POWER MACINTOSH, MACROMEDIA FREEHAND,
ADOBE PHOTOSHOP

DESIGN FIRM | LORENZ ADVERTISING & DESIGN

ART DIRECTORS | BRIAN LORENZ, ARNE RATERMANIS

DESIGNERS | ARNE RATERMANIS, BRIAN LORENZ

ILLUSTRATOR | ARNE RATERMANIS

CLIENT | DESERT DEPOT

TOOLS | MACINTOSH, ADOBE ILLUSTRATOR

PAPER/PRINTING | CLASSIC CREST/THREE COLOR OFFSET

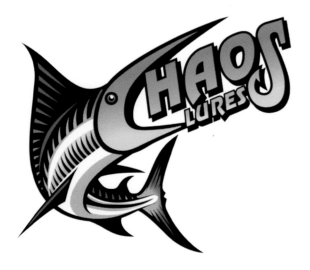

DESIGN FIRM | MIRES DESIGN

ART DIRECTOR/DESIGNER | JOSÉ A. SERRANO

ILLUSTRATOR | TRACY SABIN

CLIENT | CHAOS LURES

DESIGN FIRM | HANSON/DODGE DESIGN

ART DIRECTOR | JOE SUTTER

DESIGNER | SHAWN DOYLE

ILLUSTRATOR | JACK HARGREAVES

CLIENT | TREK BICYCLE CORPORATION

TOOLS | ADOBE ILLUSTRATOR

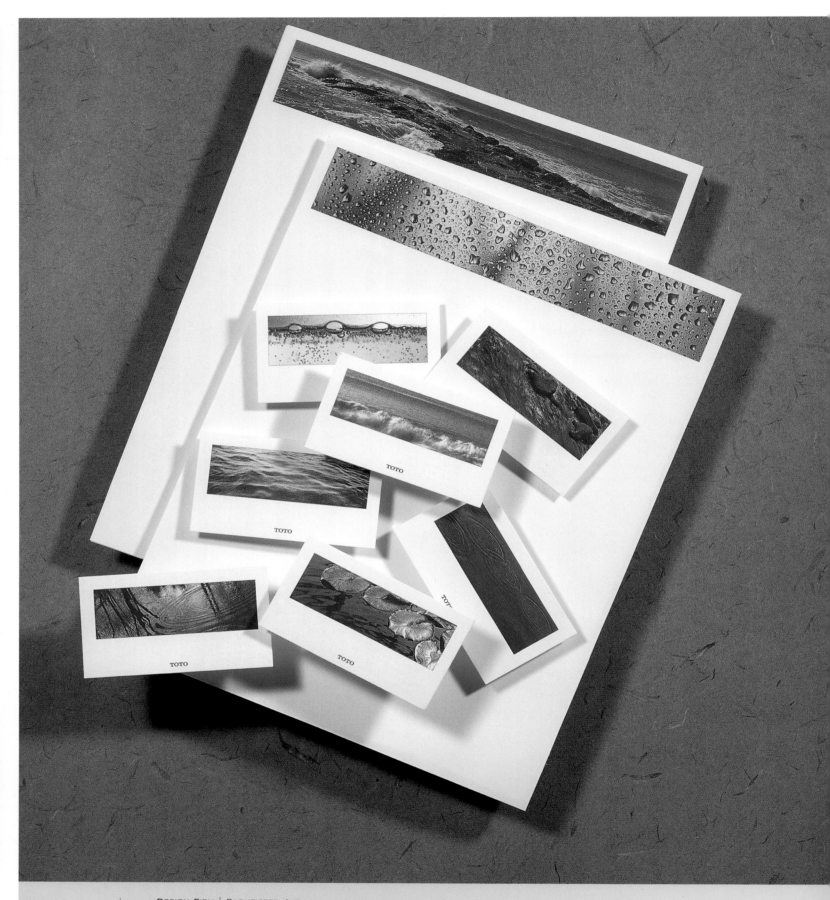

DESIGN FIRM | SAGMEISTER, INC.

ART DIRECTOR | STEFAN SAGMEISTER

DESIGNERS | STEFAN SAGMEISTER, PATRICK DAILY

ILLUSTRATOR | PATRICK DAILY

CLIENT | SCHERTLER AUDIO TRANSDUCERS

TOOLS | MACINTOSH

PAPER/PRINTING | STRATHMORE WRITING 25% COTTON

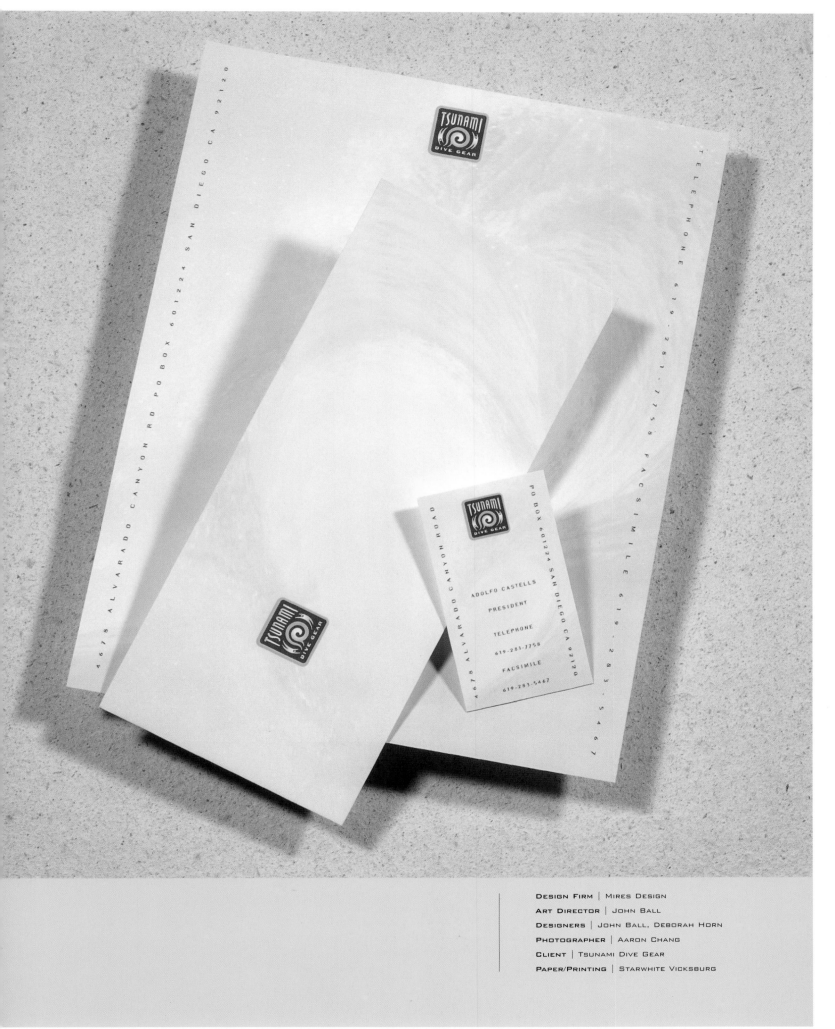

DESIGN FIRM | MIRES DESIGN
ART DIRECTOR | JOHN BALL
DESIGNERS | JOHN BALL, DEBORAH HORN
PHOTOGRAPHER | AARON CHANG
CLIENT | TSUNAMI DIVE GEAR
PAPER/PRINTING | STARWHITE VICKSBURG

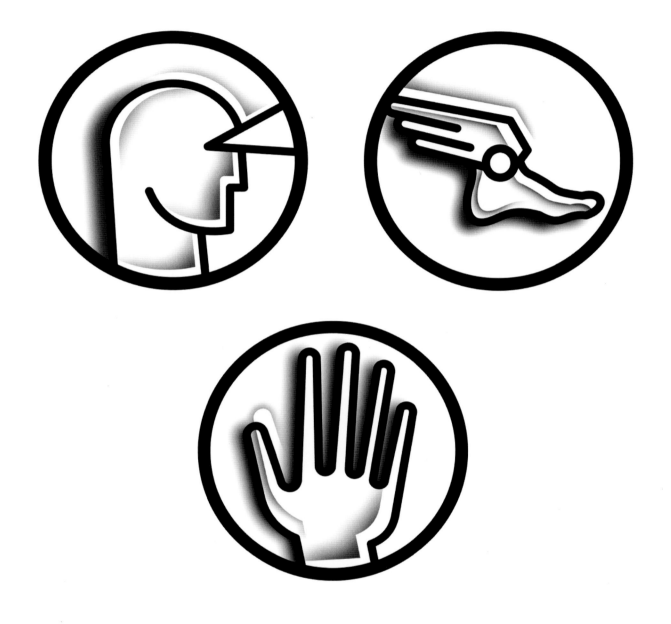

DESIGN FIRM | LOVE PACKAGING GROUP

ALL DESIGN | BRIAN MILLER

CLIENT | HOC INDUSTRIES

TOOLS | MACROMEDIA FREEHAND, ADOBE PHOTOSHOP

PAPER/PRINTING | CHAMPION

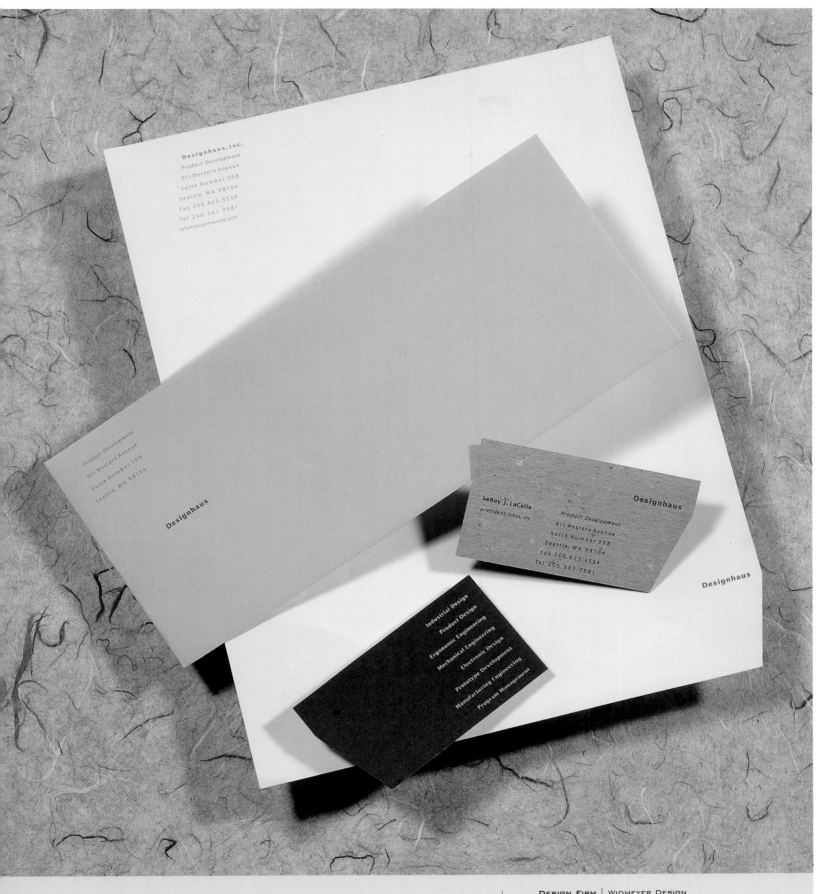

Designhaus, Inc.
Product Development
911 Western Avenue
Suite Number 308
Seattle, WA 98104
Fax 206.623.3534
Tel 206.343.7581
info@designhausinc.com

Product Development
911 Western Avenue
Suite Number 308
Seattle, WA 98104

Designhaus

LeRoy J. LaCelle
president, FIDSA, SPE

Product Development
911 Western Avenue
Suite Number 308
Seattle, WA 98104
Fax 206.623.3534
Tel 206.343.7581

Designhaus

Designhaus

Industrial Design
Product Design
Ergonomic Engineering
Mechanical Engineering
Electronic Design
Prototype Development
Manufacturing Engineering
Program Management

DESIGN FIRM | WIDMEYER DESIGN

ART DIRECTOR | KEN WIDMEYER, DALE HART

DESIGNER | DALE HART

CLIENT | DESIGNHAUS

TOOLS | POWER MACINTOSH, MACROMEDIA FREEHAND

PAPER/PRINTING | FRENCH PAPER/OFFSET

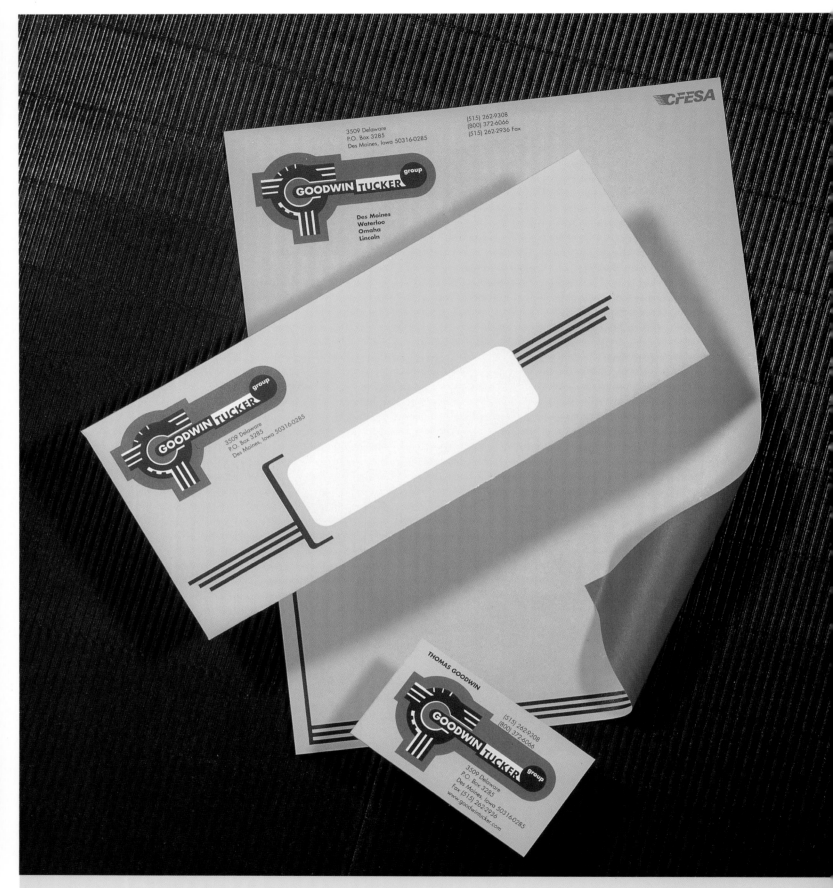

DESIGN FIRM | SAYLES GRAPHIC DESIGN

ART DIRECTOR/ILLUSTRATOR | JOHN SAYLES

DESIGNERS | JOHN SAYLES, JENNIFER ELLIOTT

CLIENT | GOODWIN TUCKER GROUP

PAPER/PRINTING | NEENAH ENVIRONMENT WHITE/OFFSET

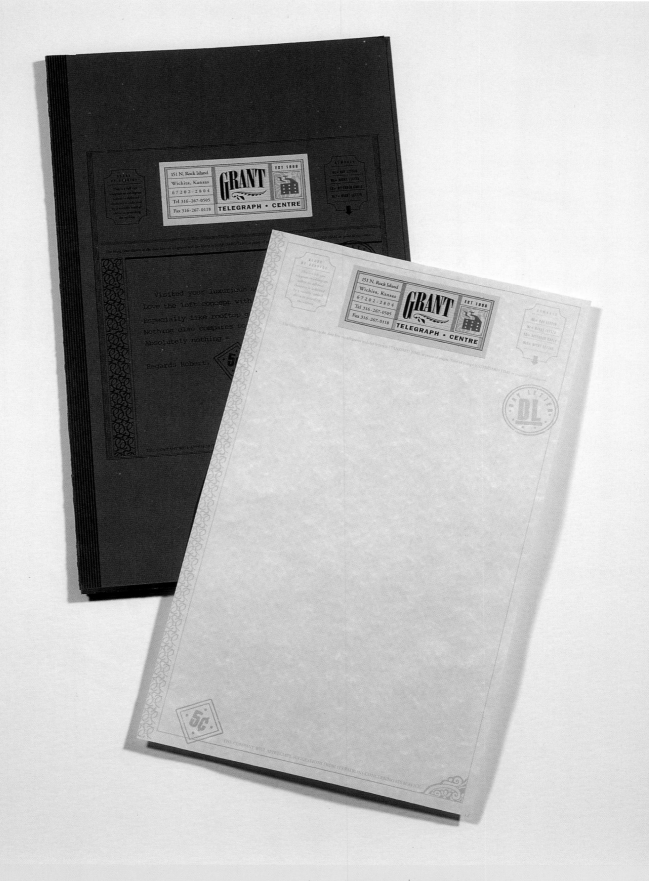

DESIGN FIRM | GRETEMAN GROUP

ART DIRECTORS/DESIGNERS | SONIA GRETEMAN, JAMES STRANGE

ILLUSTRATOR | JAMES STRANGE

CLIENT | GRANT TELEGRAPH CENTRE

TOOLS | MACROMEDIA FREEHAND

PAPER/PRINTING | ASTRO PARCHMENT, SAND +

CONFETTI SABLE BLACK/OFFSET

DESIGN FIRM | HANSON/DODGE DESIGN
ART DIRECTOR/DESIGNER | ANIA WASILEWSKA
ILLUSTRATOR | JACK HARGREAVES
CLIENT | VECTOR TECHNOLOGIES, INC.
TOOLS | ADOBE ILLUSTRATOR

DESIGN FIRM | MIRES DESIGN
ART DIRECTOR/DESIGNER | JOSÉ A. SERRANO
PHOTOGRAPHER | CARL VANDERSCHUIT
CLIENT | AGASSI ENTERPRISES

DESIGN FIRM | MIRES DESIGN
ART DIRECTOR/DESIGNER | JOSÉ A. SERRANO
ILLUSTRATOR | TRACY SABIN
CLIENT | CHINGONES

DESIGN FIRM | SAGMEISTER, INC.

ART DIRECTOR | STEFAN SAGMEISTER

DESIGNERS | STEFAN SAGMEISTER, VERONICA OH

PHOTOGRAPHY | MICHAEL GRIMM, STOCK

CLIENT | TOTO

TOOLS | MACINTOSH, 2 1/4 CAMERA

PAPER/PRINTING | STRATHMORE WRITING 25% COTTON

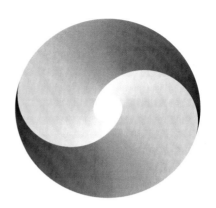

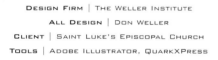

SAINT LUKE'S
EPISCOPAL CHURCH

DESIGN FIRM | THE WELLER INSTITUTE
ALL DESIGN | DON WELLER
CLIENT | SAINT LUKE'S EPISCOPAL CHURCH
TOOLS | ADOBE ILLUSTRATOR, QUARKXPRESS

DESIGN FIRM | WITHERSPOON ADVERTISING
CREATIVE DIRECTOR | DEBRA MORROW
ART DIRECTOR/DESIGNER | RANDY PADORR-BLACK
ILLUSTRATOR | JAMES MELLARD
CLIENT | WOUND HEALING & HYPERBARIC MEDICINE CENTER

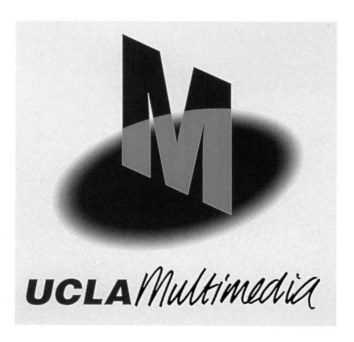

DESIGN FIRM | SHIMOKOCHI/REEVES
ART DIRECTOR | MAMORU SHIMOKOCHI, ANNE REEVES
CLIENT | UCLA MULTIMEDIA
TOOLS | ADOBE ILLUSTRATOR

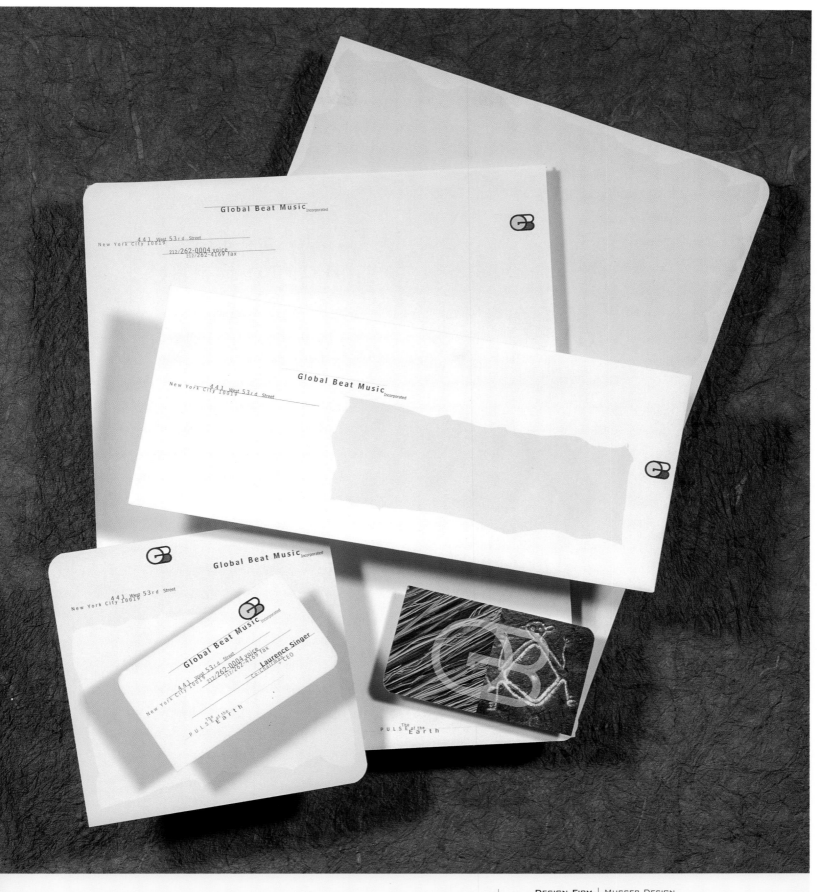

DESIGN FIRM | MUSSER DESIGN

ART DIRECTOR/DESIGNER | JERRY KING MUSSER

CLIENT | GLOBAL BEAT MEDIA

TOOLS | ADOBE ILLUSTRATOR

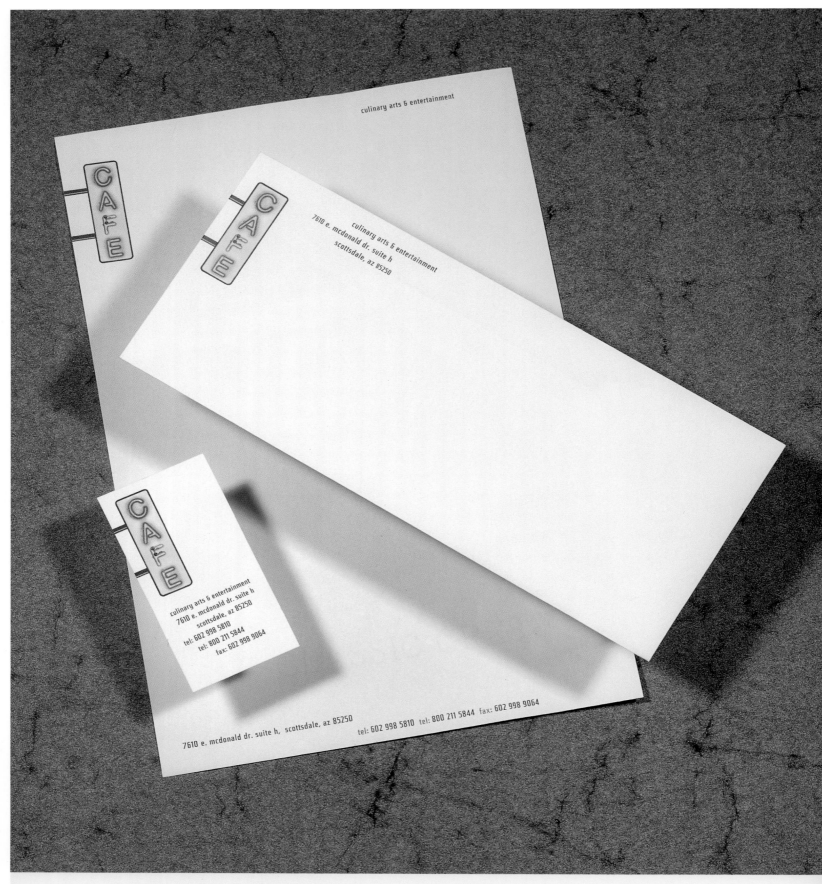

culinary arts & entertainment

culinary arts & entertainment
7610 e. mcdonald dr. suite h
scottsdale, az 85250

culinary arts & entertainment
7610 e. mcdonald dr. suite h
scottsdale, az 85250
tel: 602 998 5810
tel: 800 211 5844
fax: 602 998 9064

7610 e. mcdonald dr. suite h, scottsdale, az 85250 tel: 602 998 5810 tel: 800 211 5844 fax: 602 998 9064

DESIGN FIRM | AFTER HOURS CREATIVE
ART DIRECTOR/DESIGNER | AFTER HOURS CREATIVE
PHOTOGRAPHER | ART HOLEMAN
CLIENT | CULINARY ARTS & ENTERTAINMENT

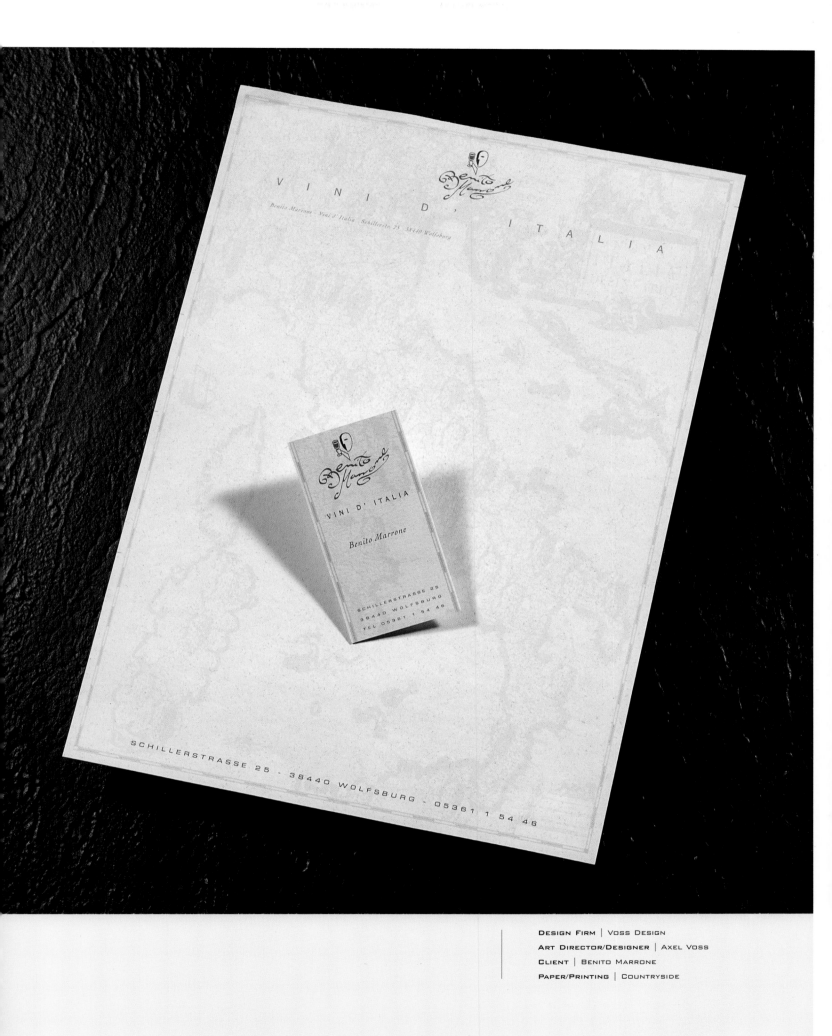

DESIGN FIRM | VOSS DESIGN
ART DIRECTOR/DESIGNER | AXEL VOSS
CLIENT | BENITO MARRONE
PAPER/PRINTING | COUNTRYSIDE

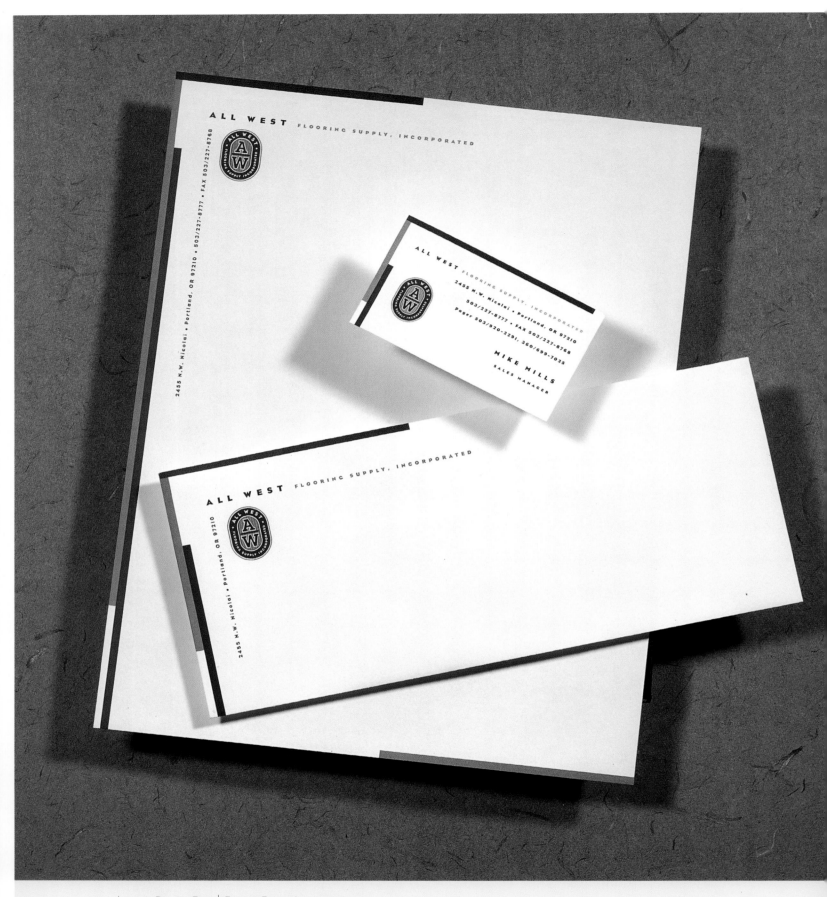

DESIGN FIRM | ROBERT BAILEY INCORPORATED

ART DIRECTOR | CONNIE LIGHTNER

DESIGNERS | CONNIE LIGHTNER, DAN FRANKLIN

CLIENT | ALL WEST FLOORING SUPPLY, INC.

TOOLS | MACROMEDIA FREEHAND, QUARKXPRESS

PAPER/PRINTING | PROTOCOL RECYCLED BRIGHT
WHITE/CNS GRAPHICS

FUTBOL **CAFE**

DESIGN FIRM | CATO BERRO DISEÑO
ART DIRECTOR | GONZALO BERRO
DESIGNER | GONZALO BERRO/ESTEBAN SERRANO
ILLUSTRATOR | ESTEBAN SERRANO
CLIENT | FUTBOL CAFE/BAR
TOOLS | ADOBE ILLUSTRATOR

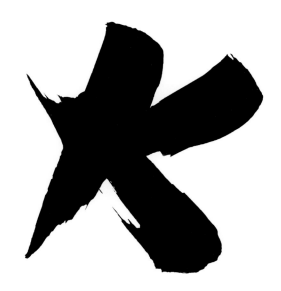

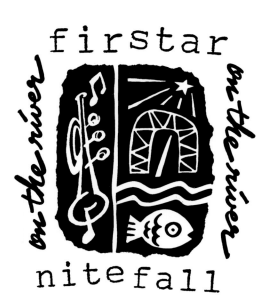

DESIGN FIRM | MICHAEL STANARD DESIGN, INC.
ART DIRECTOR | MICHAEL STANARD
DESIGNER/ILLUSTRATOR | MICHAEL STANARD, DEV HOMSI
CLIENT | NORTHWESTERN UNIVERSITY

DESIGN FIRM | SAYLES GRAPHIC DESIGN
ALL DESIGN | JOHN SAYLES
CLIENT | DES MOINES PARK & RECREATION DEPT.

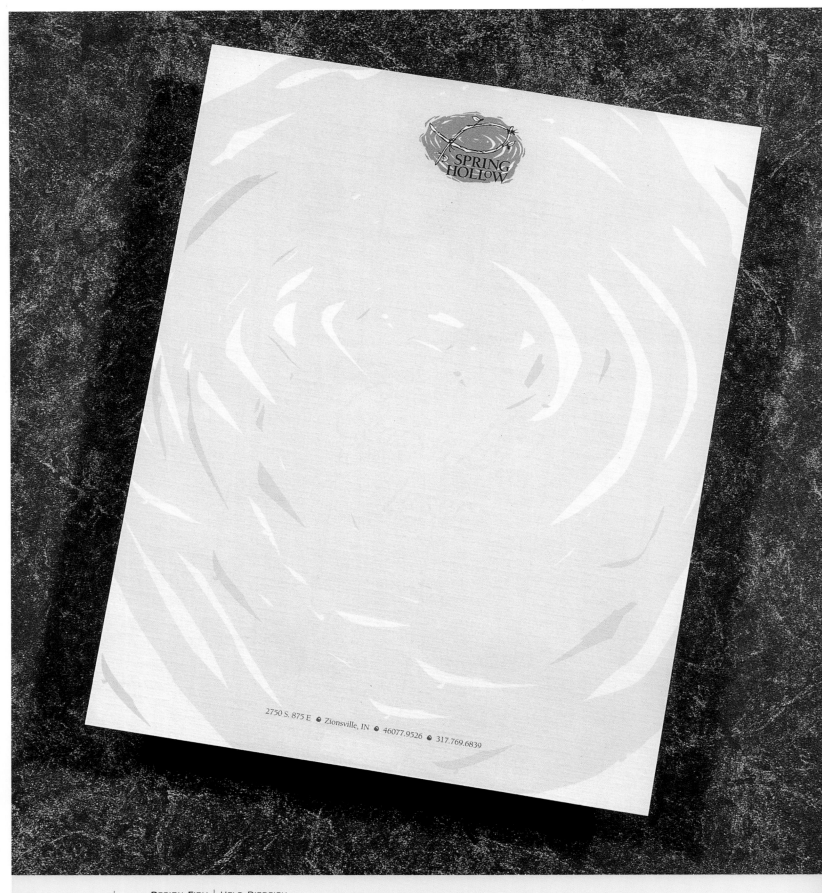

2750 S. 875 E ● Zionsville, IN ● 46077.9526 ● 317.769.6839

DESIGN FIRM | HELD DIEDRICH
ART DIRECTOR | DOUG DIEDRICH
DESIGNER/ILLUSTRATOR | MEGAN SNOW
CLIENT | SPRING HOLLOW
TOOLS | QUARKXPRESS, ADOBE ILLUSTRATOR
PAPER/PRINTING | NEENAH, CLASSIC LAID,
 NATURAL WHITE, LASER FINISH/OFFSET

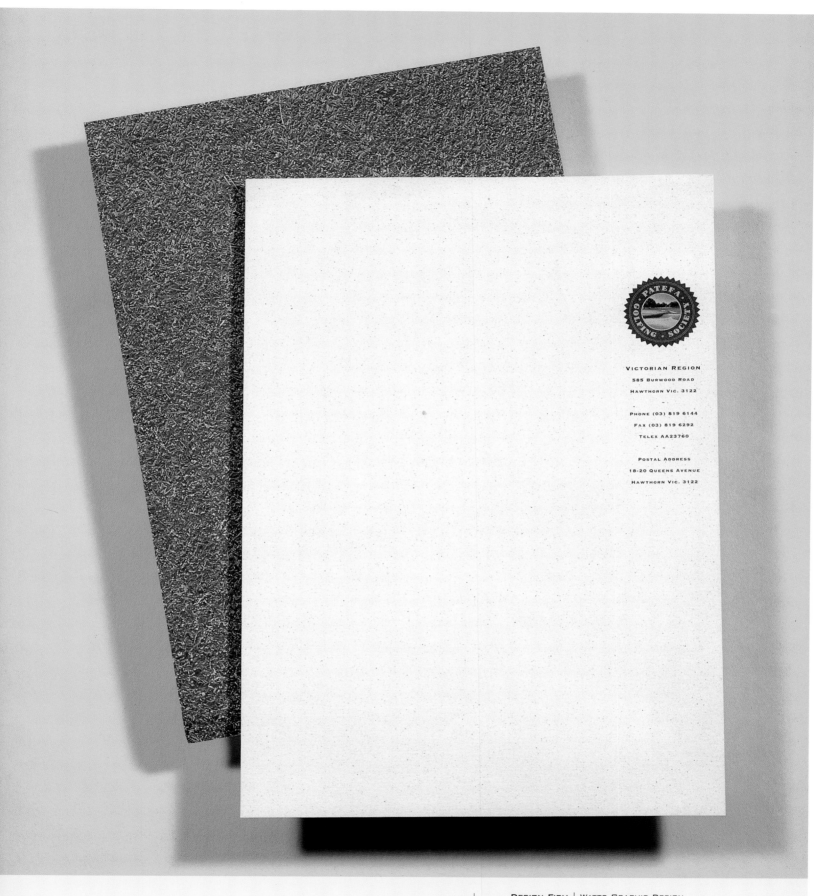

VICTORIAN REGION
585 BURWOOD ROAD
HAWTHORN VIC. 3122

PHONE (03) 819 6144
FAX (03) 819 6292
TELEX AA23760

POSTAL ADDRESS
18-20 QUEENS AVENUE
HAWTHORN VIC. 3122

DESIGN FIRM | WATTS GRAPHIC DESIGN
ART DIRECTORS/DESIGNERS | HELEN AND PETER WATTS
CLIENT | PATEFA GOLFING SOCIETY

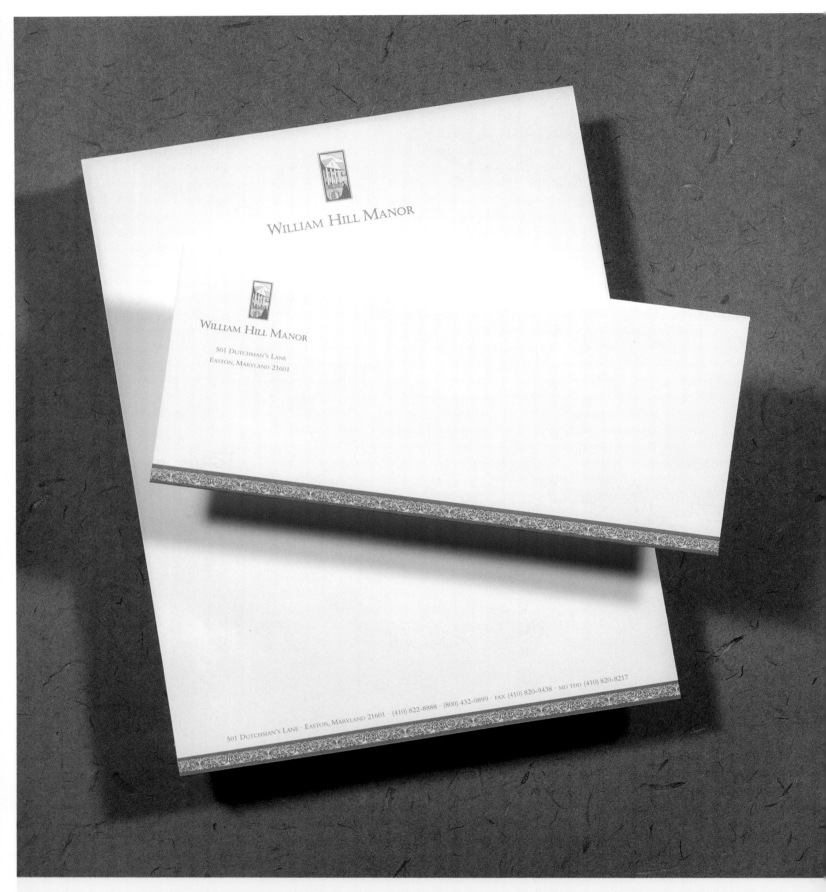

WILLIAM HILL MANOR

WILLIAM HILL MANOR

501 Dutchman's Lane
Easton, Maryland 21601

501 Dutchman's Lane · Easton, Maryland 21601 · (410) 822-8888 · (800) 432-0899 · Fax (410) 820-9438 · MD TDD (410) 820-8217

DESIGN FIRM | WHITNEY EDWARDS DESIGN

ALL DESIGN | CHARLENE WHITNEY EDWARDS

CLIENT | WILLIAM HILL MANOR

TOOLS | ADOBE PHOTOSHOP, ADOBE ILLUSTRATOR,
QUARKXPRESS

PAPER/PRINTING | CRANES/ONE COLOR

DESIGN FIRM | MUELLER & WISTER, INC.

ALL DESIGN | JOSEPH M. DELICH

CLIENT | WYETH-AYERST INTERNATIONAL

TOOLS | ADOBE PHOTOSHOP, STREAMLINE, MACROMEDIA FREEHAND

DESIGN FIRM | ARMINDA HOPKINS & ASSOCIATES

ART DIRECTOR/DESIGNER | MELANIE MATSON

CLIENT | FREDONIA HEALTH SYSTEMS

TOOLS | QUARKXPRESS, ADOBE ILLUSTRATOR

DESIGN FIRM | LOVE PACKAGING GROUP

ALL DESIGN | BRIAN MILLER

CLIENT | ELOGEN, INC.

TOOLS | MACROMEDIA FREEHAND, ADOBE PHOTOSHOP

DESIGN FIRM | MIKE SALISBURY COMMUNICATIONS, INC.

ART DIRECTOR | MIKE SALISBURY

DESIGNER | MARY EVELYN MCGOUGH

ILLUSTRATOR | BOB MAILE

CLIENT | ORANGE COUNTY MUSEUM OF ART

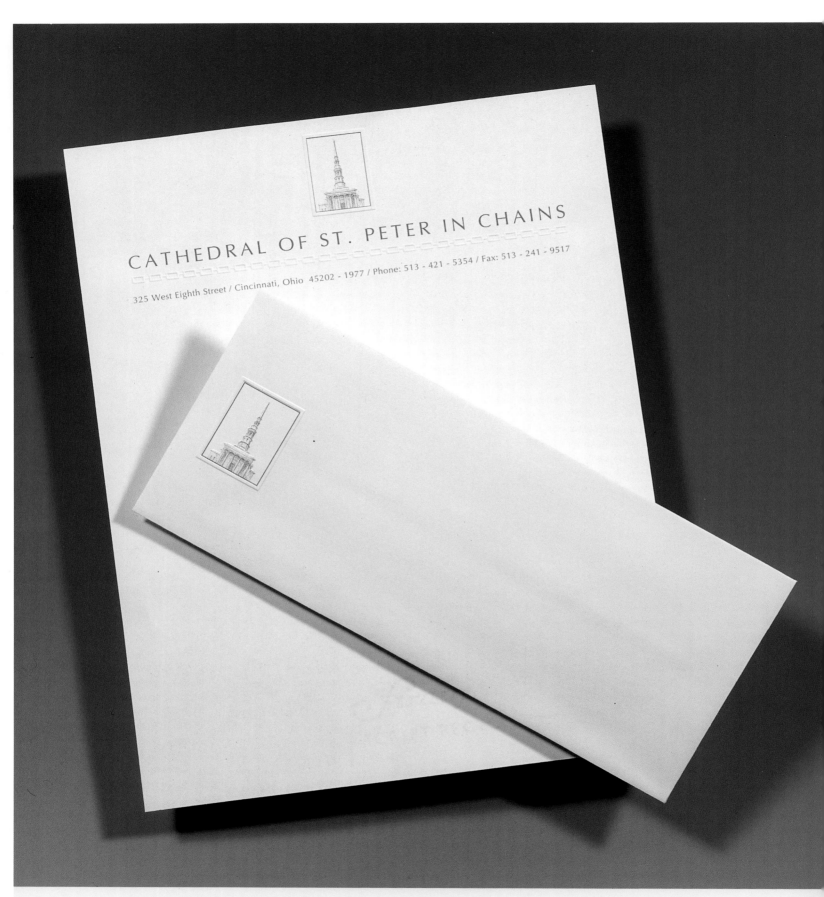

CATHEDRAL OF ST. PETER IN CHAINS

325 West Eighth Street / Cincinnati, Ohio 45202 - 1977 / Phone: 513 - 421 - 5354 / Fax: 513 - 241 - 9517

DESIGN FIRM | WOOD/BROD DESIGN

ART DIRECTOR/DESIGNER | STAN BROD

CLIENT | CATHEDRAL OF ST. PETER IN CHAINS

TOOLS | ADOBE ILLUSTRATOR

PAPER/PRINTING | STRATHMORE/HENNEGAN COMPANY

DESIGN FIRM | CLARK DESIGN
ART DIRECTOR | ANNEMARIE CLARK
DESIGNER | CRAIG STOUT
CLIENT | HOPE HOUSING/BIG WASH
TOOLS | ADOBE ILLUSTRATOR

DESIGN FIRM | RICK EIBER DESIGN (RED)
ART DIRECTOR/DESIGNER | RICK EIBER
CLIENT | COLUMBIA BAPTIST CONFERENCE
TOOLS | ADOBE ILLUSTRATOR

DESIGN FOR THE FUTURE AND
3RD ANNUAL LEARNING CONFERENCE

DESIGN FIRM | AFTER HOURS CREATIVE
ART DIRECTOR/DESIGNER | AFTER HOURS CREATIVE
PHOTOGRAPHER | ART HOLEMAN
CLIENT | CULINARY ARTS & ENTERTAINMENT

DESIGN FIRM | CECILY ROBERTS DESIGN
ALL DESIGN | CECILY ROBERTS
CLIENT | KAISER PERMANENTE/DESIGN FOR THE FUTURE CONFERENCE
TOOLS | MACROMEDIA FREEHAND, QUARKXPRESS

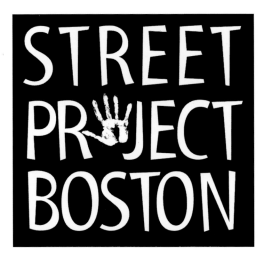

DESIGN FIRM | INSIGHT DESIGN COMMUNICATIONS
ALL DESIGN | SHERRIE AND TRACY HOLDEMAN
CLIENT | WORLD FITNESS, INC.
TOOLS | MACROMEDIA FREEHAND

DESIGN FIRM | CHRIS ST. CYR GRAPHIC DESIGN
ART DIRECTOR/DESIGNER | CHRIS ST. CYR
CLIENT | STREET PROJECT BOSTON
TOOLS | ADOBE PHOTOSHOP, QUARKXPRESS

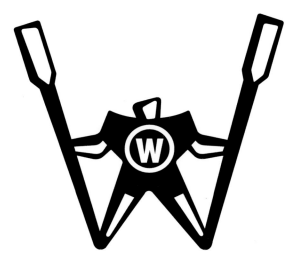

DESIGN FIRM | LOVE PACKAGING GROUP
ALL DESIGN | BRIAN MILLER
CLIENT | WICHITA STATE UNIVERSITY, MEN'S CREW TEAM
TOOLS | MACROMEDIA FREEHAND

DESIGN FIRM | RICK EIBER DESIGN (RED)
ART DIRECTOR/DESIGNER | RICK EIBER
CLIENT | COLUMBIA BAPTIST CONFERENCE
TOOLS | ADOBE ILLUSTRATOR
PAPER/PRINTING | CURTIS BRIGHTWATER/TWO COLOR OVER TWO COLOR

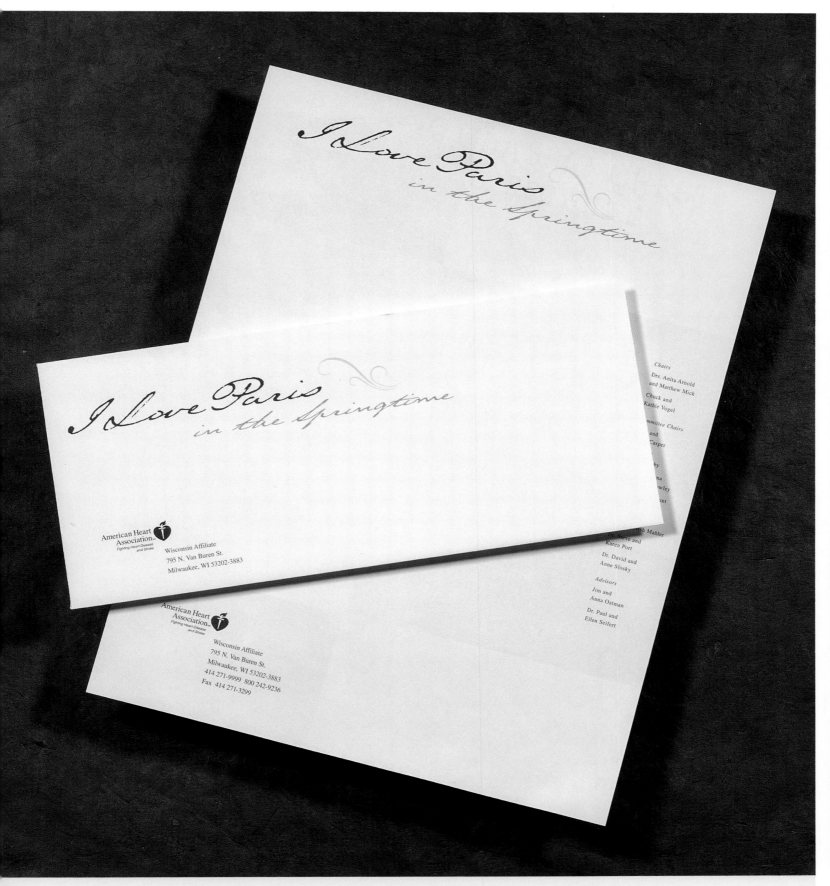

DESIGN FIRM | BECKER DESIGN
ART DIRECTOR/DESIGNER | NEIL BECKER
CLIENT | AMERICAN HEART ASSOCIATION
TOOLS | QUARKXPRESS, ADOBE ILLUSTRATOR
PAPER/PRINTING | NEENAH CLASSIC CREST RECYCLED

QUANTUM Ranger

DESIGN FIRM | DESIGN CENTER
ART DIRECTOR | JOHN REGER
DESIGNER | CORY DOCKEN
CLIENT | SCIMED

Ranger

DESIGN FIRM | DESIGN CENTER
ART DIRECTOR | JOHN REGER
DESIGNER | CORY DOCKEN
CLIENT | SCIMED

Universität Kaiserslautern

DESIGN FIRM | GEFFERT DESIGN
DESIGNER | GERALD GEFFERT
CLIENT | UNIVERSITÄT KAISERSLAUTERN

conosci Biella

VIAGGI PER STUDENTI ALLA SCOPERTA DEL BIELLESE

DESIGN FIRM | IMPRESS SAS
CLIENT | PROVINCIA DI BIELLA

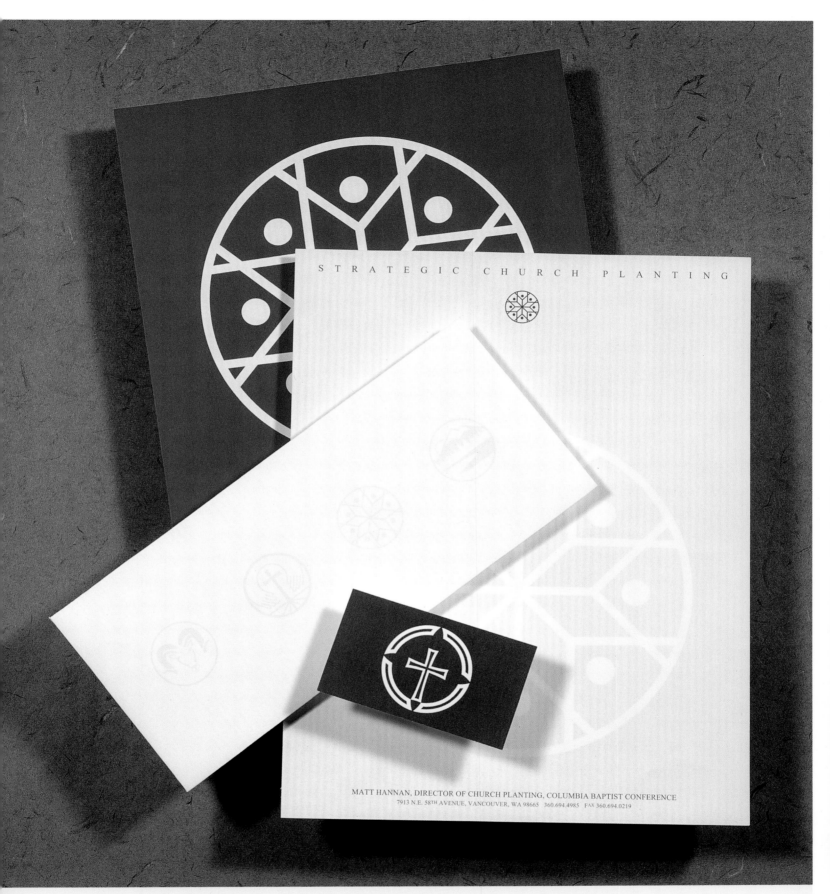

STRATEGIC CHURCH PLANTING

MATT HANNAN, DIRECTOR OF CHURCH PLANTING, COLUMBIA BAPTIST CONFERENCE
7913 N.E. 58TH AVENUE, VANCOUVER, WA 98665 360.694.4985 FAX 360.694.0219

DESIGN FIRM | RICK EIBER DESIGN (RED)

ART DIRECTOR/DESIGNER | RICK EIBER

CLIENT | COLUMBIA BAPTIST CONFERENCE

TOOLS | ADOBE ILLUSTRATOR

PAPER/PRINTING | CURTIS BRIGHTWATER/TWO
 COLOR OVER TWO COLOR

DESIGN FIRM Martiny and Company
ALL DESIGN Rick Conner
CLIENT Step By Step Packaging, Inc.
TOOL Adobe Illustrator

Initial thoughts were worked out on paper. After the concept
was conceived, mechanics were worked out on the computer.
Color tests were run on a 3M Rainbow proofing system.

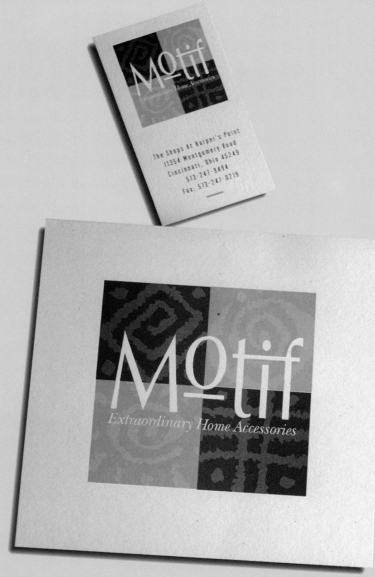

DESIGN FIRM Martiny and Company
ART DIRECTOR/DESIGNER Nancy Andrew
CLIENT Motif Home Accessories
TOOLS Adobe Illustrator, QuarkXPress

A description was added to the name for clarification. The
funky illustrations reflect products sold in store.

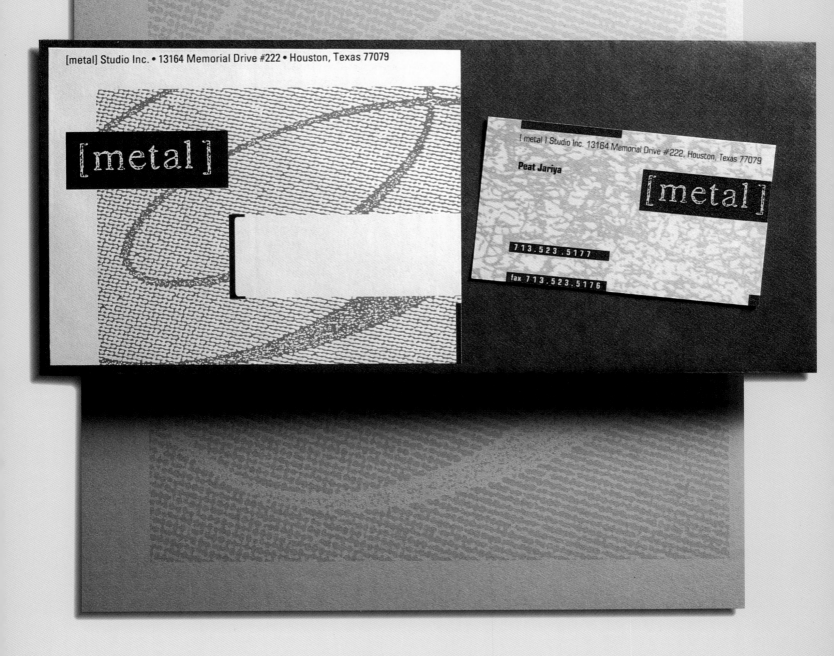

DESIGN FIRM [Metal]
ART DIRECTOR Peat Jariya
PAPER/PRINTING Champion Benefit for letterhead, UV Ultra for
business cards, printing in black and a metallic ink.

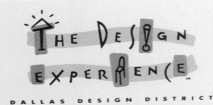

A CROW DESIGN CENTERS PROJECT
1400 TURTLE CREEK BOULEVARD, SUITE 100
DALLAS, TEXAS 75207 214.744.4250 FAX 214.744.9668

DESIGN FIRM Jon Flaming Design

ALL DESIGN Jon Flaming

CLIENT The Design Experience

PAPER/PRINTING Simpson Starwhite Vicksburg

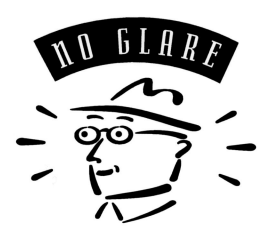

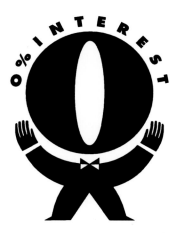

Design Firm Jon Flaming Design
All Design Jon Flaming
Client Eyemasters
Tool Adobe Illustrator

This logo for no-glare eyewear was created using Illustrator's Brush tool and a Wacom graphics tablet and pen.

Design Firm Jon Flaming Design
All Design Jon Flaming
Client Computer City
Tool Adobe Illustrator

This logo was used in a computer store's zero percent interest ad.

Design Firm Jon Flaming Design
All Design Jon Flaming
Client Eyemasters
Tool Adobe Illustrator

This logo for Eyemasters's two-for-one sale was created using Illustrator's Brush tool and a Wacom graphics tablet and pen.

Design Firm Jon Flaming Design
All Design Jon Flaming
Client Blockbuster Video
Tool Adobe Illustrator

Many logos and icons were produced for an elaborate and extensive new business pitch that was made to Blockbuster Video.

DESIGN FIRM Jon Flaming Design
ALL DESIGN Jon Flaming
CLIENT Objex Inc.
TOOL Adobe Illustrator

This logo was created for private-label coffees from Objex Inc.

DESIGN FIRM Jon Flaming Design
ALL DESIGN Jon Flaming
TOOL Adobe Illustrator

This logo was created for a design and illustration studio located in the industrial sector of downtown Dallas, next to a huge power plant with tan smokestacks.

DESIGN FIRM Jon Flaming Design
ALL DESIGN Jon Flaming
CLIENT Blockbuster Video
TOOL Adobe Illustrator

Many logos and icons were produced for an elaborate and extensive new business pitch that was made to Blockbuster Video.

DESIGN FIRM Jon Flaming Design
ALL DESIGN Jon Flaming
CLIENT Target Music Research
TOOL Adobe Illustrator

This logo was created for a company that does target market research for the music industry.

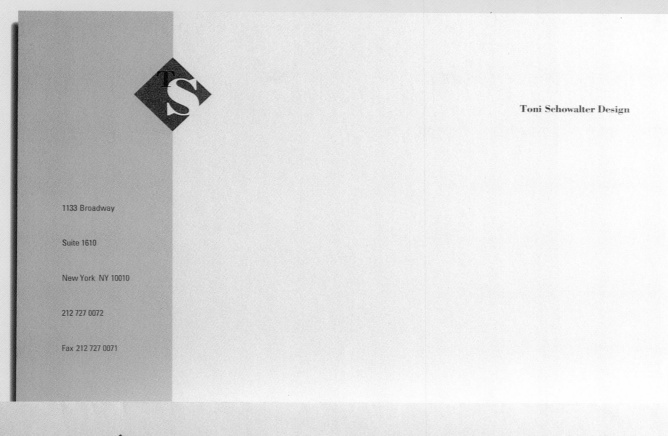

1133 Broadway

Suite 1610

New York NY 10010

212 727 0072

Fax 212 727 0071

Toni Schowalter Design

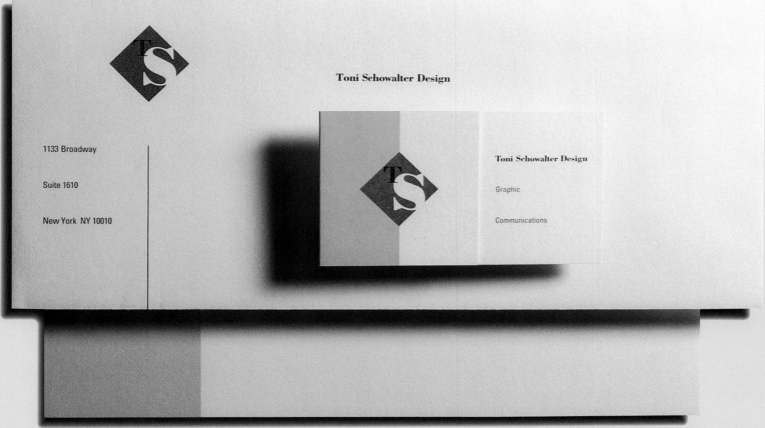

1133 Broadway

Suite 1610

New York NY 10010

Toni Schowalter Design

Toni Schowalter Design

Graphic

Communications

DESIGN FIRM Toni Schowalter Design
ART DIRECTOR/DESIGNER Toni Schowalter
PAPER/PRINTING Strathmore Natural White, Wove Finish, offset
···
The mark was created in QuarkXPress on the Macintosh.
Combining a unique color palette with unique layouts effectively
portrays this graphic design firm.

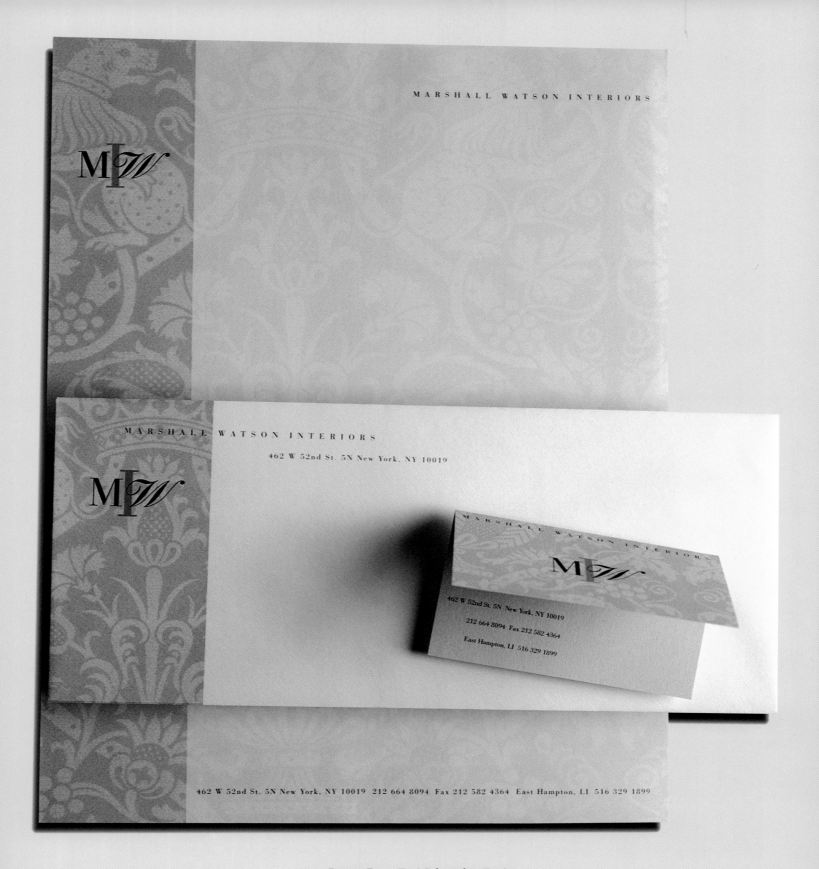

DESIGN FIRM Toni Schowalter Design
ART DIRECTOR/DESIGNER Toni Schowalter
CLIENT Marshall Watson Interiors
PAPER/PRINTING Strathmore Natural White, Wove Finish, offset
TOOL Adobe Illustrator

The logo was created to look both clean and decorated to reflect
the client's interior design styles. The background on the sta-
tionery matches the client's most common style of design.

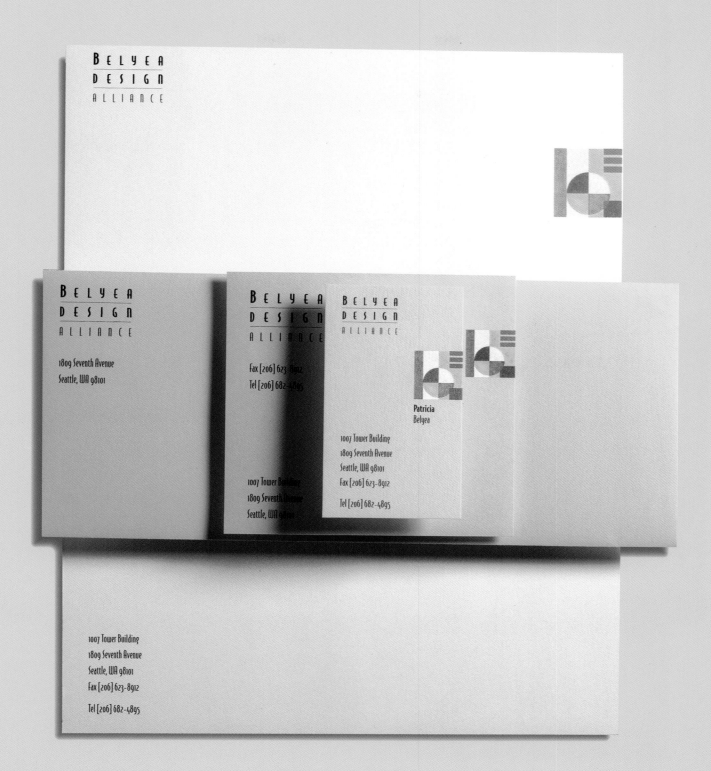

DESIGN FIRM Belyea Design Alliance
ART DIRECTOR Patricia Belyea
DESIGNERS Samantha Hunt, Adrianna Jumping Eagle
ILLUSTRATORS Jani Drewfs, Brian O'Neill
PAPER/PRINTING Simpson Protocol, Ruby Press, 4-color
TOOLS Adobe Photoshop, Aldus FreeHand, Fractal Design
Painter
...

The mark was rendered in FreeHand, colored in Painter and fil-
tered through Photoshop. The set is 4-color printed; a custom
match yellow replaces process yellow.

WDG COMMUNICATIONS

Concept-based Marketing Communications and Graphic Design

3011 Johnson Avenue NW Cedar Rapids, Iowa 52405

Telephone 319.396.1401 Facsimile 319.396.1647

WDG COMMUNICATIONS

Concept-based Marketing Communications and Graphic Design

3011 Johnson Avenue NW Cedar Rapids, Iowa 52405

DESIGN FIRM WDG Communications
ART DIRECTOR/DESIGNER Duane Wood
ILLUSTRATOR Mark Jacobson
CLIENT WDG Communications
PAPER/PRINTING Neenah Classic Crest Sawgrass, 2-color
TOOLS Adobe Illustrator, QuarkXPress

The identity presents the firm's professionalism and the dynamic
synergy. The logo was scanned into and executed in Illustrator
and the identity was assembled in QuarkXPress.

LONDON ROAD DESIGN

DESIGN FIRM London Road Design
ART DIRECTOR/DESIGNER Martin Haseman
ILLUSTRATOR Michael Schwab
PAPER/PRINTING Strathmore Bright White Wove,
letterpress printing
TOOLS Adobe Illustrator and Streamline

Michael Schwab supplied the flat art, which was scanned,
vectorized with Streamline, and colored in Illustrator. Julie
Holcomb, a letterpress printer in San Francisco, printed
the work.

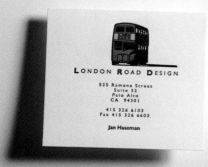

535 Ramona Street Suite 33 Palo Alto CA 94301 415 326 6103 Fax 415 326 6603

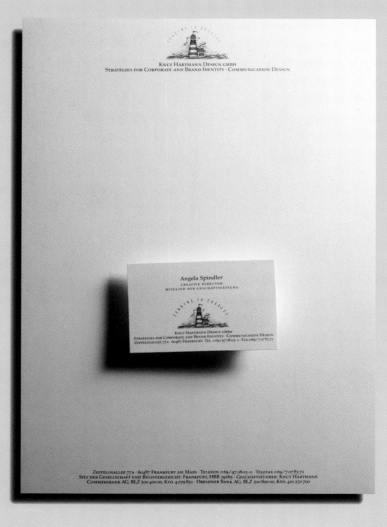

DESIGN FIRM Knut Hartmann Design
DESIGNER Angela Spindler
PAPER/PRINTING Croxley Heritage, 4-color

Letterhead and Logo of Knut Hartmann Design of Frankfurt.
The lighthouse image leading the way confidently and
reassuringly to success.

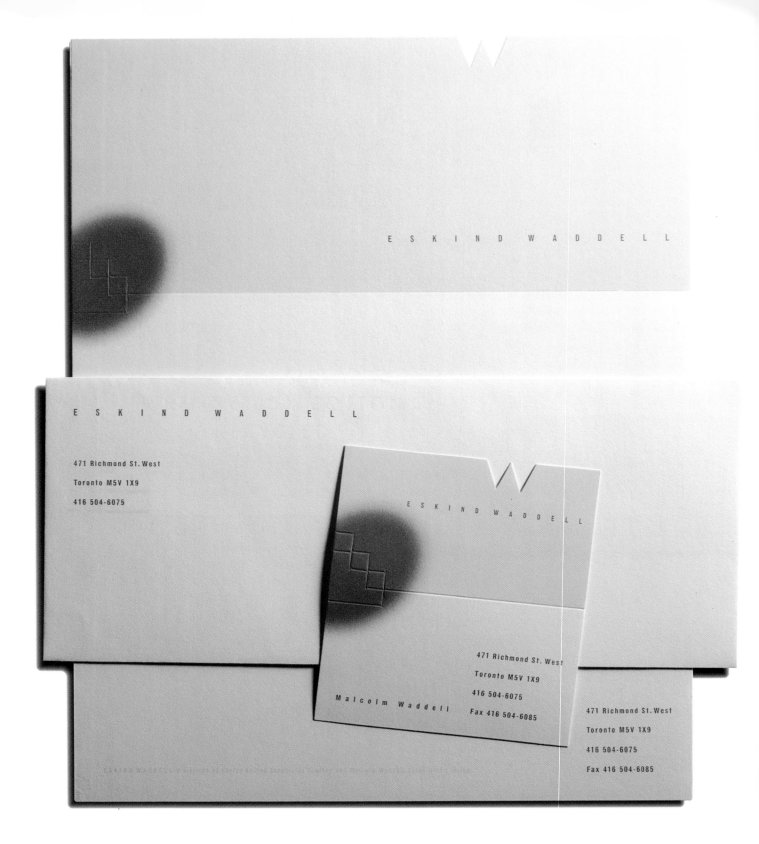

ESKIND WADDELL

ESKIND WADDELL

471 Richmond St. West

Toronto M5V 1X9

416 504-6075

ESKIND WADDELL

471 Richmond St. West

Toronto M5V 1X9

416 504-6075

Fax 416 504-6085

Malcolm Waddell

471 Richmond St. West

Toronto M5V 1X9

416 504-6075

Fax 416 504-6085

DESIGN FIRM Eskind Waddell
DESIGNERS Roslyn Eskind, Malcolm Waddell, Nicola Lyon
PAPER/PRINTING Strathmore Writing Recycled White Wove,
2-color and die cut

Eskind Waddell's distinctive die cut from the previous
stationery, was incorporated into a more contemporary layout.
Revising typography and color also gave the firm a fresh logo
without breaking entirely with the past.

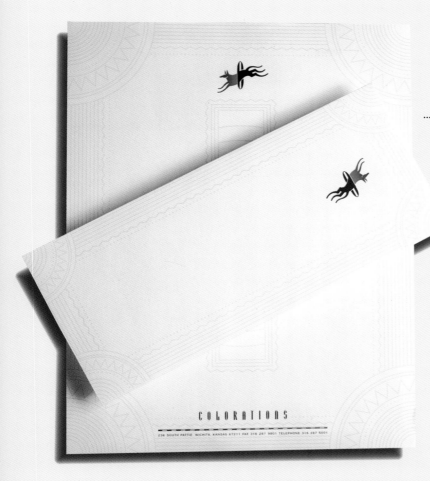

Design Firm Greteman Group
Art Director Sonia Greteman
Designers Sonia Greteman, Bill Gardner
Client Colorations
Paper/Printing Classic Crest, 4-color process
Tool Aldus FreeHand

This service bureau jumps through hoops for its clients. The big "C" changes color from black-and-white to magical color creating a circus-like atmosphere.

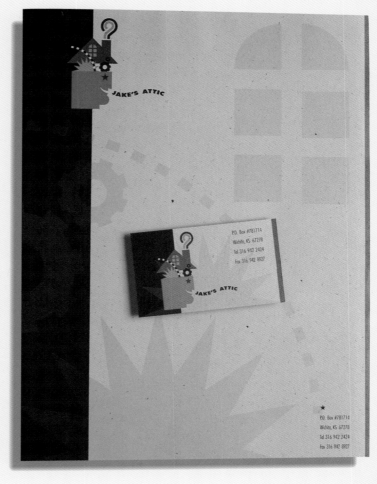

Design Firm Greteman Group
Art Director Sonia Greteman
Designers Sonia Greteman, Karen Hogan
Illustrator Sonia Greteman
Client Jakes Attic Science Show
Paper/Printing Benefit, 4-color process
Tool Aldus FreeHand

This design displays a fun level of playfulness, curiosity, and excitement while developing a "character" with an attic hat, question-mark smoke, and a sparkle in his eye.

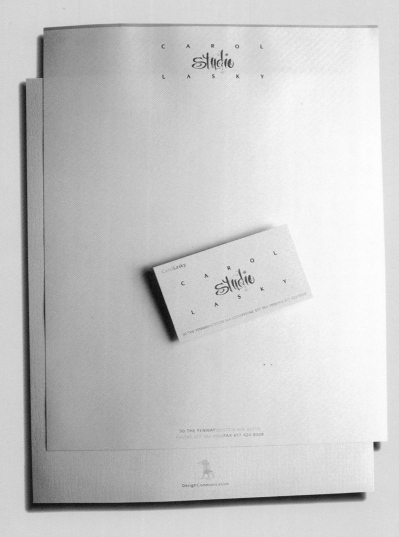

DESIGN FIRM Carol Lasky Studio
ART DIRECTOR Carol Lasky
DESIGNER Erin Donnellan
ILLUSTRATOR Mark Allen
CLIENT Carol Lasky Studio
PAPER/PRINTING Curtis Brightwater, Strathmore Elements,
United Lithograph
TOOLS Aldus FreeHand, QuarkXPress

The system is a study in juxtapositions: calligraphy with a serif font; color against color. It juxtaposes bright white paper with diagonal ribs, polka dots, lush texture, and vertical grooves.

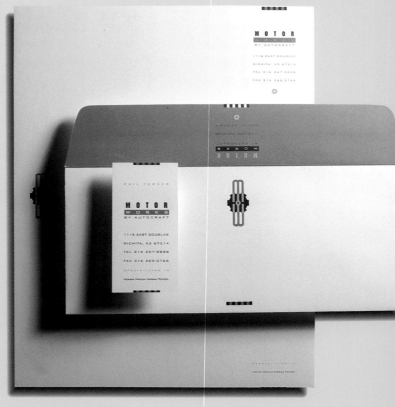

DESIGN FIRM Greteman Group
ART DIRECTORS Sonia Greteman, James Strange
DESIGNER James Strange
CLIENT Motorworks
PAPER/PRINTING Classic Crest, 3-color
TOOL Aldus FreeHand

The client wanted an image that appeared fast, racy and mechanical. Since the "M" and "W" mirror each other, a gear was added in the center.

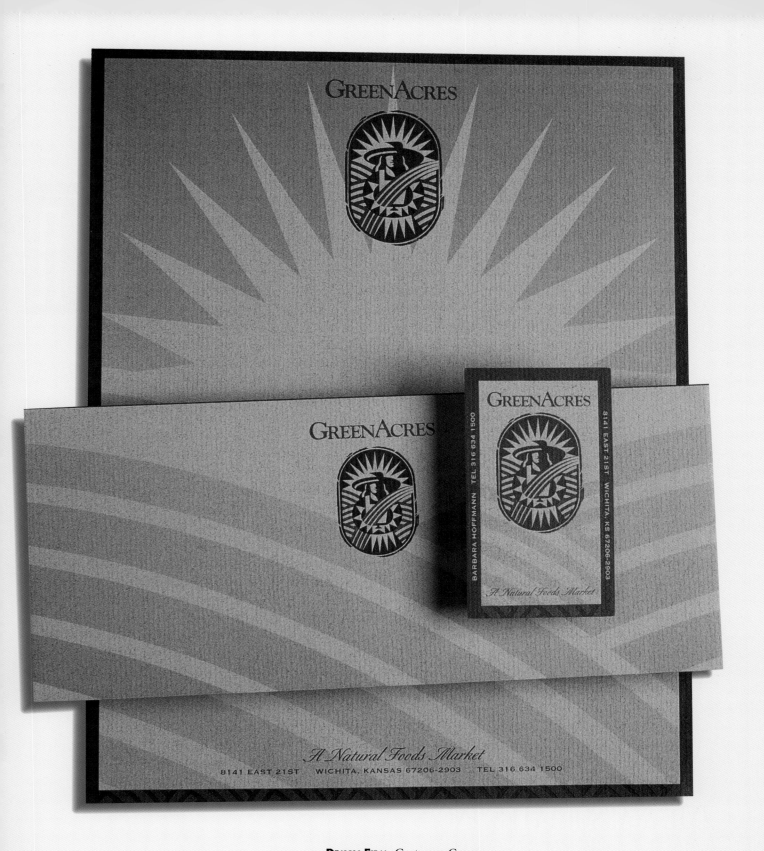

DESIGN FIRM Greteman Group
ART DIRECTOR Sonia Greteman
DESIGNERS Sonia Greteman, Karen Hogan
ILLUSTRATOR Sonia Greteman
CLIENT Green Acres
PAPER/PRINTING Peppered Bronze, 2-color
TOOL Aldus FreeHand
..
This earthy identity combines the simple pure image of a
farm girl with lush green fields and a warm sunny sky, to
communicate health and wellness.

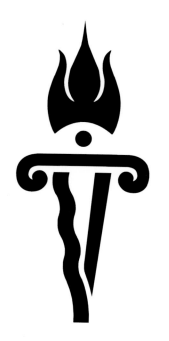

DESIGN FIRM Pinto Design
DESIGNER John Pinto
TOOL Adobe Illustrator

PINTODESIGN

DESIGN FIRM Greteman Group
ART DIRECTOR/DESIGNER Sonia Greteman
CLIENT Winning Visions

In this logo for an advertising firm, the torch forms a "V," and the flame forms an eye.

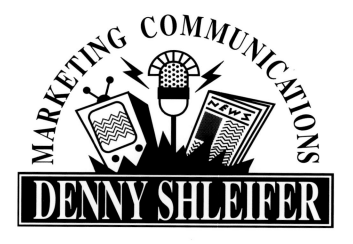

IVIE & ASSOCIATES, INC.
MARKETING COMMUNICATIONS

DESIGN FIRM Ivie & Associates Inc.
ALL DESIGN Jeff Taylor
CLIENT Ivie & Associates, Inc.
TOOL QuarkXPress

The ivy leaf was hand-illustrated, then scanned and imported into a QuarkXPress document, where type was added.

DESIGN FIRM Jeff Fisher Design
ALL DESIGN Jeff Fisher
CLIENT Denny Shleifer Marketing Communications

The FreeHand illustrations of a television, radio mike and newspaper breaking through the surface convey enthusiasm and excitement.

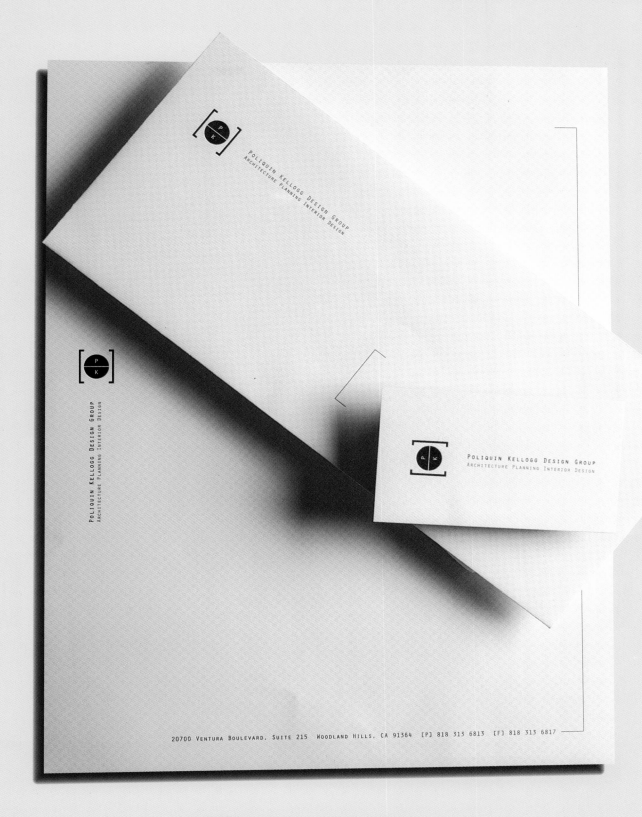

DESIGN FIRM Georgopoulos Design Associates
ART DIRECTOR John Georgopoulos
DESIGNER/ILLUSTRATOR Joe Doucet
CLIENT Poliquin Kellogg Design Group
PAPER/PRINTING Strathmore Elements Squares, Login Printing
TOOLS Adobe Illustrator, QuarkXPress

The logo reflects the architectural firm's focus on defining space.
The logo was created in Illustrator, saved as an EPS file, then
placed into QuarkXPress, where the layout was developed.

mark duebner design

mark duebner design

176 horizon circle carol stream, illinois 60188

176 horizon circle carol stream, illinois 60188 phone/fax 708.871.9040

DESIGN FIRM Mark Duebner Design
ART DIRECTOR/DESIGNER Mark Duebner
PAPER/PRINTING Strathmore Elements (Lines, Squares
and Dots), 2-color
TOOLS Adobe Illustrator, QuarkXPress

The designer used his initials, which almost mimic the initials of
the company as the main visual element because it demands a
second look. The paper stock is engaging.

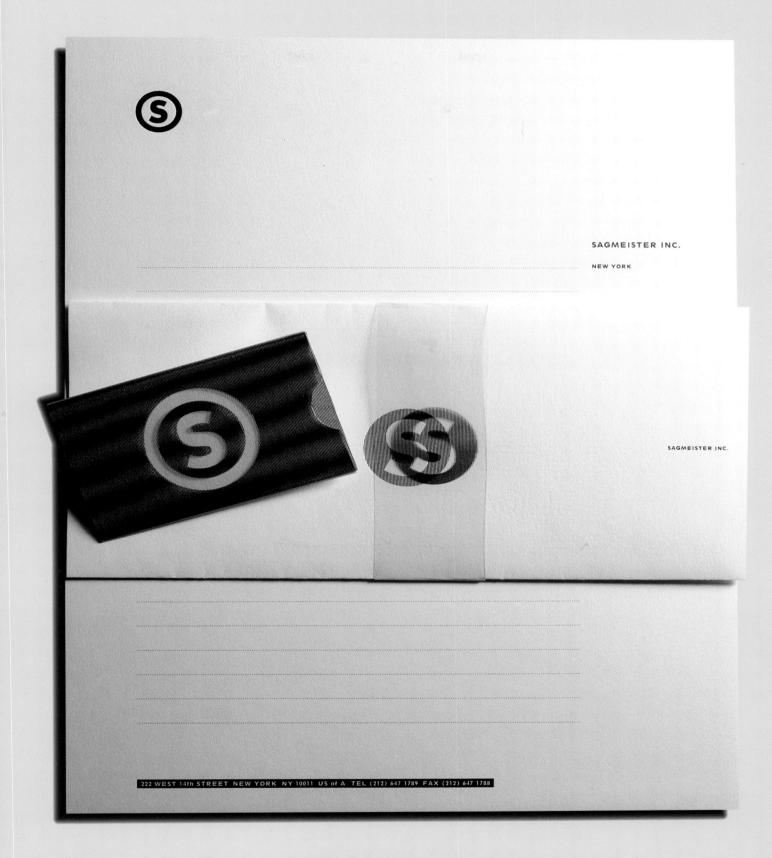

SAGMEISTER INC.

NEW YORK

SAGMEISTER INC.

222 WEST 14th STREET NEW YORK NY 10011 US of A TEL (212) 647 1789 FAX (212) 647 1788

DESIGN FIRM Sagmeister Inc.
ART DIRECTOR/DESIGNER Stefan Sagmeister
PAPER/PRINTING Strathmore Bond

The logo is as simple as possible. Since a New York restau-
rant/laundry service uses the same "S" in a circle, there are now
napkins with the same logo.

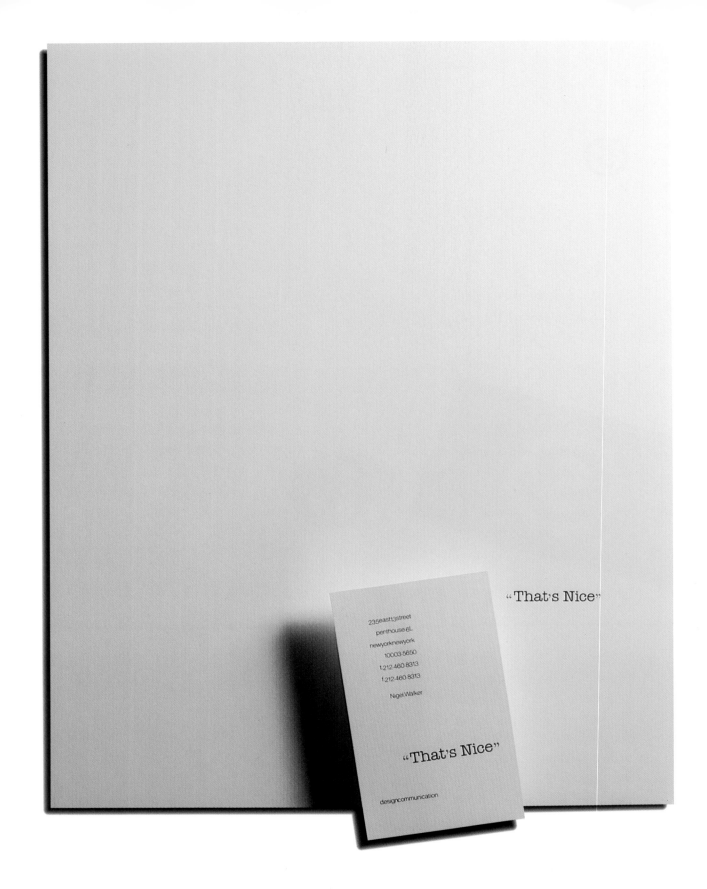

"That's Nice"

235east13street

penthouse.6L

newyorknewyork

10003-5650

t.212.460.8313

f.212.460.8313

Nigel.Walker

"That's Nice"

designcommunication

DESIGN FIRM "That's Nice"
ART DIRECTOR/DESIGNER Nigel Walker
PAPER/PRINTING Strathmore Elements, Anchor Engraving
TOOLS Adobe Illustrator, Aldus FreeHand, QuarkXPress

This logo uses old, roman-style numerals with a sans serif face,
no word spacing, and a rigid grid engraved on Strathmore's
Elements paper, double-warm red and reflex blue.

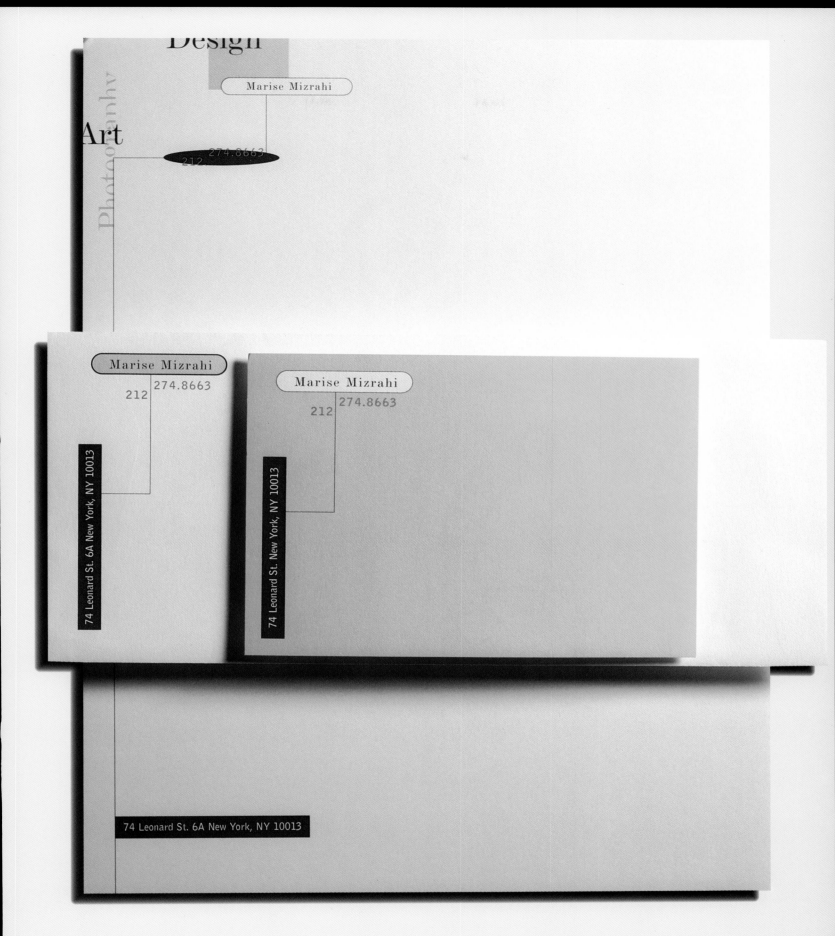

DESIGN FIRM Marise Mizrahi Design
ART DIRECTOR/DESIGNER Marise Mizrahi
PAPER/PRINTING Hammermill, 3-color, Sterling Bianco

DESIGN FIRM Amar's Design
ALL DESIGN Amar Aziz
CLIENTS Spar Klipp, Indian Tandoori Restaurant & Bar, and
Kismat Indisk Restaurant
TOOL QuarkXPress

All the logos were drawn by hand, and all the letters and head-
ings were created in QuarkXPress.

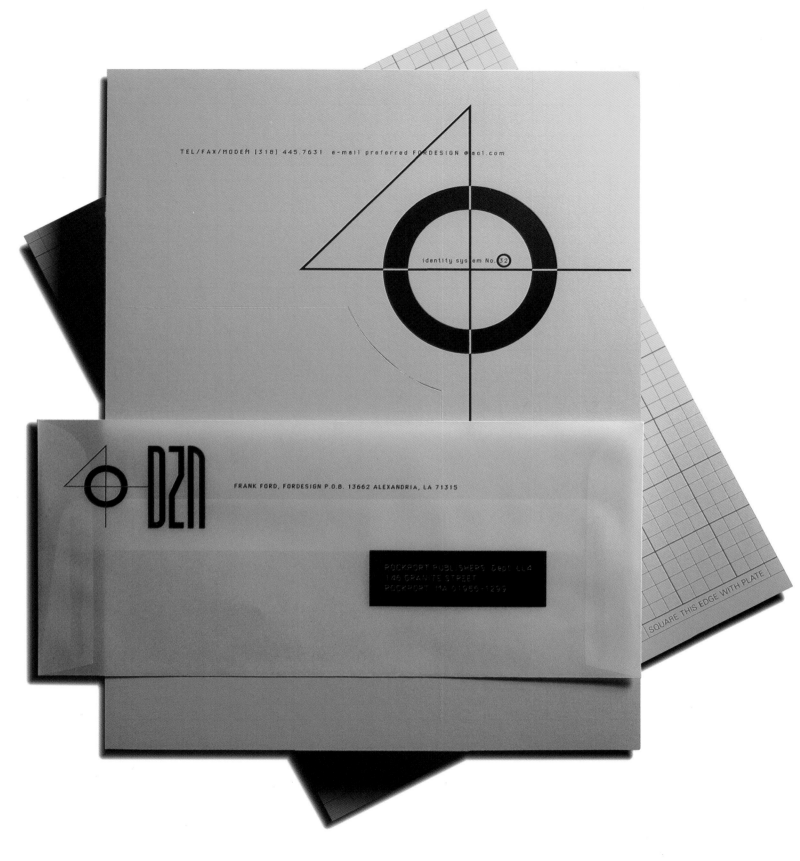

TEL/FAX/MODEM [318] 445.7631 e-mail preferred FORDESIGN @aol.com

identity system No. 32

DZN

FRANK FORD, FORDESIGN P.O.B. 13662 ALEXANDRIA, LA 71315

ROCKPORT PUBLISHERS Dept LL4
146 GRANITE STREET
ROCKPORT MA 01966-1299

SQUARE THIS EDGE WITH PLATE

DESIGN FIRM FORDESIGN
ART DIRECTOR/DESIGNER Frank Ford
PAPER/PRINTING Masking sheets, vellum

The I.D. system, accomplished on the desktop on low budget
indicates specialization with print media. The masking sheets
indicate that the client follows the job from start to finish.

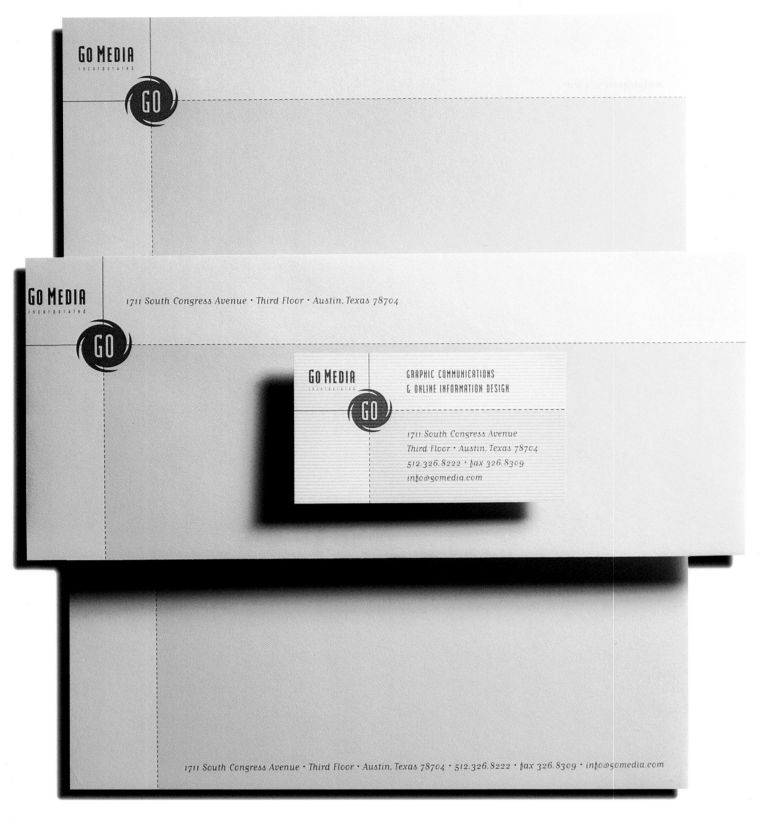

GO MEDIA
incorporated

DESIGN FIRM Go Media Inc.
ALL DESIGN Sonya Cohen
PAPER/PRINTING Champion Benefit, Lithoprint
TOOLS Adobe Illustrator, QuarkXPress

..

The logo captures that sense of motion and the energy of "Go,"
while the layout, paper and color palette enjoy the more formal
and tactile qualities of traditional printed "Media."

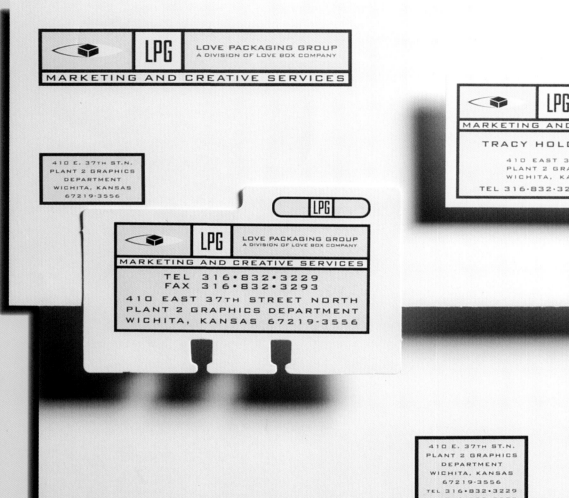

Design Firm Love Packaging Group
Art Director/Illustrator Tracy Holdeman
Designers Tracy Holdeman, Brian Miller
Paper/Printing Strathmore Elements
Tool Macromedia FreeHand

Love Packaging Group identity was created entirely in
FreeHand. The iris and pupil represent creative vision
in packaging.

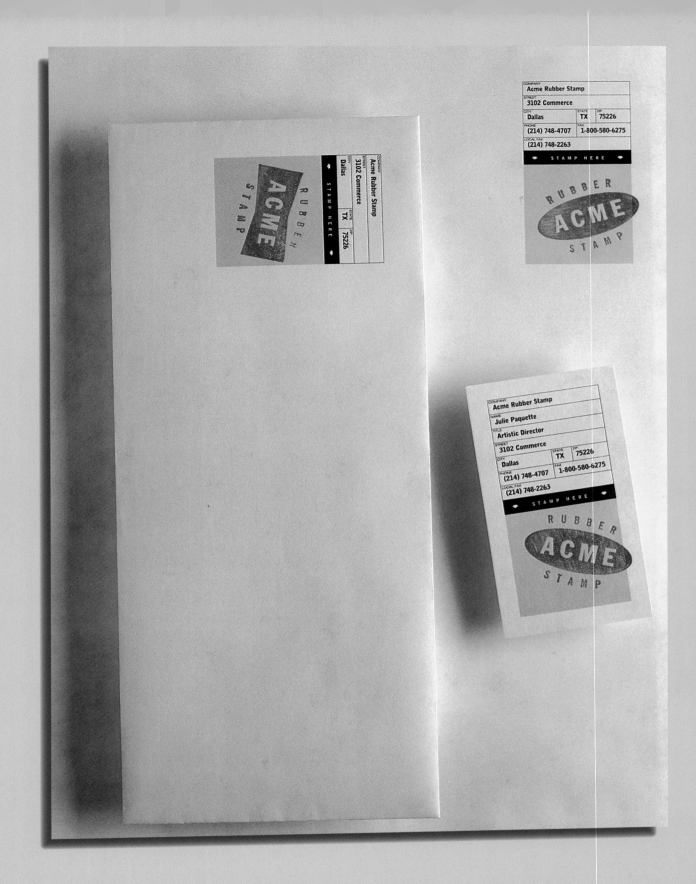

DESIGN FIRM Peterson & Company
ART DIRECTOR/DESIGNER Dave Eliason
CLIENT ACME Rubber Stamp Co.
PAPER/PRINTING French Duratone Butcher, Monarch Press
TOOLS Adobe Illustrator, QuarkXPress
...
This piece was printed offset, 2-color, on a mottled, industrial-
looking paper. The logo was then rubber-stamped in red ink.

INFOFusion

Revolutionary institutional research methods
Rigorous audience identification and classification
Targeted copy, graphic design, and photography
Budget-sensitive print communications
Result-oriented distribution strategies
Exit analysis and product evaluation

1
Robert Topor
280 Easy Street
Suite 114
Mountain View, CA 94043-3736

2
Ann Granning Bennett
10634 Southwest Hedlund Avenue
Suite 193
Portland, OR 97219-7916

3
Bryan Peterson
2200 North Lamar Street
Suite 310
Dallas, TX 75202-1073

INFOFusion

1
Ann Granning Bennett
10634 Southwest Hedlund Avenue
Suite 193
Portland, OR 97219-7916

Call Ann at 503 635-6462

DESIGN FIRM Peterson & Company
ART DIRECTOR/DESIGNER Bryan L. Peterson
CLIENT Infofusion
PAPER/PRINTING Champion Benefit, South Press
TOOL Adobe Photoshop, QuarkXPress

The Polaroid photograph was shot in the design studio and
bitmapped using Photoshop. The columns were printed in an
opaque white on a small letterpress.

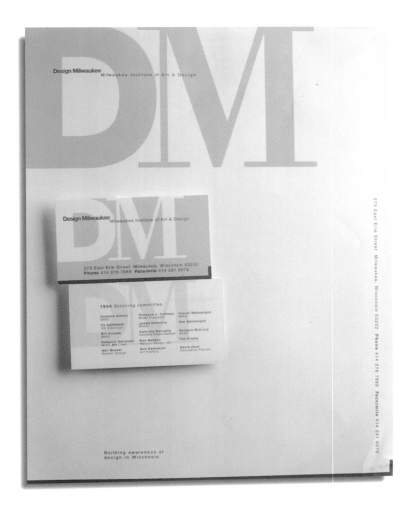

DESIGN FIRM Becker Design
ART DIRECTOR/DESIGNER Neil Becker
CLIENT Design Milwaukee
PAPER/PRINTING Neenah Classic Crest, 2-color, lithography
TOOLS Adobe Illustrator, QuarkXPress

Design Milwaukee, which reaches the entire design community of Milwaukee needed a look that would be appropriate for a wide range of disciplines. The logo was created with Illustrator and Quark Express.

DESIGN FIRM Duck Soup Graphics
ALL DESIGN William Doucette
PAPER/PRINTING French Speckletone, three match colors

The firm specializes in corporate identity, brochure, and packaging design. "Duck Soup" is a slang term that means something is easy to do. The logo was drawn in ink.

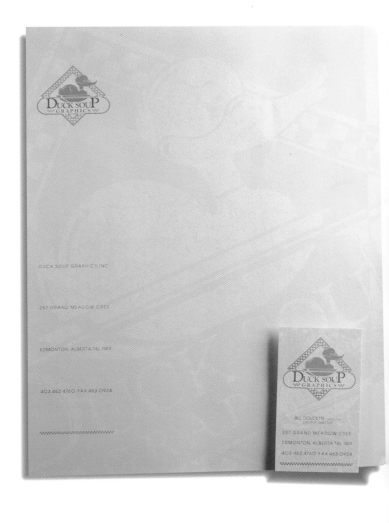

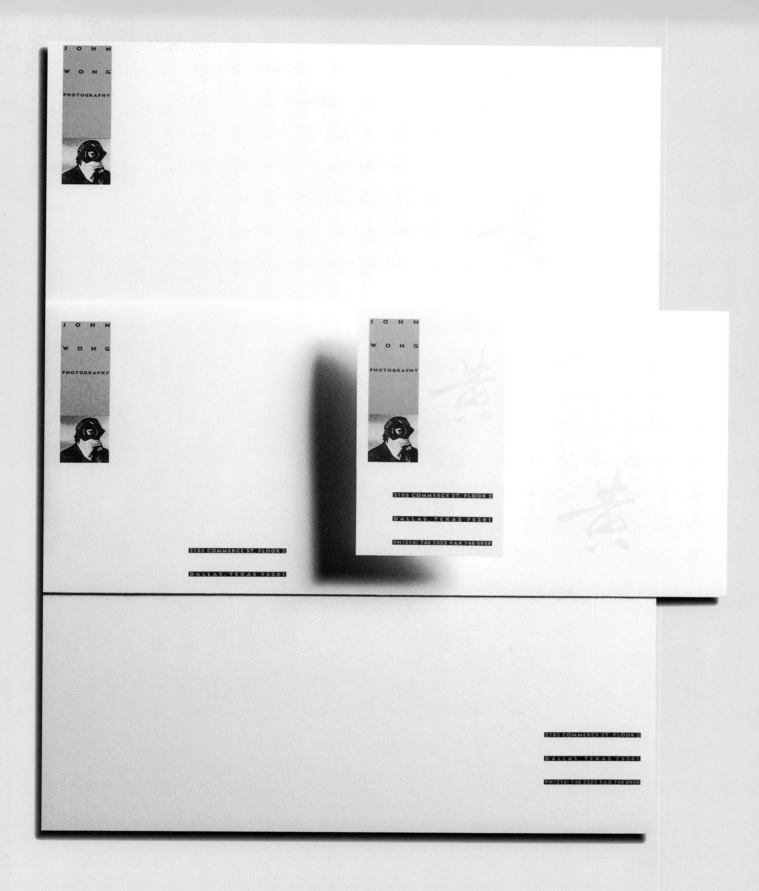

DESIGN FIRM Peterson & Company
ART DIRECTOR/DESIGNER Bryan L. Peterson
CLIENT John Wong Photography
PAPER/PRINTING Neenah Classic Crest, South Press
TOOL QuarkXPress

The photo was a halftone stripped in at the press. This package
was printed inexpensively on a small letterpress.

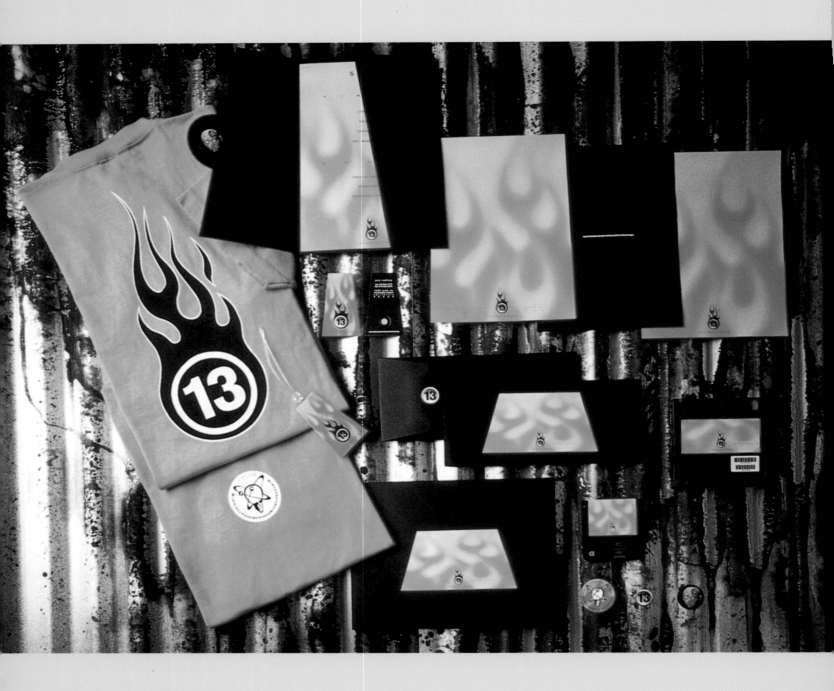

DESIGN FIRM 13TH FLOOR

ART DIRECTORS/DESIGNERS Eric Ruffing, Dave Parmley

ILLUSTRATOR Dave Parmley

PAPER/PRINTING Smith McKay Printing

TOOLS Adobe Photoshop, Aldus FreeHand, MetaTools,
Kai's Power Tools

This logo was hand-drawn and scanned into FreeHand where it
was traced. It was rasterized in Photoshop and repeated to get
the flame background used on all pieces.

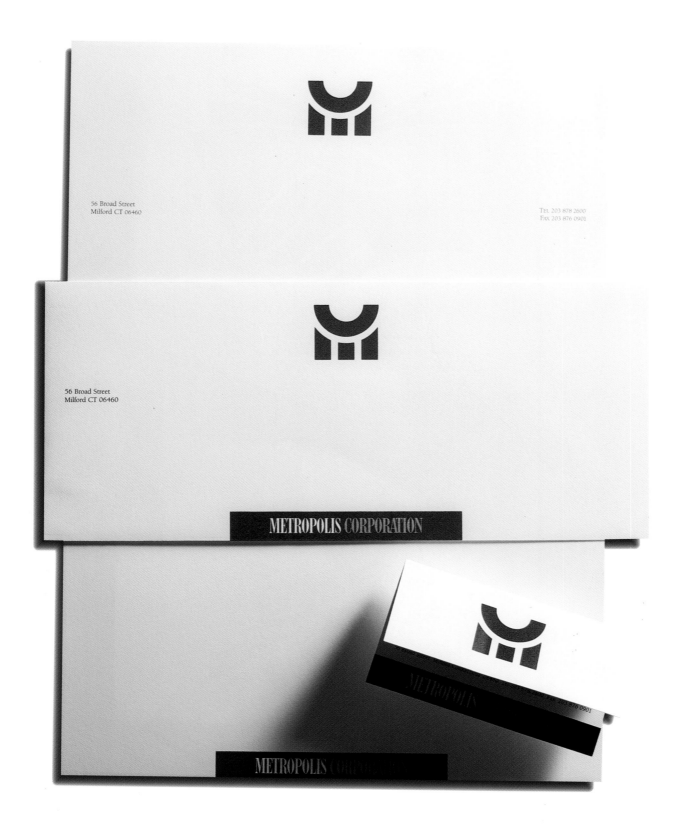

DESIGN FIRM Metropolis Corp.

DESIGNER Denise Davis Mendelsohn

PAPER/PRINTING Cranes Crest

TOOL QuarkXPress

The Metropolis logo was traditionally made and the copy was
created in Quark Express. The unique "M" that was produced
is not seen in any typographic font format.

DESIGN FIRM Peterson & Company
ART DIRECTOR/DESIGNER Nhan T. Pham
CLIENT Women's National Book Association
TOOL Adobe Illustrator

Even though the logo was created for WNBA (Dallas Chapter),
the focus was on the association rather than on gender.

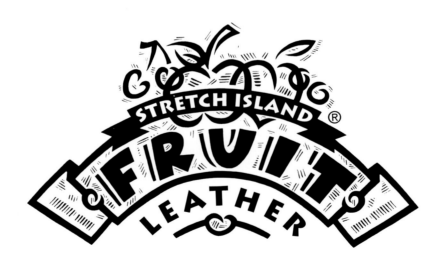

DESIGN FIRM Hornall Anderson Design Works Inc.
ART DIRECTOR Jack Anderson
DESIGNERS Mary Hermes, Jack Anderson, Leo Raymundo
ILLUSTRATOR Fran O'Neill
CLIENT Stretch Island
PAPER/PRINTING Stoneway Carton Co.

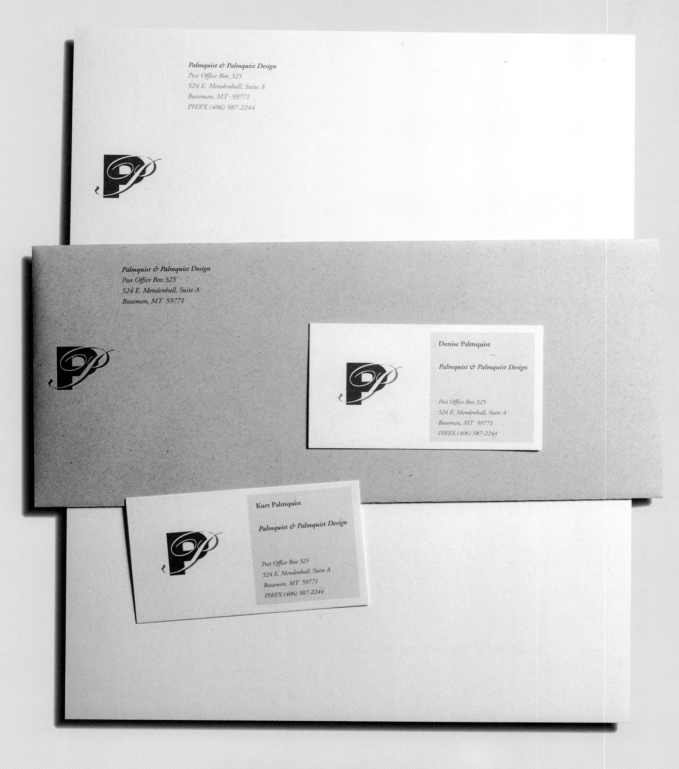

DESIGN FIRM Palmquist & Palmquist Design
ART DIRECTORS/DESIGNERS Kurt and Denise Palmquist
PAPER/PRINTING Environment Moonrock, two PMS colors
TOOL Aldus FreeHand

..

The masculine "P" and the feminine script "P" reflect different
latitudes in design. The colors are intentionally conservative.
The paper stock reflects nature and the outdoor lifestyle
of the northwest.

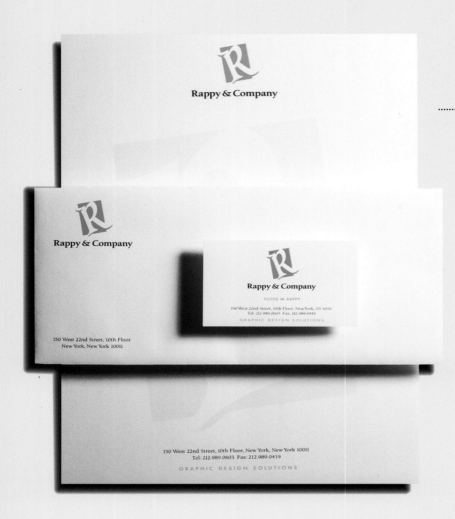

DESIGN FIRM Rappy & Company
ALL DESIGN Floyd Rappy
CLIENT Rappy & Company
PAPER/PRINTING Strathmore Writing Wove
TOOLS Adobe Illustrator, QuarkXPress

The "R" was hand-lettered, scanned, and brought into Illustrator and integrated with type.

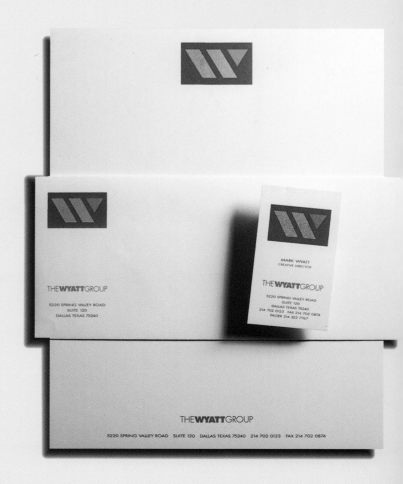

DESIGN FIRM The Wyatt Group
ALL DESIGN Mark Wyatt
PAPER/PRINTING Simpson Starwhite Vicksburg, three spot metallic inks
TOOLS Aldus FreeHand, QuarkXPress

Mark Wyatt gave the logo a geometric design in forming the letter "W." In the printed pieces, metallic inks added a unique look and feel to the stationery.

DESIGN FIRM Toni Schowalter Design
ART DIRECTOR/DESIGNER Toni Schowalter
CLIENT Decisions Strategies International

The mark was used to portray an international strategist corporation.

DESIGN FIRM Greteman Group
ART DIRECTOR Sonia Greteman
DESIGNERS Sonia Greteman, Bill Gardner
CLIENT Colorations

DESIGN FIRM Jeff Fisher Design
ALL DESIGN Jeff Fisher
CLIENT City Laundry Northwest
TOOL Aldus FreeHand

City Laundry's owners wanted a logo that conveyed a fun image of doing your laundry. The business is known as the "dancing washer and dryer" laundry because of the logo.

DESIGN FIRM Greteman Group
ART DIRECTOR/DESIGNER Sonia Greteman
CLIENT Abell Pearson Printing

This is a heroic figure that can handle any job.

DESIGN FIRM Squadra Design Studio
ART DIRECTOR Guillermo Caceres
DESIGNERS Jorge Caceres, Claudia Izquierdo,
Guillermo Caceres
CLIENT Auditta
PAPER/PRINTING Bond 24 lb. Opalina 280 grs, offset 2/0 color

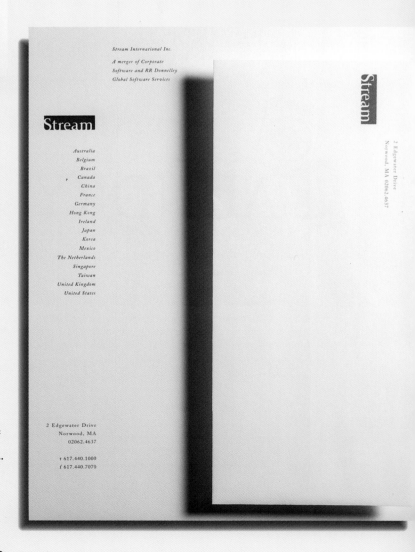

DESIGN FIRM Clifford Selbert Design
ART DIRECTOR Lynn Riddle
DESIGNERS Lynn Riddle, Tony Dowers, Mike Balint,
April Skinnard, Bill Crosby
CLIENT Stream International
PAPER/PRINTING Strathmore Ultimate White 24 lb. Wove, offset
TOOL Adobe Illustrator

Stream International, a software licensing, packaging, distribu-
tion, and support company, is the world's largest software
distributor. There is a subtle reference made to water while
maintaining a corporate feel.

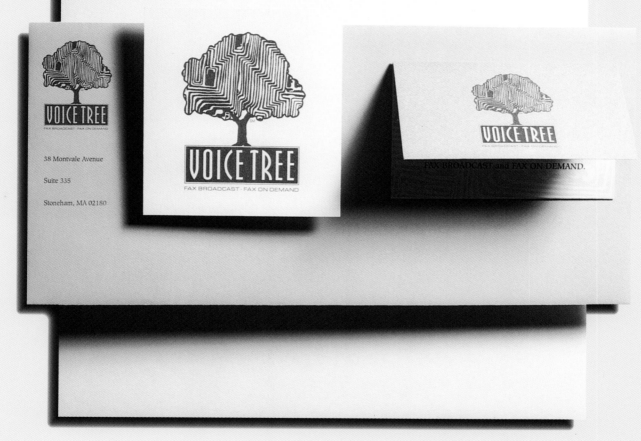

38 Montvale Avenue

Suite 335

Stoneham, MA 02180

Phone 617 · 279 · 4900

Fax 617 · 279 · 4473

38 Montvale Avenue

Suite 335

Stoneham, MA 02180

FAX BROADCAST and FAX ON DEMAND.

Design Firm Carol Lasky Studio
Art Director Carol Lasky
Designer/Illustrator Erin Donnellan
Client Voice Tree
Paper/Printing Beckett Enhance, Strathmore Writing,
Champion Benefit, Printed at The Ink Spot
Tools Aldus FreeHand, QuarkXPress
..
The business card functions as a mini-brochure, making it
stand out—literally. Mixing a variety of papers from different
manufacturers achieved the right blend of stock colors.

Design Firm Thomas Hillman Design
Art Director/Designer Thomas Hillman
Client RGB Visuals
Tool Aldus PageMaker

Three letters—RGB—offer the name and color concept in an overstated and dramatic presentation on a white sheet to enhance colors. The final stationery package was assembled in PageMaker.

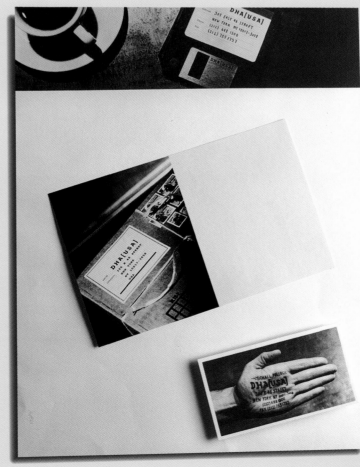

Design Firm Sagmeister Inc.
Art Director/Designer Stefan Sagmeister
Photographer Tom Schierlitz
Client DHA (USA)
Paper/Printing Strathmore Opaque Bond

DHA (USA) is a consulting company whose services are difficult to pin down. For the identity system, photographs containing all the information demonstrate the services

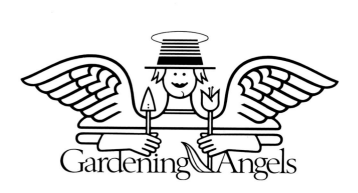

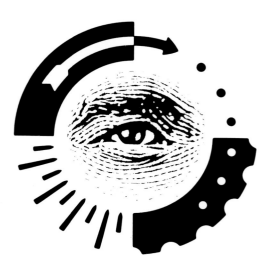

Design Firm Bob Korn Design

All Design Bob Korn

Client Gardening Angels

The mark was created by hand for an urban horticulture firm to reflect the pun in the company's name.

Design Firm Zauhar Design

All Design David Zauhar

Client RPM Video Productions

To depict RPM (revolutions per minute) graphically, there is a cross section of time, movement, and gears rotating around an eye, which represents video. All art was done freehand.

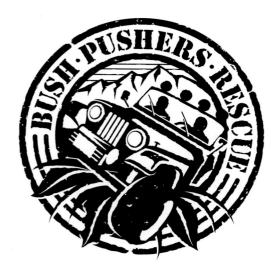

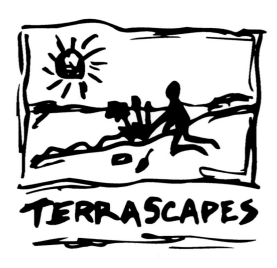

Design Firm Price Learman Associates

All Design Ross West

Client Bush Pushers Rescue

Tools Adobe Photoshop and Streamline, Aldus FreeHand

Bush Pushers Rescue is a group of Jeep enthusiasts that aid in the search and rescue of lost hikers and recreational vehicles. It is a purely volunteer group and receives no compensation.

Design Firm Alfred Design

All Design John Alfred

Client Terrascapes

Tool Adobe Illustrator and Streamline

The thumbnail art was scanned, worked in Streamline, and manipulated in Illustrator. Using the thumbnail as a base maintained the organic feel that the client wanted for its landscaping business.

DESIGN FIRM Elena Design
ALL DESIGN Elena Baca
PAPER Simpson Quest
TOOLS Adobe Illustrator

Some people find it hard to pronounce my name thus the reason for the treatment on the logo. In designing the letterhead, I wanted to keep the cost down by using only one color. I opted for the use of different shades of paper instead.

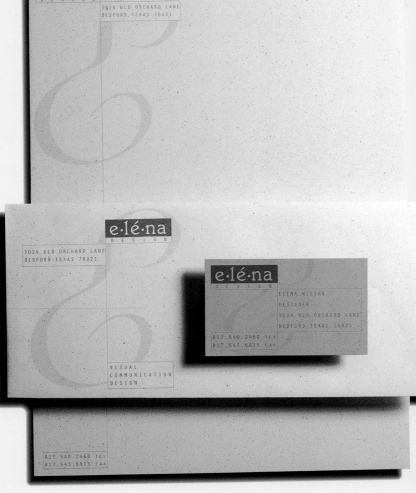

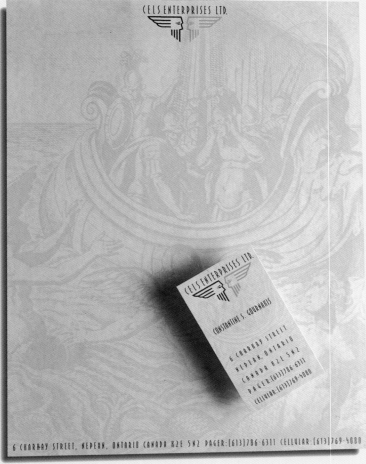

DESIGN FIRM 246 Fifth Design
ART DIRECTOR/DESIGNER Sid Lee
CLIENT Cels Enterprises Ltd.
PAPER/PRINTING Custom Printers of Renfrew

Cels Enterprises wanted to express its Greek roots, so the "Jason and the Argonauts" imagery also symbolizes a great adventure or a fantastical voyage which reflects the company's services.

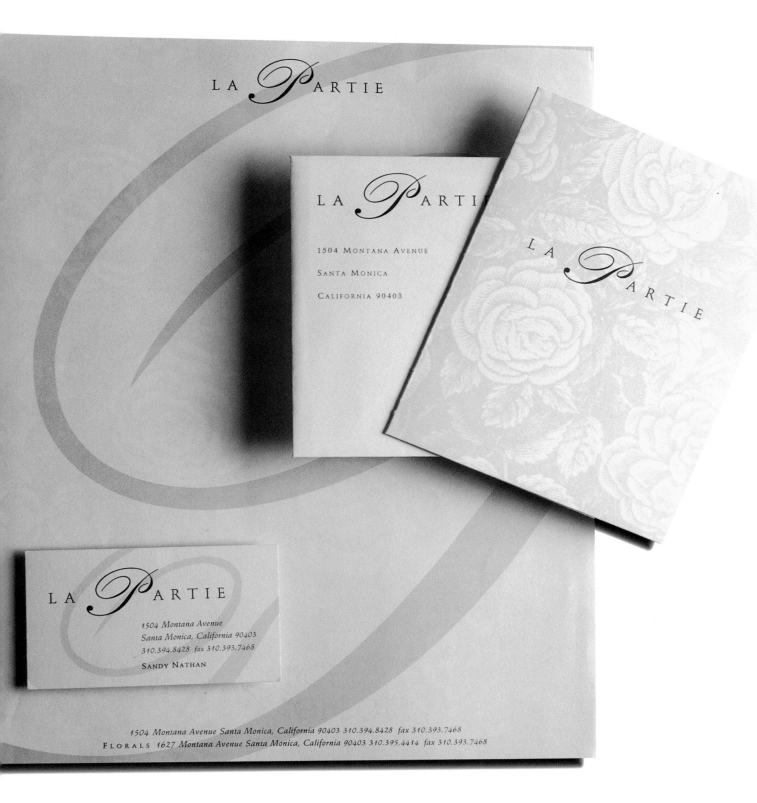

ART DIRECTOR/DESIGNER Christine Cava
CLIENT La Partie; Sandy Nathan
PAPER/PRINTING Circa Select
TOOLS Aldus FreeHand, Adobe Photoshop, QuarkXPress

The swirl is the "P" in the La Partie logo modified using
FreeHand; the floral pattern was supposed to be printed in
cream, but a printer's serendipitous error made it green.

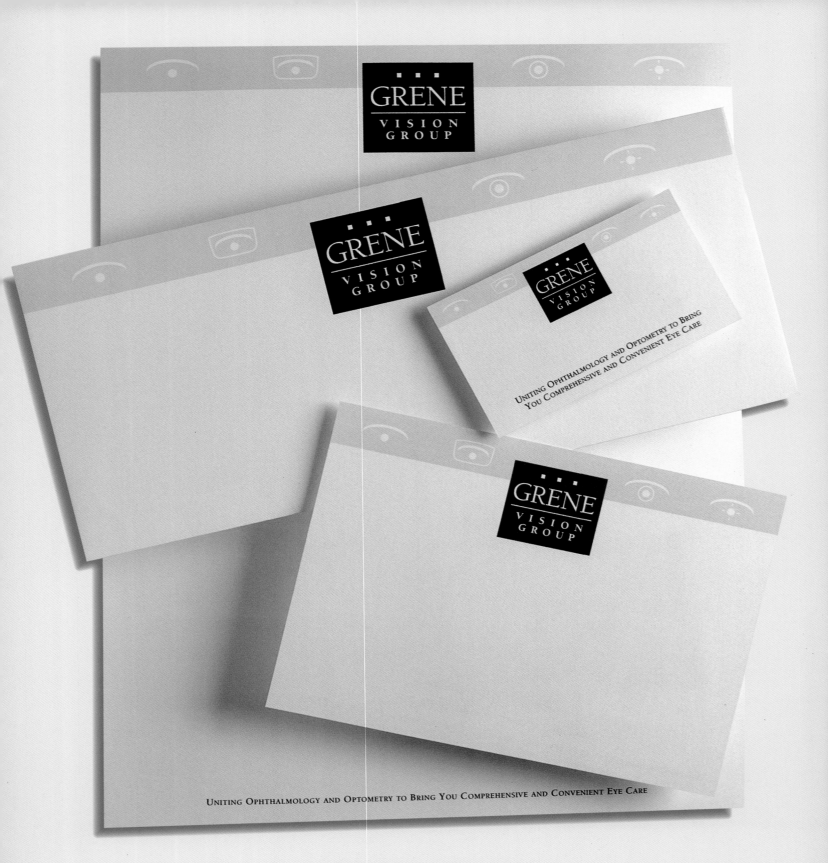

DESIGN FIRM Incite Design Communications
ALL DESIGN Sherrie and Tracy Holdeman
CLIENT Grene Vision Group
PAPER/PRINTING Classic Crest
TOOL Macromedia FreeHand

Grene Vision Group is one of the first total eye care facilities in
the country. The eye icons represent (from left to right) the eye,
glasses, contacts, and radial keratotomy.

2551 RIVA ROAD

ANNAPOLIS, MARYLAND 21401-7465

PHONE 410-266-4170

FAX 410-266-2820

2551 RIVA ROAD
ANNAPOLIS, MARYLAND 21401-7465

2551 RIVA ROAD
ANNAPOLIS, MARYLAND 21401-7465

2551 RIVA ROAD
ANNAPOLIS, MARYLAND 21401-7465
PHONE 410-266-4221
FAX 410-266-2820

Communications By
PROXY

BRIAN A. KRISAK
SENIOR DIRECTOR, BUSINESS DEVELOPMENT

DESIGN FIRM Kiku Obata & Company
ART DIRECTOR/DESIGNER Rich Nelson
CLIENT Communications by Proxy
PAPER/PRINTING Neenah Classic Crest, Reprox
TOOLS Aldus FreeHand, QuarkXPress

···

The logo features traditional typography and colors with the
globe as a supporting element, and suggests the technology and
ever-expanding communications network the company provides.

DESIGN FIRM John Evans Design
ART DIRECTORS John Evans, Greg Chapman
DESIGNER Walter Horton
ILLUSTRATOR John Evans
CLIENT Tracy Locke, GTE
TOOL Adobe Illustrator

..

This mark was drawn by hand then scanned and redrawn in
Illustrator. It symbolizes a fiber optic cable encircling
the globe.

DESIGN FIRM Grafik Communications Inc.
DESIGNERS David Collins, Judy Kirpich
ILLUSTRATOR David Collins
CLIENT National Football League Players Association
TOOL Adobe Illustrator.

..

Representing football in a non-cliché way and focusing on the
players was a challenge. The logo needed to work on printed
material, video, hats, gym bags, T-shirts and banners.

DESIGN FIRM Mires Design Inc.
ART DIRECTOR/DESIGNER Mike Brower
ILLUSTRATOR Tracy Sabin
CLIENT M.G. Swing Company

DESIGN FIRM Lambert Design Studio
ART DIRECTOR/DESIGNER Joy Cathey Price
CLIENT Nature Bound Publishing
PAPER/PRINTING 3-color
TOOL Adobe Illustrator

..

The client for this logo publishes magazines on outdoor sports,
recreation, and conservation. This mark incorporates both a
book (or magazine) and the great outdoors.

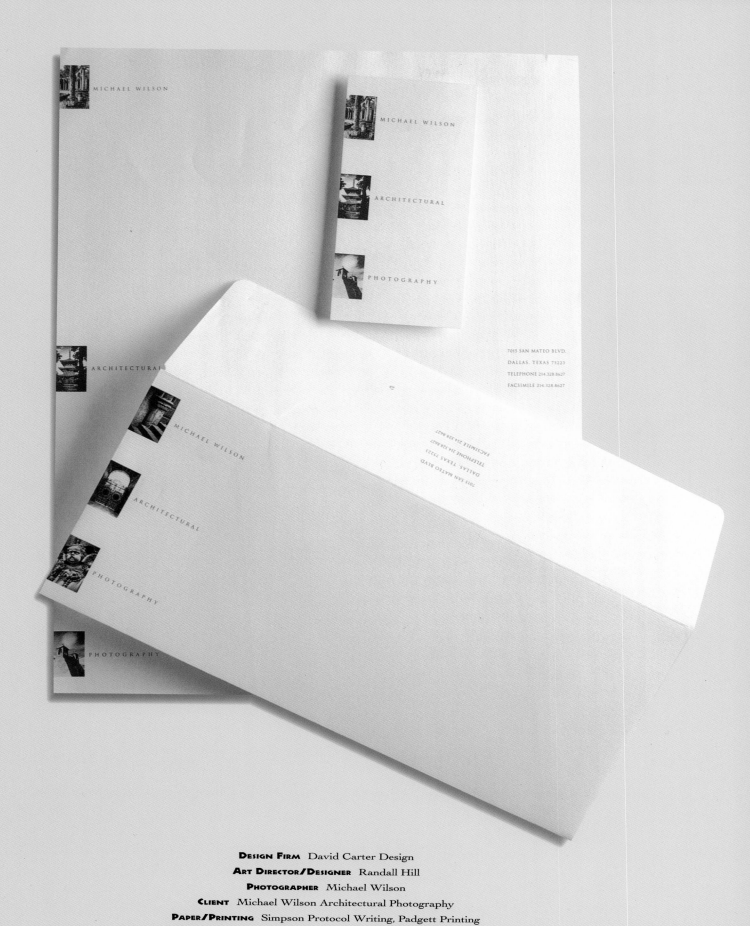

DESIGN FIRM David Carter Design
ART DIRECTOR/DESIGNER Randall Hill
PHOTOGRAPHER Michael Wilson
CLIENT Michael Wilson Architectural Photography
PAPER/PRINTING Simpson Protocol Writing, Padgett Printing

The stationery package was created to highlight the unique
niche this photographer has on the market. Waterless plates
were used in the printing process.

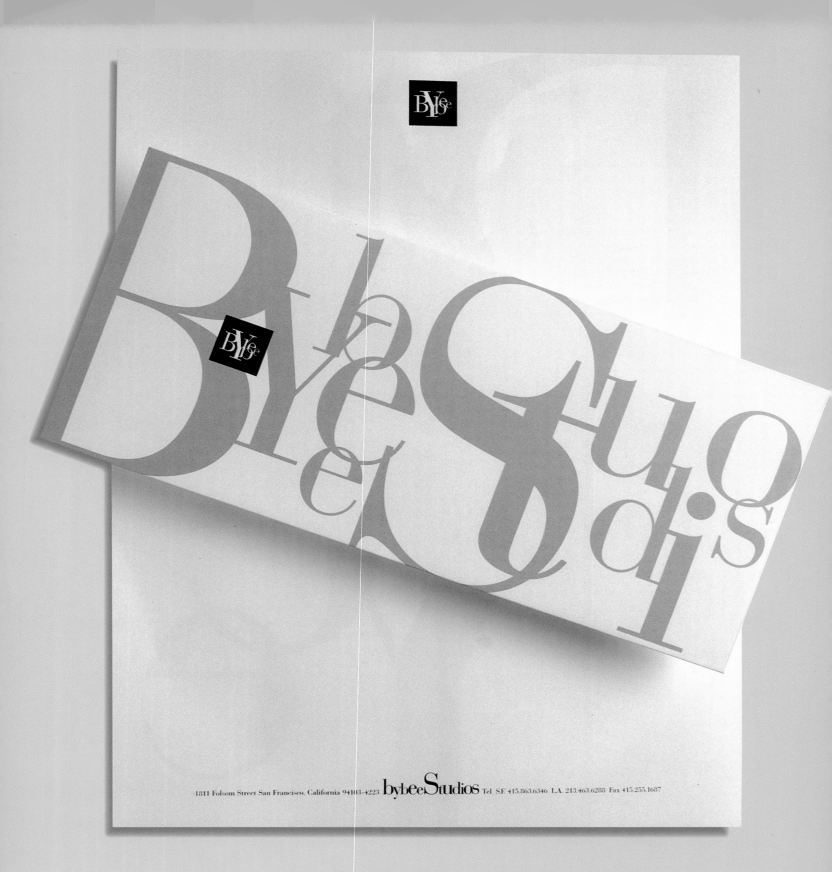

1811 Folsom Street San Francisco, California 94103-4223 bybeeStudios Tel S.F. 415.863.6346 L.A. 213.463.6288 Fax 415.255.1687

DESIGN FIRM Sackett Design Associates
ART DIRECTOR Mark Sackett
DESIGNERS Mark Sackett, James Sakamoto
CLIENT Bybee Studios
PAPER/PRINTING Simpson Starwhite Vicksburg 80 lb. text,
130 lb. cover, offset litho

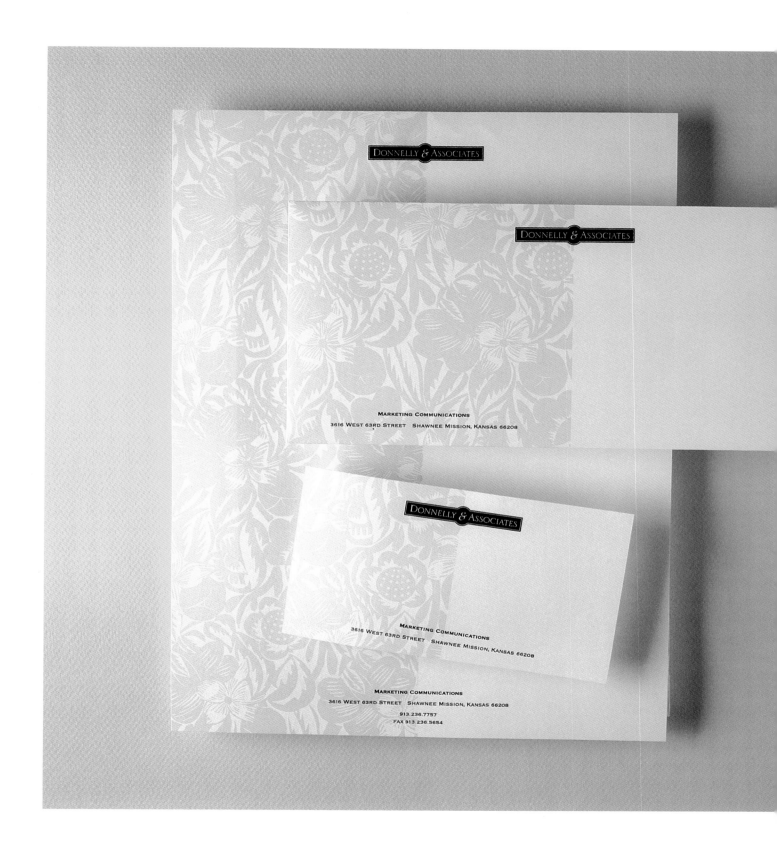

DESIGN FIRM Sackett Design Associates
ART DIRECTOR/DESIGNER Mark Sackett
ILLUSTRATORS Mark Sackett, Wayne Sakamoto
CLIENT Donnelly & Associates
PAPER/PRINTING Neenah Classic Crest Natural White 80 lb.
text, offset lithography, two match colors

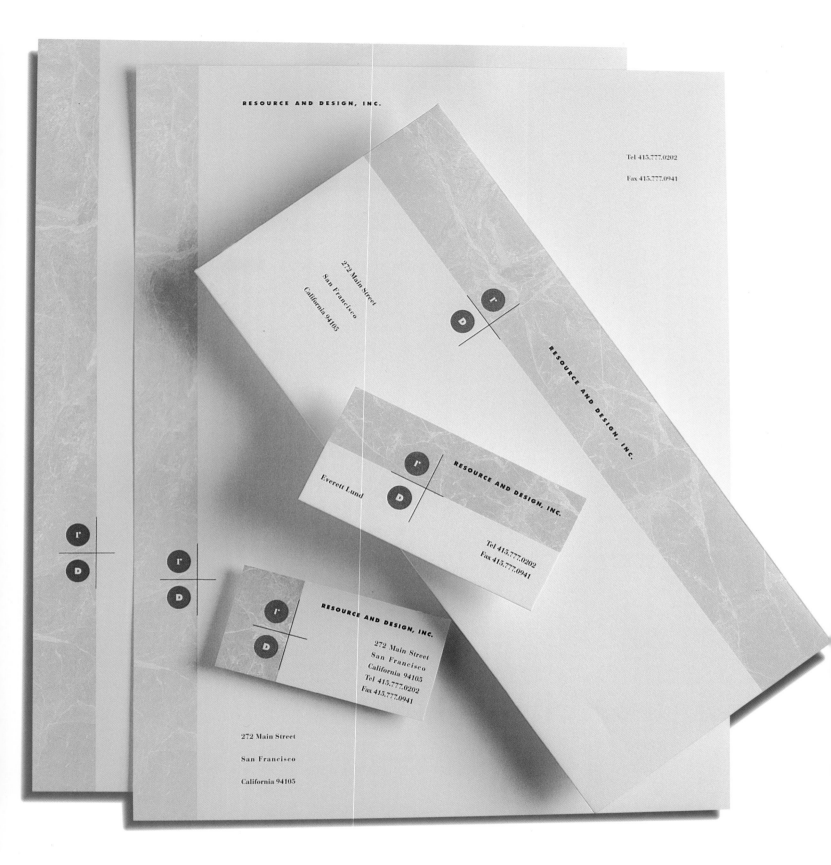

DESIGN FIRM Sackett Design Associates
ART DIRECTOR/ILLUSTRATOR Mark Sackett
DESIGNERS Mark Sackett, Wayne Sakamoto
CLIENT Resource and Design Inc.
PAPER/PRINTING Neenah Classic Crest Natural 80 lb. text with
110 lb. cover, offset lithography

AFFILIATED OFFICES:
London • Paris • Innsbruck • Rome
Brussels • Shenyang • Dublin • Frankfurt
Auckland • Sydney • Rio de Janerio

JOERG KRAMER
DIRECTOR ~ EUROPEAN SALES

10224 N. PORT WASHINGTON RD. MEQUON, WISCONSIN 53092-5755
PHONE 414.241.6373 FAX 414.241.6379
TELEX 201.323.YWOTUR NATIONWIDE 1.800.558.8850

10224 N. PORT WASHINGTON RD. MEQUON, WISCONSIN 53092-5755

10224 NORTH PORT WASHINGTON ROAD MEQUON, WISCONSIN 53092-5755
PHONE 414.241.6373 TELEX 201.323.YWOTUR FAX 414.241.6379 NATIONWIDE 1.800.558.8850

DESIGN FIRM Becker Design
ART DIRECTOR/DESIGNER Neil Becker
DESIGNER Neil Becker
CLIENT Value Holidays
PAPER/PRINTING Classic Crest Solar White, 2-color lithography
TOOLS Adobe Illustrator, QuarkXPress

The globe is an appropriate symbol for Value Holidays because
it does only international travel packages.

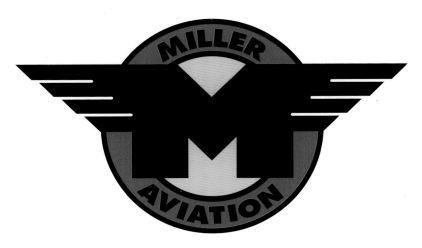

DESIGN FIRM Swieter Design U.S.
ART DIRECTOR John Swieter
DESIGNER Mark Ford
CLIENT Miller Aviation
TOOL Adobe Illustrator

DESIGN FIRM Swieter Design U.S.
ART DIRECTOR John Swieter
DESIGNER Julie Poth
CLIENT Dallas Mavericks
TOOL Adobe Illustrator

DESIGN FIRM Swieter Design U.S.
ART DIRECTOR John Swieter
DESIGNER Mark Ford
CLIENT Sports Lab Inc.
TOOL Adobe Illustrator

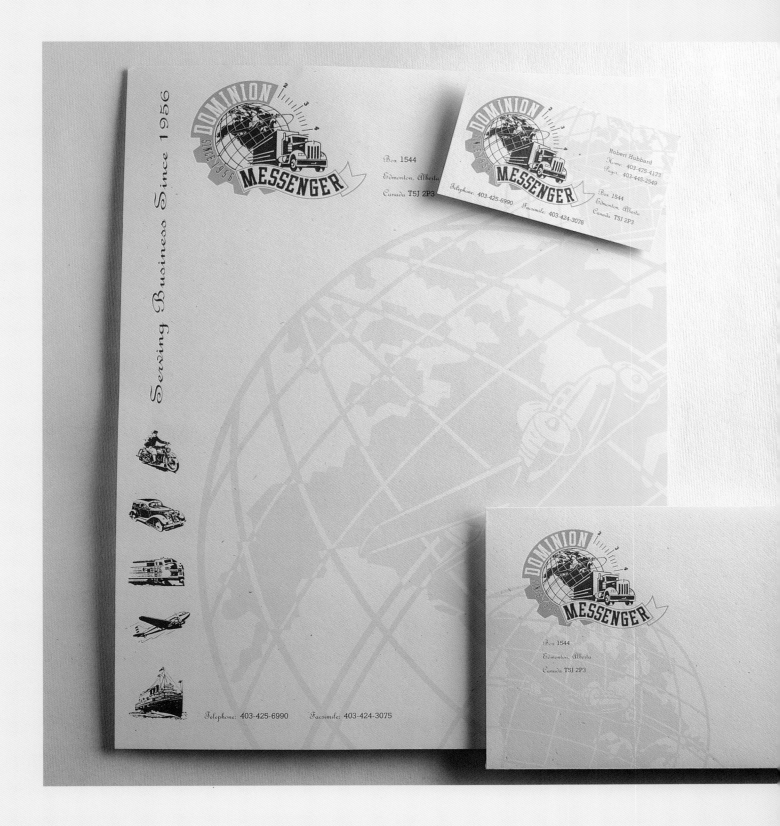

Serving Business Since 1956

DOMINION
SINCE 1956
MESSENGER

Box 1544
Edmonton, Alberta
Canada T5J 2P3

Telephone: 403-425-6990 Facsimile: 403-424-3075

Robert Hubbard
Home: 403-475-4173
Pager: 403-445-2549

Box 1544
Edmonton, Alberta
Canada T5J 2P3

Telephone: 403-425-6990
Facsimile: 403-424-3075

DESIGN FIRM Duck Soup Graphics
ALL DESIGN William Doucette
CLIENT Dominion Messenger Ltd.
PAPER/PRINTING French Speckletone, three match colors
...
The client is the oldest messenger company in western Canada
and requested a corporate image that would reflect a nostalgic
theme. The illustrations were done in ink.

DESIGN FIRM Ciro Giordano Associates
ART DIRECTOR/DESIGNER Ciro Giordano
ILLUSTRATOR Gary Contic
CLIENT Ciro Giordano Associates
PAPER/PRINTING Strathmore Writing Bright White Wove,
three PMS colors

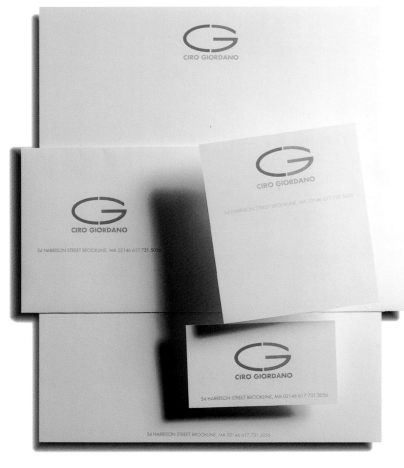

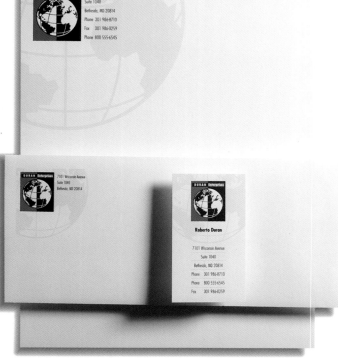

DESIGN FIRM Jill Tanenbaum Graphic Design & Advertising
ART DIRECTOR Jill Tanenbaum
DESIGNER Pat Mulcahy
CLIENT Duran Enterprises
PAPER/PRINTING Strathmore Writing, Westland Printers

The company will be involved in a variety of areas and wanted a
generic, strong, corporate/international look that was not specif-
ic to any one type of business venture.

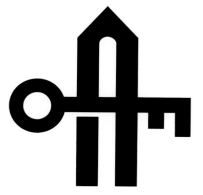

Design Firm Mohr : Design
Art Director/Designer Jack N. Mohr
Client Hoepfner Baukonzept

The design of this stationery is still in its early stages.

Design Firm Greteman Group
Art Directors/Designers Sonia Greteman,
James Strange
Client Anita Freg

This real estate firm's logo is a combination of house and key.

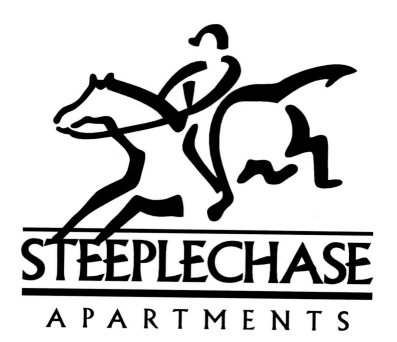

Design Firm Kelly O. Stanley Design
All Design Kelly O'Dell Stanley
Client Sizeler Real Estate Management Company Inc.

The image was drawn by hand, then scanned and redrawn in
FreeHand. The typeface was modified so that the horizontal
strokes of the letterforms took on the same energy as the logo.

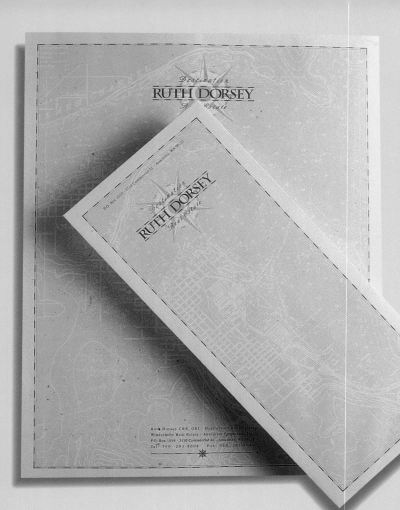

DESIGN FIRM Price Learman Associates
ALL DESIGN Ross West
CLIENT Ruth Dorsey, Realtor
PAPER/PRINTING Classic Crest Peppercorn
TOOLS Aldus FreeHand, Adobe Photoshop

The background map was scanned into Photoshop, manipulated and imported into FreeHand where it was placed. All other logos and copy were produced in FreeHand and sent directly to film.

DESIGN FIRM Price Learman Associates
ALL DESIGN Ross West
CLIENT Laura Bennett
PAPER/PRINTING Classic Crest Millstone
TOOL Aldus FreeHand

The client wanted to portray a vibrant and energetic image. Simple, geometric shapes were used to give a sense of movement and excitement.

Laura Bennett CRS, GRI - Real Estate With A Personal Touch

RE/MAX Eastside Broker's, Inc. • 11711 SE Eighth Street • Bellevue, Washington, 98005 • Office: (206) 450-1644 Residence: (206) 868-9501 Fax: (206) 453-4778

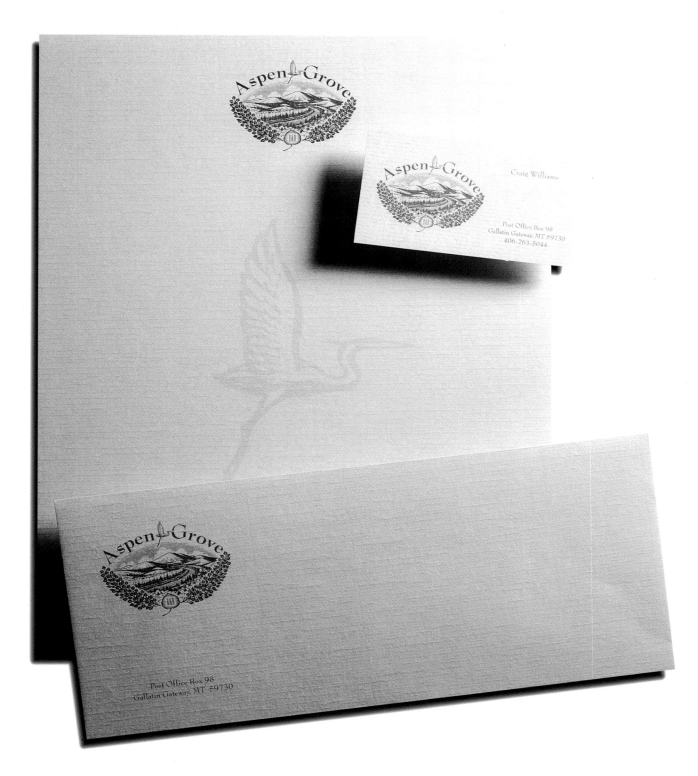

DESIGN FIRM Palmquist & Palmquist Design
ART DIRECTORS AND DESIGNERS Kurt and Denise Palmquist
ILLUSTRATOR James Lindquist
CLIENT Aspen Grove Bed & Breakfast
PAPER/PRINTING Classic Laid Recycled, Brushed Pewter,
1- and 2-color PMS

The logo was designed to reflect the quaint and quiet ambience
of this bed-and-breakfast and to provide an idea of the sur-
rounding geography. The logo was created on scratchboard.

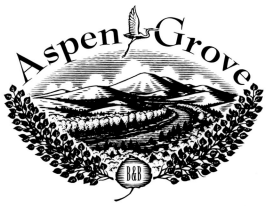

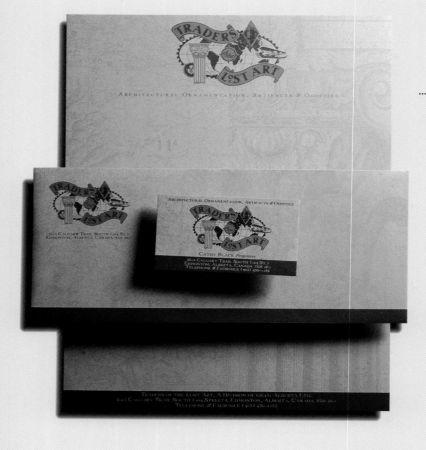

DESIGN FIRM Duck Soup Graphics
ALL DESIGN William Doucette
CLIENT Traders of the Lost Art
PAPER/PRINTING Hopper Proterra, three match colors
TOOL Adobe Illustrator

The stationery features a subtle background screen of an old map and a Roman column to represent the company's origins. Envelopes were printed in two passes on a 2-color press.

DESIGN FIRM Laurie Bish
ALL DESIGN Laurie Bish
CLIENT MVA
PAPER/PRINTING Classic Columns, lithography, 2-color

The color was inspired by architectural paper used by architects. The design was illustrated by hand, and finished art was done by typesetter on computer program.

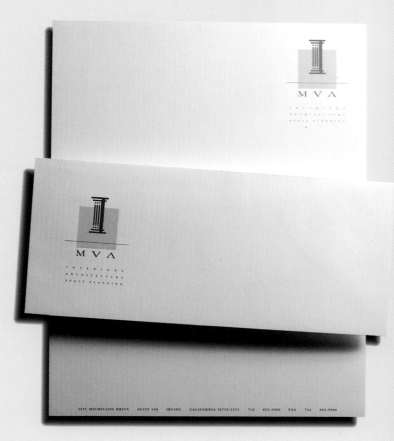

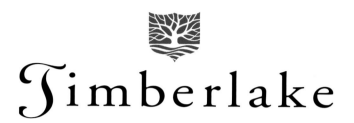

Timberlake

DESIGN FIRM Plaid Cat Design
ALL DESIGN Eric Scott Stevens
CLIENT Timberlake, Powell Construction

The logo for the Timberlake community features a shield, which incorporates images that describe Timberlake. The shield and rest of the logo were created in FreeHand.

DESIGN FIRM Harrisberger Creative
ART DIRECTOR/DESIGNER Lynn Harrisberger
CLIENT Glenn & Sadler
TOOL Macromedia FreeHand

Glenn & Sadler specializes in land and water construction, and this is reflected in the logo.

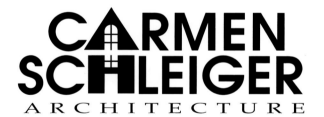

CARMEN SCHLEIGER
ARCHITECTURE

DESIGN FIRM Jeff Fisher Design
ALL DESIGN Jeff Fisher
CLIENT Carmen Schleiger

Carmen Schleiger is an architect who designs residences. The logo was designed in FreeHand, with Avant Garde and Palatino. Stacking the text elements permitted using a house as a graphic.

Westwood CoHousing Community

DESIGN FIRM Plaid Cat Design
ALL DESIGN Eric Scott Stevens
CLIENT Westwood CoHousing Community
TOOL Macromedia FreeHand

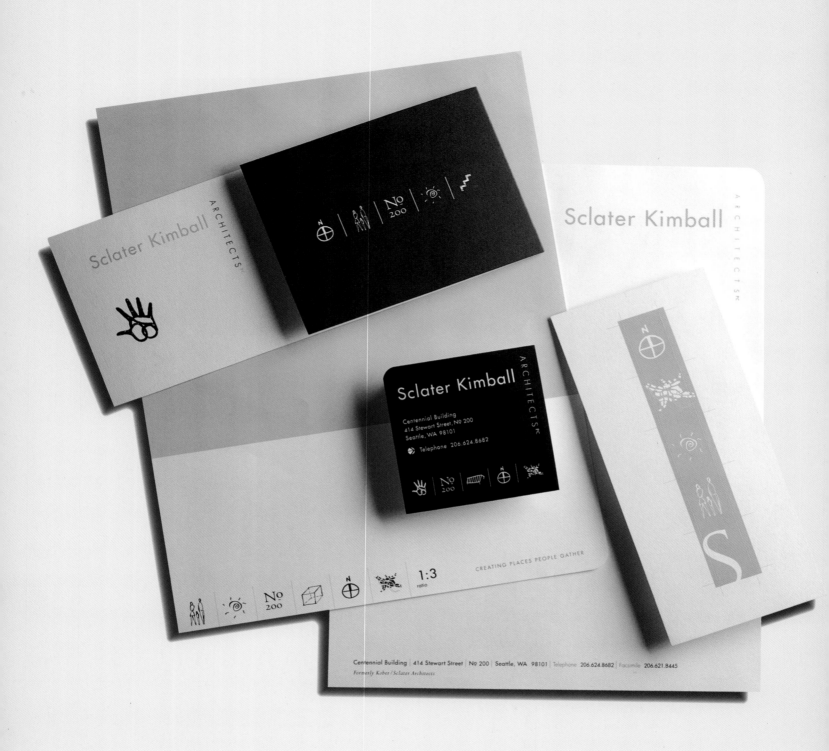

DESIGN FIRM The Leonhardt Group
DESIGNERS Ray Ueno, Jon Cannell
CLIENT Sclater Kimball Architects
PAPER/PRINTING Classic Crest Natural White, three PMS colors

This corporate identity is a complete system that allows for
flexibility. The various icons were created to show the many
characteristics of architecture.

Cooper-Hewitt
National **Design** Museum
Smithsonian Institution

nal **Design** M

2 EAST 91 STREET NEW YORK NY 10128-0669 | TEL 212 860 6868 | FAX 212 860 6909

DESIGN FIRM Drenttel Doyle Partners
ART DIRECTOR Stephen Doyle
DESIGNERS Terry Mastin, Rosemarie Turk
CLIENT National Design Museum
PAPER/PRINTING Benefit Waylaid
TOOL QuarkXPress

This corporate I.D. emphasizes the word "design" and pays homage to the museum's mission.

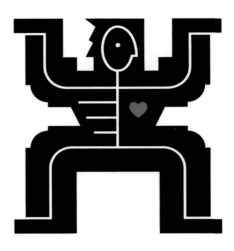

Design Firm Greteman Group
Art Directors/Designers Sonia Greteman,
James Strange
Client City of Wichita

...

The logo for Wichita's Fair + Festival used a festive character
to capture the feeling of the event.

Design Firm Sibley/Peteet Design
Art Director/Designer David Beck
Illustrators David Beck, Mike Broshous
Client Charles James
Tool Adobe Illustrator

...

The final design was done in Illustrator from a scan from a
pencil drawing. Crack-and-peel stickers were created to give
to Charles James's clients.

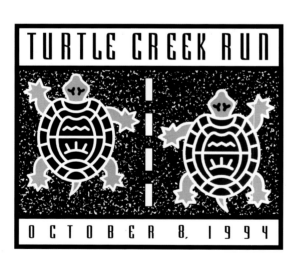

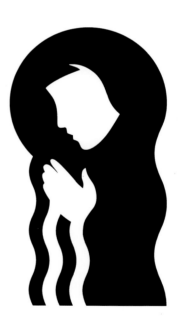

Design Firm Sibley/Peteet Design
Art Director Donna Aldridge
Designer Donna Aldridge
Client American Heart Association
Tool Adobe Illustrator and Photoshop

...

The background texture for the pavement began as a photo-
copy from an old schoolbook, which was then manipulated on
the photocopier and by hand, then scanned into Photoshop.

Design Firm Greteman Group
Art Directors/Designers Sonia Greteman,
James Strange
Client Our Lady of Lourdes

...

This logo is for a rehabilitation hospital representing the Patron
Saint of Our Lady of Lourdes and her healing attributes.

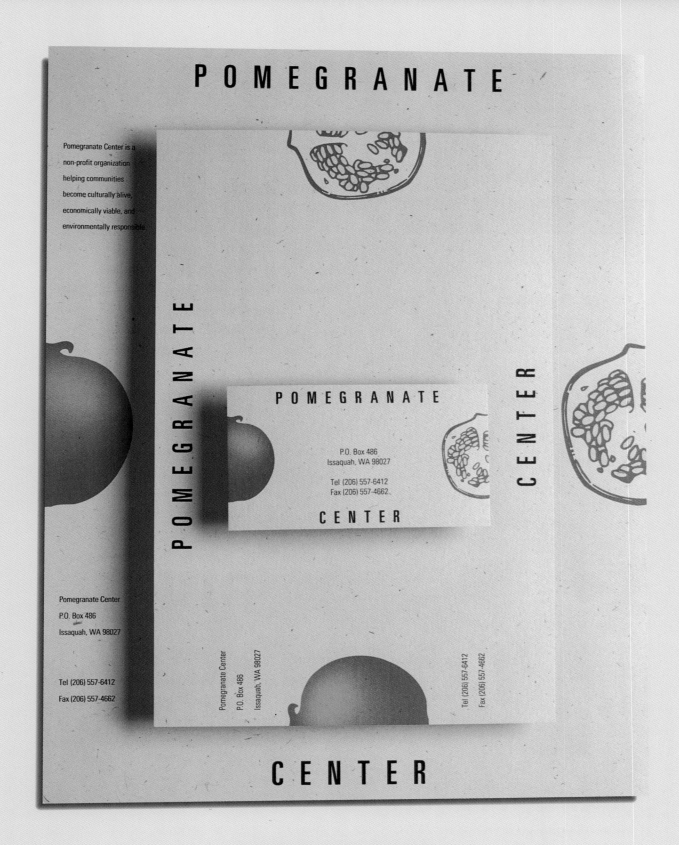

DESIGN FIRM Rick Eiber Design (RED)
ART DIRECTOR/DESIGNER Rick Eiber
ILLUSTRATOR David Verwolf
CLIENT Pomegranate Center
PAPER/PRINTING French Speckletone Natural text

Stationery uses a redundant verbal and visual form which says
the name Pomegranate Center.

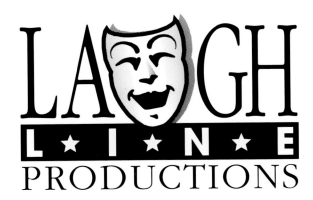

Design Firm Jeff Fisher Design
All Design Jeff Fisher
Client Laugh Line Productions
Tool Aldus FreeHand

Laugh Line Productions presents stand-up comedy to raise funds for AIDS. Using the traditional comedy mask as the "U" in the word laugh gives the logo a strong visual.

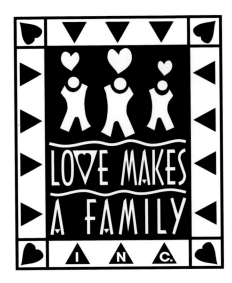

Design Firm Jeff Fisher Design
All Design Jeff Fisher
Client Love Makes A Family Inc.
Tool Aldus FreeHand

The logo was created in FreeHand and is the combination of two designs. The heart symbolizes love, and the triangle is an adopted gay-rights symbol.

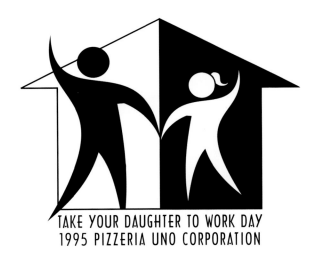

Design Firm Pizzeria Uno Corp. In-House Art Department
Art Director/Designer Christopher Consullo
Client Pizzeria Uno, Human Resources Dept.
Tool Macromedia FreeHand

This logo was for materials promoting "Take Your Daughter to Work Day". It appeared on items given to the girls on that day, like gift certificates and name badges.

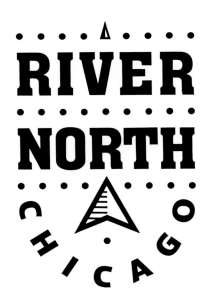

Design Firm Bullet Communications Inc.
All Design Tim Scott
Client River North Association
Tool QuarkXPress

The River North Association logo was created using both QuarkXPress and conventional production techniques. The logo was created to promote the River North area in Chicago.

the merrill c. berman collection
twentieth century modernist art and graphic design
international corporate center
555 theodore fremd avenue, suite b203
rye, new york 10580 usa
tel 914.967.8200
fax 914.967.8252

the merrill c. berman collection
twentieth century modernist art and graphic design
international corporate center
555 theodore fremd avenue, suite b203
rye, new york 10580 usa

Design Firm Matsumoto Incorporated
Art Director/Designer Takaaki Matsumoto
Client The Merrill C. Berman Collection
Paper/Printing Crane's Crest Antique White Wove,
Letterpress, two colors
Tools Adobe Illustrator, QuarkXPress

..

Because the Berman Collection is a modern art collection, the
Futura type family was used. The stationery system, composed
of letterhead, envelope, and mailing label, was printed using
a letterpress.

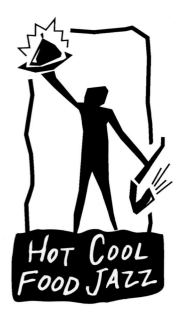

Design Firm Delmarva Power Corporate Comm.
All Design John Alfred
Client Meals on Wheels
Tools Adobe Illustrator and Streamline

This logo for Hot Food, Cool Jazz, a non-profit fund-raiser, was created by scanning a thumbnail sketch, Streamlining it, and manipulating it in Illustrator.

Design Firm Swieter Design U.S.
Art Director John Swieter
Designer Jenice Heo
Client Arlington Museum of Art

This logo was created for the museum's "Raise the Roof Fun Run."

SEE YOU IN SANTA FE

Design Firm Dept. of Art as Applied to Medicine, Johns Hopkins University
Art Director/Designer Joseph M. Dieter, Jr.
Client The Wilmer Eye Institute, The Johns Hopkins Hospital
Tool Adobe Illustrator

This logo was developed for a professional meeting for ophthalmologists held in Santa Fe, New Mexico. The familiar symbol used by New Mexico was appropriately turned into an eyeball.

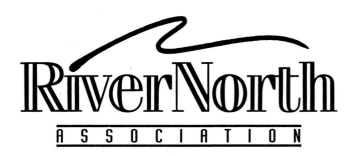

Design Firm Bullet Communications Inc.
All Design Tim Scott
Client River North Association
Tool QuarkXPress

The graphic swash was drawn then scanned into a Macintosh system. The swash was then combined with type, which was set and customized in QuarkXPress.

C O M M U N I T Y

R E H A B I L I T A T I O N

C E N T E R S , I N C .

C O M M U N I T Y
R E H A B I L I T A T I O N
C E N T E R S , I N C .

Debbie Angle
Vice President

6001 Indian School Rd. NE

Albuquerque, New Mexico 87110

505 · 881 · 4961

F A X 505 · 881 · 5097

C O M M U N I T Y

R E H A B I L I T A T I O N

C E N T E R S , I N C .

22 West Monument Avenue, Suite 3 · Kissimmee, Florida 34741 · 407·847·6003 · FAX 407·847·6290

DESIGN FIRM Vaughn Wedeen Creative
ART DIRECTORS Steve Wedeen, Dan Flynn
DESIGNER/ILLUSTRATOR Dan Flynn
CLIENT Horizon Health Care
PAPER/PRINTING Classic Crest, Prisma Graphics
TOOL Adobe Illustrator

The client, a therapy organization, wanted the logo to look hand-
done. After the initial illustration was finished, it was then
scanned in and cleaned up in Illustrator.

DESIGN FIRM Palmquist & Palmquist Design
ART DIRECTORS/DESIGNERS Kurt and Denise Palmquist
ILLUSTRATORS James Lindquist, Denise Palmquist
CLIENT Downtown Bozeman Association

This logo could not focus on one specific building or street because of politics. The illustration was done on scratchboard and the type was a combination of computer- and hand-rendering.

DESIGN FIRM Palmquist & Palmquist Design
ART DIRECTORS/DESIGNERS Kurt and Denise Palmquist
ILLUSTRATOR Kurt Palmquist
CLIENT Coalition for Montanans Concerned with Disabilities
TOOL Aldus FreeHand

The logo design focused on the objectives the organization was trying to accomplish: To help disabled persons while educating politicians and professionals about the concerns and goals of the disabled.

DESIGN FIRM Mires Design Inc.
ART DIRECTOR/DESIGNER José Serrano
ILLUSTRATOR Tracy Sabin
CLIENT Harcourt Brace & Co.

This logo is for a children's fantasy book series.

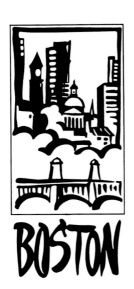

DESIGN FIRM Mires Design Inc.
ART DIRECTOR Mike Brower
DESIGNER Mike Brower
CLIENT Bod-E

The client is a personal health trainer.

DESIGN FIRM Misha Design Studio
ALL DESIGN Michael Lenn
CLIENT Combined Jewish Philanthropies General Assembly '95

The '95 Convention for CJP being held in Boston must demonstrate beauty and excitement. This logo shows the significant landmarks in Boston and invites a participant to the assembly.

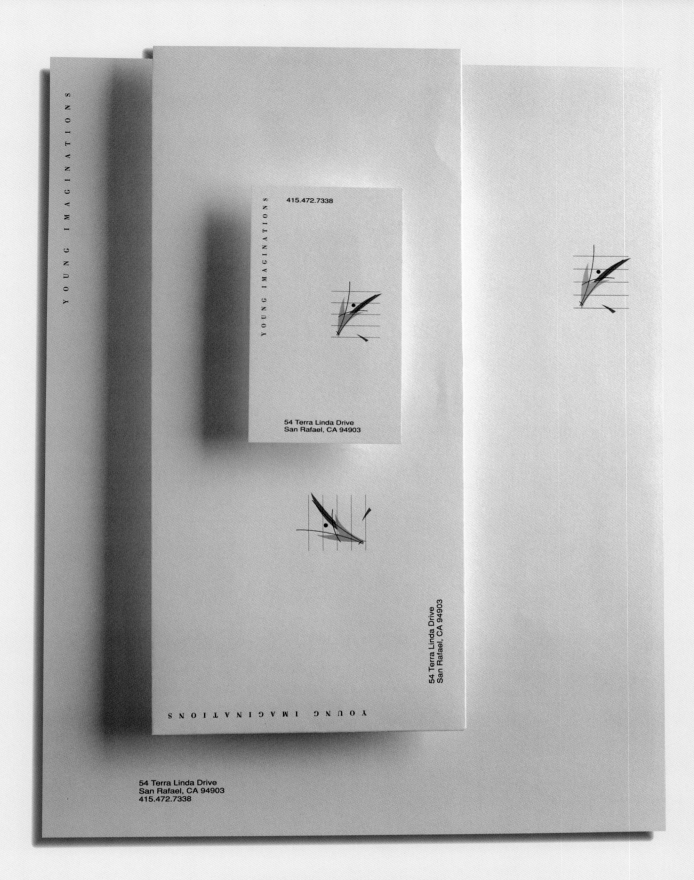

Design Firm Sackett Design Associates
Art Director/Designer Mark Sackett
Designer Mark Sackett
Illustrator Wayne Sakamoto
Client Young Imaginations
Paper/Printing Simpson Coronado SST Recycled 80 lb. text,
offset lithography, two match colors and black

WALK-A-THON

DESIGN FIRM Jon Flaming Design
ALL DESIGN Jon Flaming
CLIENT March of Dimes
PAPER/PRINTING T-shirts
TOOL Adobe Illustrator

This is a logo that was produced for the March of Dimes walk-a-thon. It was used on T-shirts.

DESIGN FIRM Anderson Hanson & Company
ART DIRECTOR/DESIGNER Raul Varela
CLIENT AdvoCare International Fiber 10
TOOL Adobe Illustrator

The logo's appeal is due in part to the pleasing-to-the-eye design of the wheat stalks, which are used to convey Fiber 10's purpose: to cleanse the stomach.

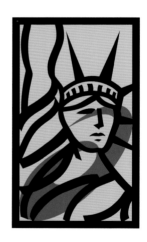

DESIGN FIRM Swieter Design U.S.
ART DIRECTOR John Swieter
DESIGNER Jenice Heo
CLIENT ASICS

This logo was designed for the ASICS Tiger Corporation and the 1994 New York City Marathon commemorating the Marathon's 25th Anniversary. The design was applied to everything from posters, to in-store merchandising displays, to tattoos and lapel pins.

DESIGN FIRM Palmquist & Palmquist Design
ART DIRECTORS/DESIGNERS Kurt and Denise Palmquist
ILLUSTRATOR Kurt Palmquist
CLIENT National Chapter of Trout Unlimited

The bottom line of type is dropped in to double as the logo for a commemorative rod (limited edition), produced to celebrate Trout Unlimited's 35th anniversary.

DESIGN FIRM Swieter Design U.S.
ART DIRECTOR John Swieter
DESIGNER Julie Poth
CLIENT Young Presidents' Organization
TOOL Adobe Illustrator

This icon was created for the Global Masters Program.

AMERICA'S FAMILY
B o o k s

DESIGN FIRM Jon Wells Associates
ART DIRECTOR/DESIGNER Jon Wells
ILLUSTRATOR Michael Schwab
TOOL Adobe Illustrator
CLIENT The Corporation for Cultural Literacy

"America's Family Books" feature children's stories which chronicle America's racial history. The logo highlights this heritage. The image was hand drawn and then it was combined with the type in Illustrator.

CHAPTER OFFICERS' WORKSHOP

DESIGN FIRM Swieter Design U.S.
ART DIRECTOR John Swieter
DESIGNER Mark Ford
CLIENT Young Presidents' Organization
TOOL Adobe Illustrator

QUEENSLAND
THE FAMILY UNIVERSITY AT COOLUM

DESIGN FIRM Swieter Design U.S.
ART DIRECTOR/DESIGNER John Swieter
CLIENT Young Presidents' Organization
TOOL Adobe Illustrator

DESIGN FIRM Swieter Design
ART DIRECTOR John Swieter
DESIGNERS John Swieter, Mark Ford, Paul Munsterman
CLIENT Young Presidents' Organization
TOOL Adobe Illustrator

BOMBAY

DESIGN FIRM Swieter Design U.S.
ART DIRECTOR John Swieter
DESIGNER Mark Ford
CLIENT Young Presidents' Organization
TOOL Adobe Illustrator

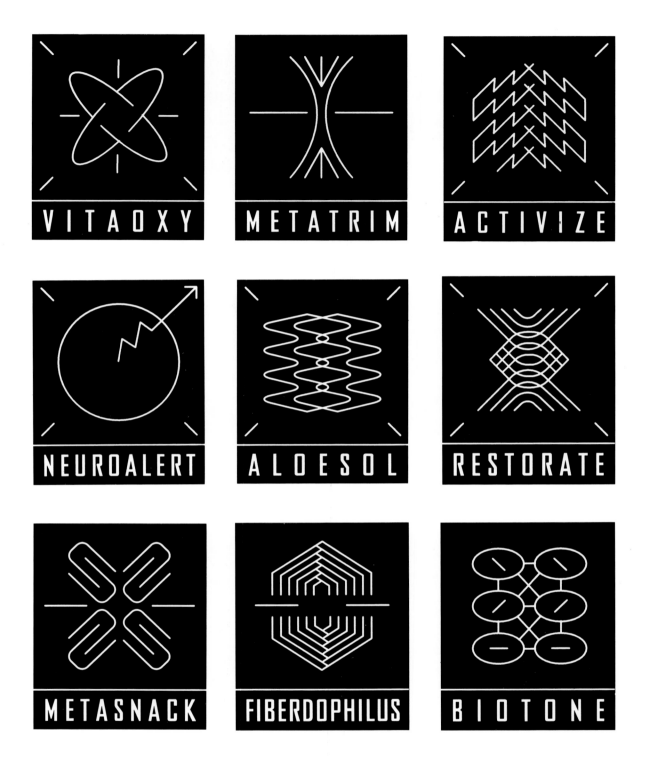

DESIGN FIRM Anderson Hanson & Company

ART DIRECTOR/DESIGNER Raul Varela

CLIENT LifeTronix product packaging logos (Vitaoxy, Metatrim, Activize, Neuroalert, Aloesol, Restorate, Metasnack, Fiberdophilus, Biotone)

TOOL Adobe Illustrator

Each logo was created to give a subconscious reference to the products. The company wanted to convey sophistication and let the logo designs build themselves with product usage.

Design Firm John Evans Design
All Design John Evans
Illustrator John Evans
Client Mary Kay Cosmetics
Tool Adobe Illustrator

These icons were originally drawn with marker then scanned and redrawn in Illustrator. They were used in a line of packaging for Mary Kay Cosmetics.

Design Firm Toni Schowalter Design
Art Director/Designer Toni Schowalter
Client Parfumerie
Tool Adobe Illustrator

The font was manipulated to create the swirling effect for a natural cosmetic line from Hawaii.

Design Firm John Evans Design
All Design John Evans
Client Milton Bradley
Tool Adobe Illustrator

...

These icons are just a few of about 50 created for the game of *Life Jr.* Originally done in pencil, they were faxed to the client for approval, then redrawn in Illustrator.

Design Firm Toni Schowalter Design
Art Director/Designer Toni Schowalter
Client Tri Mark
Tool Aldus FreeHand

...

This logo was used to portray a furniture designer and manufacturer.

Design Firm Toni Schowalter Design
Art Director/Designer Toni Schowalter
Designer Toni Schowalter
Client Johnson & Johnson
Tool Adobe Illustrator

...

This mark was used to differentiate the research and development department in a large health product manufacturer.

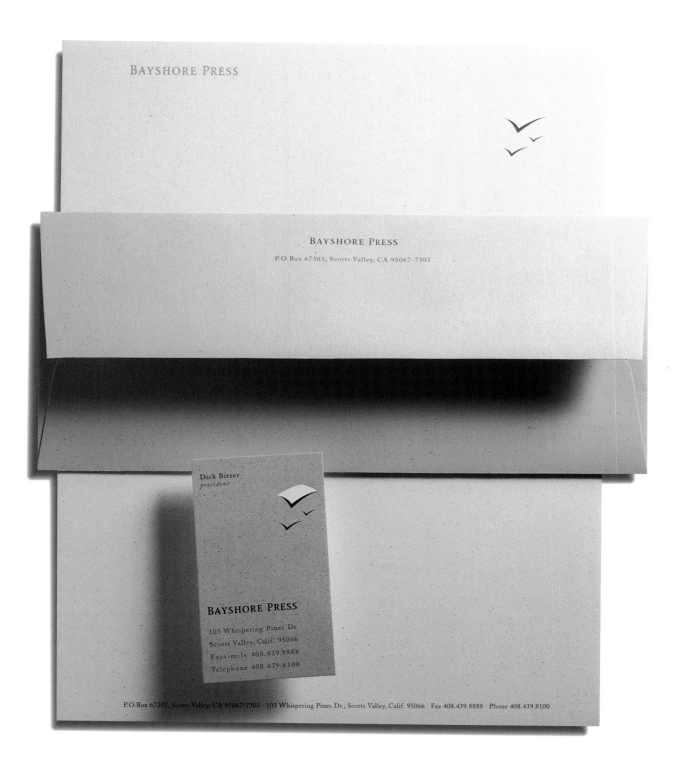

Design Firm THARP DID IT

Art Director Rick Tharp

Designers Rick Tharp, Jana Heer, Laurie Carberry,
Amy Bednarek

Client Bayshore Press

Paper/Printing Simpson Quest Recycled, offset lithography

Tool Adobe Illustrator

The logo was rendered by hand and scanned into the computer.
The custom logotype was created in Illustrator and traditional
art board mechanicals were produced for all print materials.

MR. CUT RATE

Design Firm Witherspoon Advertising
Art Director/Designer Rishi Seth
Client FFP Partners
Tool Adobe Illustrator

This logo was intended for displays at gasoline outlets. The client insisted that a gas pump and scissors be included. The "scissors guy" came from bringing these diverse elements together.

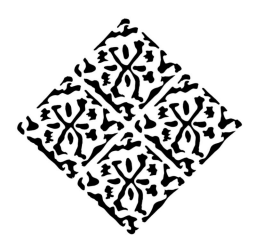

Design Firm Fernandez Vs. Miller Design
Art Director/Designer Bryan M. Miller
Client A Tile Store
Tool Adobe Illustrator

A Tile Store, in Seattle, Washington specializes in custom handcrafted and specialty tiles. The client's favorite tiles were charcoal rubbed for the logo. A little stylizing in Illustrator and the rest is history.

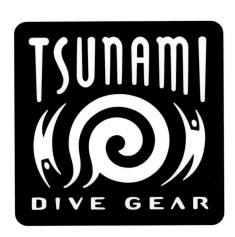

Design Firm Mires Design Inc.
Art Director/Designer John Ball
Client Tsunami Dive Gear, underwater communication equipment

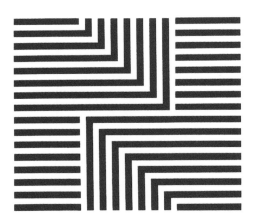

Design Firm Félix Beltrán + Asociados
Art Director/Designer Félix Beltrán
Client Novum, Mexico
Tool CorelDRAW

In the creation of this logo for a videocassette factory, CorelDRAW was used for printing the initial sketches. The logo was silk-screened to improve the color.

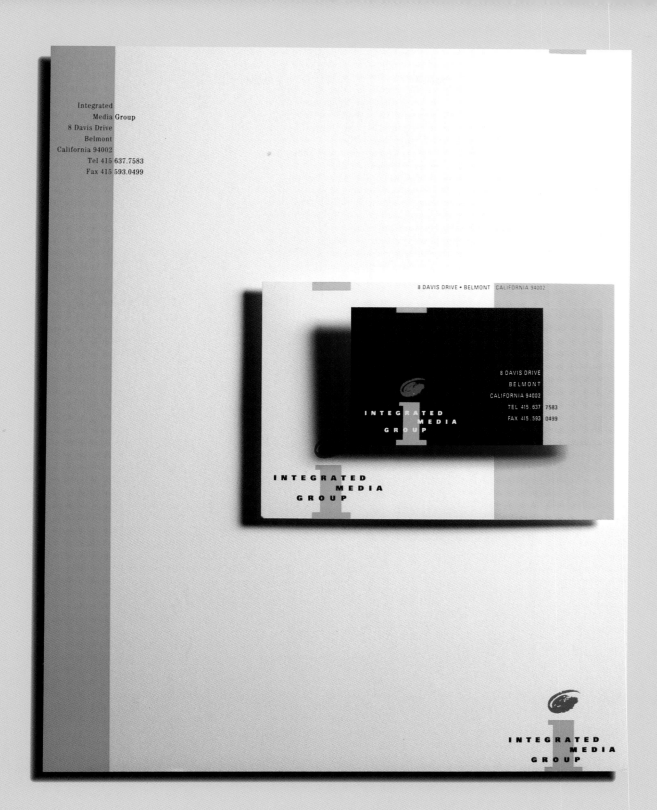

Integrated
Media Group
8 Davis Drive
Belmont
California 94002
Tel 415 637.7583
Fax 415 593.0499

8 DAVIS DRIVE • BELMONT CALIFORNIA 94002

8 DAVIS DRIVE
BELMONT
CALIFORNIA 94002
TEL 415 637 7583
FAX 415 593 0499

INTEGRATED
MEDIA
GROUP

INTEGRATED
MEDIA
GROUP

INTEGRATED
MEDIA
GROUP

DESIGN FIRM THARP DID IT
ART DIRECTOR Rick Tharp
DESIGNERS Rick Tharp, Colleen Sullivan
ILLUSTRATOR Georgia Deaver
CLIENT Integrated Media Group
PAPER/PRINTING Simpson Starwhite Vicksburg, three match
colors, offset lithography

This logo was created for a publisher of interactive multimedia
teaching programs. It includes a graphic style guide. Art was
rendered by hand, scanned into the computer, and composed in
Illustrator.

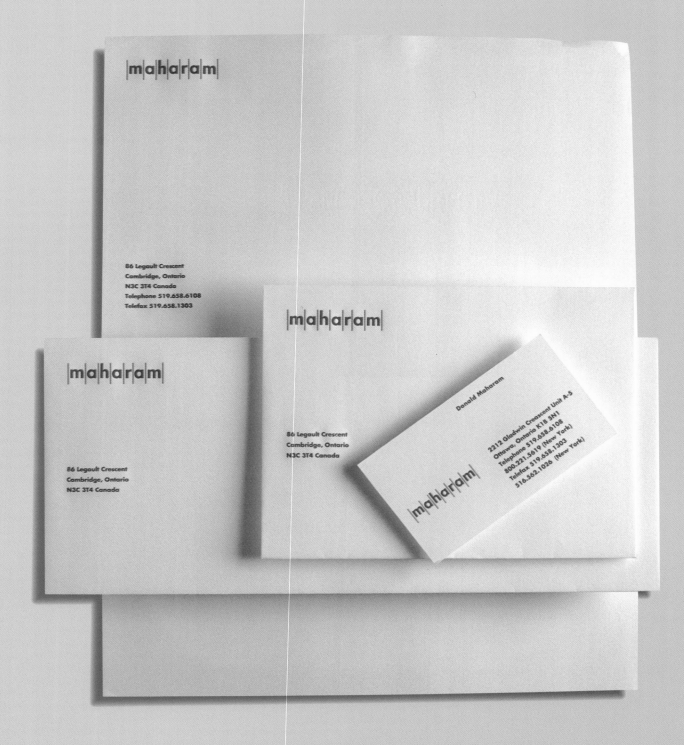

DESIGN FIRM Matsumoto Incorporated

ART DIRECTOR/DESIGNER Takaaki Matsumoto

CLIENT Maharam

PAPER/PRINTING Cranes Crest Fluorescent White,
3-color engraved

TOOLS Adobe Illustrator, QuarkXPress

The vertical elements in the design are an abstract suggestion of threads of fabric. The components of the stationery system were engraved using three colors.

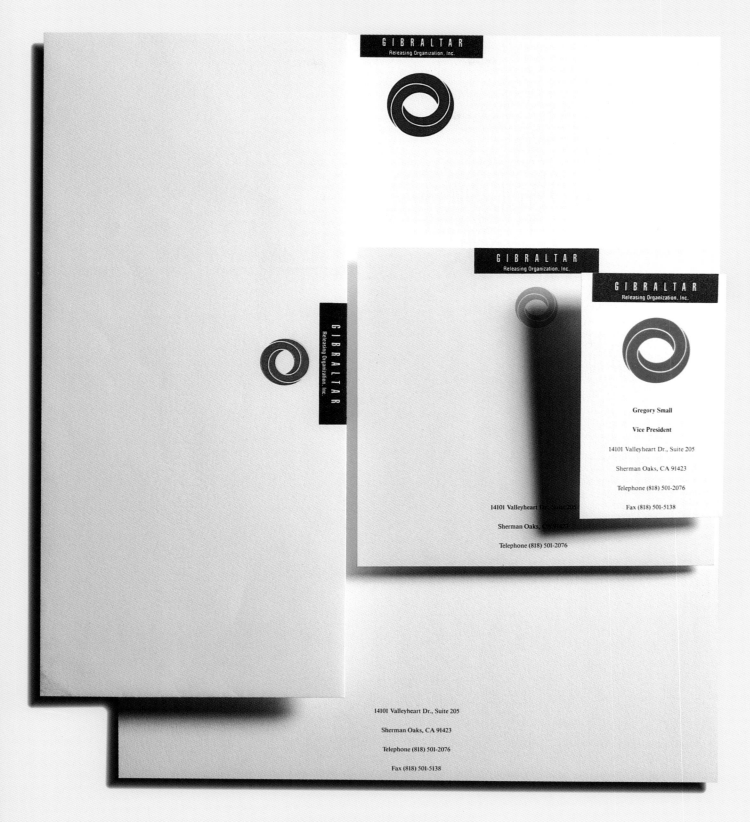

DESIGN FIRM Melissa Passehl Design
ART DIRECTOR/DESIGNER Melissa Passehl
CLIENT Gibraltar Releasing Organization Inc.

This identity system and logo were designed to reflect the creative, thought provoking, and interactive films produced by this movie company.

DESIGN FIRM Mires Design Inc.
ART DIRECTOR José Serrano
DESIGNER José Serrano
ILLUSTRATOR Tracy Sabin
CLIENT Found Stuff Paperworks
PAPER/PRINTER Terra Sketch—100% recycled organic
sketch paper.

DESIGN FIRM Mires Design Inc.
ART DIRECTOR/DESIGNER John Ball
ILLUSTRATOR Tracy Sabin
CLIENT S.D. Johnson Co.

ORCA fishing products

DESIGN FIRM MacVicar Design & Communications
ART DIRECTOR John Vance
DESIGNER William A. Gordon
CLIENT Benchmark Communications
TOOL Adobe Illustrator

Logo was developed for use as the corporate identity of a radio-
industry management/promotions firm.

DESIGN FIRM Caldera Design
ILLUSTRATORS Dave Kottler, Paul Caldera,
Doreen Caldera, Bart Welch
CLIENT Frogskins

Design Firm Segura Inc.

Art Director Carlos Segura

Designer Carlos Segura, Laura Alberts

Illustrator Tony Klassen

Client Tires on Fire

Paper/Printing Argus Press, 4-color

Tools Adobe Illustrator and Photoshop, QuarkXPress

DESIGN FIRM Clifford Selbert Design
ART DIRECTORS Clifford Selbert, Robin Perkins
DESIGNERS Robin Perkins, Julia Daggett, Michele Phelan, Kamren Colson, Kim Reese, John Lutz
ILLUSTRATOR Gerald Bustamante
CLIENT Stride Rite Inc.

The concept focused on "the joy of growing up." The color palette has three simple, vibrant colors, and Stride Rite's "i's" reflect a youthful energy and spirit.

DESIGN FIRM The Kamber Group
ART DIRECTOR Dennis Walston
DESIGNER Page Miller
CLIENT Montague Branch

Montague Branch crafts fine cabinetry and outfits entire kitchens for its clients.

DESIGN FIRM Sackett Design Associates
ART DIRECTOR/DESIGNER Mark Sackett
ILLUSTRATOR Wayne Sakamoto
CLIENT Quest

DESIGN FIRM Clifford Selbert Design
ART DIRECTOR Robin Perkins
DESIGNERS Robin Perkins, Jeff Breidenbach
CLIENT Ahead Inc.
TOOL Aldus FreeHand

The fonts used in these pieces were Industrial, Template Gothic, and Oblong. The three logos used a common element — the V— in a variety of ways.

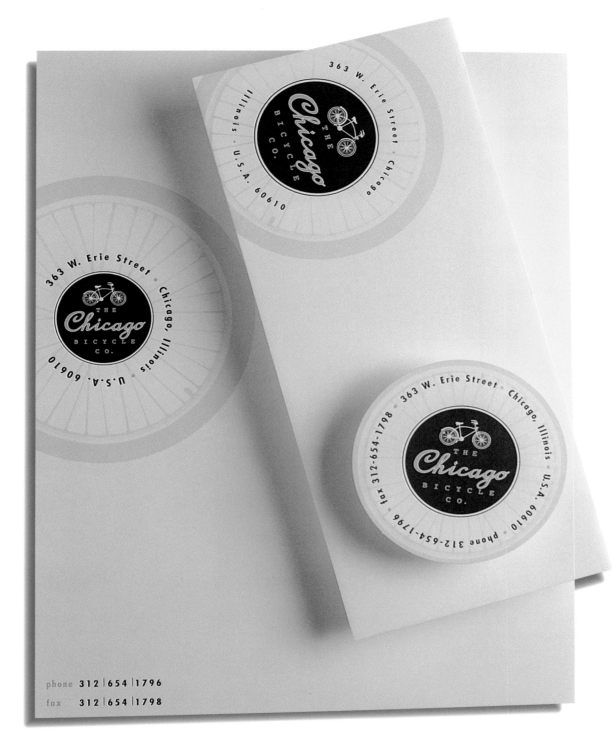

Design Firm Maximum Marketing
Art Director Ed Han
Designer/Illustrator Deirdre Boland
Client The Chicago Bicycle Co.
Tools Adobe Illustrator, QuarkXPress

The warm-toned paper along with the beige and blue inks enhance the retro feel. It is used on signage, printed materials, apparel, and advertising. The red and yellow version is used on all store signage.

DESIGN FIRM Swieter Design U.S.
ART DIRECTOR John Swieter
DESIGNER Mark Ford
CLIENT Street Savage Roller Blade Gear
TOOL Adobe Illustrator

This icon was developed for a company that manufactures street hockey equipment.

DESIGN FIRM Swieter Design U.S.
ART DIRECTOR John Swieter
DESIGNER Mark Ford
CLIENT ASICS
TOOL Adobe Illustrator

This icon was created for the "Sound Mind Sound Body" series.

DESIGN FIRM Swieter Design U.S.
ART DIRECTOR John Swieter
DESIGNER Paul Munsterman
CLIENT Converse Basketball
TOOL Adobe Illustrator

This product icon was developed for a line of basketballs featuring the highest grade synthetic leather which is durable on all court surfaces.

DESIGN FIRM Swieter Design U.S.
ART DIRECTOR/DESIGNER John Swieter
CLIENT Converse Basketball
TOOL Adobe Illustrator

This product icon features a global rendition of the traditional seams on a basketball and is targeted as the first genuine leather ball sold internationally for Converse.

DESIGN FIRM Swieter Design U.S.
ART DIRECTOR John Swieter
DESIGNER Mark Ford
CLIENT Fujitsu
TOOL Adobe Illustrator

This logo was created for **Envoy**, Fujitsu's Quarterly Technical Journal.

DESIGN FIRM Swieter Design U.S.
ART DIRECTOR John Swieter
DESIGNER Kevin Flatt
CLIENT Converse Basketball
TOOL Adobe Illustrator

This product icon, created for Converse Inc., symbolizes the use of this product as an indoor and outdoor basketball.

DESIGN FIRM Design One
ALL DESIGN David Guinn
CLIENT Handmade in America
TOOL Aldus FreeHand
PAPER/PRINTING Confetti Tan, Offset White, copper metallic
PMS on uncoated sheet

··

This logo captures a handmade feel and used a loose rendition of
a hand and letters "H," "M," and "A." It was drawn in
FreeHand with tablet pen.

DESIGN FIRM Swieter Design U.S.
ART DIRECTOR/DESIGNER John Swieter
CLIENT Timberform Builders
TOOL Adobe Illustrator

DESIGN FIRM Swieter Design U.S.
ART DIRECTOR John Swieter
DESIGNER Kevin Flatt
CLIENT Pet Rite
TOOL Adobe Illustrator
..
This identity was created for dog shampoo and conditioner.

DESIGN FIRM Go Media Inc.
ALL DESIGN Sonya Cohen
CLIENT Active Paper
TOOL Adobe Illustrator
..
After many drawings of "active" paper and information in motion, the elements and the quirky drawing style were honed.

DESIGN FIRM Cato Design Inc.
DESIGNER Ken Cato
CLIENT Poppy Industries
TOOL Adobe Illustrator
..
The logo was hand drawn but put together in Illustrator. The packaging symbol was derived from the name of the company's founder, Poppy King.

DESIGN FIRM Swieter Design U.S.
ART DIRECTOR John Swieter
DESIGNER Kevin Flatt
CLIENT Converse Basketball
TOOL Adobe Illustrator
..
The title "Security Panel" refers to a signature strip on the basketball itself. The Converse "Security Panel" ball was the first basketball designed with a debossed panel for personalizing each ball.

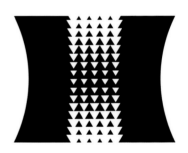

DESIGN FIRM Rousso+Associates Inc.
ART DIRECTOR/DESIGNER Steve Rousso
CLIENT Harbinger Corporation
..
This logo suggests the interchange flow of information with the arrows traveling vertically through the bold "H" shape. The curved sides added dynamism to the otherwise solid, stable shape.

DESIGN FIRM JiWon Shin

ART DIRECTOR/DESIGNER JiWon Shin

CLIENT Color Kit

PAPER/PRINTING Tracing (Transparent) paper

Overlapping rotating Modulars produce changing color and
shape combinations. There are six colored Modulars in acrylic
and hardboard. Transparent paper was used for the stationery
because the clock parts are transparent.

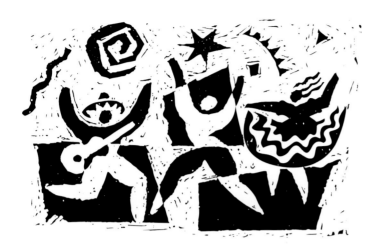

DESIGN FIRM John Evans Design
ART DIRECTORS John Evans, Michael Reyes
DESIGNER/ILLUSTRATOR John Evans
CLIENT Quaker Oats, Berry Brown Advertising
TOOL Adobe Streamline

This mark was done with traditional scratchboard, then it was scanned and Streamlined to create the final logo.

DESIGN FIRM Robert Bailey Incorporated
ART DIRECTOR Robert Bailey
DESIGNER/ILLUSTRATOR Dan Franklin
CLIENT CA One Services Inc.
TOOL Macromedia FreeHand

This logo is for a proposed lounge for Los Angeles International Airport. It is based on the architecture of Greene & Greene, the well-known "bungalow" architects of southern California.

DESIGN FIRM Robert Bailey Incorporated
ART DIRECTOR Robert Bailey
DESIGNER Ellen Bednarek
CLIENT CA One Services Inc.
TOOL Macromedia FreeHand

This logo is for a proposed delicatessen for Los Angeles International Airport. The theme is based on the old-fashioned, friendly, full-service Jewish delicatessen.

DESIGN FIRM Kelly O. Stanley Design
ALL DESIGN Kelly O'Dell Stanley
CLIENT Caffé di Cielo
TOOL Aldus FreeHand

This logo needed to represent quality since many coffee shops are trendy. The logo was drawn in FreeHand and the typeface used for Cielo was created specifically for this logo.

ARMENO
COFFEE
ROASTERS
LTD

ARMENO
COFFEE
ROASTERS
LTD
▲
75 Otis Street, Northborough
Massachusetts 01532

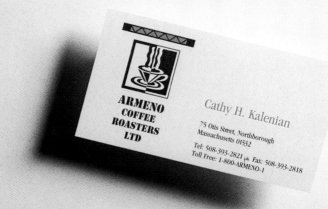

ARMENO
COFFEE
ROASTERS
LTD

Cathy H. Kalenian

75 Otis Street, Northborough
Massachusetts 01532
Tel: 508-393-2821 ▲ Fax: 508-393-2818
Toll Free: 1-800-ARMENO-1

75 Otis Street
Northborough
Massachusetts 01532
▲
Tel: 508-393-2821
Fax: 508-393-2818
Toll Free:
1-800-ARMENO-1

DESIGN FIRM Smith Korch Daly
ART DIRECTOR Patricia B. Korch
DESIGNER Barbara A. Truell
ILLUSTRATOR Linda Rice
CLIENT Armeno Coffee Roasters Ltd.
PAPER/PRINTING Classic Crest Earthstone, Image Press
TOOLS Aldus FreeHand, QuarkXPress
..
This logo needed to be a contemporary and easily recognizable
symbol that would work well with the old stencil font. The
blend of old and new complemented the client's business.

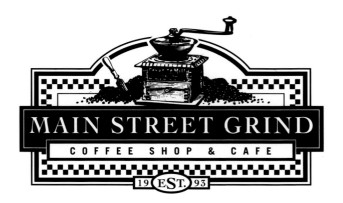

Design Firm Robert Bailey Incorporated
Art Director Robert Bailey
Designer/Illustrator Dan Franklin
Client CA One Services Inc.
Tool Macromedia FreeHand

This logo is for a proposed lounge for Los Angeles International Airport. The theme is based on the Italian countryside, to relate to the adjoining local restaurant, Rosti.

Design Firm Mind's Eye Design
All Design Stephen Brown
Client Main Street Grind
Tools Adobe Photoshop and Streamline, Macromedia FreeHand

The client wanted a logo to convey the impression of a well-established business. They wanted it to be easily adaptable for T-shirts, coffee mugs, and shopping bags.

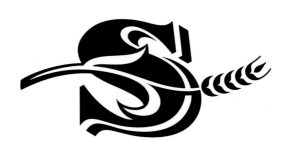

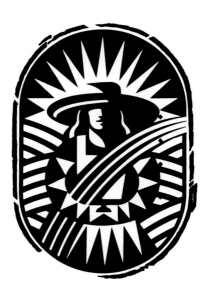

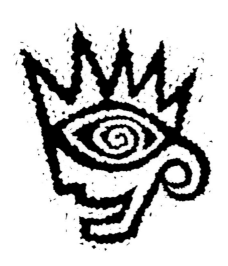

Design Firm Sibley/Peteet Design
Art Director Rex Peteet
Designer Tom Hough
Client Shawnee Milling Company
Tool Adobe Illustrator

The logo's curves have to be exactly right in relation to each other. It took much longer on the computer than it would have drawing it by hand with French curves.

Design Firm Greteman Group
Art Director/Designer Sonia Greteman
Client Green Acres

The logo is rough and natural. It represents a homey, family feeling.

Design Firm Incite Design Communications
All Design Sherrie and Tracy Holdeman
Client Jitters All Night Coffee House
Tool Macromedia FreeHand

Jitters was hand drawn, scanned and opened in Streamline to convert it into vector lines. It was opened into FreeHand to modify the line work to give it the extra jitters.

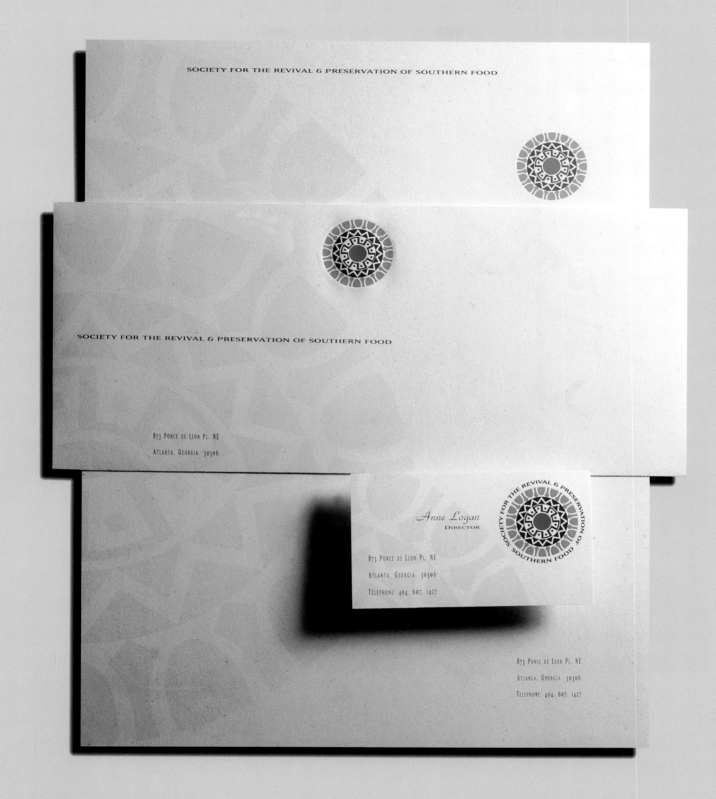

SOCIETY FOR THE REVIVAL & PRESERVATION OF SOUTHERN FOOD

SOCIETY FOR THE REVIVAL & PRESERVATION OF SOUTHERN FOOD

873 PONCE DE LEON PL. NE
ATLANTA, GEORGIA 30306

Anne Logan
DIRECTOR

873 PONCE DE LEON PL. NE
ATLANTA, GEORGIA 30306
TELEPHONE: 404. 607. 1427

SOCIETY FOR THE REVIVAL & PRESERVATION OF SOUTHERN FOOD

873 PONCE DE LEON PL. NE
ATLANTA, GEORGIA 30306
TELEPHONE 404. 607. 1427

DESIGN FIRM Rousso+Associates, Inc.
ART DIRECTOR/DESIGNER Steve Rousso
CLIENT Society for the Revival & Preservation of Southern Food

The society, trying to bring back the heritage and appreciation
of American Southern cuisine, wanted an image that was upscale
and did not convey the typical thinking about Southern food.

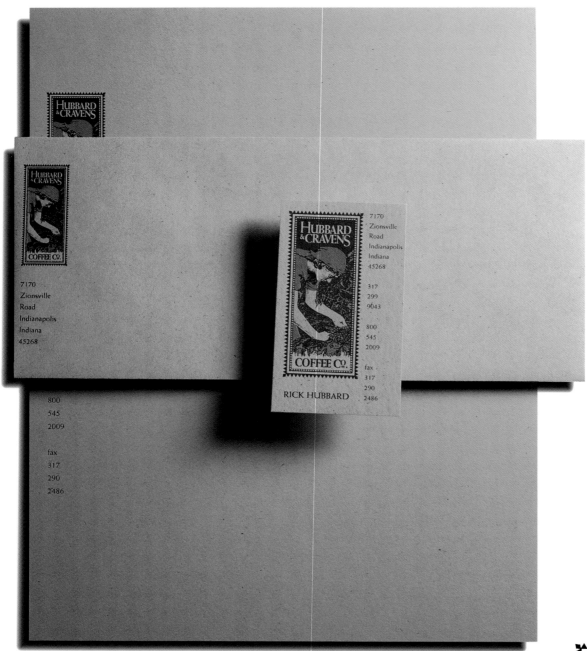

DESIGN FIRM Kelly O. Stanley Design
ALL DESIGN Kelly O'Dell Stanley
CLIENT Hubbard & Cravens Coffee Co.
PAPER/PRINTING Champion Benefit
TOOL Aldus FreeHand

The logo and illustration are based on a photo of women picking coffee beans. It was illustrated by hand and the frame and typography were created in FreeHand.

27100 PIONEER HIGHWAY • P. O. BOX 1359 • STANWOOD, WA 98292

Ronald W. Haveman
Controller

NORTH STAR COLD STORAGE, INC.
27100 PIONEER HIGHWAY
P. O. BOX 1359
STANWOOD, WA 98292

(360) 629-9591
FAX: (206) 778-8440
SEATTLE DIRECT:
(206) 778-8189

NORTH STAR COLD STORAGE, INC.

27100 PIONEER HIGHWAY • P. O. BOX 1359 • STANWOOD, WA 98292
(360) 629–9591 • FAX: (206) 778-8440 • SEATTLE DIRECT: (206) 778-8189

DESIGN FIRM Walsh and Associates Inc.
ART DIRECTOR Miriam Lisco
DESIGNER Katie Dolejsi
ILLUSTRATOR Larry Jost
CLIENT Northstar Cold Storage
PAPER/PRINTING Classic Crest, 2-color
TOOL Adobe Illustrator

An illustrator drew the polar bear, while the logo was designed
in Illustrator for corporate identity. The pieces were printed in
2-color, maintaining quality and dimension.

LA · TAVOLATA

A GATHERING OF FRIENDS AND NEIGHBORS FOR CHARITY

DESIGN FIRM Price Learman Associates
ALL DESIGN Ross West
CLIENT La Tavolata
TOOLS Adobe Photoshop, Aldus FreeHand

..

"La Tavolata" has many meanings: family, community, caring, giving. The challenge was to convey this message without straying from the table. This was accepted into the 1995 *Print Regional Design Annual.*

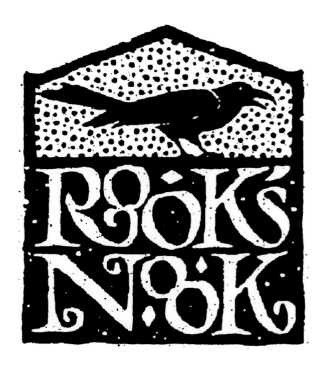

DESIGN FIRM Plaid Cat Design
ALL DESIGN Eric Scott Stevens
CLIENT Rook's Nook Coffeehouse

..

The logo uses a hand lettering style that works well with the antiquated feel. Since a rook is a crow-like bird, black lends itself to the design quite nicely.

DESIGN FIRM Price Learman Associates
ALL DESIGN Ross West
CLIENT Burnt Rat Brewing Co.
TOOLS Adobe Photoshop, Aldus FreeHand

..

Burnt Rat Brewing Co. is a start-up home microbrewery that makes batches of hand crafted brew. The rat imagery refers to stories of the origins of beer.

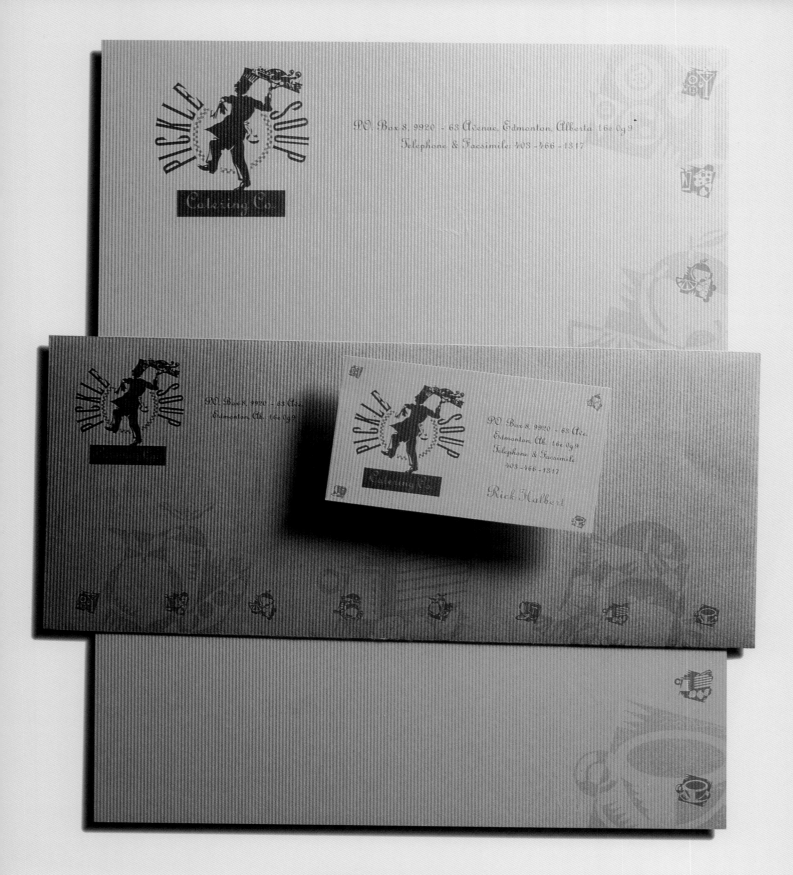

DESIGN FIRM Duck Soup Graphics
ALL DESIGN William Doucette
CLIENT Pickle Soup Catering Co.
PAPER/PRINTING Domtar Naturals, two match colors

..

Two colors of the same paper stock were used for a visual con-
trast. The hand-drawn logo represents the chef/president who
had built a reputation before starting the catering division.

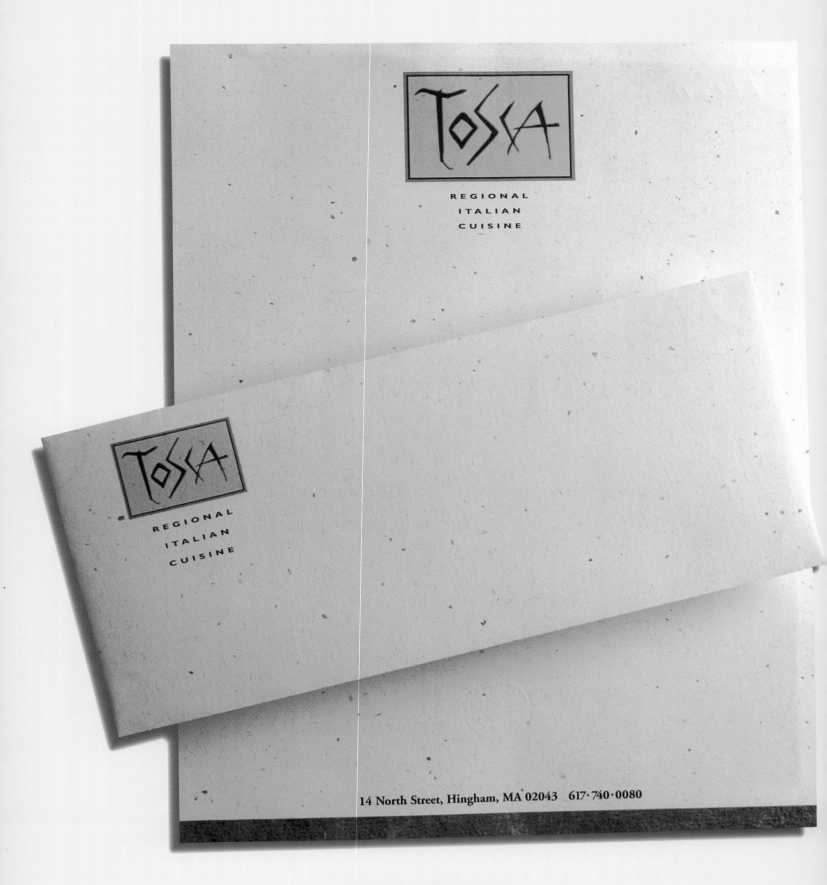

REGIONAL
ITALIAN
CUISINE

REGIONAL
ITALIAN
CUISINE

14 North Street, Hingham, MA 02043 617·740·0080

DESIGN FIRM Adkins/Balchunas
ART DIRECTOR/DESIGNER Jerry Balchunas
CLIENT Tosca
PAPER/PRINTING Fox River Confetti, Village Press,
Universal Printing

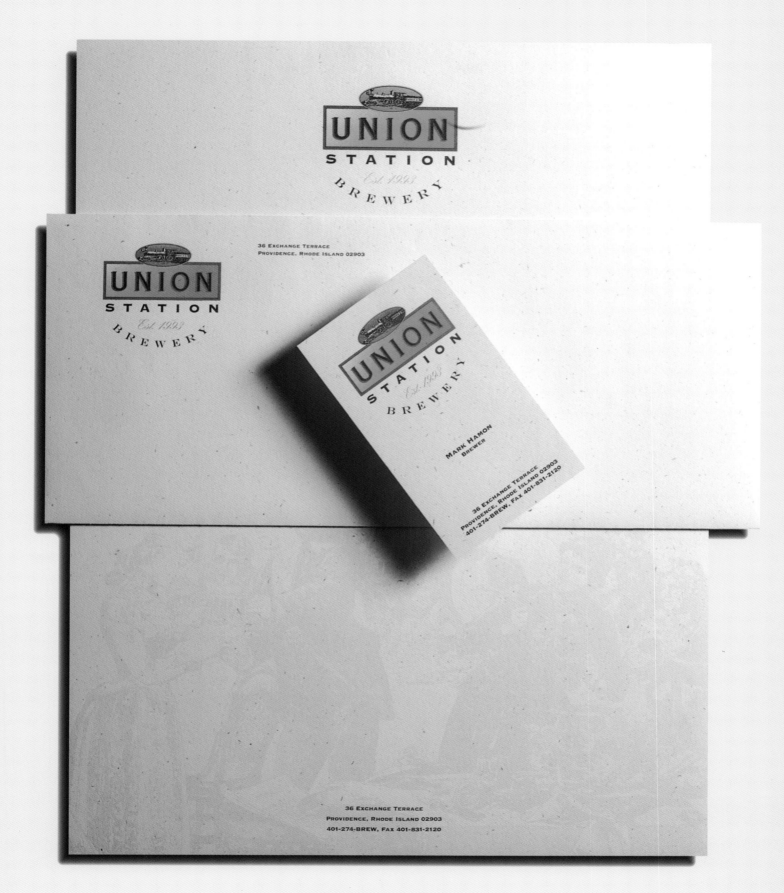

DESIGN FIRM Adkins/Balchunas
ART DIRECTOR/DESIGNER Jerry Balchunas
CLIENT Union Station Brewery
PAPER/PRINTING Cross Pointe, Genesis Village Press

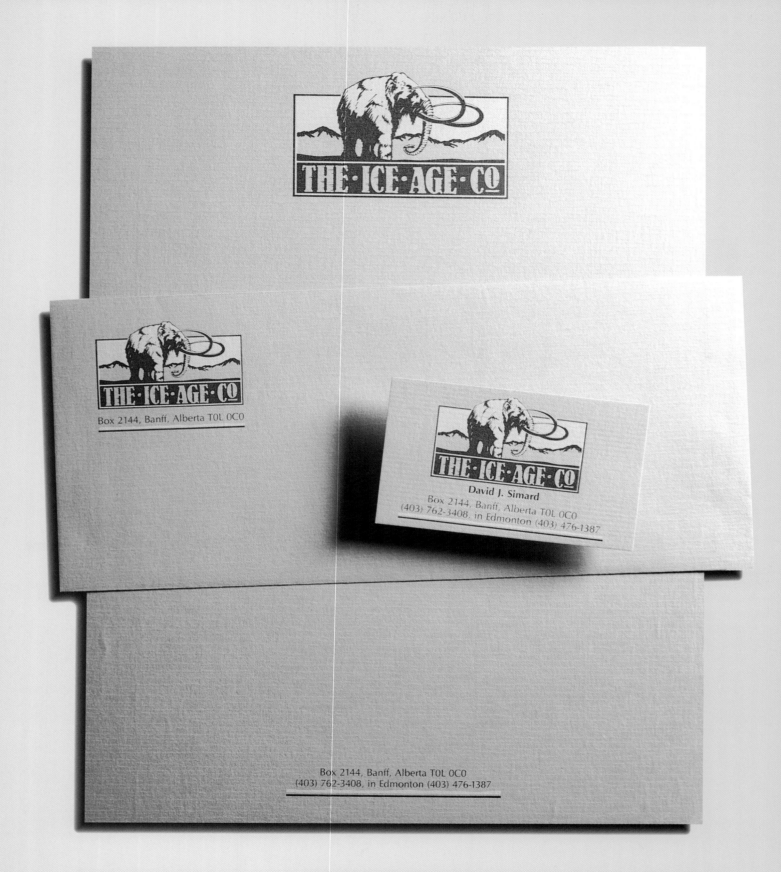

DESIGN FIRM Duck Soup Graphics
ALL DESIGN William Doucette
CLIENT The Ice Age Co.
PAPER/PRINTING Classic Laid, two match colors

This client was the first company in Canada to offer 100 percent
pure, prehistoric glacier ice to the consumer as gourmet ice. The
logo was hand drawn in ink.

Design Firm Swieter Design U.S.
Art Director John Swieter
Designer Jim Vogel
Client Lunar Lodge Night Club
Tool Adobe Illustrator

Design Firm Walsh and Associates
Art Director/Designer Miriam Lisco
Illustrator Jim Hays
Client Chukar Cherries
Tool Adobe Illustrator

An illustrator drew the Chukar bird, and the design was created in Illustrator. The logo needed to be used in 1-color, 2-color, and 4-color applications.

Design Firm Swieter Design U.S.
Art Director John Swieter
Designer Mark Ford
Client Eclipse Restaurant
Tool Adobe Illustrator

Design Firm Hornall Anderson Design Works Inc.
Art Director Jack Anderson
Designers Jack Anderson, Julia LaPine, Jill Bustamante
Illustrator Julia LaPine
Client Talking Rain

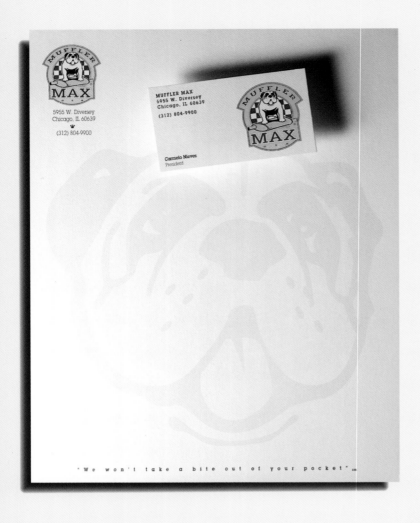

DESIGN FIRM ZGraphics Ltd.
ART DIRECTOR Joe Zeller
DESIGNER Eric Halloran
CLIENT Muffler Max USA
PAPER/PRINTING Strathmore Writing Bright White Wove

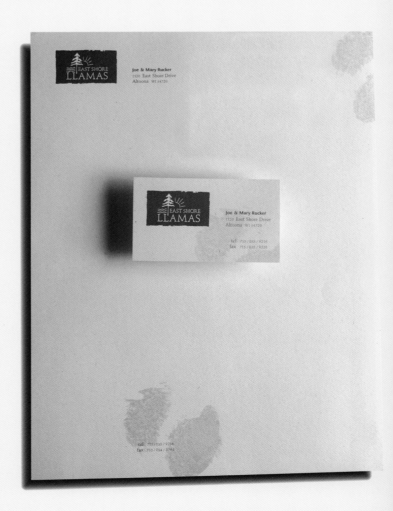

DESIGN FIRM Corridor Design
ALL DESIGN Ejaz Saifullah
CLIENT East Shore Llamas
PAPER/PRINTING French True White, Rooney Printing Co.
TOOLS Adobe Illustrator, QuarkXPress

All logo components, except type, were drawn on paper and fine tuned in Illustrator. Footprints were taken using mud and paper and were later scanned. The stationery was typeset in QuarkXPress.

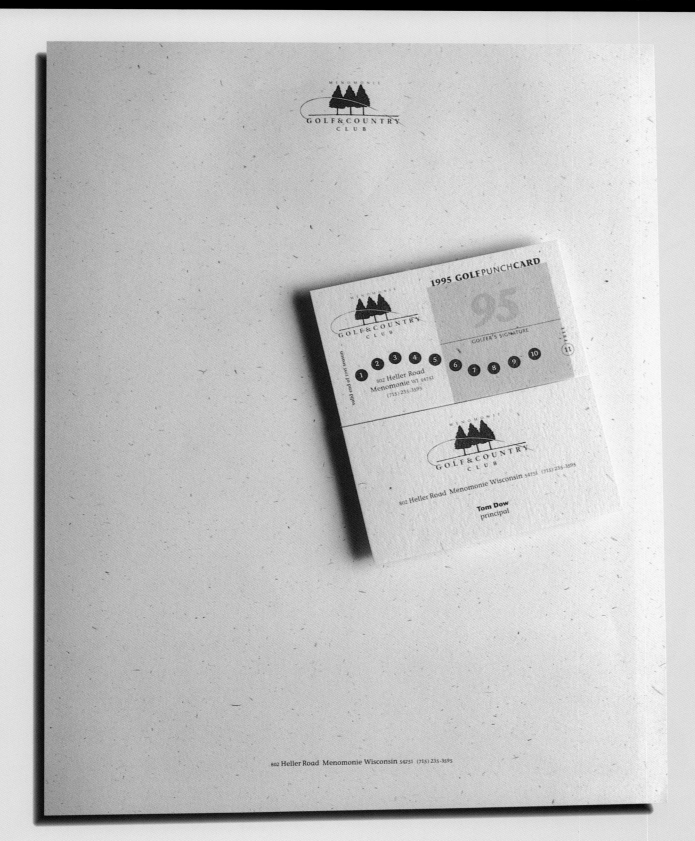

DESIGN FIRM Corridor Design
ALL DESIGN Ejaz Saifullah
CLIENT Menomonie Golf & Country Club
PAPER/PRINTING French True White Speckletone,
Rooney Printing Co.
TOOLS Adobe Illustrator, QuarkXPress

All logo components, except type, were drawn on paper
and fine tuned in Illustrator. The stationery was typeset
in QuarkXPress.

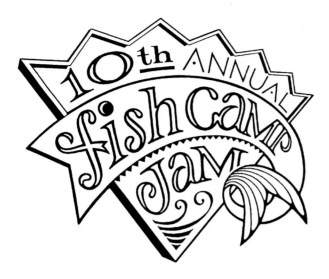

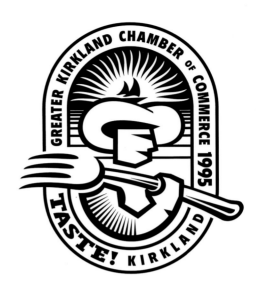

DESIGN FIRM Plaid Cat Design

DESIGNER/ILLUSTRATOR Eric Scott Stevens

CLIENT Fish Camp Jam, Gaston Festivals

Since fish is the main focus of Fish Camp Jam, fish forms part of the logo. The logo and type were created by hand and then later taken into the computer to add coloration.

DESIGN FIRM Price Learman Associates

ALL DESIGN Ross West

CLIENT Kirkland Chamber of Commerce

TOOL Aldus FreeHand

Taste! Kirkland is an annual summer event that features local restaurants and their assortment of foods and beverages. The shoreline community of Kirkland is situated on Lake Washington.

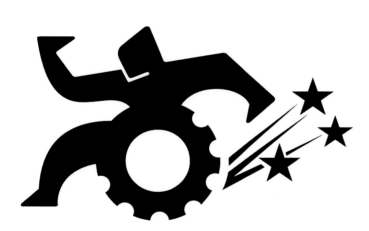

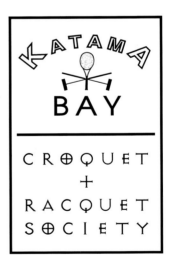

DESIGN FIRM Love Packaging Group

ALL DESIGN Brian Miller

CLIENT Adaptive Athletics

TOOL Macromedia FreeHand

This is a proposed logo for an annual race for wheelchair athletes. It started as a pencil sketch, was scanned into the computer and traced/refined in FreeHand.

DESIGN FIRM John Reynolds Design

ART DIRECTOR/DESIGNER John Reynolds

CLIENT Katama Bay Croquet + Racquet Society

PAPER/PRINTING Apple Laserwriter Pro 600

TOOLS Adobe Illustrator, QuarkXPress

The racquet was scanned and the mallets were drawn in Illustrator. The "Croquet" font modified in Fontographer; the "Katama" font was created in Illustrator. The logo was assembled in QuarkXPress.

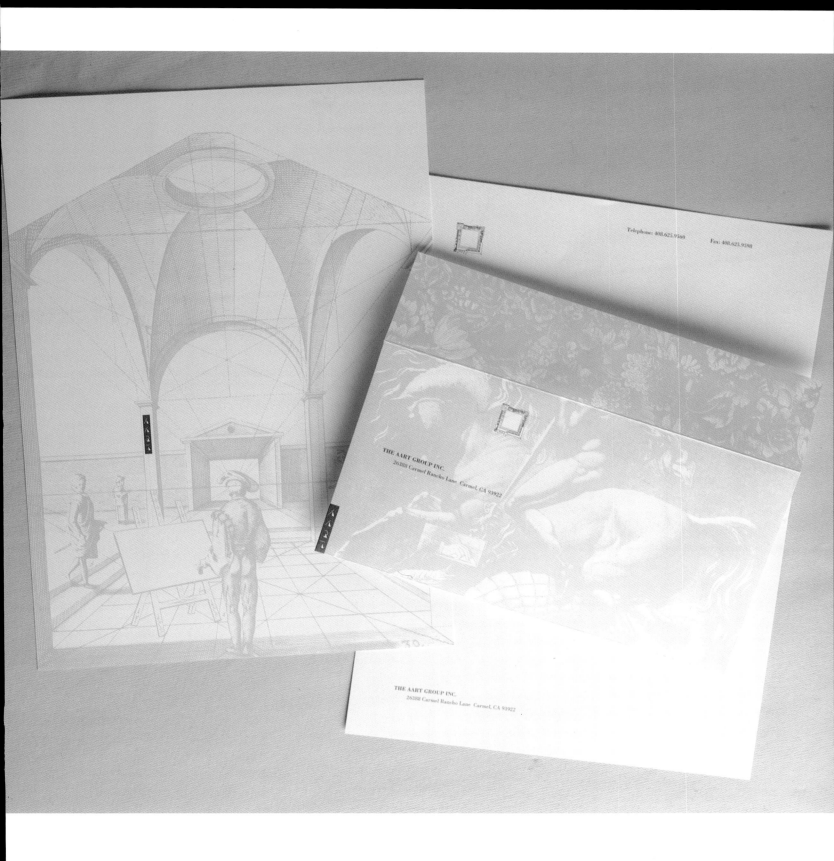

DESIGN FIRM Sackett Design Associates
ART DIRECTOR/DESIGNER Mark Sackett
ILLUSTRATOR Chris Yaryan
CLIENT The AART Group
PAPER/PRINTING Simpson Starwhite Vicksburg 80 lb. text,
offset lithography, black and one match color

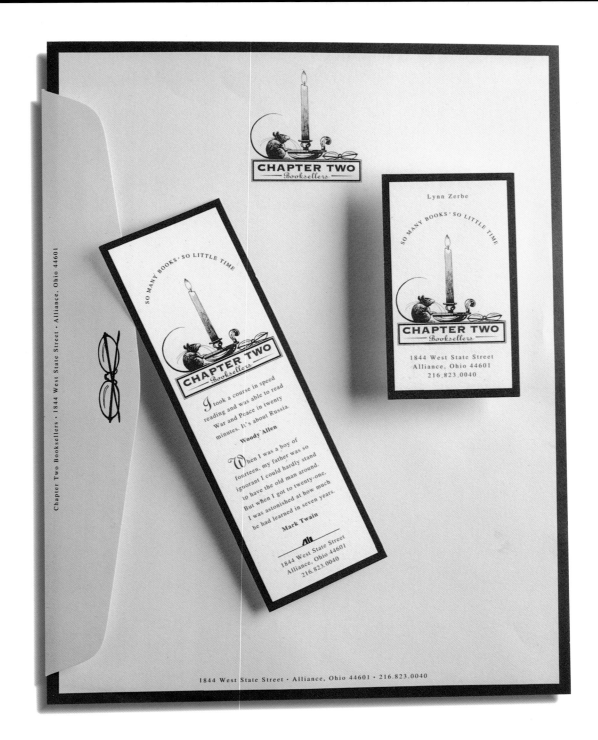

Design Firm THARP DID IT
Art Director Rick Tharp
Designers Rick Tharp, Laurie Carberry
Illustrator Susan Jaekel
Client Chapter Two Booksellers
Paper/Printing Simpson Evergreen Recycled, two match colors, offset lithography

The illustration was rendered by hand and scanned into the computer. The art and type was lino output, and traditional mechanicals were produced for all print materials.

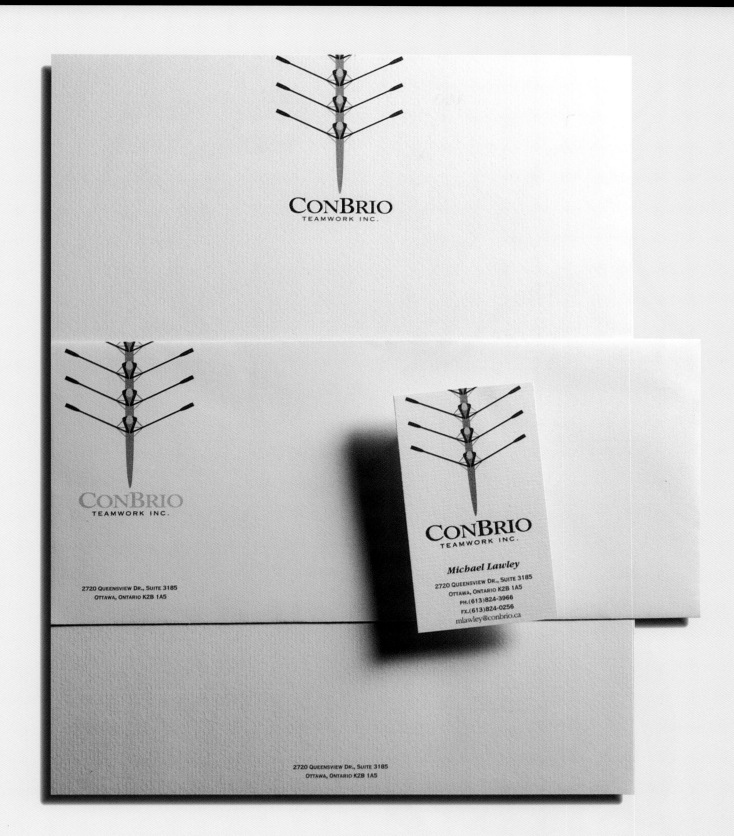

DESIGN FIRM S.A. Design Group

ALL DESIGN Daniel Rogall

CLIENT ConBrio Teamwork Inc.

PAPER/PRINTING Circa '83 Nantucket Grey, one PMS color
and silver foil

This client wanted a memorable image representing teamwork.
Since the client was concerned about the cost of a foil stamp, the
silver foil was reproduced using a tint of the PMS color.

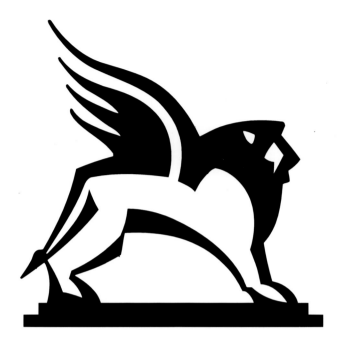

DESIGN FIRM Greteman Group
ART DIRECTOR/DESIGNER Sonia Greteman
CLIENT City of Wichita

This logo is for a community program. The lion with wing represents community courage with leadership.

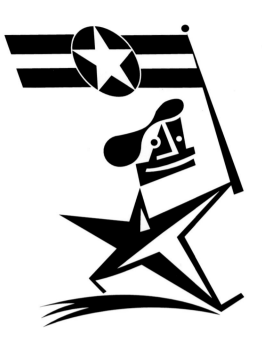

DESIGN FIRM John Evans Design
ALL DESIGN John Evans
CLIENT N.E. Waz
TOOL Adobe Illustrator

This series of symbols was developed for a line of T-shirts produced by a new clothing manufacturer. The themes were golf, fishing, basketball, and Americana.

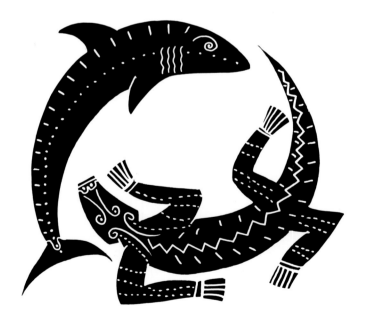

DESIGN FIRM Cato Design Inc.
DESIGNER Cato Design Inc.
CLIENT Hyatt Regency Surabaya

This Indonesian hotel was conceived as a "wealthy western mansion" that displayed national artifacts. The identity had to appeal to local residents and tourists. The final logo was hand drawn.

'NiGHT LOUiE

DESIGN FIRM Swieter Design U.S.
ART DIRECTOR John Swieter
DESIGNER Kevin Flatt
CLIENT Night Louie Jazz Band
TOOL Adobe Illustrator

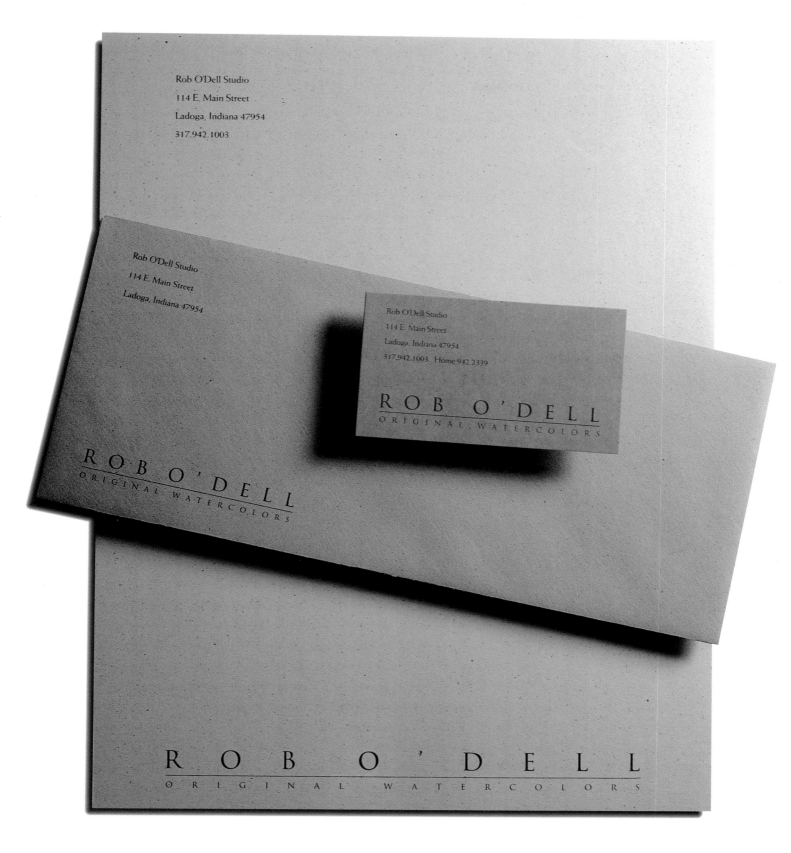

DESIGN FIRM Kelly O. Stanley Design
ART DIRECTOR/DESIGNER Kelly O'Dell Stanley
CLIENT Rob O'Dell
PAPER/PRINTING Simpson Quest
TOOL QuarkXPress

Since the project was limited to 1-color, color was brought into
the identity pieces by using three different colors of paper—col-
ors found throughout the client's work.

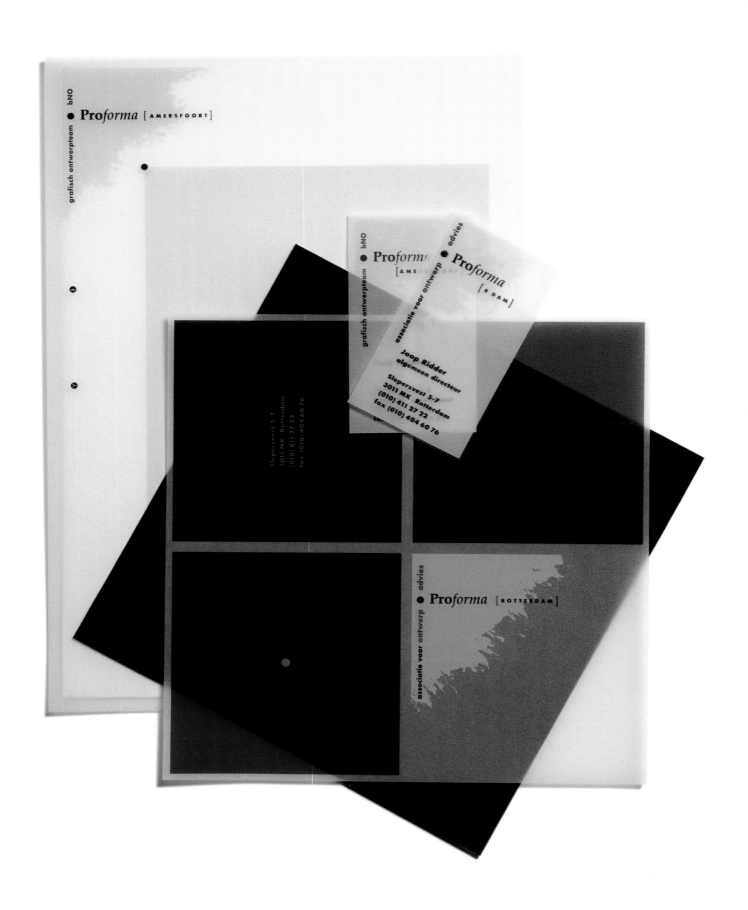

DESIGN FIRM	Proforma Rotterdam
ART DIRECTOR	Aadvan Dommelen
DESIGNER	Gert Jan Rooijakkers
CLIENT	Proforma
PAPER/PRINTING	Calque

The Best of Letterhead and Logo Design

Ron Kellum Inc. 151 First Avenue PH-1 NY, NY 10003

Telephone: 212-979-2661 Fax/Modem: 212-260-3525

Ron Kellum

Ron Kellum Inc.
151 First Ave. PH-1 NewYork, NY 10003
Tel: 212-979-2661 Fax: 212-260-3525

Ron Kellum Inc. 151 First Ave. PH-1 NY, NY 10003

DESIGN FIRM	Ron Kellum Inc.
ART DIRECTOR	Ron Kellum
DESIGNER	Ron Kellum
ILLUSTRATOR	Ron Kellum Inc.
PAPER/PRINTING	Strathmore Writing

DESIGN FIRM	38 North
ART DIRECTOR	Nida Zada
CLIENT	38 North
PAPER/PRINTING	4 colors

DESIGN FIRM	Musikar Design
ART DIRECTOR	Sharon R. Musikar
DESIGNER	Sharon R. Musikar
PHOTOGRAPHER	Sharon R. Musikar
CLIENT	Musikar Design
PAPER/PRINTING	Classic Crest, 2 colors

DESIGN FIRM	Bartels & Company, Inc.
ART DIRECTOR	David Bartels
DESIGNER	Brian Barclay
ILLUSTRATOR	Brian Barclay
CLIENT	Bartels & Company, Inc.

DESIGN FIRM	Cisneros Design
ART DIRECTOR	Fred Cisneros
DESIGNER	Fred Cisneros
CLIENT	Cisneros Design
PAPER/PRINTING	Classic Crest

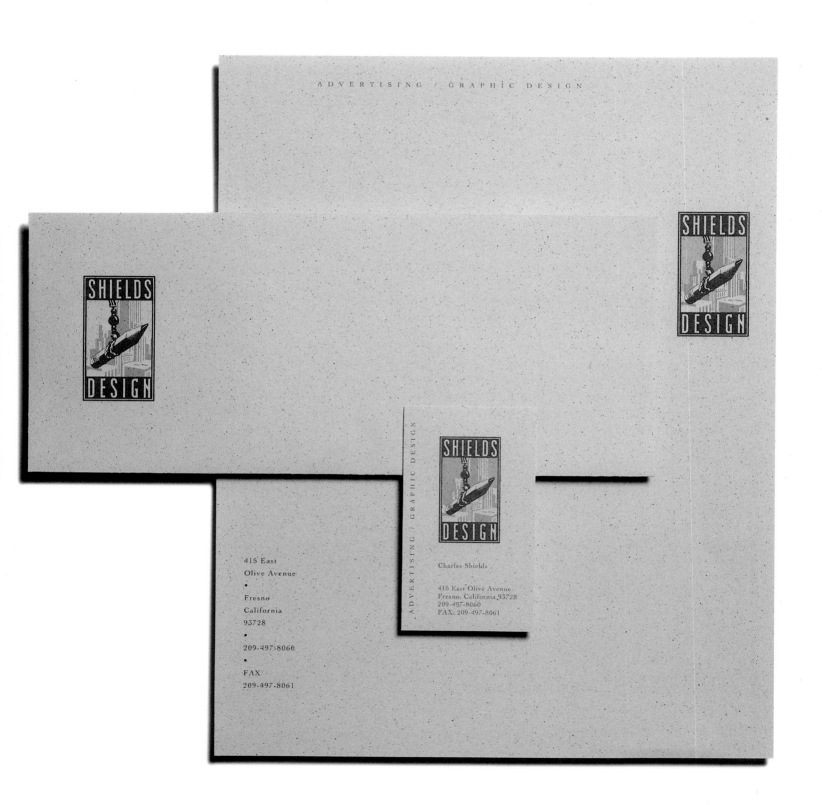

DESIGN FIRM Shields Design
ART DIRECTOR Charles Shields
DESIGNER Charles Shields
CLIENT Shields Design
PAPER/PRINTING Simpson Quest

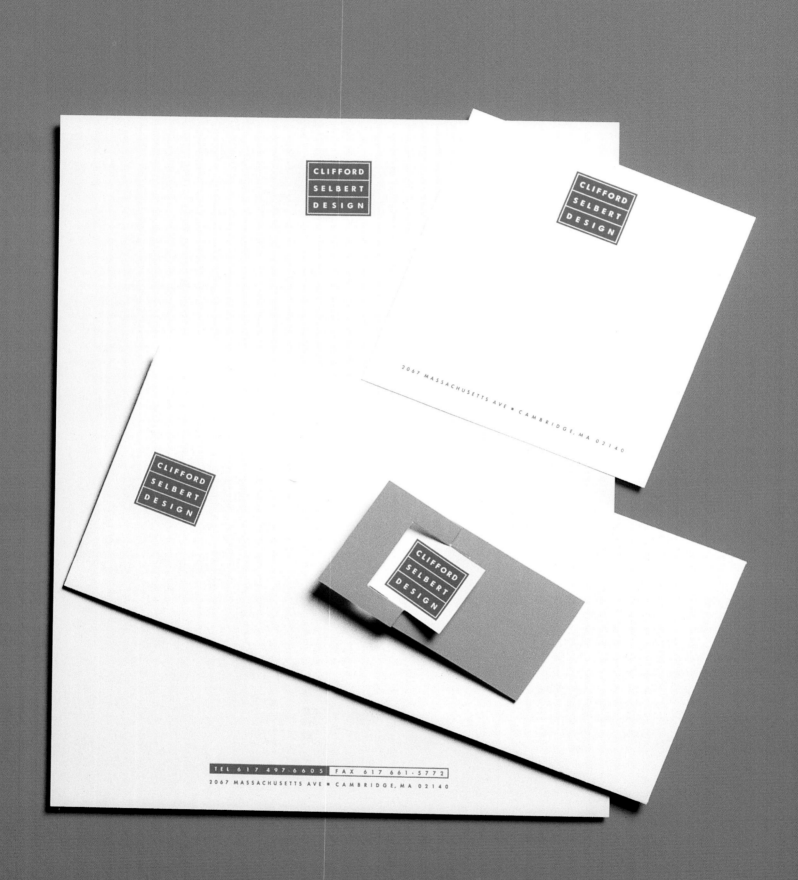

DESIGN FIRM	Clifford Selbert Design
ART DIRECTOR	Clifford Selbert, Melanie Lowe
DESIGNER	Melanie Lowe
CLIENT	Clifford Selbert Design
PAPER/PRINTING	Strathmore

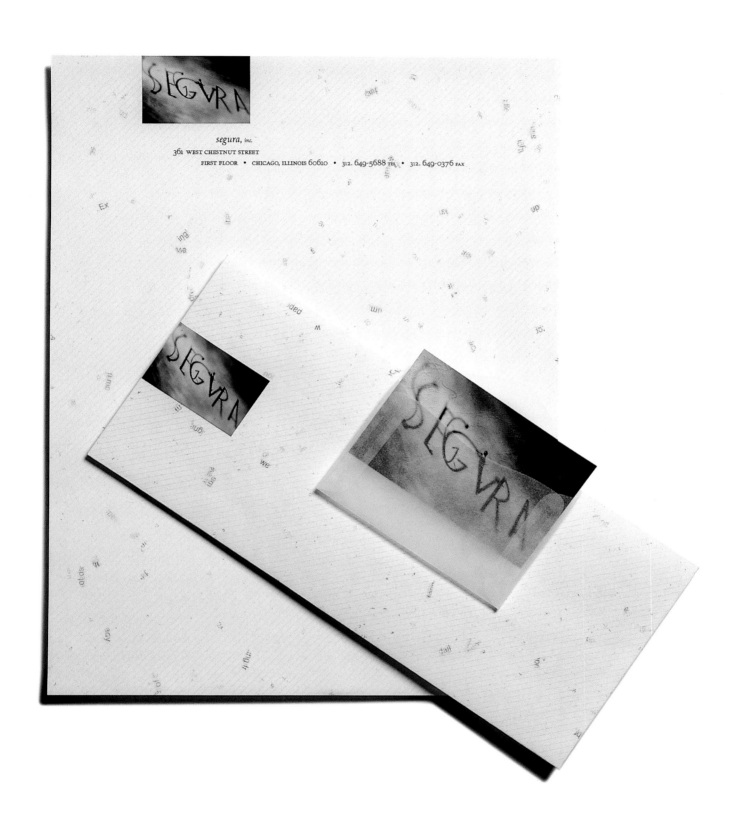

DESIGN FIRM	Segura Inc.
ART DIRECTOR	Carlos Segura
DESIGNER	Carlos Segura
ILLUSTRATOR	Greg Heck
CLIENT	Segura Inc.
PAPER/PRINTING	Wagner

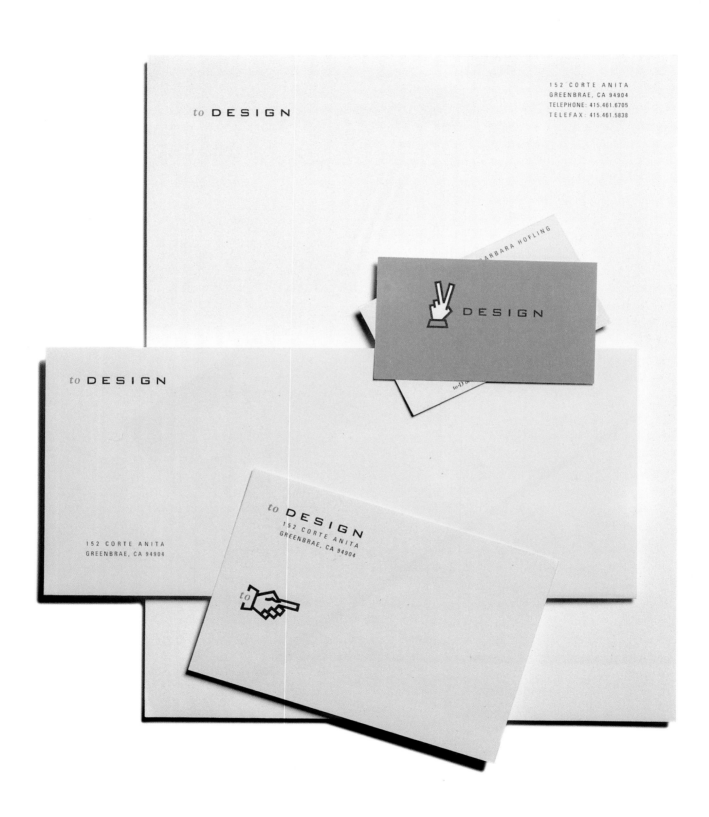

DESIGN FIRM	THARP DID IT
DESIGNER	Rick Tharp, Jean Mogannam
CLIENT	to DESIGN/Barbara Hofling
PAPER/PRINTING	Neenah Paper

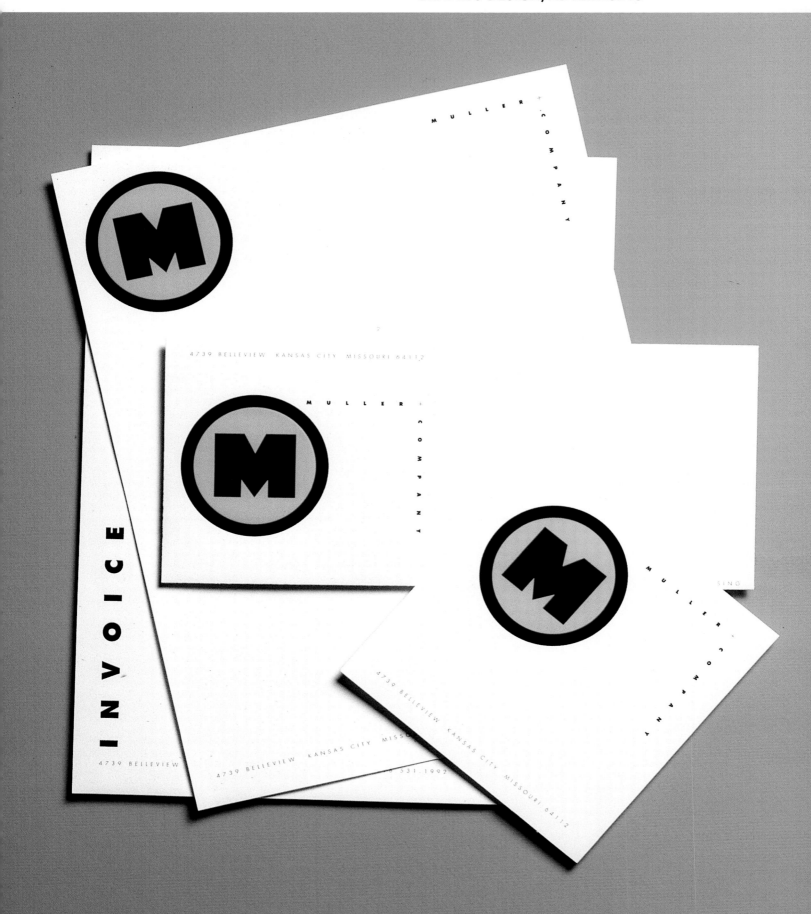

DESIGN FIRM Muller + Company
ART DIRECTOR John Muller
DESIGNER John Muller
CLIENT Muller + Company
PAPER/PRINTING Proterra Chalk Vellum

DESIGN FIRM	Cactus Design
ART DIRECTOR	Susan Hankoff-Estrella
DESIGNER	Susan Hankoff-Estrella
ILLUSTRATOR	Theo Camut
CLIENT	Cactus Design
PAPER/PRINTING	Strathmore Renewal, Chamois

DESIGN FIRM	Jeff Shelly
ILLUSTRATOR	Jeff Shelly
CLIENT	Jeff Shelly

DESIGN FIRM	M. Renner Design
ART DIRECTOR	Michael Renner
DESIGNER	Michael Renner
ILLUSTRATOR	Michael Renner
CLIENT	Studio Pignatelli

DESIGN FIRM	Blue Sky Design
ART DIRECTOR	Bob Little, Joanne Little,
	Maria Dominguez
CLIENT	Blue Sky Design
PAPER/PRINTING	Crane's Crest Fluorescent White

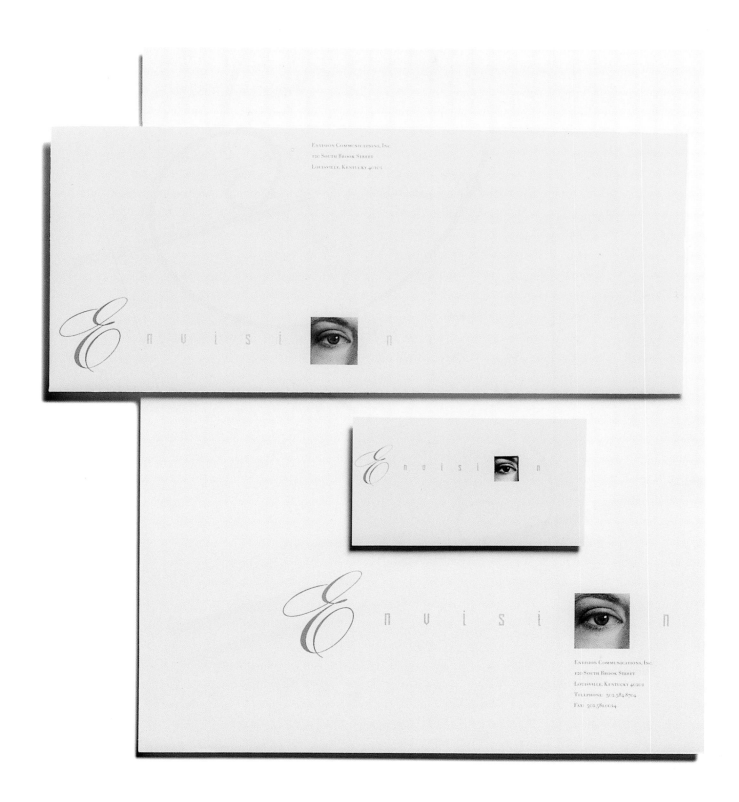

DESIGN FIRM	Envision
ART DIRECTOR	Julia Comer, Walter McCord
DESIGNER	Julia Comer, Walter McCord
ILLUSTRATOR	Julia Comer, Walter McCord
CLIENT	Envision
PAPER/PRINTING	Strathmore Alexandra Brilliant, 3 colors

DESIGN FIRM	Studio Michael
ART DIRECTOR	Michael Esordi
DESIGNER	Michael Esordi
ILLUSTRATOR	Michael Esordi
CLIENT	Studio Michael
PAPER/PRINTING	Classic Crest, UV Vellum

DESIGN FIRM	Randy McCafferty
DESIGNER	Randy McCafferty
ILLUSTRATOR	Randy McCafferty
CLIENT	Randy McCafferty
PAPER/PRINTING	Speckletone

DESIGN FIRM	Elizabeth Resnick Design
ART DIRECTOR	Elizabeth Resnick
DESIGNER	Elizabeth Resnick
CLIENT	Elizabeth Resnick Graphic Design
PAPER/PRINTING	Strathmore Writing, embossed flourescent, offset dark green

DESIGN FIRM	Heart Graphic Design
ART DIRECTOR	Clark Most
DESIGNER	Clark Most
CLIENT	Heart Graphic Design
PAPER/PRINTING	Benefit Natural Flax

DESIGN FIRM	Puccinelli Design
ART DIRECTOR	Keith Puccinelli
DESIGNER	Keith Puccinelli, Heidi Palladino
ILLUSTRATOR	Keith Puccinelli
CLIENT	Puccinelli Design
PAPER/PRINTING	Gilbert Neo

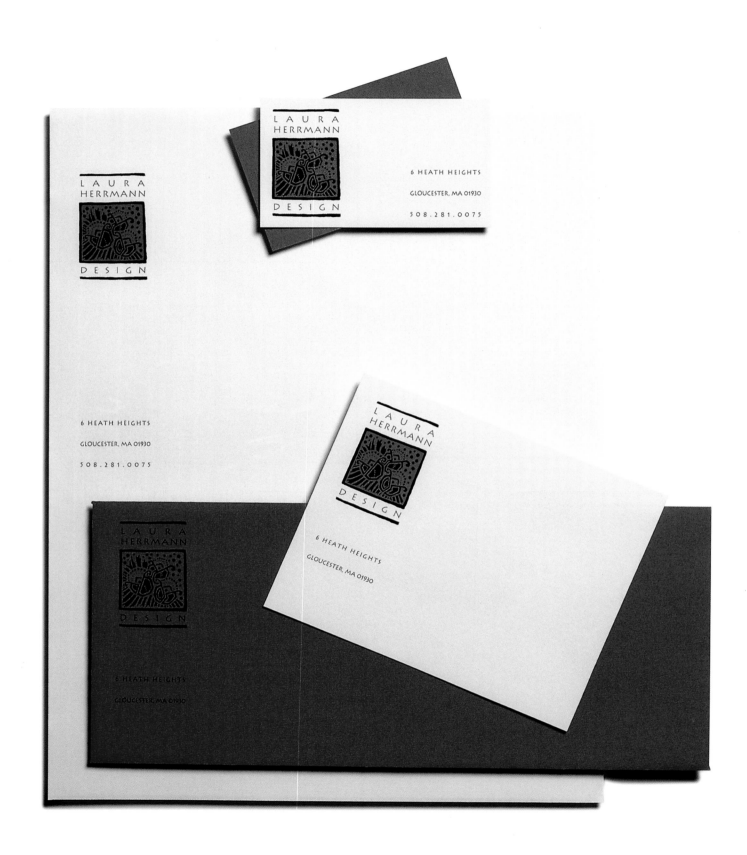

DESIGN FIRM	Laura Herrmann Design
ART DIRECTOR	Laura Herrmann
DESIGNER	Laura Herrmann
CLIENT	Laura Herrmann Design
PAPER/PRINTING	Classic Linen, Writing and Duplex

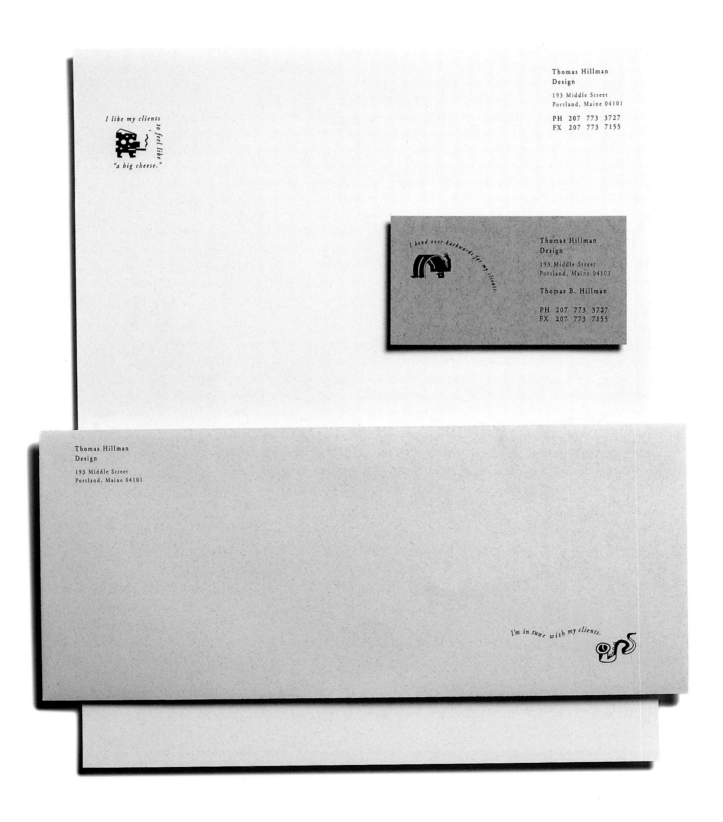

I like my clients
to feel like
"a big cheese."

Thomas Hillman
Design

193 Middle Street
Portland, Maine 04101

PH 207 773 3727
FX 207 773 7155

I bend over backwards for my clients.

Thomas Hillman
Design

193 Middle Street
Portland, Maine 04101

Thomas B. Hillman

PH 207 773 3727
FX 207 773 7155

Thomas Hillman
Design

193 Middle Street
Portland, Maine 04101

I'm in tune with my clients.

DESIGN FIRM	Thomas Hillman Design
ART DIRECTOR	Thomas Hillman
DESIGNER	Thomas Hillman
ILLUSTRATOR	Bob Aufuzdish, Eric Donelan
CLIENT	Thomas Hillman Design
PAPER/PRINTING	Neenah Environment

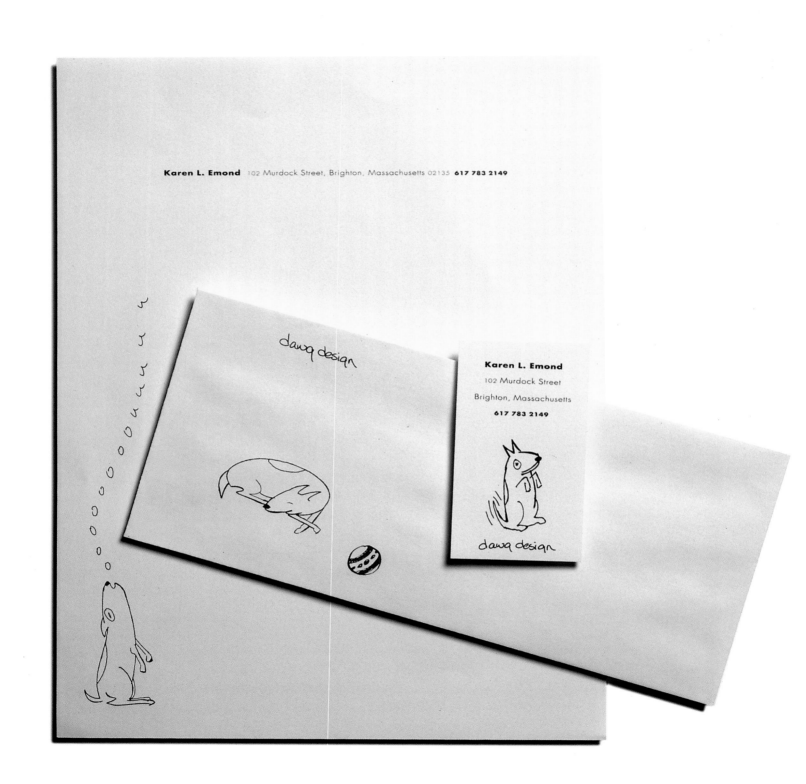

Karen L. Emond 102 Murdock Street, Brighton, Massachusetts 02135 **617 783 2149**

dawg design

Karen L. Emond
102 Murdock Street
Brighton, Massachusetts
617 783 2149

dawg design

DESIGN FIRM	Hawley & Armian Marketing/Design
DESIGNER	Karen Emond
CLIENT	Dawg Design
PAPER/PRINTING	Strathmore Writing

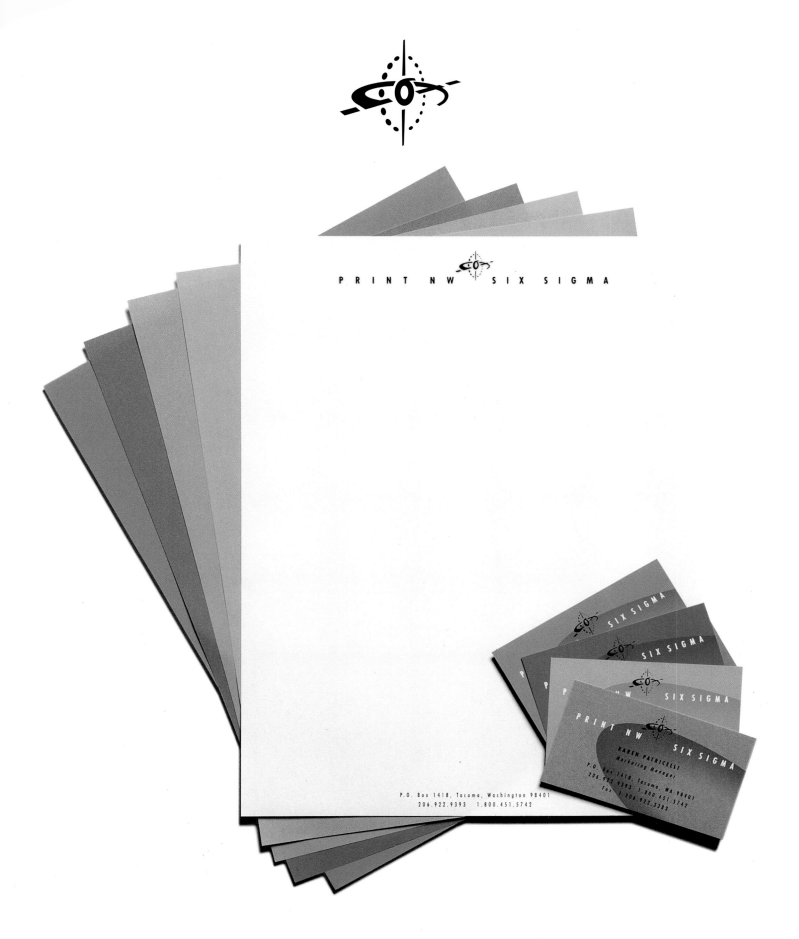

PRINT NW ✦ SIX SIGMA

P.O. Box 1418, Tacoma, Washington 98401
206.922.9393 1.800.451.5742

DESIGN FIRM	Hornall Anderson Design Works
ART DIRECTOR	Jack Anderson
DESIGNER	Jack Anderson, Heidi Hatlestad, Mary Hutchinson, Bruce Branson-Meyer
ILLUSTRATOR	Scott McDougall
CLIENT	Print NW/Six Sigma
PAPER/PRINTING	Neenah Classic Crest Recycled

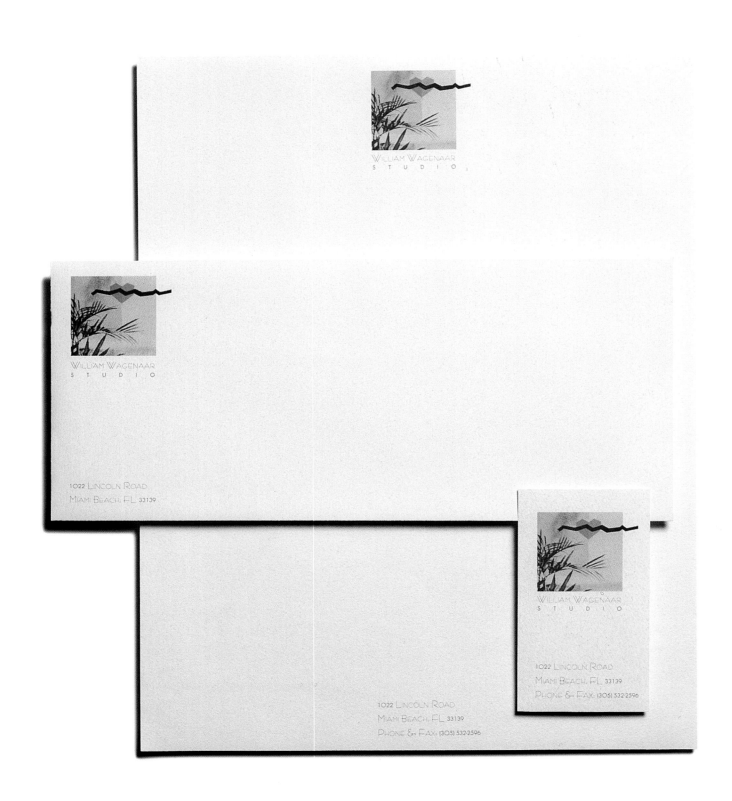

DESIGN FIRM	Dewitt Kendall – Chicago
ART DIRECTOR	Dewitt Kendall
DESIGNER	Dewitt Kendall
ILLUSTRATOR	Dewitt Kendall
CLIENT	William Wagenaar Studios
PAPER/PRINTING	Passport

MIKE HERNACKI
Mystery Writer

2757 STATE STREET
SAN DIEGO, CA 92103

619 542 0902
FAX 297 8895

2757 STATE STREET
SAN DIEGO, CA 92103

DESIGN FIRM	Linnea Gruber Design
ART DIRECTOR	Linnea Gruber
DESIGNER	Linnea Gruber
CLIENT	Mike Hernacki
PAPER/PRINTING	Speckletone, die-cut, embossed

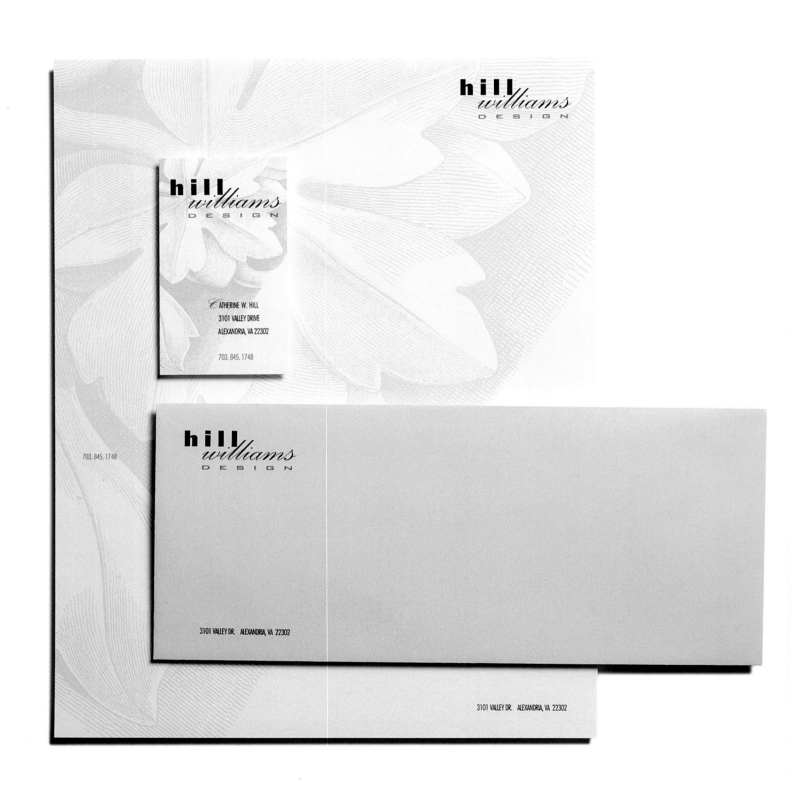

DESIGN FIRM	Barbara Raab Design
ART DIRECTOR	Barbara Raab Sgouros
DESIGNER	Lee Ann Rhodes
CLIENT	Hill Williams Design
PAPER/PRINTING	Classic Crest, 2 colors

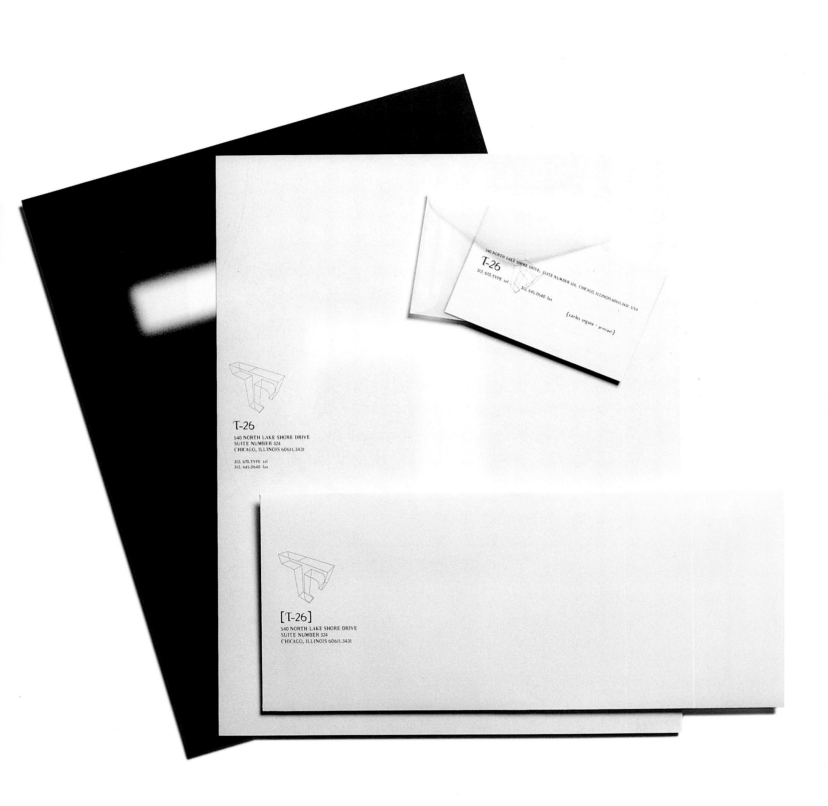

DESIGN FIRM	Segura Inc.
ART DIRECTOR	Carlos Segura
DESIGNER	Carlos Segura
ILLUSTRATOR	Carlos Segura
CLIENT	T-26
PAPER/PRINTING	Argus

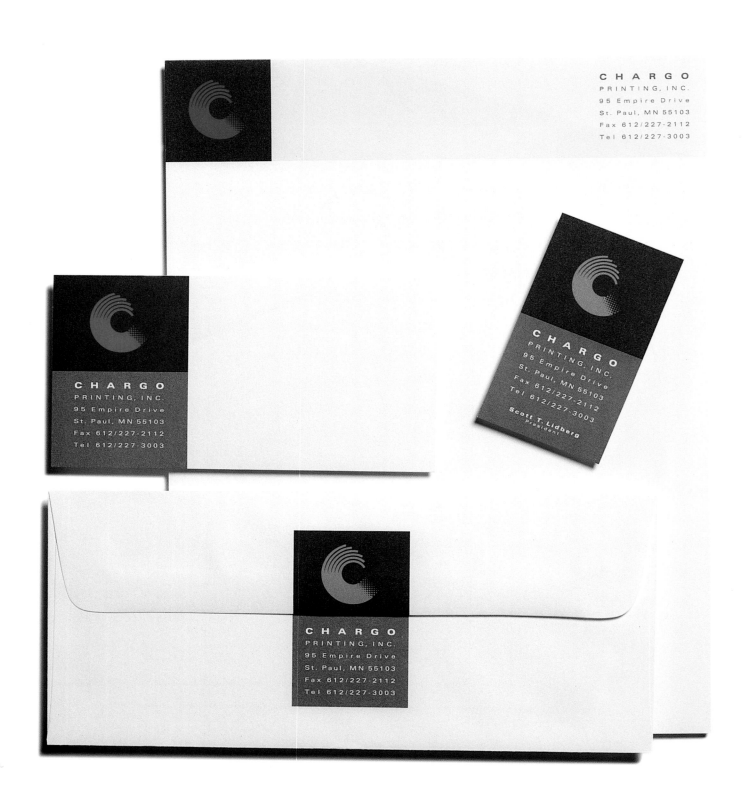

DESIGN FIRM	GrandPré and Whaley, Ltd.
ART DIRECTOR	Kevin Whaley
DESIGNER	Kevin Whaley
CLIENT	Chargo Printing, Inc.
PAPER/PRINTING	Strathmore

DESIGN FIRM Lorna Stovall Design
ART DIRECTOR Lorna Stovall
DESIGNER Lorna Stovall
CLIENT Printology
PAPER/PRINTING Simpson Evergreen

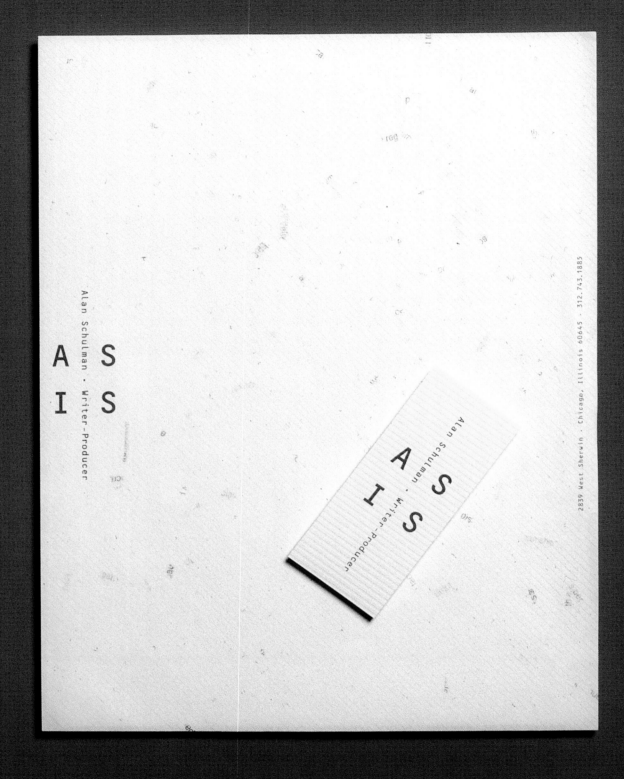

DESIGN FIRM Segura Inc.
ART DIRECTOR Carlos Segura
DESIGNER Carlos Segura
CLIENT Shulman

DESIGN FIRM	The Green House
ART DIRECTOR	Brian Green
DESIGNER	Brian Green
ILLUSTRATOR	Colin Mechan
CLIENT	Berkeley
PAPER/PRINTING	4 colors

DESIGN FIRM	Bartels & Company, Inc.
ART DIRECTOR	David Bartels
DESIGNER	Brian Barclay
ILLUSTRATOR	Brian Barclay
CLIENT	Wordsworth Typography

DESIGN FIRM	Patri-Keker Design
DESIGNER	Bobby Patri
CLIENT	Beth Clements-Gutcheon
PAPER/PRINTING	Evergreen cottonwood script

DESIGN FIRM	Nora Robbins
ART DIRECTOR	Nora Robbins
DESIGNER	Nora Robbins
CLIENT	Insight/Leslie Larocca
PAPER/PRINTING	Fox River Confetti/Kaliedascope

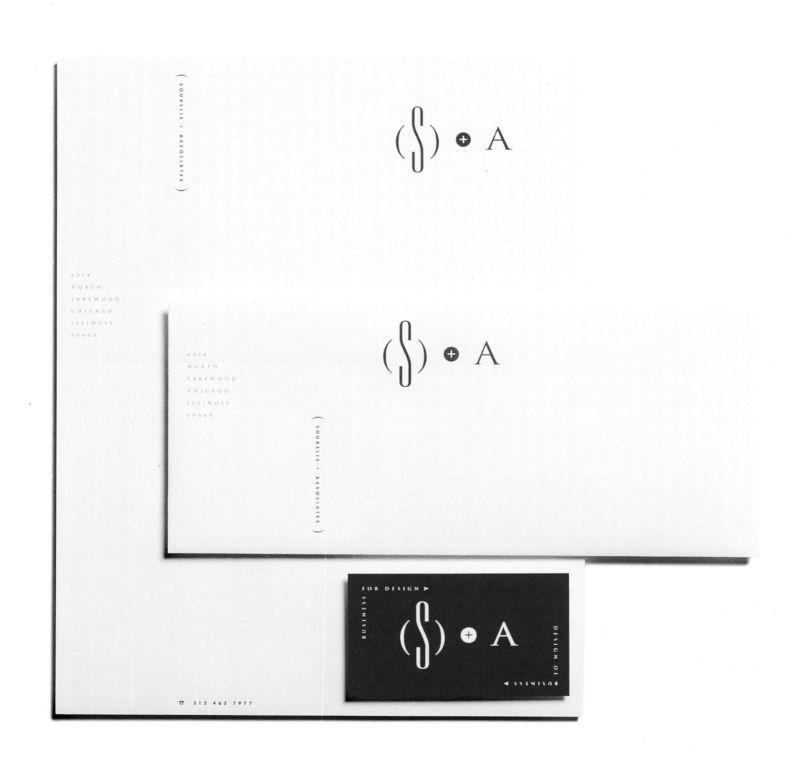

DESIGN FIRM	Mark Oldach Design
ART DIRECTOR	Mark Oldach
DESIGNER	Mark Oldach
CLIENT	Sourelis & Associates
PAPER/PRINTING	Neenah Classic Crest

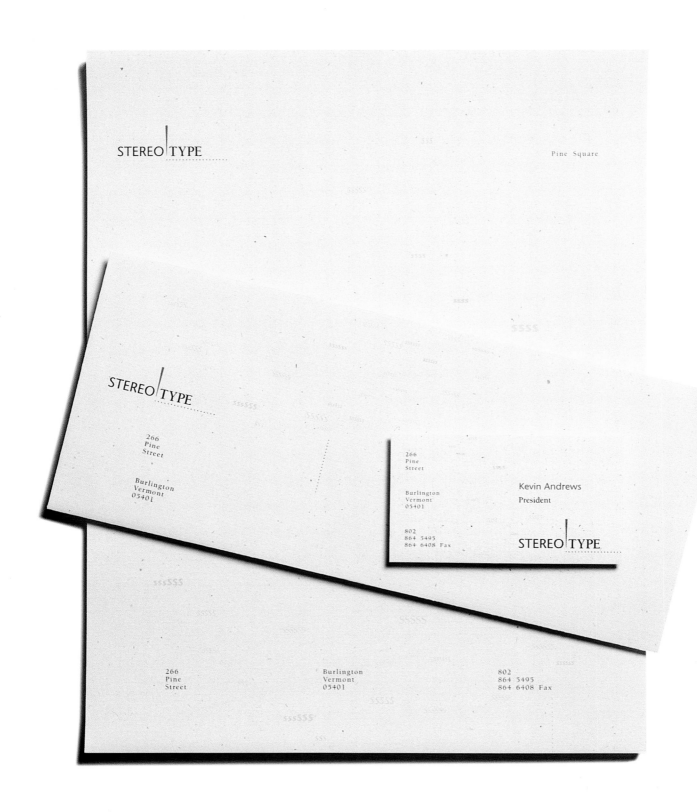

DESIGN FIRM Creative EDGE
DESIGNER Rick Salzman, Barbara Pitfido
CLIENT Stereo Type
PAPER/PRINTING Classic Laid

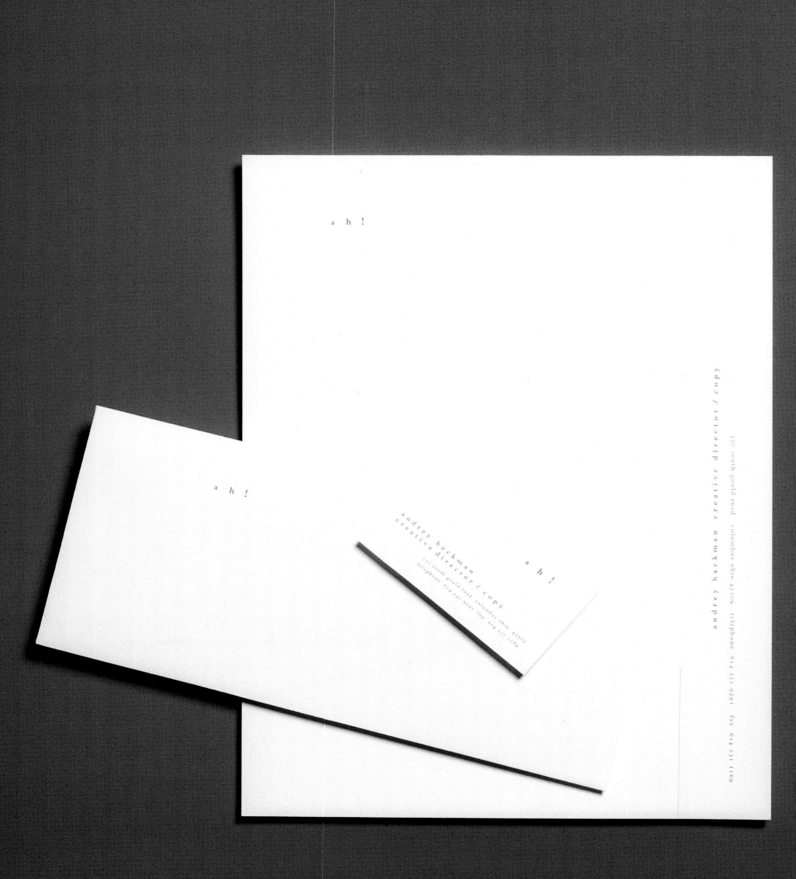

DESIGN FIRM	Schmeltz & Warren
ART DIRECTOR	Crit Warren
DESIGNER	Crit Warren
CLIENT	"Ah!" — Audrey Hackman
PAPER/PRINTING	Protocol

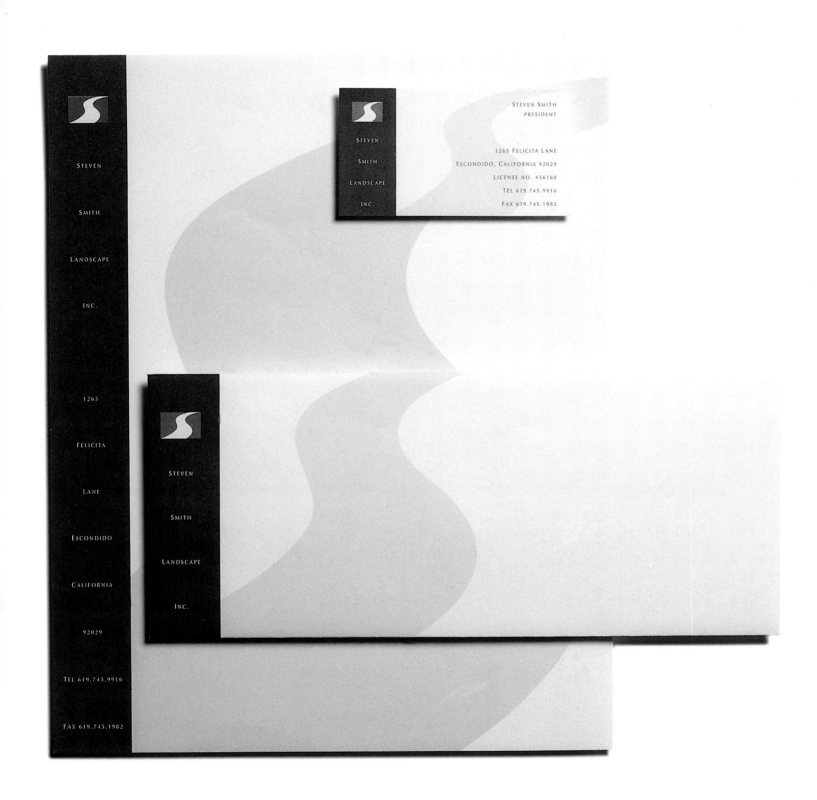

DESIGN FIRM	Beauchamp Design
ART DIRECTOR	Michele Beauchamp
DESIGNER	Michele Beauchamp
CLIENT	Steve Smith Landscape Inc.
PAPER/PRINTING	Evergreen

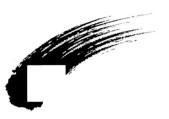

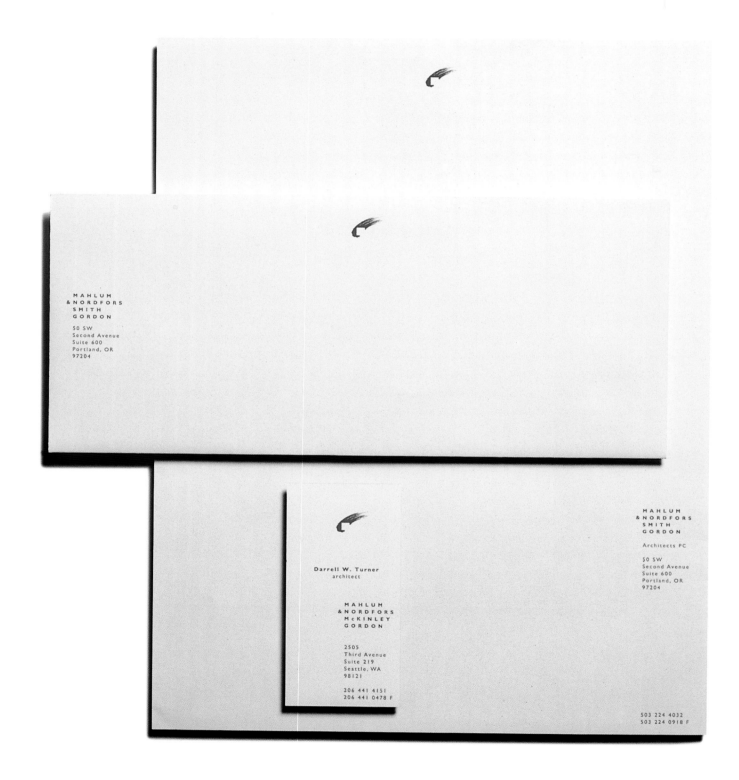

MAHLUM
& NORDFORS
SMITH
GORDON

50 SW
Second Avenue
Suite 600
Portland, OR
97204

Darrell W. Turner
architect

MAHLUM
& NORDFORS
McKINLEY
GORDON

2505
Third Avenue
Suite 219
Seattle, WA
98121

206 441 4151
206 441 0478 F

MAHLUM
& NORDFORS
SMITH
GORDON

Architects PC

50 SW
Second Avenue
Suite 600
Portland, OR
97204

503 224 4032
503 224 0918 F

DESIGN FIRM	Hornall Anderson Design Works
ART DIRECTOR	Jack Anderson
DESIGNER	Jack Anderson, Scott Eggers, Leo Raymundo
CLIENT	Mahlum & Nordfors McKinley Gordon
PAPER/PRINTING	Monadnock Astro Lite, embossed

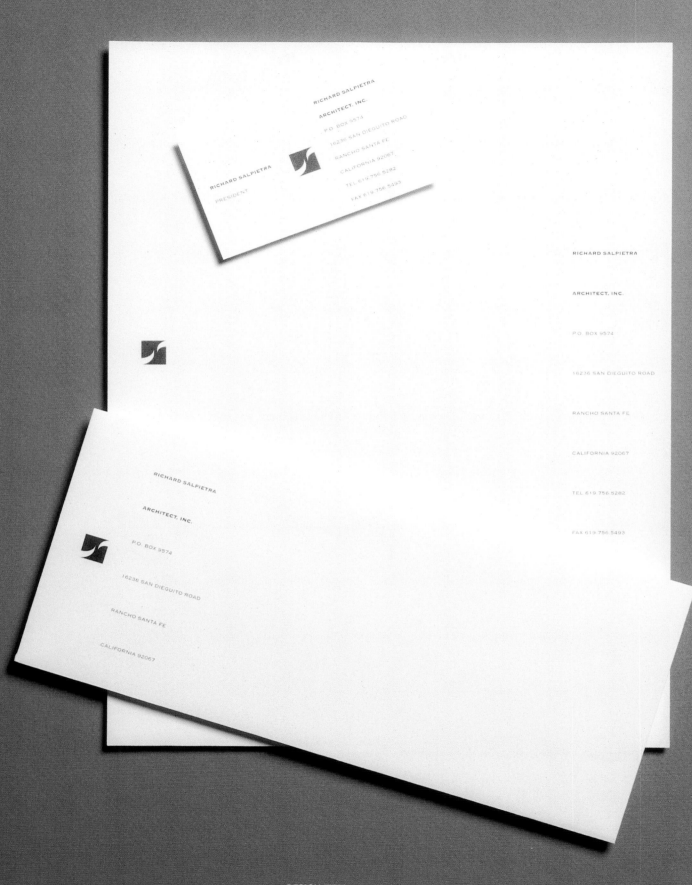

DESIGN FIRM	Beauchamp Design
ART DIRECTOR	Michele Beauchamp
DESIGNER	Michele Beauchamp
CLIENT	Richard Salpietra Architect, Inc.
PAPER/PRINTING	Classic Crest

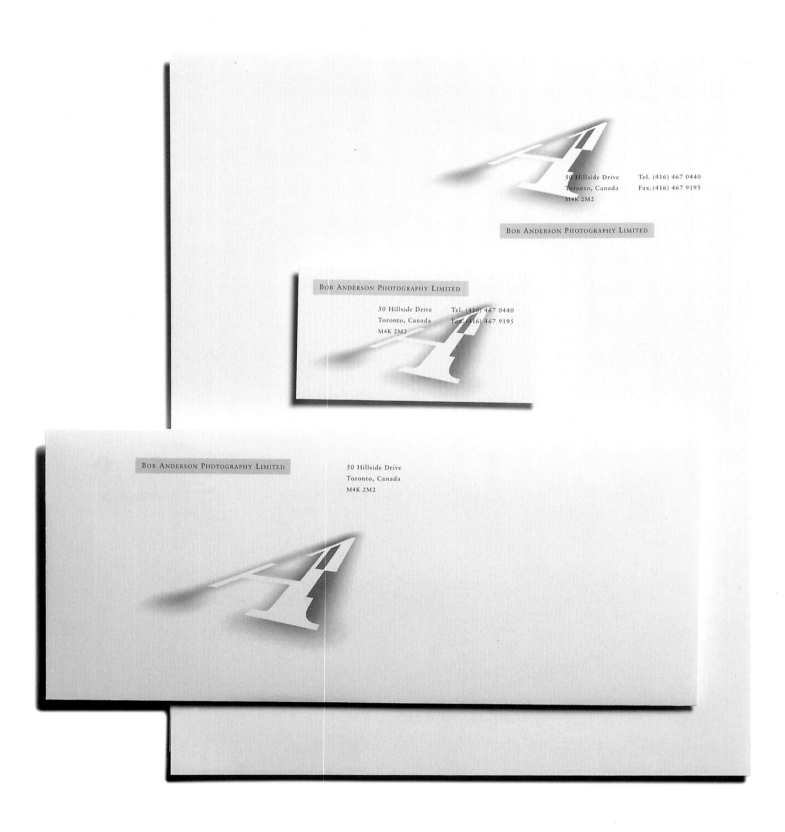

DESIGN FIRM	Eskind Waddell
ART DIRECTOR	Malcolm Waddell
DESIGNER	Nicola Lyon
CLIENT	Bob Anderson Photography Ltd.
PAPER/PRINTING	Strathmore Script

DESIGN FIRM	Choplogic
ART DIRECTOR	Walter McCord, Mary Cawein
DESIGNER	Walter McCord, Mary Cawein
ILLUSTRATOR	Walter McCord, Mary Cawein
CLIENT	Argabrite Architects
PAPER/PRINTING	Monadnock, 1 color

DESIGN FIRM	William Field Design
ART DIRECTOR	Willy Field
DESIGNER	Willy Field
ILLUSTRATOR	Peter Marquez
CLIENT	Turner, Marquez & Romero
PAPER/PRINTING	Environment

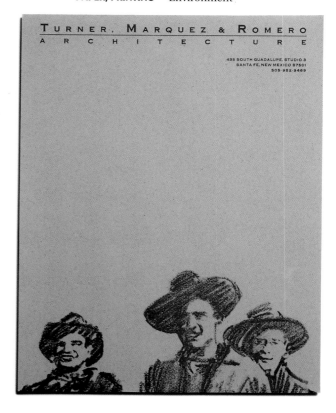

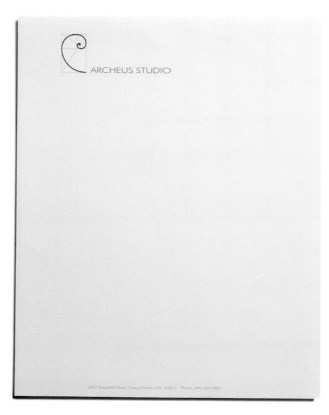

DESIGN FIRM	Musikar Design
ART DIRECTOR	Sharon R. Musikar
DESIGNER	Sharon R. Musikar, Lynn Iadarola
ILLUSTRATOR	Sharon R. Musikar
CLIENT	Archeus Studio
PAPER/PRINTING	Gilbert Writing, 2 colors

DESIGN FIRM	Bartels & Company, Inc.
ART DIRECTOR	David Bartels
DESIGNER	Mark Illig
ILLUSTRATOR	Mark Illig
CLIENT	The Lawrence Group

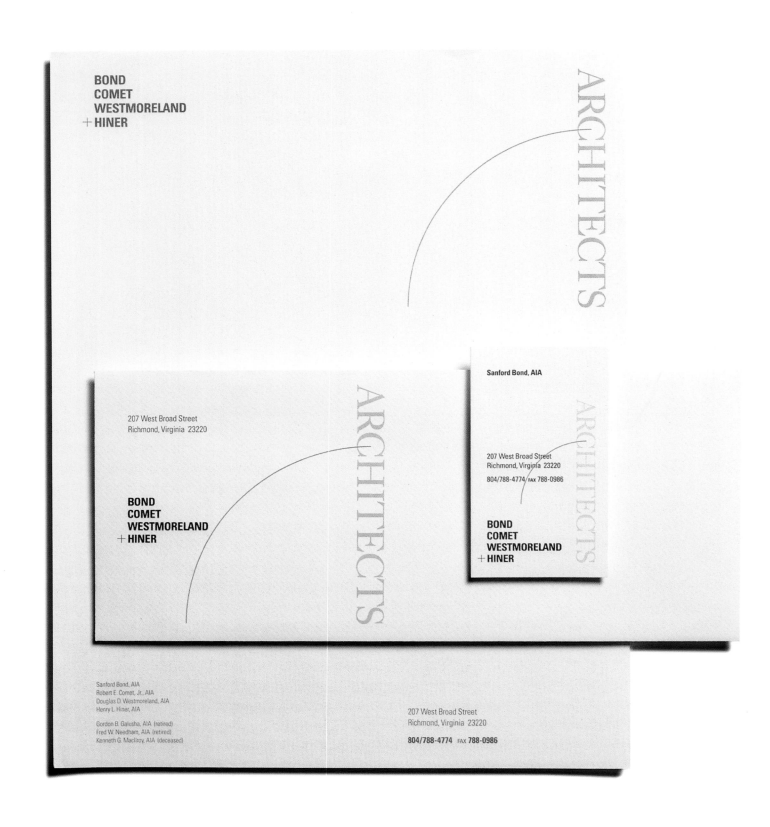

DESIGN FIRM Communication Design, Inc.
ART DIRECTOR Robert Meganck
DESIGNER Tim Priddy, Bil Cullen
CLIENT Bond Comet Westmoreland & Hiner Architects
PAPER/PRINTING Dillard

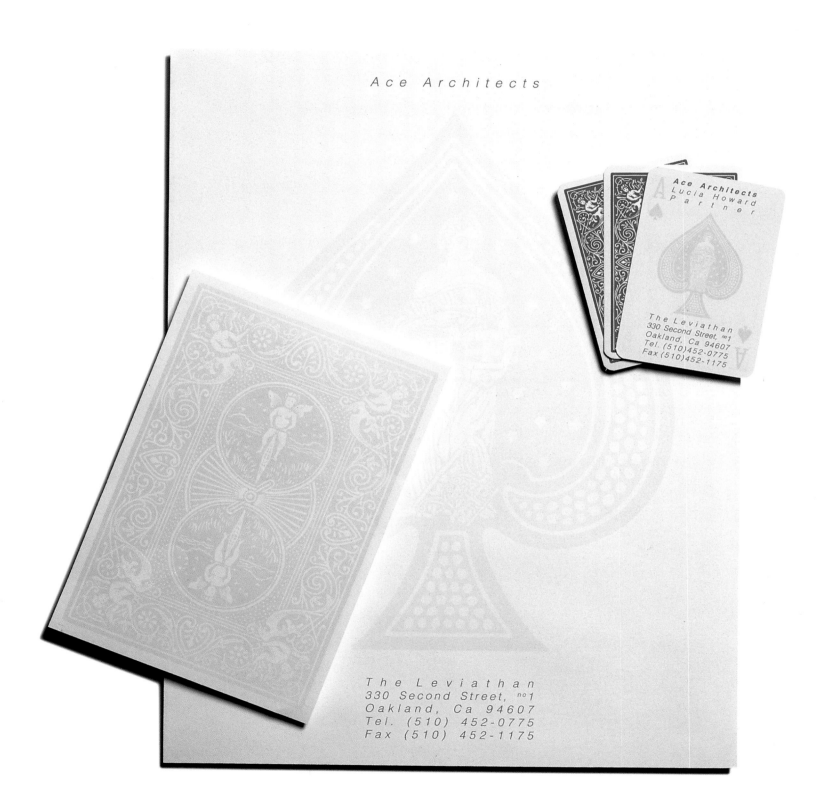

DESIGN FIRM	Ace Architects by Judith Oaus
ILLUSTRATOR	Judith Oaus
CLIENT	Ace Architects
PAPER/PRINTING	Ampersand

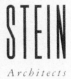

DESIGN FIRM	Clifford Selbert Design
ART DIRECTOR	Clifford Selbert, Robin Perkins
DESIGNER	Robin Perkins
CLIENT	Stein Architects
PAPER/PRINTING	Strathmore Starwhite Vicksburg, 3 colors

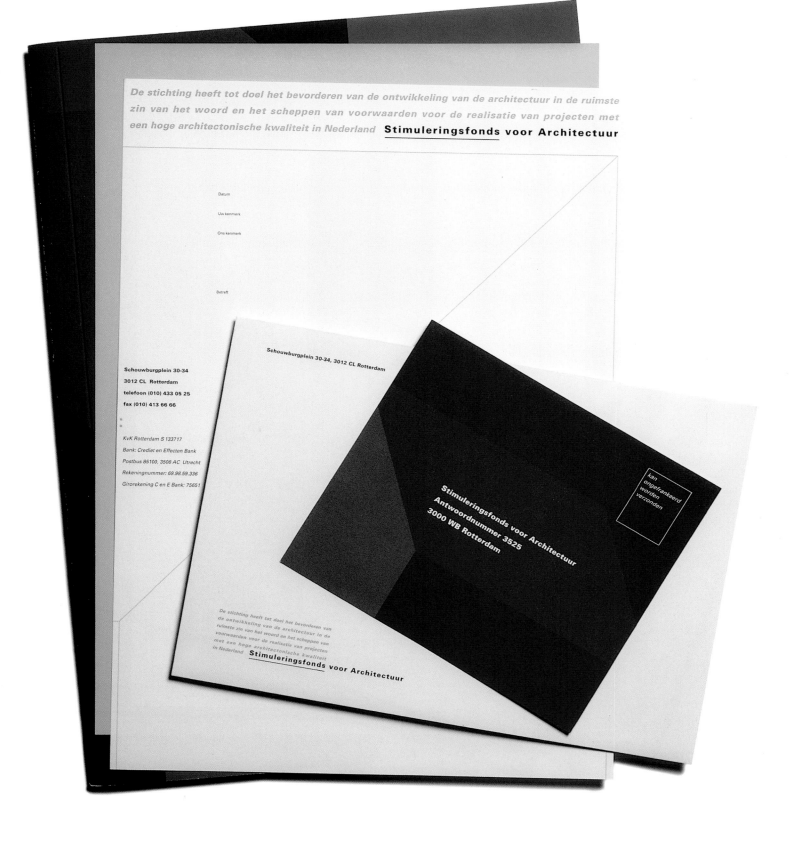

De stichting heeft tot doel het bevorderen van de ontwikkeling van de architectuur in de ruimste zin van het woord en het scheppen van voorwaarden voor de realisatie van projecten met een hoge architectonische kwaliteit in Nederland **Stimuleringsfonds** voor Architectuur

Datum

Uw kenmerk

Ons kenmerk

Betreft

Schouwburgplein 30-34
3012 CL Rotterdam
telefoon (010) 433 05 25
fax (010) 413 66 66

KvK Rotterdam S 133717
Bank: Crediet en Effecten Bank
Postbus 85100, 3508 AC Utrecht
Rekeningnummer: 69.98.59.336
Girorekening C en E Bank: 75651

Schouwburgplein 30-34, 3012 CL Rotterdam

De stichting heeft tot doel het bevorderen van de ontwikkeling van de architectuur in de ruimste zin van het woord en het scheppen van voorwaarden voor de realisatie van projecten met een hoge architectonische kwaliteit in Nederland **Stimuleringsfonds** voor Architectuur

Stimuleringsfonds voor Architectuur
Antwoordnummer 3525
3000 WB Rotterdam

kan ongefrankeerd worden verzonden

DESIGN FIRM	Proforma Rotterdam
DESIGNER	Ciaran O'Gaora
CLIENT	Stimuleringsfonds voor Architectuur
PAPER/PRINTING	Strathmore Writing Wove

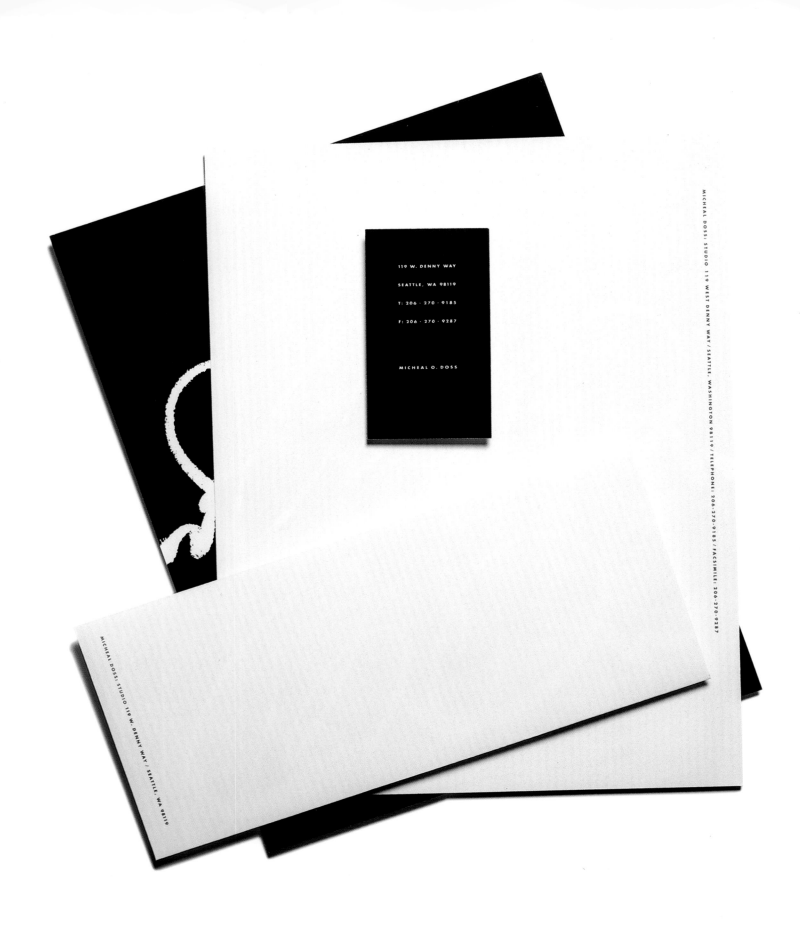

DESIGN FIRM	Hornall Anderson Design Works
ART DIRECTOR	Jack Anderson
DESIGNER	Jack Anderson
CLIENT	Micheal Doss

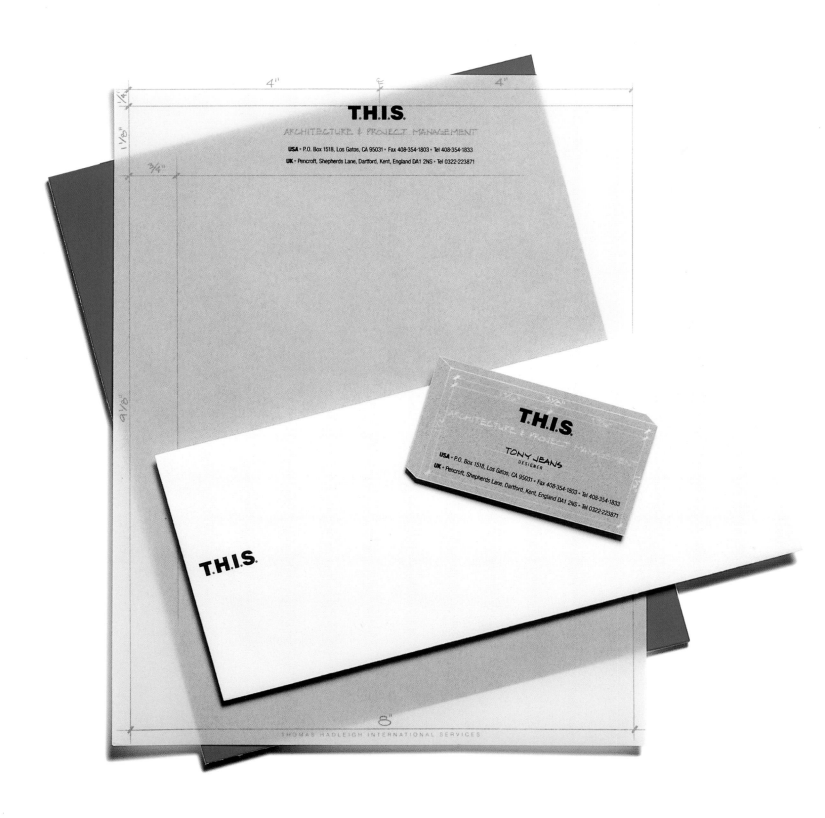

DESIGN FIRM THARP DID IT
DESIGNER Rick Tharp, Jana Heer
CLIENT Thoma Hadley International Services
PAPER/PRINTING Gilbert Paper

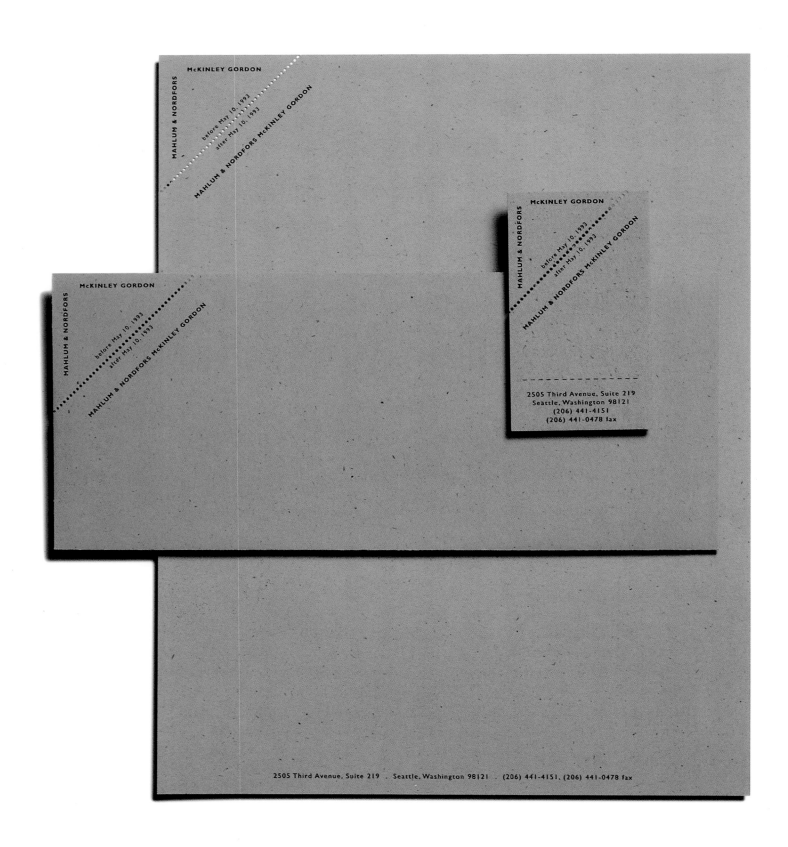

DESIGN FIRM Hornall Anderson Design Works
ART DIRECTOR Jack Anderson
DESIGNER Jack Anderson, Scott Eggers, Leo Raymundo
CLIENT Mahlum & Nordfors McKinley Gordon
PAPER/PRINTING French Speckletone, perforation

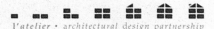

l'atelier • architectural design partnership

l'atelier • architectural design partnership

l'atelier • architectural design partnership

ralph c. ortiz

113 east st. joseph street • arcadia ca 91006 • 818 446 9400

113 east st. joseph street • arcadia ca 91006 • 818 446 9400 • fax 818 446 9533

DESIGN FIRM	Adele Bass & Co. Design
ART DIRECTOR	Adele Bass
DESIGNER	Adele Bass
ILLUSTRATOR	Adele Bass
CLIENT	L'aterlier
PAPER/PRINTING	Kraft Speckletone, 2 PMS

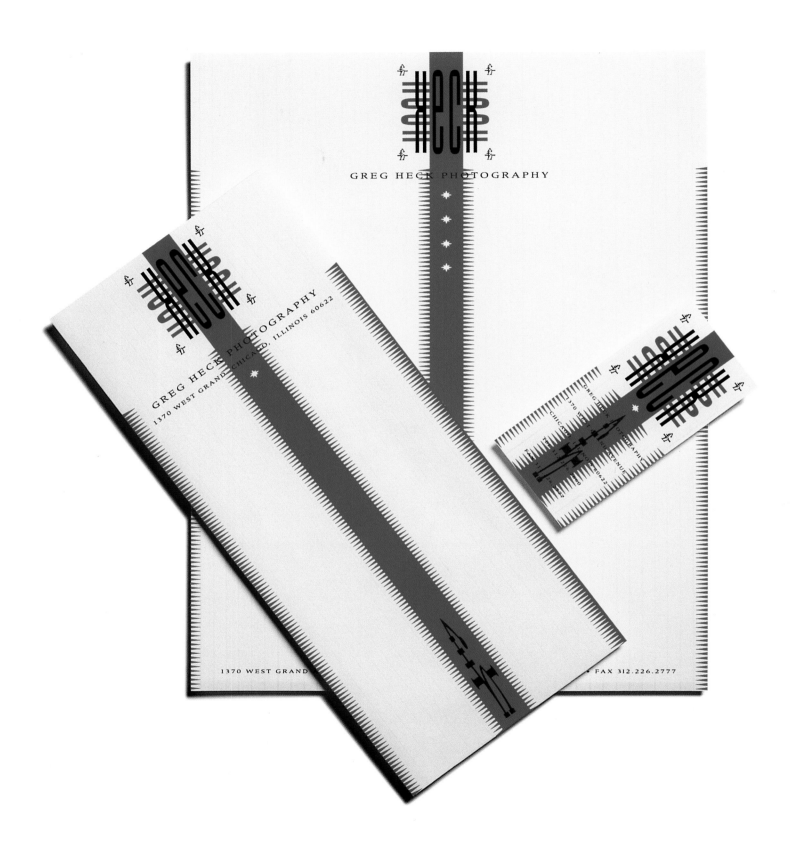

DESIGN FIRM	Segura Inc.
ART DIRECTOR	Carlos Segura
DESIGNER	Carlos Segura
ILLUSTRATOR	Carlos Segura
CLIENT	Greg Heck Photography
PAPER/PRINTING	Argus

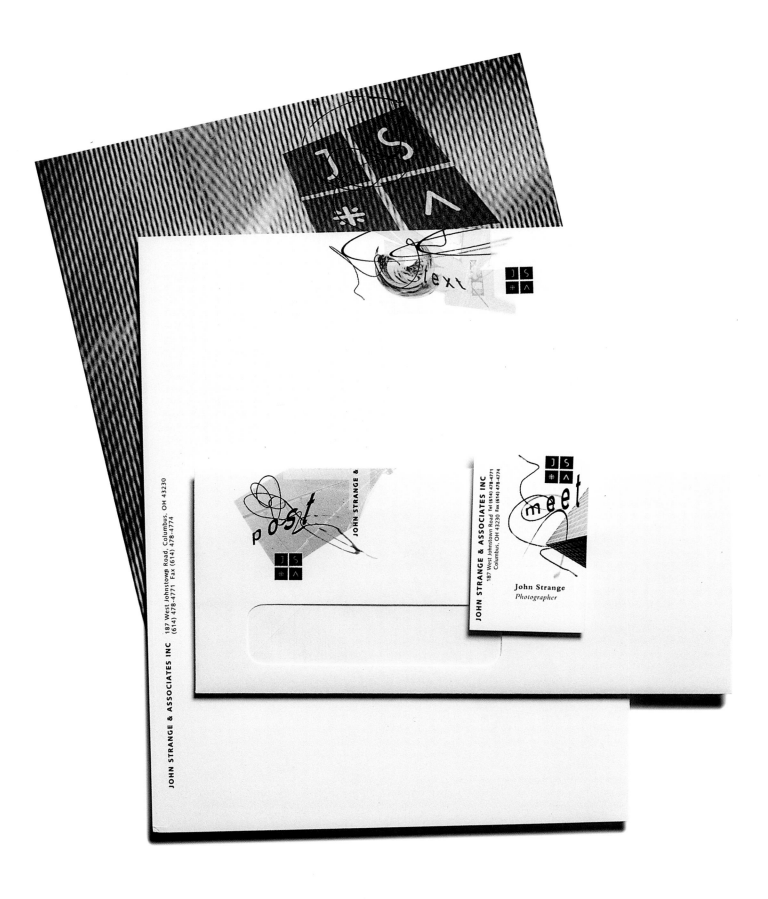

JOHN STRANGE & ASSOCIATES INC 187 West Johnstown Road, Columbus, OH 43230
(614) 478-4771 Fax (614) 478-4774

JOHN STRANGE & ASSOCIATES INC
187 West Johnstown Road Tel (614) 428-4771
Columbus, OH 43230 Fax (614) 478-4774

John Strange
Photographer

DESIGN FIRM	Schmeltz & Warren
ART DIRECTOR	Crit Warren
DESIGNER	Crit Warren
PHOTOGRAPHY	John Strange
PHOTO MANIPULATIONS	Crit Warren
CLIENT	John Strange & Associates
PAPER/PRINTING	Gilbert Esse

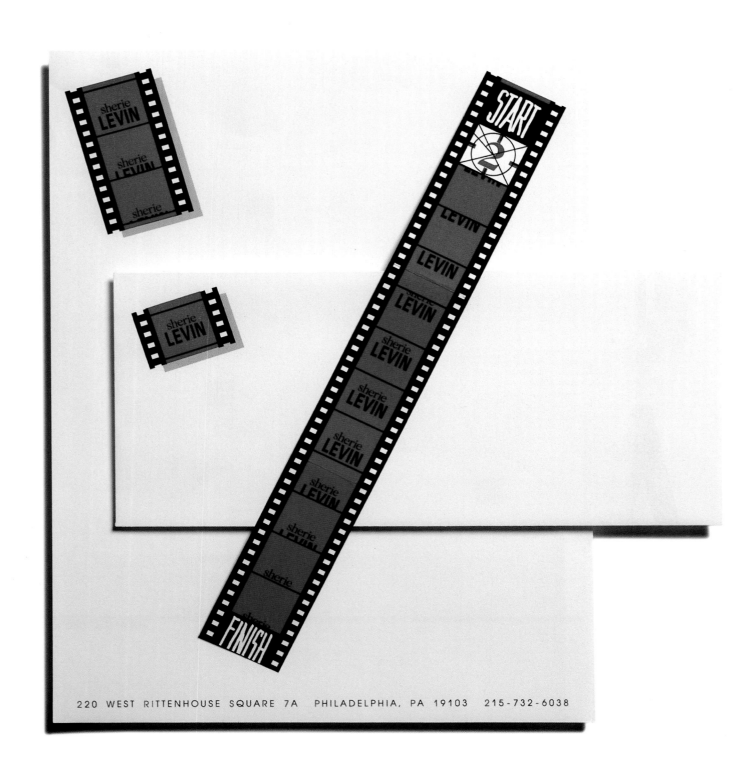

220 WEST RITTENHOUSE SQUARE 7A PHILADELPHIA, PA 19103 215-732-6038

DESIGN FIRM Peter Hermesmann
DESIGNER Peter Hermesmann
CLIENT Sherie Levin

DESIGN FIRM	Segura Inc.
ART DIRECTOR	Carlos Segura
DESIGNER	Carlos Segura
ILLUSTRATOR	Carlos Segura
CLIENT	Heimo Photograpy

DESIGN FIRM	Segura Inc.
ART DIRECTOR	Carlos Segura
DESIGNER	Carlos Segura
ILLUSTRATOR	Carlos Segura
CLIENT	Guy Hurka Photography

DESIGN FIRM	Eilts Anderson Tracy
ART DIRECTOR	Jan Tracy
DESIGNER	Jan Tracy
ILLUSTRATOR	Jan Tracy
CLIENT	Steve Fuller, Photographer

DESIGN FIRM	Segura Inc.
ART DIRECTOR	Carlos Segura
DESIGNER	Carlos Segura
ILLUSTRATOR	Carlos Segura
CLIENT	Anthony Arcievo Photography

DESIGN FIRM	Segura Inc.
ART DIRECTOR	Carlos Segura
DESIGNER	Carlos Segura
ILUSTRATOR	Carlos Segura
CLIENT	Heck Photography

DESIGN FIRM	Hornall Anderson Design Works
ART DIRECTOR	Jack Anderson
DESIGNER	Jack Anderson, Debra Hampton, Mary Chin Hutchison
ILLYSTRATOR	Debra Hampton
CLIENT	Rod Ralston Photography

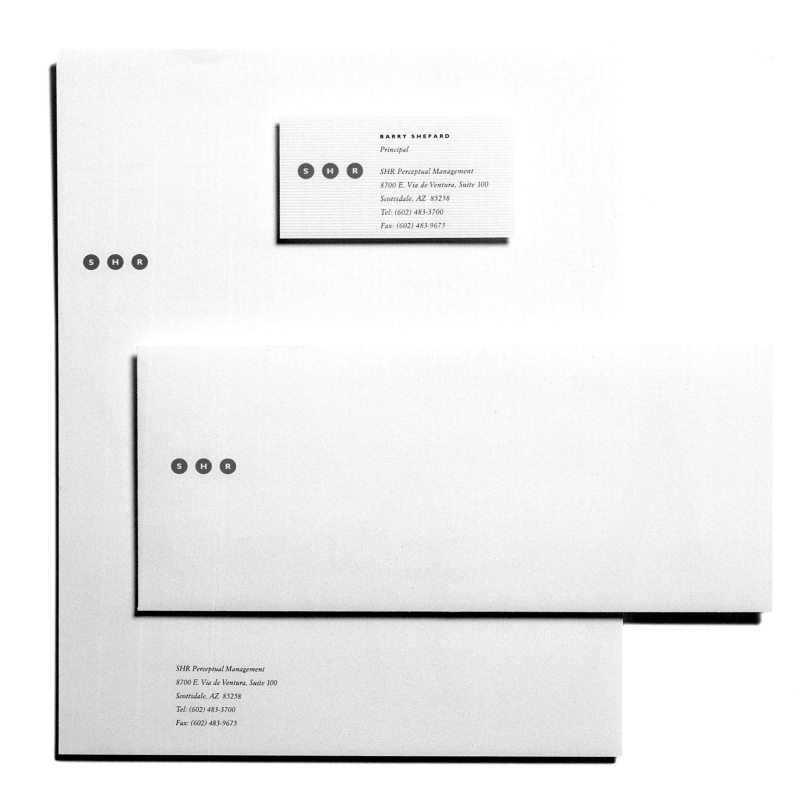

DESIGN FIRM	SHR Perceptual Management
ART DIRECTOR	Barry Shepard
DESIGNER	Nathan Joseph
CLIENT	SHR Perceptual Management
PAPER/PRINTING	Simpson Starwhite Vicksburg

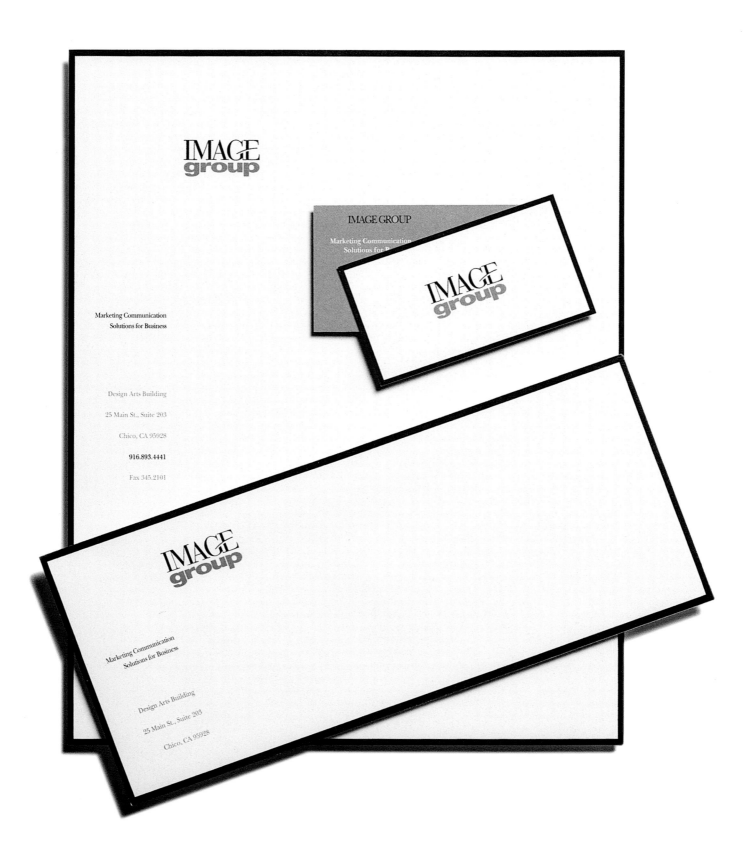

DESIGN FIRM Image Group
ART DIRECTOR Charles Osborn
DESIGNER Charles Osborn, David Zavala, Eric Sanchez
CLIENT Image Group
PAPER/PRINTING Concept

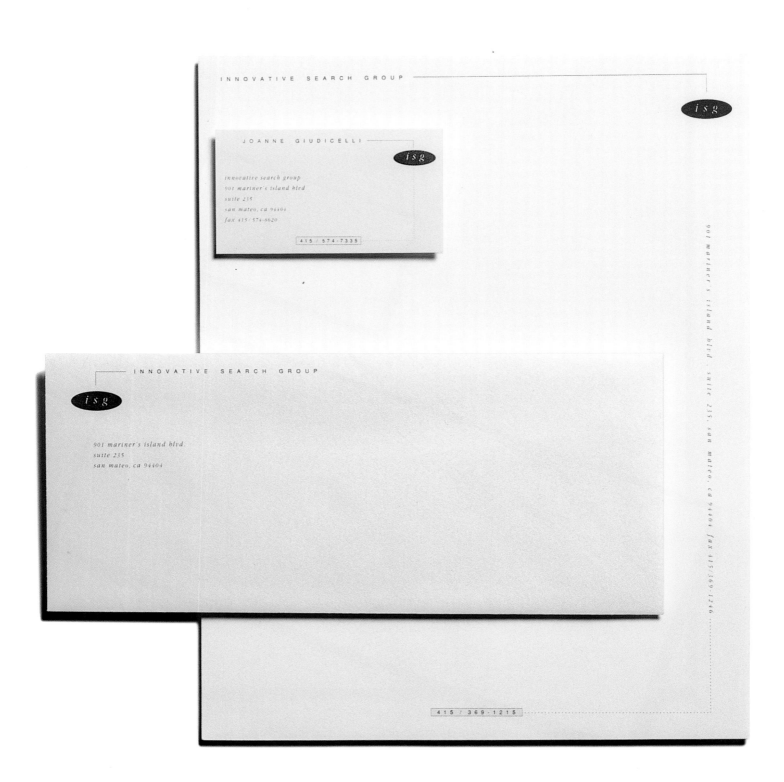

INNOVATIVE SEARCH GROUP

i s g

JOANNE GIUDICELLI

innovative search group
901 mariner's island blvd
suite 235
san mateo, ca 94404
fax 415/574-8620

i s g

415 / 574-7335

INNOVATIVE SEARCH GROUP

i s g

901 mariner's island blvd.
suite 235
san mateo, ca 94404

415 / 369-1215

901 mariner's island blvd, suite 235, san mateo, ca 94404 fax 415/369-1246

DESIGN FIRM	Dan Frazier Design
ART DIRECTOR	Dan Frazier
DESIGNER	Dan Frazier
CLIENT	Innovative Search Group
PAPER/PRINTING	Strathmore Writing

DESIGN FIRM	Walsh and Associates, Inc.
ART DIRECTOR	Miriam Lisco
DESIGNER	Miriam Lisco
CLIENT	Concord Mortgage Corporation, Inc.
PAPER/PRINTING	Classic Crest

DESIGN FIRM	Thomas Hillman Design
ART DIRECTOR	Thomas Hillman
DESIGNER	Thomas Hillman
ILLUSTRATOR	Thomas Hillman
CLIENT	Radical Radio
PAPER/PRINTING	Strathmore Renewal

DESIGN FIRM	Jim Ales Design
ART DIRECTOR	Jim Ales
DESIGNER	Jim Ales
ILLUSTRATOR	Tim Clark
CLIENT	Technical Publishing Services
PAPER/PRINTING	Strathmore

DESIGN FIRM	Eilts Anderson Tracy
ART DIRECTOR	Jan Tracy
DESIGNER	Jan Tracy
ILLUSTRATOR	Jan Tracy
CLIENT	Embry & Company
PAPER/PRINTING	Evergreen

G A T T O R N A
S T R A T E G Y

Gattorna Strategy
Consultants Pty Ltd
Inc in NSW
1 James Place North Sydney
NSW 2060 Australia
Tel: (02) 959 3899
Fax: (02) 959 3990

131 Rokeby Road
Subiaco
WA 6008 Australia
Tel: (09) 381 3580
Fax: (09) 382 2519

708C Swanson Road
Swanson
PO Box 83163 Edmonton
Auckland 8 New Zealand
Tel: (09) 833 9991
Fax: (09) 833 9992

33 South Montilla
San Clemente
CA 92672
USA
Tel: (714) 498 9440
Fax: (714) 492 1152

DESIGN FIRM	Jenssen Design Pty. Limited
ART DIRECTOR	David Jenssen
DESIGNER	David Jenssen
ILLUSTRATOR	David Jenssen, Yahyeh Abouloukme
CLIENT	Gattorna Strategy Consultants Pty. Ltd.
PAPER/PRINTING	Strathmore Writing, Bright White Laid

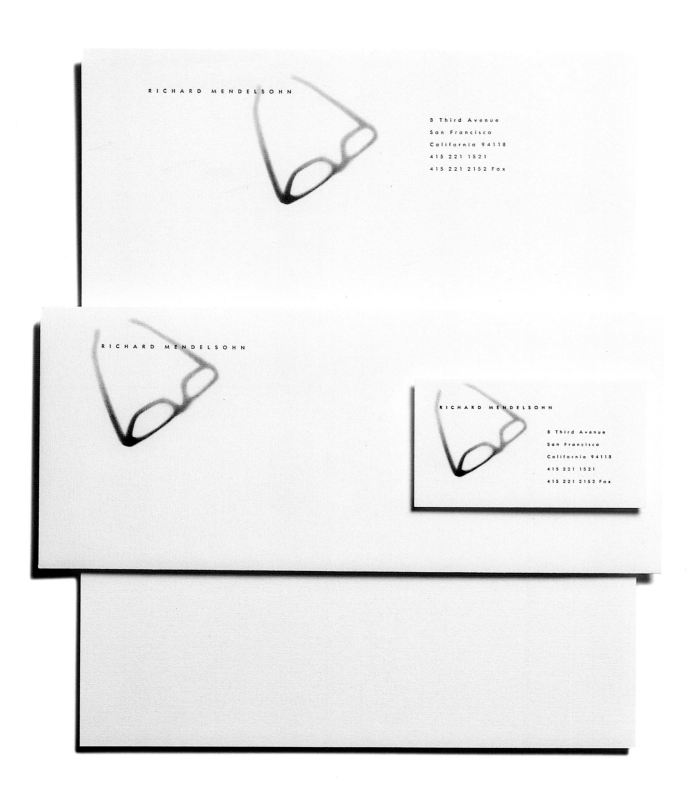

DESIGN FIRM	Debra Nichols Design
ART DIRECTOR	Debra Nichols
DESIGNER	Debra Nichols, Kelan Smith
ILLUSTRATOR	Mark Schroeder
CLIENT	Richard Mendelsohn

DESIGN FIRM	Smith Group Communications
ART DIRECTOR	Thom Smith, Gregg Frederickson
DESIGNER	Thom Smith, Gregg Frederickson
ILLUSTRATOR	Gregg Frederickson
CLIENT	Lightman & Associates
PAPER/PRINTING	Protocol Writing

DESIGN FIRM	Source/Inc.
ART DIRECTOR	Michael Livolsi
DESIGNER	Source Staff
CLIENT	Source/Inc.
PAPER/PRINTING	Strathmore Writing

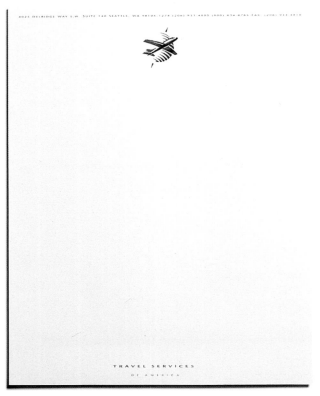

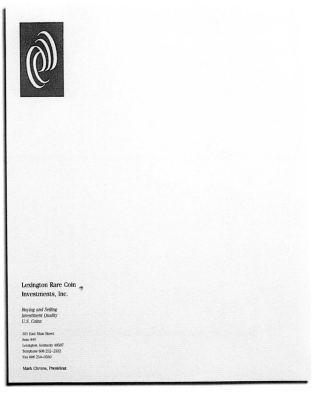

DESIGN FIRM	Hornall Anderson Design Works
ART DIRECTOR	Jack Anderson
DESIGNER	Jack Anderson, David Bates, Mary
ILLUSTRATOR	Hermes, Julia LaPine
CLIENT	Yutaka Sasaki
PAPER/PRINTING	Travel Services of America
	Simpson Environment

DESIGN FIRM	Ellen Kendrick Creative, Inc.
ART DIRECTOR	Ellen K. Spalding
DESIGNER	Ellen K. Spalding
ILLUSTRATOR	Ellen K. Spalding
CLIENT	Lexington Rare Coin Investments, Inc.
PAPER/PRINTING	Simpson Gainsborough black and metallic
	green registered to sculptured brass die

BROOKS MARKETING LTD.
475 Cleveland Avenue N., Suite 315
Saint Paul, Minnesota 55104
Fax: 612 / 645-5250
Tel: 612 / 645-1282

BROOKS MARKETING LTD.
475 Cleveland Avenue N., Suite 315
Saint Paul, Minnesota 55104

MICHAEL BROOKS **BROOKS MARKETING LTD.**
475 Cleveland Avenue N., Suite 315
Saint Paul, Minnesota 55104
Fax: 612 / 645-5250
Tel: 612 / 645-1282

DESIGN FIRM	GrandPré and Whaley, Ltd.
ART DIRECTOR	Kevin Whaley
DESIGNER	Kevin Whaley
CLIENT	Brooks Marketing, Ltd.
PAPER/PRINTING	Strathmore

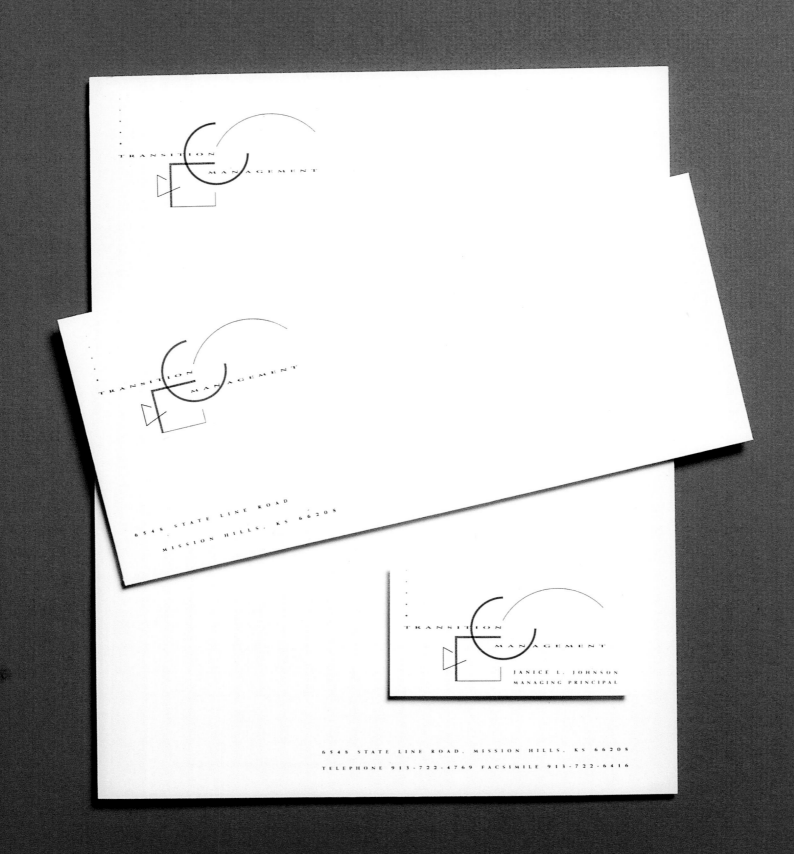

DESIGN FIRM	Eilts Anderson Tracy
ART DIRECTOR	Jan Tracy
DESIGNER	Jan Tracy
ILLUSTRATOR	Jan Tracy
CLIENT	Transition Management
PAPER/PRINTING	Vicksburg/Instyprints

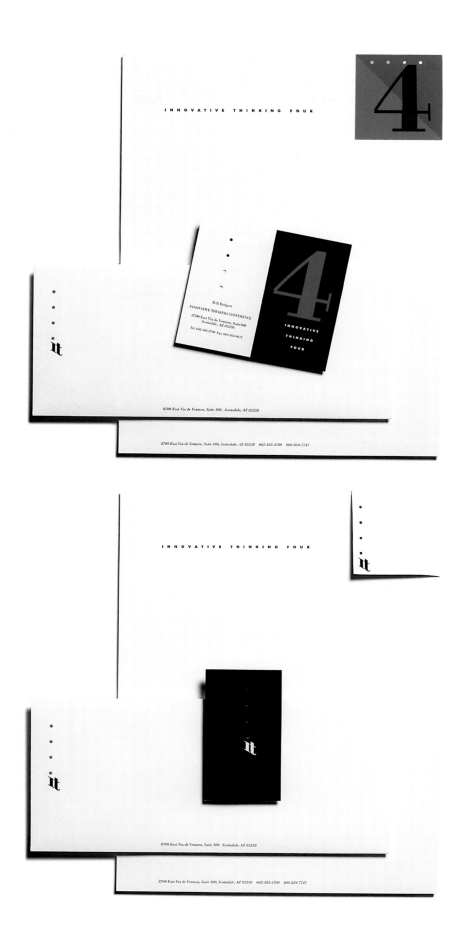

DESIGN FIRM	SHR Perceptual Management
ART DIRECTOR	Barry Shepard
DESIGNER	Mike Shanks
CLIENT	SHR Perceptual Management
PAPER/PRINTING	Curtis Brightwater Aretsian

DESIGN FIRM	Lambert Design Studio	**DESIGN FIRM**	Aslan Grafix	**DESIGN FIRM**	TW Design
ART DIRECTOR	Christie Lambert	**ART DIRECTOR**	Tracy Grubbs	**DESIGNER**	Jordan Patsios
DESIGNER	Joy Cathey	**DESIGNER**	Tracy Grubbs	**CLIENT**	MARCAM Corporation
CLIENT	Ideas & Solutions	**CLIENT**	Argadine Publishing		

DESIGN FIRM	Riley Design Associates	**DESIGN FIRM**	Lambert Design Studio	**DESIGN FIRM**	Vaughn Wedeen Creative
ART DIRECTOR	Daniel Riley	**ART DIRECTOR**	Christie Lambert	**ART DIRECTOR**	Steve Wedeen
DESIGNER	Daniel Riley	**DESIGNER**	Christie Lambert, Joy Cathey	**DESIGNER**	Lisa Graff
ILLUSTRATOR	Daniel Riley	**ILLUSTRATOR**	Joy Cathey	**ILLUSTRATOR**	Lisa Graff
CLIENT	Hiring Resources	**CLIENT**	ProjectWorks	**COMPUTER PRODUCTION**	Chip Wyly
				CLIENT	Stratecom

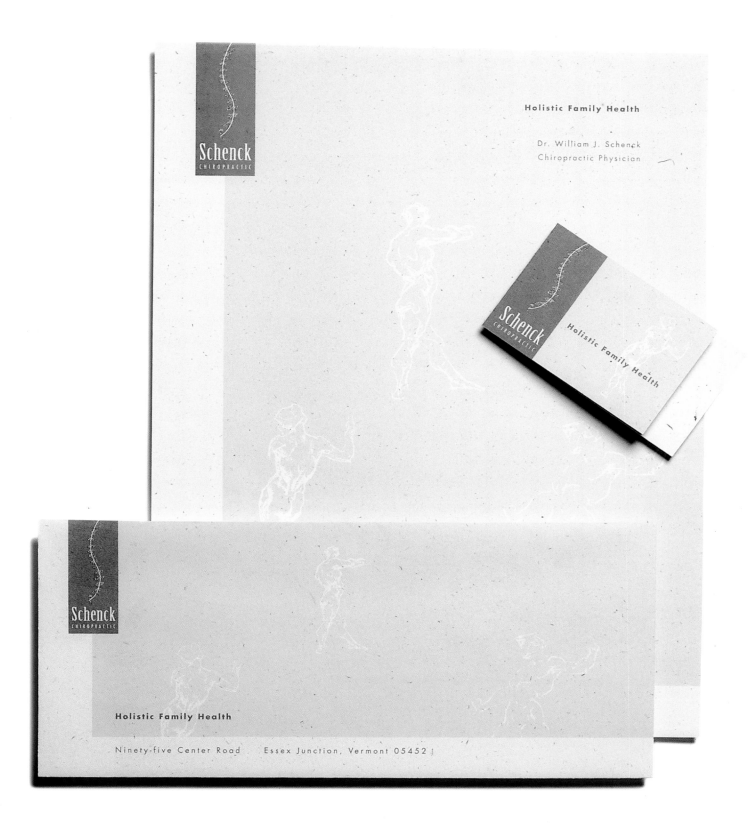

DESIGN FIRM Creative EDGE
DESIGNER Rick Salzman, Barbara Pitfido
CLIENT Schenck Chiropractic
PAPER/PRINTING Strathmore Renewal

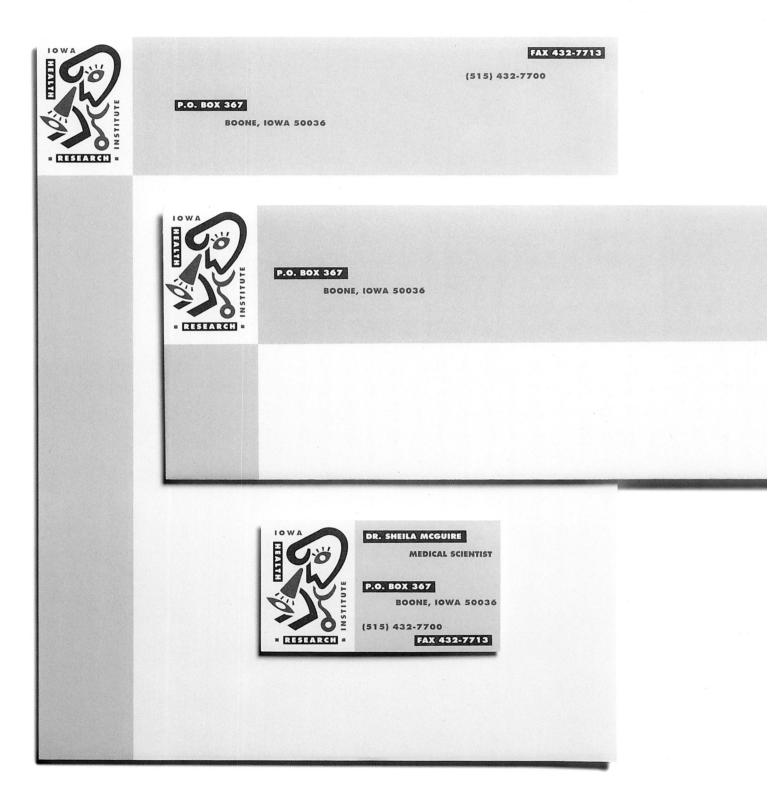

DESIGN FIRM	Sayles Graphic Design
ART DIRECTOR	John Sayles
DESIGNER	John Sayles
ILLUSTRATOR	John Sayles
CLIENT	Iowa Health Research Institute
PAPER/PRINTING	James River, Graphika Vellum White, 2 colors

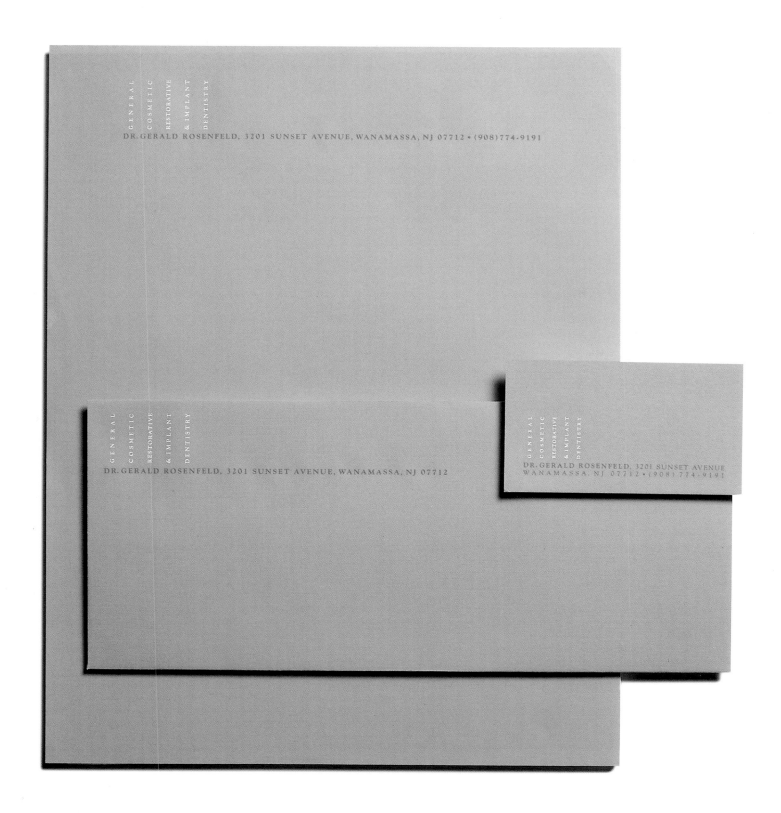

DESIGN FIRM	The Marketing & Design Group
ART DIRECTOR	Howard Levy
DESIGNER	Howard Levy
CLIENT	Dr. Gerald Rosenfeld, Dentist
PAPER/PRINTING	Neenah Classic, linen-engraved in 2 colors

Friends Of The Zoo

Friends of the
Washington Park Zoo

4001 S.W. Canyon Road
Portland, OR 97221-2799
(503) 226-1561
FAX (503) 226-6836

Friends Of The Zoo

Friends of the
Washington Park Zoo

4001 S.W. Canyon Road
Portland, OR 97221-2799
(503) 226-1561
FAX (503) 226-6836

Margie Mee Pate
Executive Director

"Caring Now for
the Future of Life"

Friends Of The Zoo

Friends of the
Washington Park Zoo

4001 S.W. Canyon Road
Portland, OR 97221-2799

"Caring Now for the Future of Life"

"Caring Now for the Future of Life"

DESIGN FIRM	Smith Group Communications
ART DIRECTOR	Gregg Frederickson
DESIGNER	Lena James
ILLUSTRATOR	Lena James
CLIENT	Friends of the Zoo
PAPER/PRINTING	Classic Crest

DESIGN FIRM Ramona Hutko
Design
ART DIRECTOR Ramona Hutko
DESIGNER Ramona Hutko
CLIENT American Red Cross,
Rochester Chapter

DESIGN FIRM Richard Danne &
Associates Inc.
ART DIRECTOR Richard Danne
DESIGNER Gayle Shimoun,
Richard Danne
CLIENT American Academy
on Physician and
Patient

DESIGN FIRM The Great American
Logo Company
ART DIRECTOR Gregg Frederickson
DESIGNER Gregg Frederickson
CLIENT Ewing Institute of
Therapeutic Massage

DESIGN FIRM New Idea Design Inc.
DESIGNER Ron Boldt
ILLUSTRATOR Ron Boldt
CLIENT Midwest Children's
Chest Physicians

DESIGN FIRM Schowalter² Design
ART DIRECTOR Toni Schowalter
DESIGNER Ilene Price, Toni
Schowalter
ILLUSTRATOR Ilene Price, Toni
Schowalter
CLIENT Towers Perrin

DESIGN FIRM Frank D'Astolfo
Design
ART DIRECTOR Frank D'Astolfo
DESIGNER Frank D'Astolfo
CLIENT Visual and
Performing Arts,
Rutgers University,
New Jersey

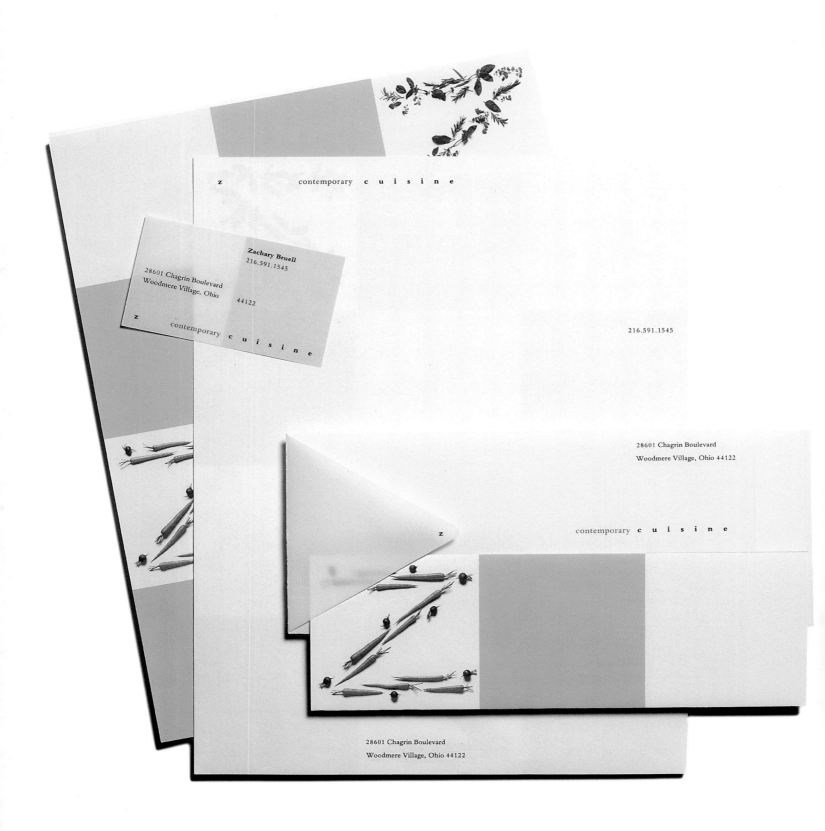

DESIGN FIRM	Nesnadny & Schwartz
ART DIRECTOR	Joyce Nesnadny, Mark Schwartz
DESIGNER	Joyce Nesnadny
CLIENT	Z Contemporary Cuisine
PAPER/PRINTING	Crane's (letterhead), Neenah (envelope, 2/2)

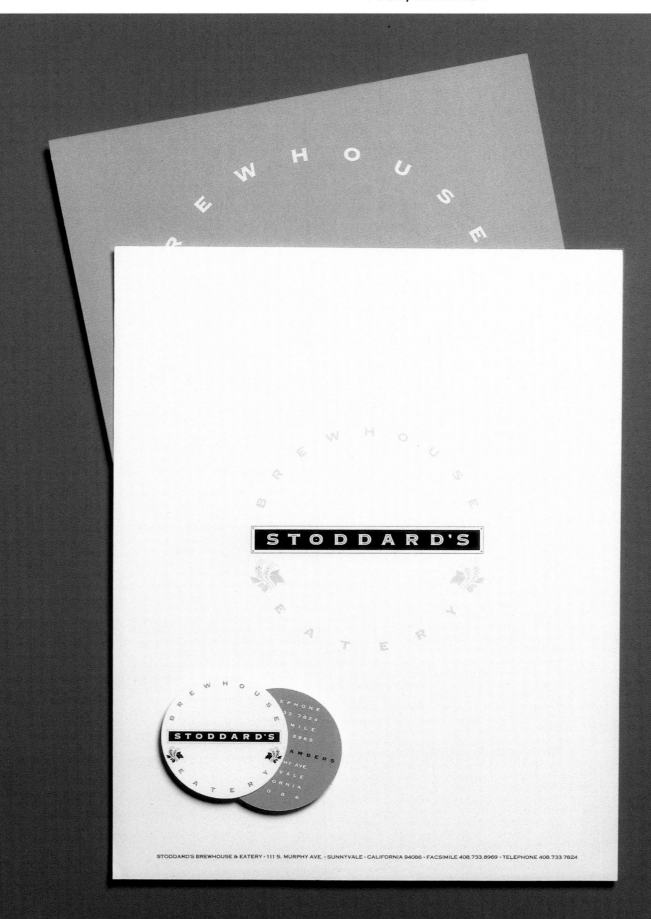

DESIGN FIRM	THARP DID IT
ART DIRECTOR	Rick Tharp
DESIGNER	Sandy Russell, Colleen Sullivan, Rick Tharp
CLIENT	Stoddard's Brewhouse & Eatery
PAPER/PRINTING	Simpson

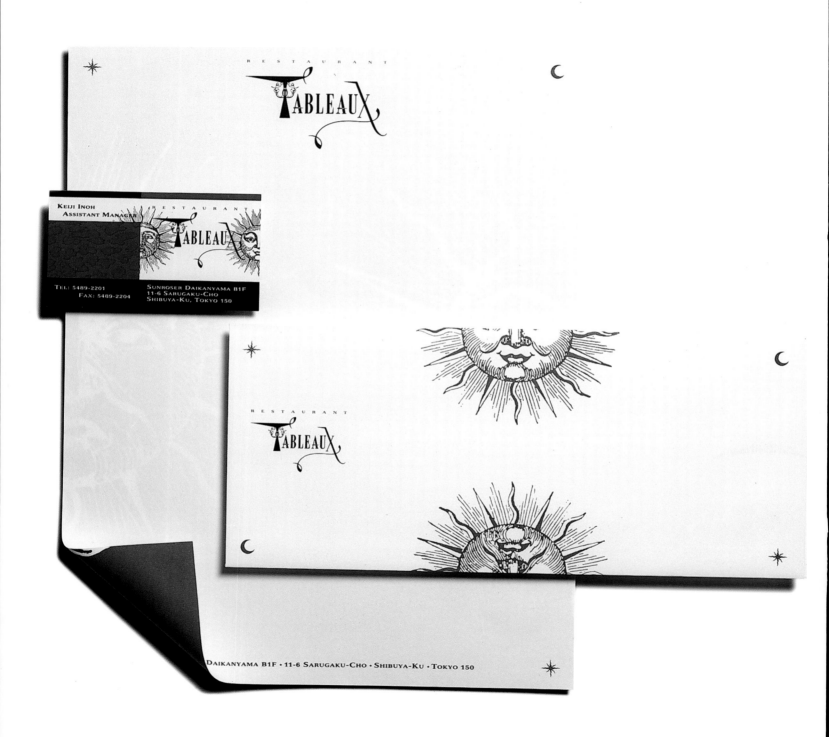

DESIGN FIRM	Vrontikis Design Office
ART DIRECTOR	Petrula Vrontikis
DESIGNER	Kim Sage
CLIENT	Tableaux
PAPER/PRINTING	Classic Crest Solar White

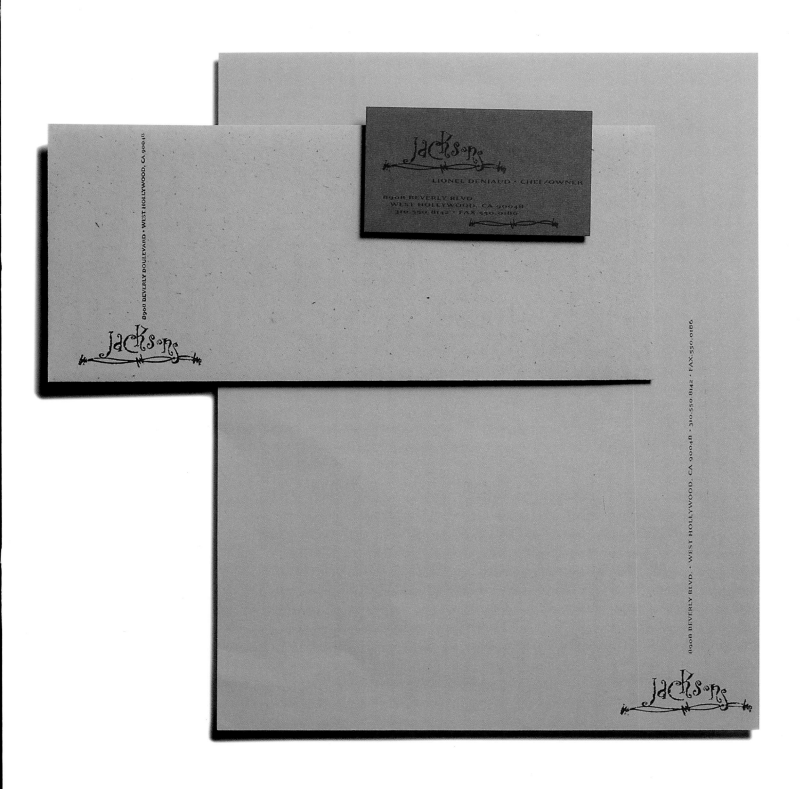

DESIGN FIRM	Vrontikis Design Office
ART DIRECTOR	Petrula Vrontikis
DESIGNER	Kim Sage
CLIENT	Jacksons
PAPER/PRINTING	French Durotone

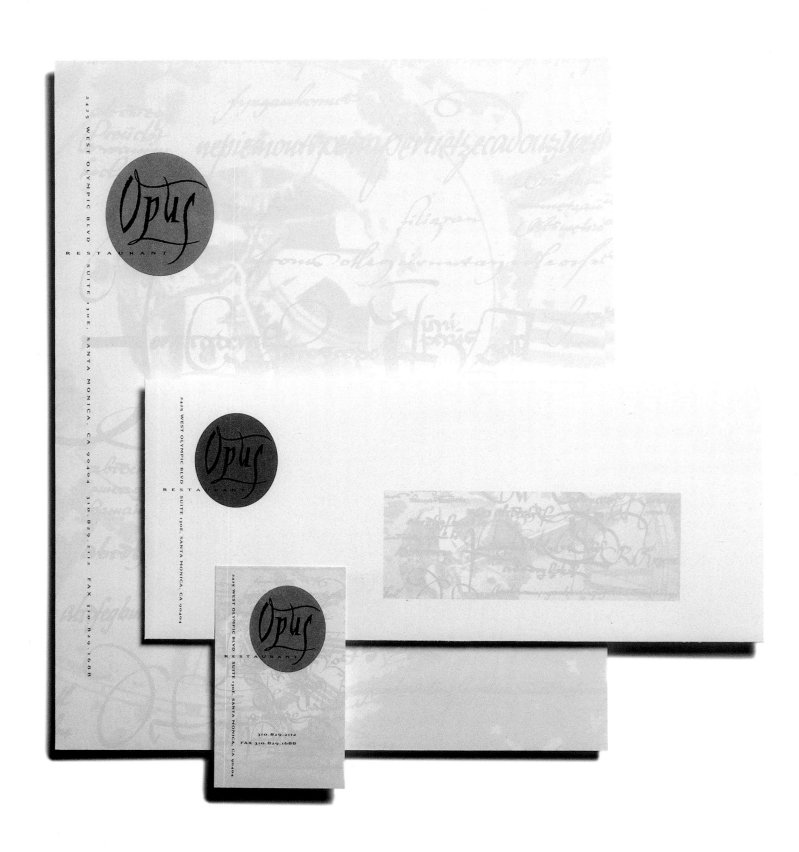

DESIGN FIRM	Let Her Press
ART DIRECTOR	Heather Van Haaften, Lorna Stovall
DESIGNER	Lorna Stovall, Heather Van Haaften
CLIENT	L'Orfe/Opus Restaurant
PAPER/PRINTING	Starwhite Vicksberg

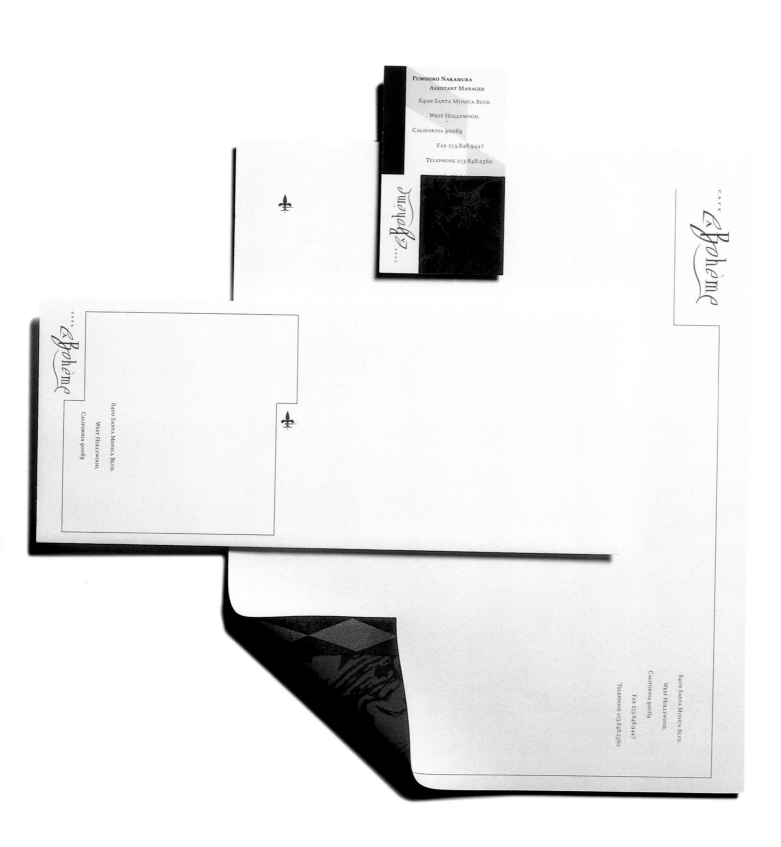

DESIGN FIRM	Vrontikis Design Office
ART DIRECTOR	Petrula Vrontikis
DESIGNER	Kim Sage, Lorna Stovall
CLIENT	Café La Boheme
PAPER/PRINTING	Simpson Starwhite Vicksburg

Joan Deccio Wickham
Food Stylist & Culinary Instructor

Joan Deccio Wickham
Food Stylist & Culinary Instructor

P.O. Box 442
Vashon, WA
98070
206-463-3647
Fax 206-463-9223

Joan Deccio Wickham
Food Stylist & Culinary Instructor

P.O. Box 442
Vashon, WA
98070

P.O. Box 442

Vashon, WA

98070

206-463-3647

Fax 206-463-9223

DESIGN FIRM	Walsh and Associates, Inc.
ART DIRECTOR	Miriam Lisco
DESIGNER	Katie Dolejsi
CLIENT	Joan Deccio Wickham
PAPER/PRINTING	Classic Crest Recycled

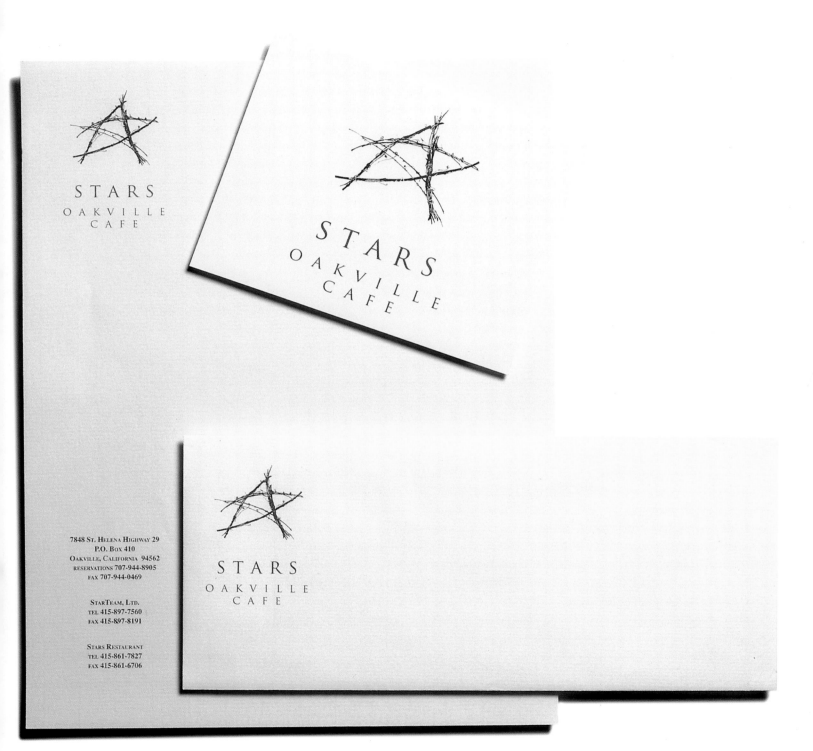

DESIGN FIRM Debra Nichols Design
ART DIRECTOR Debra Nichols
DESIGNER Debra Nichols, Roxanne Malek
CLIENT Stars Restaurant

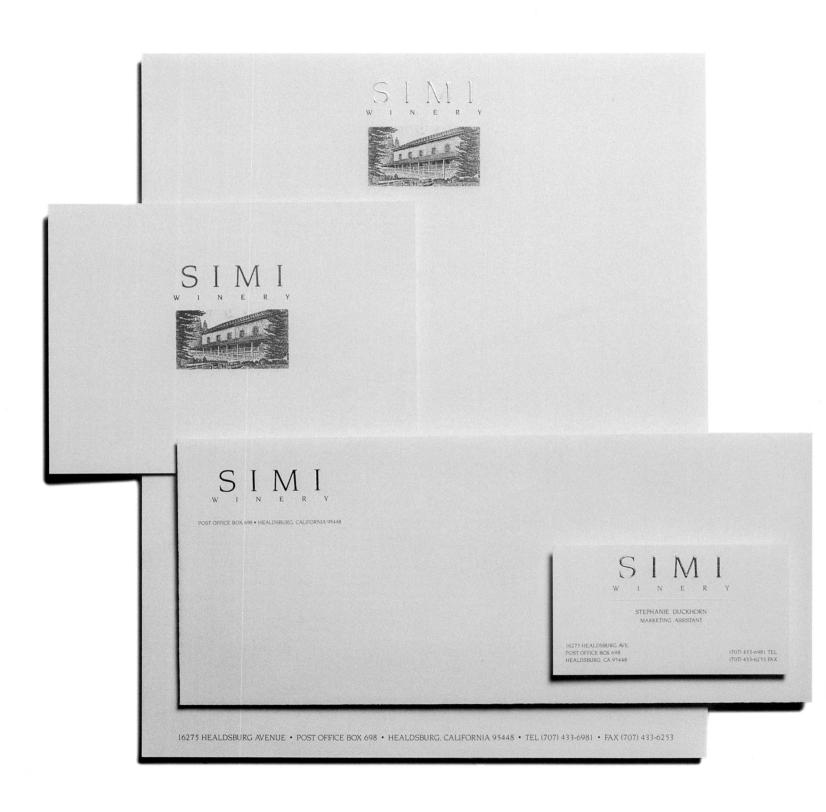

DESIGN FIRM	Ortega Design Studio
ART DIRECTOR	Susann Ortega, Joann Ortega
DESIGNER	Susann Ortega
ILLUSTRATOR	Robert Swartly
CLIENT	Simi Winery
PAPER/PRINTING	Enhance

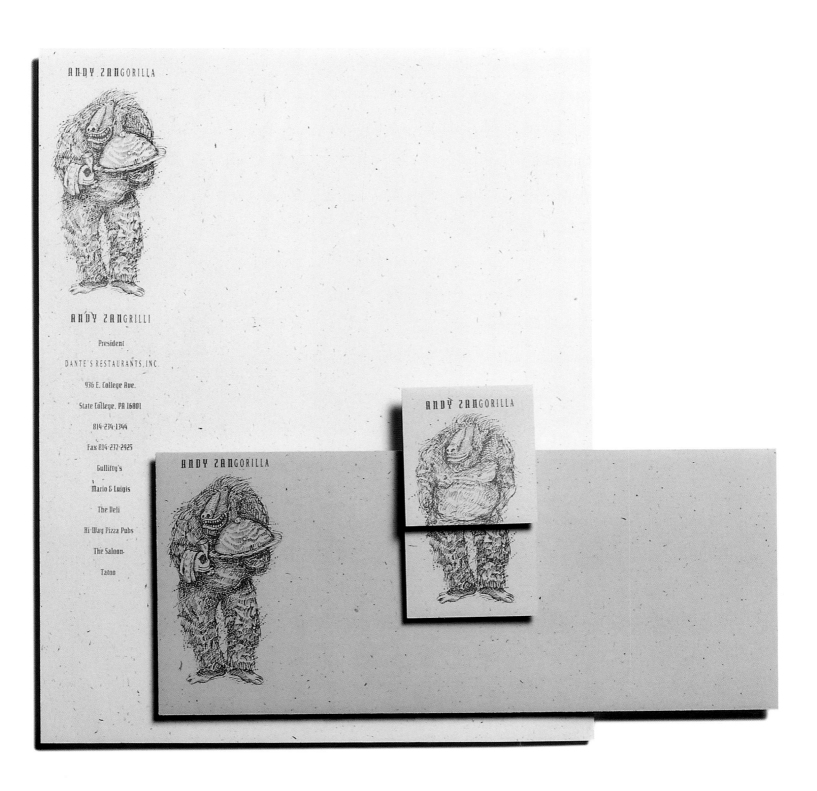

DESIGN FIRM Sommese Design
ART DIRECTOR Lanny Sommese, Kristin Sommese
DESIGNER Kristin Sommese
ILLUSTRATOR Lanny Sommese
CLIENT Dante's Restaurants Inc., Andy Zangrilli
PAPER/PRINTING Cross Pointe Genesis Script

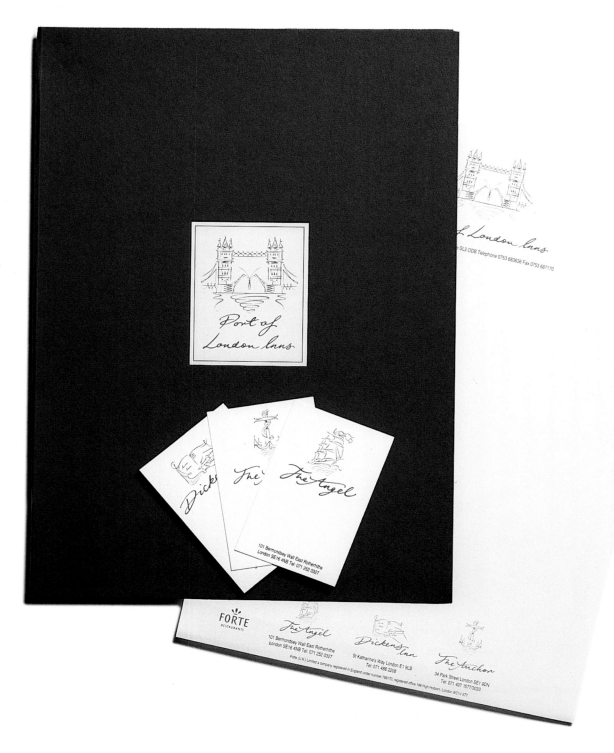

DESIGN FIRM	Hartmann & Mehler Designers GmbH
ART DIRECTOR	Roland Mehler
DESIGNER	Roland Mehler
ILLUSTRATOR	Roland Mehler
CLIENT	Steigenberger Consulting
PAPER/PRINTING	Enhance

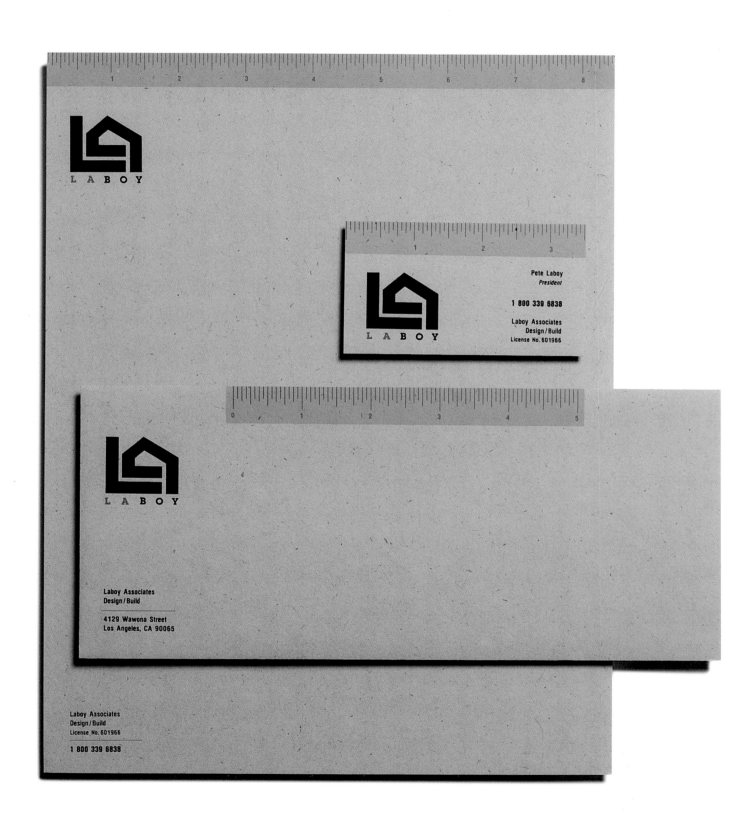

DESIGN FIRM	Adele Bass & Co. Design
ART DIRECTOR	Adele Bass
DESIGNER	Adele Bass
ILLUSTRATOR	Adele Bass
CLIENT	Laboy & Associates
PAPER/PRINTING	Kraft Speckletone, 3 colors

DESIGN FIRM	Focus 2
ART DIRECTOR	Todd Hart, Shawn Freeman
DESIGNER	Todd Hart
ILLUSTRATOR	Todd Hart
CLIENT	American Equity
PAPER/PRINTING	Protocol Writing

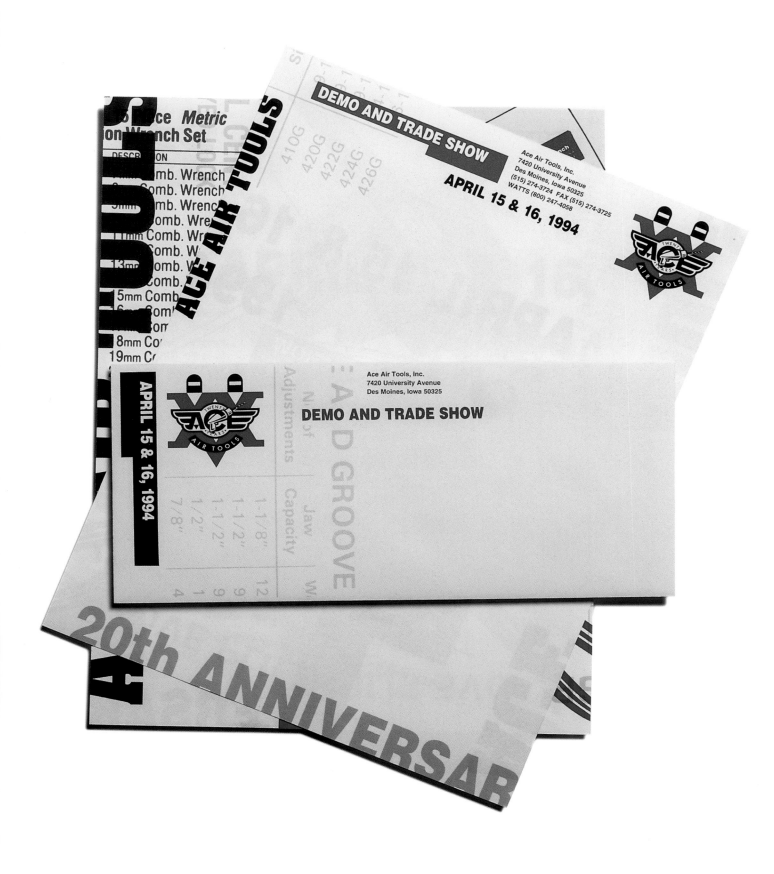

DESIGN FIRM Sayles Graphic Design
ART DIRECTOR John Sayles
DESIGNER John Sayles
ILLUSTRATOR John Sayles
CLIENT Ace Air Tools
PAPER/PRINTING James River, Graphika Vellum White, 2 colors

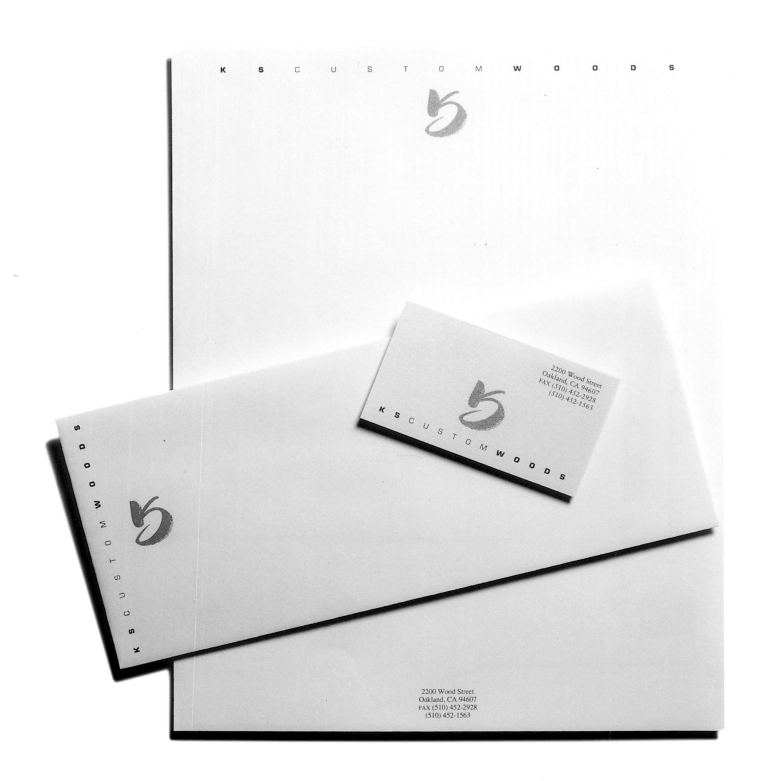

DESIGN FIRM Dan Frazier Design
ART DIRECTOR Dan Frazier
DESIGNER Dan Frazier
ILLUSTRATOR Sandra Bruce
CLIENT KS Custom Woods
PAPER/PRINTING Strathmore Writing

DESIGN FIRM	Carl Seltzer Design Office
ART DIRECTOR	Carl Seltzer
DESIGNER	Carl Seltzer, Luis Alvarado
CLIENT	Grace Cocoa

DESIGN FIRM	Riley Design Associates
ART DIRECTOR	Daniel Riley
DESIGNER	Daniel Riley
ILLUSTRATOR	Daniel Riley
CLIENT	The Bear Group, Inc.
PAPER/PRINTING	1 color, deboss, foil

DESIGN FIRM	Ellen Kendrick Creative, Inc.
ART DIRECTOR /DESIGNER	Ellen K. Spalding
ILLUSTRATOR	Ellen K. Spalding
CLIENT	Coins & Carats, Inc.
PAPER/PRINTING	Neenah Classic Crest, black and metallic blue, silver and holographic foils, sculptured brass die

DESIGN FIRM	Elizabeth Resnick Design
ART DIRECTOR	Elizabeth Resnick
DESIGNER	Elizabeth Resnick
CLIENT	CIBA Corning Diagnostics Corporation
PAPER/PRINTING	Curtis Brightwater, 2 colors

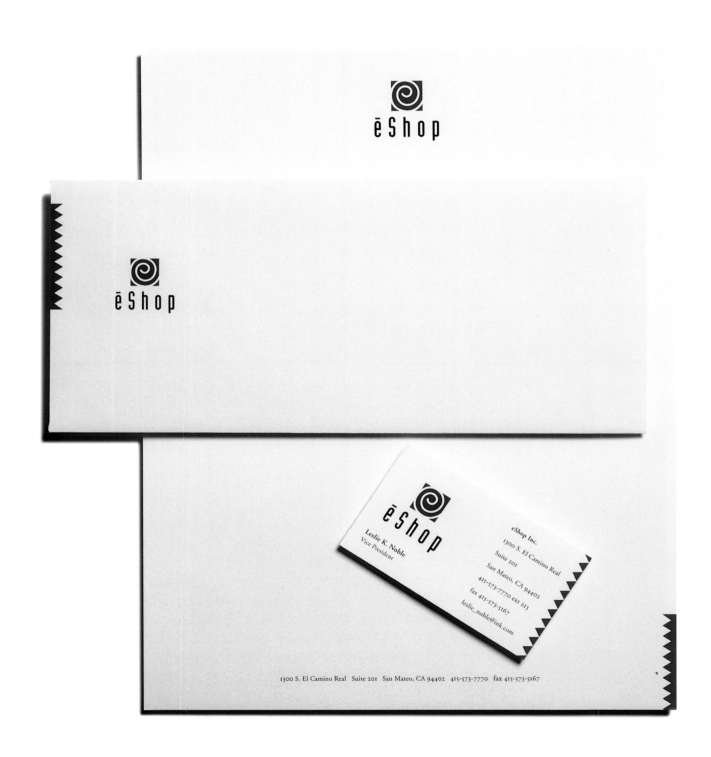

DESIGN FIRM Mortensen Design
ART DIRECTOR Gordon Mortensen
DESIGNER Gordon Mortensen
CLIENT eShop Inc.
PAPER/PRINTING Classic Crest/Foreman

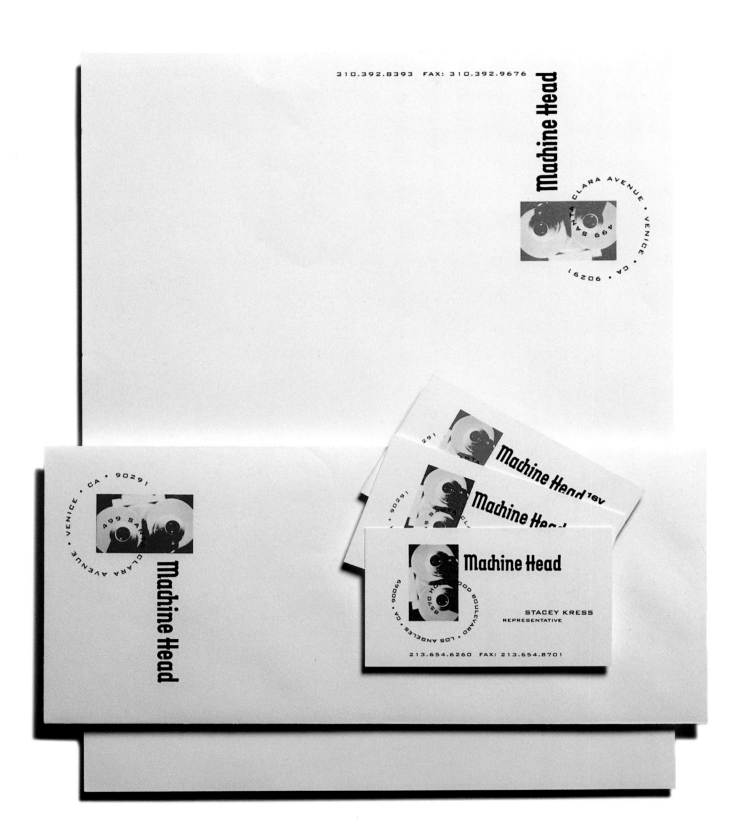

DESIGN FIRM Lorna Stovall Design
ART DIRECTOR Lorna Stovall
DESIGNER Lorna Stovall
CLIENT Machine Head
PAPER/PRINTING Starwhite Vicksberg

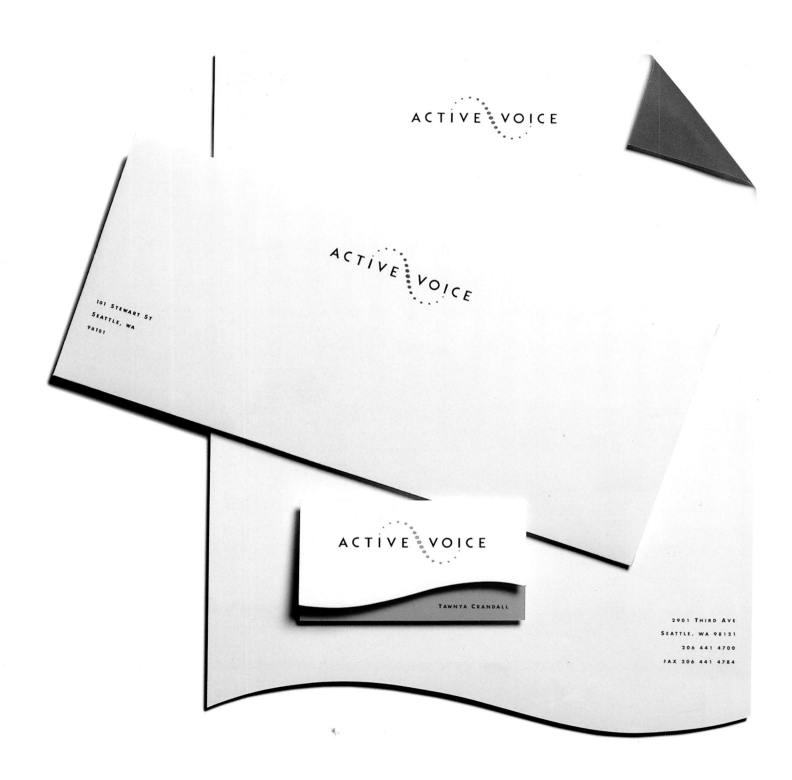

DESIGN FIRM	Hornall Anderson Design Works
ART DIRECTOR	Jack Anderson
DESIGNER	Jack Anderson, Julia LaPine, David Bates, Mary Hermes, Lian Ng
CLIENT	Active Voice
PAPER/PRINTING	Starwhite Vicksburg Tiara Smoothtext

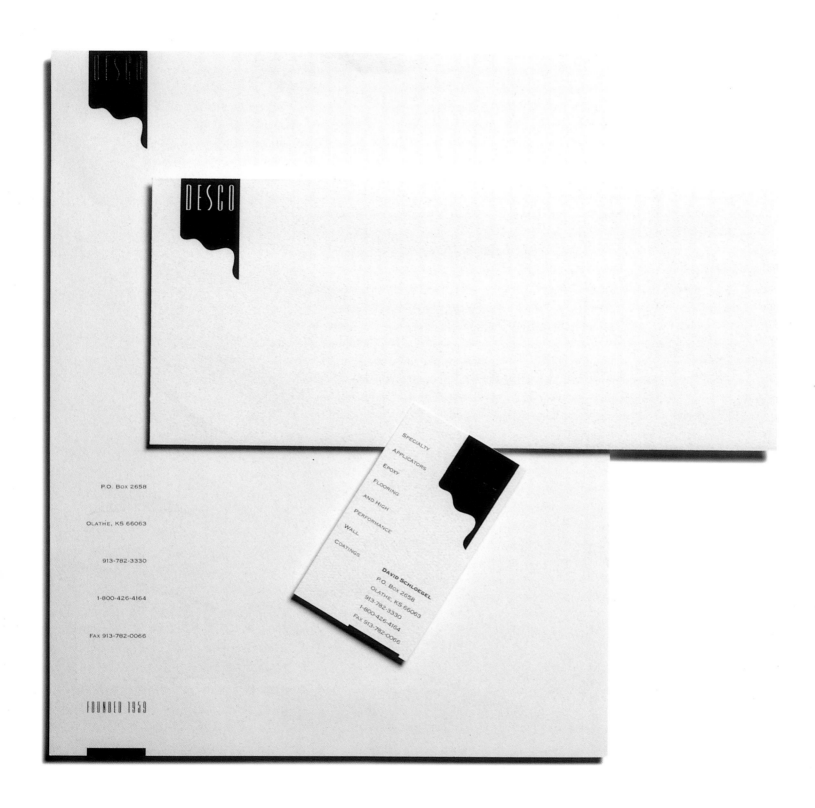

DESIGN FIRM	Muller & Company
ART DIRECTOR	David Shultz
DESIGNER	David Shultz
CLIENT	Desco Coatings, Inc.
PAPER/PRINTING	Cross Pointe, Passport/LaGue

DESIGN FIRM	James Clark Design Images
ART DIRECTOR	James Clark
DESIGNER	James Clark, Linda Sewell
ILLUSTRATOR	Linda Sewell
CLIENT	United Paint Sundry Distributor of America

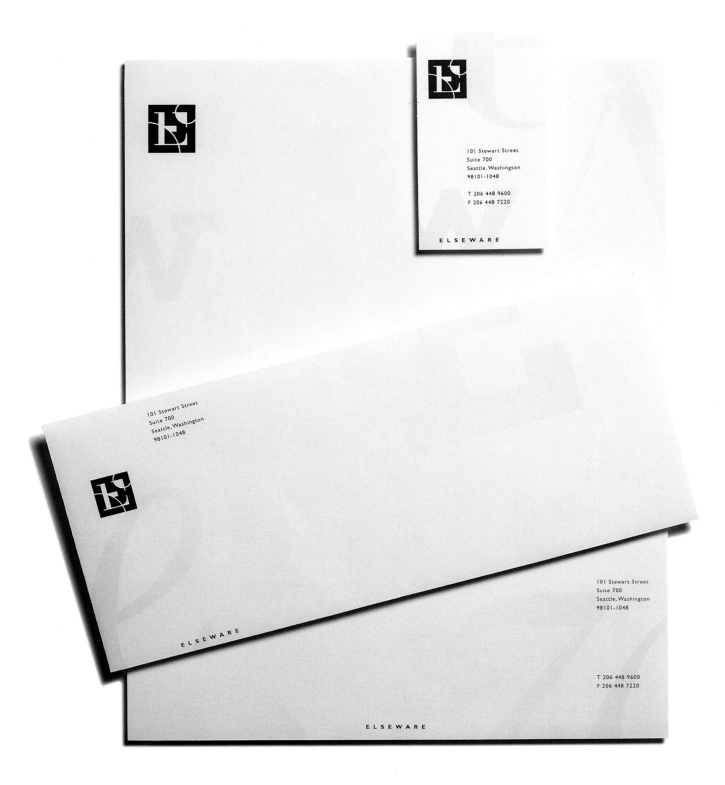

101 Stewart Street
Suite 700
Seattle, Washington
98101-1048

T 206 448 9600
F 206 448 7220

ELSEWARE

101 Stewart Street
Suite 700
Seattle, Washington
98101-1048

ELSEWARE

101 Stewart Street
Suite 700
Seattle, Washington
98101-1048

T 206 448 9600
F 206 448 7220

ELSEWARE

DESIGN FIRM	Hornall Anderson Design Works
ART DIRECTOR	Jack Anderson
DESIGNER	Jack Anderson, Debra Hampton, Leo Raymundo
CLIENT	Elseware Corporation
PAPER/PRINTING	Neenah Classic Crest

GRANITE SOFTWARE

GRANITE SOFTWARE

300 EAST MAIN STREET MILFORD, MA 01757

300 EAST MAIN STREET MILFORD, MA 01757 TEL 508 634.3200 FAX 508 634.8381

DESIGN FIRM	Steven Gulla Graphic Design
ART DIRECTOR	Steven Gulla
DESIGNER	Steven Gulla
CLIENT	Granite Software
PAPER/PRINTING	Passport Pumice

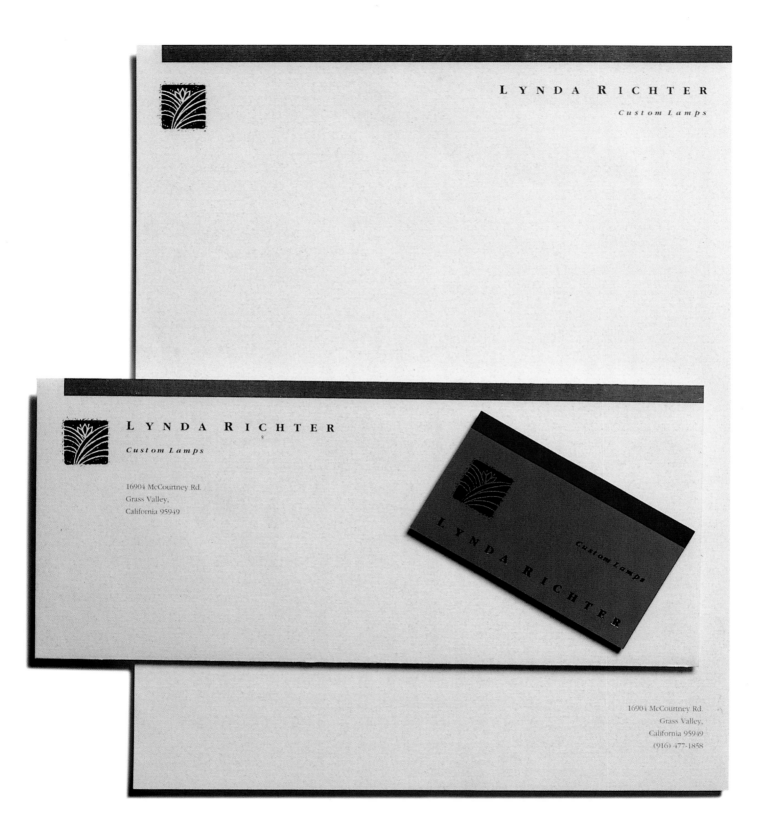

DESIGN FIRM	LeeAnn Brook Design
ART DIRECTOR	LeeAnn Brook
DESIGNER	LeeAnn Brook
ILLUSTRATOR	LeeAnn Brook
CLIENT	Lynda Richter
PAPER/PRINTING	Classic Laid Millstone, foil emboss

$$\left[\begin{array}{c} \text{W O R L D W I D E} \\ \text{O P E R A T I O N S} \end{array} \right]$$

$$\left[\begin{array}{c} \text{M I S S I O N} \\ \text{S T A T E M E N T} \end{array} \right]$$

$$\left[\begin{array}{c} \text{S T R A T E G I C} \\ \text{I N I T I A T I V E S} \end{array} \right]$$

$$\left[\text{V A L U E S} \right]$$

$$\left[\begin{array}{c} \text{A R C H I T E C T U R A L} \\ \text{D I R E C T I O N} \end{array} \right]$$

$$\left[\text{C O M P O N E N T S} \right]$$

DESIGN FIRM Earl Gee Design
ART DIRECTOR Earl Gee
DESIGNER Earl Gee, Fani Chung
ILLUSTRATOR Earl Gee
CLIENT Sun Microsystems
Worldwide Operations

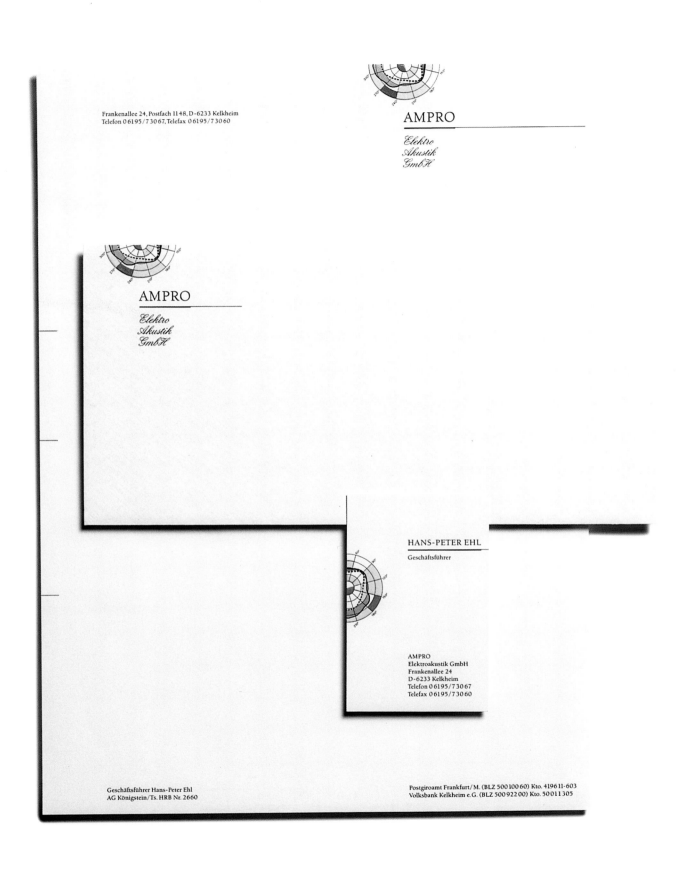

Frankenallee 24, Postfach 1148, D-6233 Kelkheim
Telefon 06195/73067, Telefax 06195/73060

AMPRO
Elektro
Akustik
GmbH

AMPRO
Elektro
Akustik
GmbH

HANS-PETER EHL

Geschäftsführer

AMPRO
Elektroakustik GmbH
Frankenallee 24
D-6233 Kelkheim
Telefon 06195/73067
Telefax 06195/73060

Geschäftsführer Hans-Peter Ehl
AG Königstein/Ts. HRB Nr. 2660

Postgiroamt Frankfurt/M. (BLZ 500 100 60) Kto. 4196 11-603
Volksbank Kelkheim e.G. (BLZ 500 922 00) Kto. 500 11 305

DESIGN FIRM	Hartmann & Mehler Designers GmbH
ART DIRECTOR	Roland Mehler
DESIGNER	Roland Mehler
ILLUSTRATOR	Roland Mehler
CLIENT	Ampro
PAPER/PRINTING	Croxley Heritage

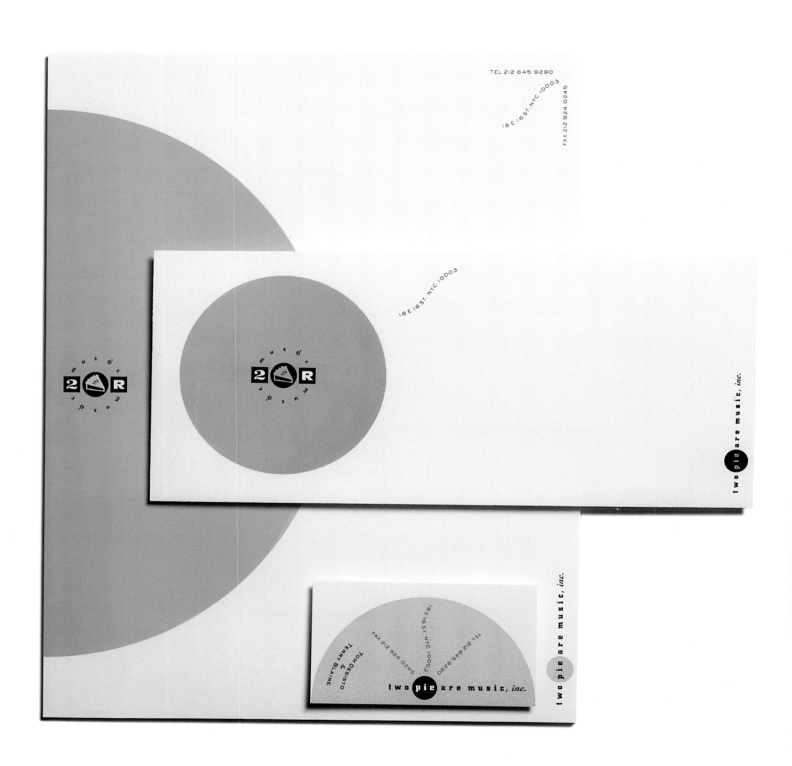

DESIGN FIRM	Pig Studios
ART DIRECTOR	Brandon Griffin
DESIGNER	Sandra Smarp, Brandon Griffin
ILLUSTRATOR	Sandra Smarp
CLIENT	Two Pie Are Music, Inc.
PAPER/PRINTING	Strathmore Writing, Bright White, 2 PMS

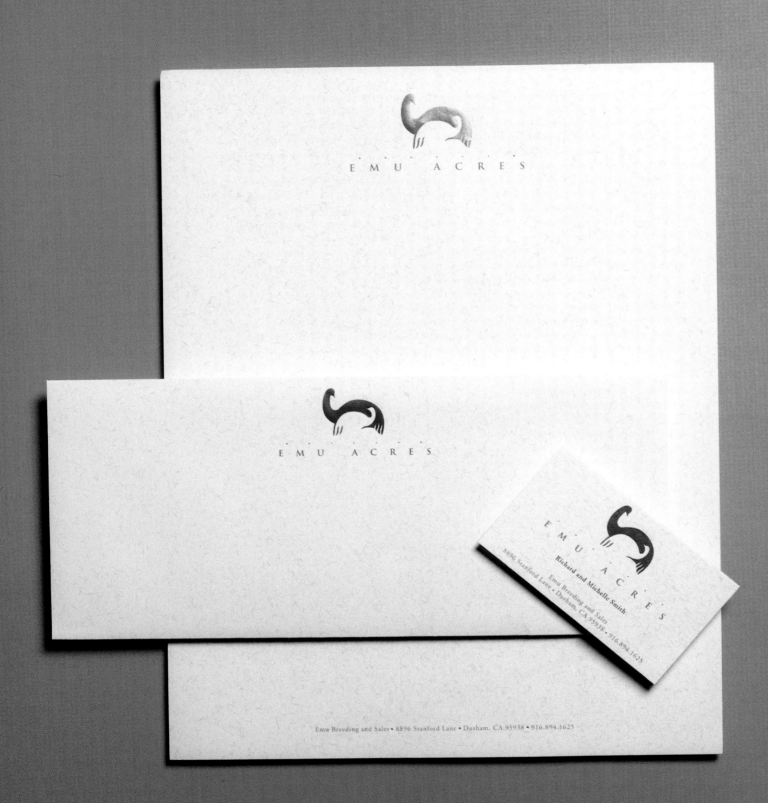

DESIGN FIRM	Image Group
ART DIRECTOR	Dan Frazier
DESIGNER	David Zavala
ILLUSTRATOR	David Zavala
CLIENT	EMU Acres
PAPER/PRINTING	Evergreen

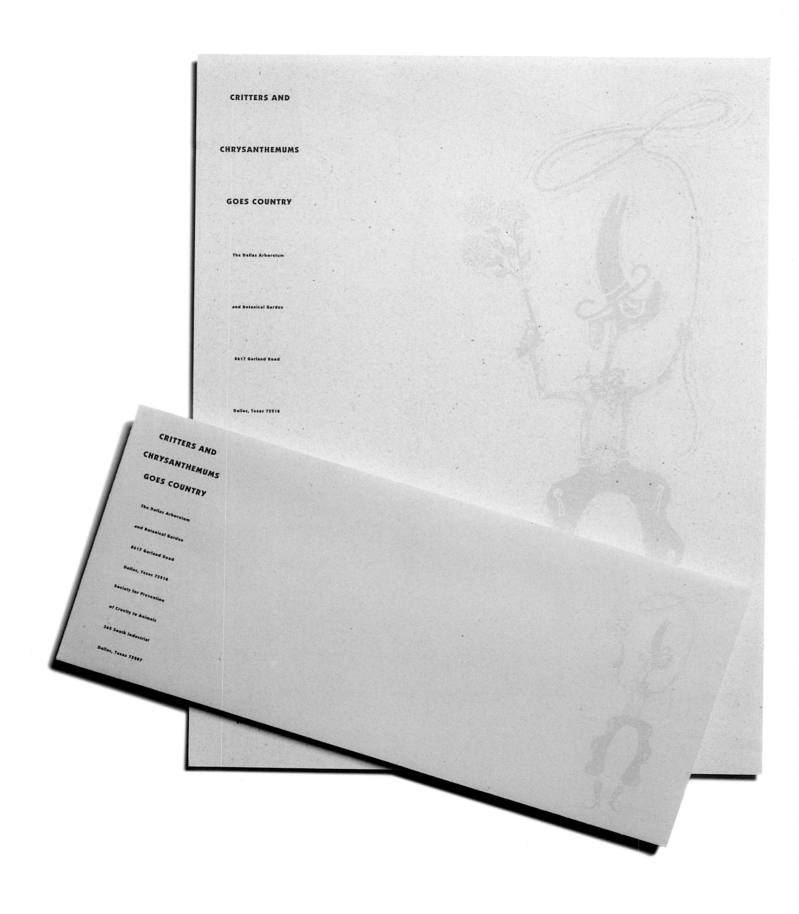

CRITTERS AND

CHRYSANTHEMUMS

GOES COUNTRY

The Dallas Arboretum

and Botanical Garden

8617 Garland Road

Dallas, Texas 75218

CRITTERS AND
CHRYSANTHEMUMS
GOES COUNTRY

The Dallas Arboretum

and Botanical Garden

8617 Garland Road

Dallas, Texas 75218

Society for Prevention

of Cruelty to Animals

362 South Industrial

Dallas, Texas 75207

DESIGN FIRM	Focus 2
ART DIRECTOR	Todd Hart, Shawn Freeman
DESIGNER	Todd Hart
ILLUSTRATOR	Todd Hart
CLIENT	SPCA of Texas
PAPER/PRINTING	Evergreen

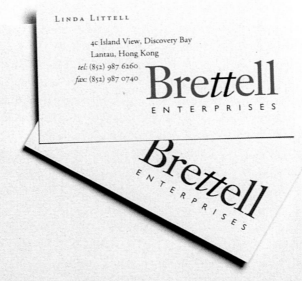

BRETTELL ENTERPRISES

4c Island View, Discovery Bay, Lantau, Hong Kong.

tel: (852) 987 6260 *fax:* (852) 987 0740

Bre*tt*ell
ENTERPRISES

LINDA LITTELL

4c Island View, Discovery Bay
Lantau, Hong Kong
tel: (852) 987 6260
fax: (852) 987 0740

Bre*tt*ell
ENTERPRISES

*Bre*tt*ell*
ENTERPRISES

Bre*tt*ell
ENTERPRISES

4c Island View, Discovery Bay, Lantau, Hong Kong.

DESIGN FIRM	The Design Associates
ART DIRECTOR	Victor Cheong
DESIGNER	Victor Cheong, Philip Sven
CLIENT	Brettell Enterprises
PAPER/PRINTING	Gilbert

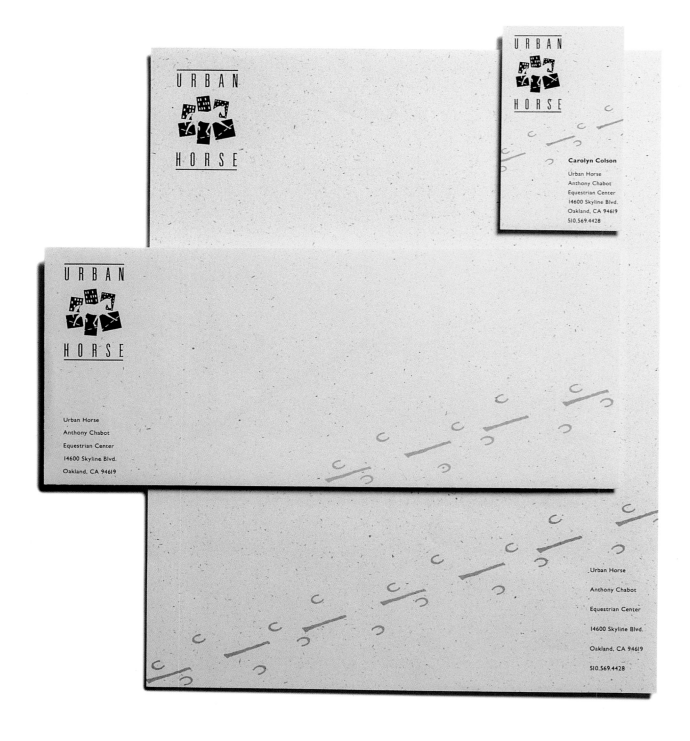

DESIGN FIRM	Bruce Yelaska Design
ART DIRECTOR	Bruce Yelaska
DESIGNER	Bruce Yelaska
ILLUSTRATOR	Bruce Yelaska
CLIENT	Urban Horse
PAPER/PRINTING	Champion Benefit

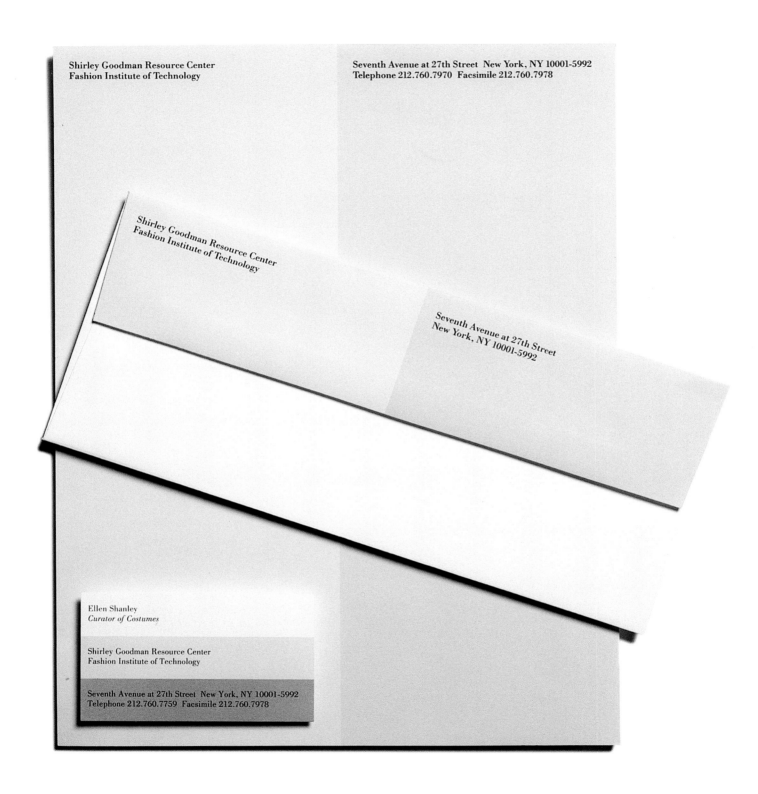

DESIGN FIRM M Plus M Incorporated
ART DIRECTOR Takaaki Matsumoto, Michael McGinn
DESIGNER Takaaki Matsumoto
CLIENT Fashion Institute of Technology

DIRECTORY OF DESIGNERS

A1 Design
601 Minnesota Street #120
San Francisco, CA 94107
USA
24

Able Design, Inc.
54 W. 21st Street, #705
New York, NY 10010 USA
67

Ace Architects
330 2nd Street
Oakland, CA 94607 USA
289

Adele Bass + Co. Design
758 E. Colorado Boulevard,
Suite 209
Pasadena, CA 91101 USA
47, 295, 327

Adkins/Balchunas
163 Exchange Street
Pawtucket, RI 02860 USA
244, 245

Advertising Agency Incognito
Oy
150 Roobertinhato 1A
00120 Helsinki, Finland
59

Aerial
58 Federal Street
San Francisco, CA 94107
USA
28, 105, 115, 117

After Hours Creative
1201 East Jefferson B100
Phoenix, AZ 85034 USA
138, 147

Alfred Design
1020 Bellevue Avenue
Wilmington, DE 19809 USA
189

Amar's Design
Hans Nielsen Haugesgt 17
0481-Oslo, Norway
172

Anderson Hanson & Company
9714 Forest Lane #5804
Dallas, TX 75243 USA
218, 220

Anderson-Thomas Design, Inc.
110 29th Avenue N., Suite
301
Nashville, TN 37203 USA
36, 58

Arminda Hopkins & Associates
818 University Drive, Suite 201
Nacogdoches, TX 75961 USA
145

Aslan Grafix
6507 Rain Creek Parkway
Austin, TX 78759 USA
310

Axis Design
7 Franklin Avenue
Rosemont, PA 19010 USA
21, 102

Barbara Brown Marketing &
Design
791 Colina Vista
Ventura, CA 93003 USA
57, 74

Barbara Raab Design
3105 Valley Drive
Alexandria, VA 22302 USA
274

Bartels & Company, Inc.
3284 Ivanhoe Avenue
St. Louis, MO 63139 USA
258, 279, 287

Beauchamp Design
9848 Mercy Road #8
San Diego, CA 92129 USA
281, 285

Becker Design
225 East St. Paul Avenue,
Suite 300
Milwaukee, WI 53202 USA
149

Belyea Design Alliance
1809 Seventh Avenue, Suite
1007
Seattle, WA 98101 USA
49, 89

Big Fish Creative
14 Paseo Estrellas
Rancho Santa Margarita, CA
92688 USA
72

Blue Sky Design
6401 SW 132 Ct. Circle
Miami, FL 33183 USA
264

Blue Suede Studios
2525 Ontario Street
Vancouver, BC V5T 2X7,
Canada
66

Bob Korn Design
370 1/2 Pacific Street
Brooklyn, NY 11217 USA
189

Bohl
Karl Marxstrasse 80
D-54290 Trier, Germany
42

Bruce Yelaska Design
1546 Grant Avenue
San Francisco, CA 94133
USA
346

Bullet Communications Inc.
200 South Midland Avenue
Joliet, IL 60436 USA
212, 214

Cactus Design
312 Montgomery Street
Alexandria, VA 22314 USA
264

Caldera Design
1201 East Jefferson #A25
Phoenix, AZ 85034 USA
228

Carl Seltzer Design Office
120 Newport Center Drive,
Suite 206
Newport Beach, CA 92660
USA
331

Carol Lasky Studio
30 The Fenway
Boston, MA 02215 USA
164, 187

Cato Berro Diseño
Estanislao Diaz 102
San Isidro, B5 A5, Argentina
15, 141

Cato Design Inc.
254 Swan Street
Richmond 3121, Australia
234, 254

Cecily Roberts Design
209 Hilton Avenue
Baltimore, MD 21228-5729
USA
62, 147

Chris St. Cyr Graphic Design
4 Electric Avenue
Somerville, MA 02144 USA
148

Choplogic
2014 Cherokee Parkway
Louisville, KY 40204 USA
287

Ciro Giordano Associates
54 Harrison Street
Brookline, MA 02146 USA
202

Cisneros Design
3168 Plaza Blanca
Santa Fe, NM 87505 USA
258

Clark Design
444 Spear Street, Suite 210
San Francisco, CA 94105
USA
147

Clifford Selbert Design
Collaborative
2067 Massachusetts Avenue
Cambridge, MA 02140 USA
121, 260, 290

Commonwealth Creative
Associates
345 Union Avenue
Framingham, MA 01702 USA
44

Communication Design, Inc.
One North Fifth Street, Suite
500
Richmond, VA 23219 USA
288

Communications Arts
Company
129 East Pascagoula Street
Jackson, MS 39201-3902
USA
12, 95

Cornoyer-Hedrick, Inc.
2425 East Camelback Road,
Suite 400
Phoenix, AZ 85016 USA
106

Corridor Design
2302 Hendrickson Drive
Eau Claire, WI 54701 USA
248, 249

Creative Company
3276 Commercial Street, 9E
Salem, OR 97302 USA
24

Creative EDGE
2 Church Street
Burlington, VT 05401 USA
281, 311

Dan Frazier/Image Group
25 Main Street, Suite 203
Chico, CA 95928 USA
302, 330

David Carter Design
4112 Swiss Avenue
Dallas, TX 75204 USA
96, 114

Debra Nichols Design
468 Jackson Street
San Francisco, CA 94111
USA
305, 323

Delmarva Power Corporate
 Comm.
800 King Street
Wilmington, DE 19801 USA
214

The Design Associates
89 Wellington Street 5A1
Central, Hong Kong, China
345

Design Center
15119 Minnetonka Boulevard
Minnetonka, MN 55345 USA
23, 57, 150

Design One
One North Pack Square,
Suite 301
Asheville, NC 28801 USA
233

Dewitt Kendall—Chicago
5000 Marine Drive 4D
Chicago, IL 60640 USA
272

Drenttel Doyle Partners
1123 Broadway
New York, NY 10010 USA
209

Druvi Art and Design
8200 Wisconsin Avenue,
Suite 1607
Bethesda, MD 20814 USA
76

Dogstar
626 54th Street South
Birmingham, AL 35212 USA
25, 39, 57, 103

Duck Soup Graphics, Inc.
257 Grand Meadow Crescent
Edmonton, AL T6L 1W9,
Canada
116, 178, 201, 206, 243,
246

Earl Gee Design
501 Second Street, Suite 700
San Francisco, CA 94107
USA
340

E. Christopher Klumb
Associates, Inc.
260 Norton
Darien, CT 06820 USA
37

Eilts Anderson Tracy
4111 Baltimore Avenue
Kansas City, MO 64111 USA
299, 303, 308

Elena Design
3024 Old Orchard Lane
Bedford, TX 76021 USA
34, 190

Elizabeth Resnick Design
126 Payson Road
Chestnut Hill, MA 02167
USA
267, 331

Ellen Kendrick Creative, Inc.
1707 Nicholasville Road
Lexington, KY 40503 USA
306, 331

Envision Communications,
Inc.
120 South Brook Street
Louisville, KY 40202 USA
265

Eskind Waddell
471 Richmond Street West
Toronto, Ontario M5V 1X9,
Canada
162, 286

Eye Design Incorporated
8180 Greensboro Drive,
#180
McLean, VA 22102 USA
32

Félix Beltrán + Associados
Apartado Postal M-10733
Mexico 06000 DF
224

Fernandez Vs. Miller Design
1420 Merkley Avenue,
Suite 5
West Sacto, CA 95691 USA
224

Fire House, Inc.
314 North Street Joseph
Avenue
Evansville, IN 47712 USA
107

Flaherty Art & Design
28 Jackson Street
Quincy, MA 02369 USA
105, 112

Focus 2
3333 Elm Street, Suite 203
Dallas, TX 75226 USA
328, 344

FORDESIGN
P.O. Box 13667
Alexandria, VA 71315 USA
173

Frank D'Astonfo Design
80 Warren Street #32
New York, NY 10007 USA
315

FRCH Design Worldwide
Graphic Design Society, Inc.
444 North Front Street, #211
Columbus, OH 43215 USA
105, 120

GAF Advertising Design
7215 Holly Hill #102
Dallas, TX 75231 USA
65

Geffert Design
Eichendorffstrasse 6
31135 Hildesheim, Germany
150

Georgopoulos Design
Associates
937 Traction Avenue, Suite
203
Los Angeles, CA 90013 USA
167

Get Smart Design Company
899 Jackson Street
Dubuque, IA 52001 USA
32

Gills & Smiler
1105 Glendon Avenue
Los Angeles, CA 90024 USA
21, 51

Go Media Inc.
1711 South Congress
Avenue, 3rd Floor
Austin, TX 78704 USA
174, 234

Grafik Communications Inc.
1199 North Fairfax Street,
Suite 700
Alexandria, VA 22314 USA
194

Grand Design Company
1902 Valley Centre 80-82
Morrison Hill Road
Hong Kong, China
26, 29

GrandPre and Whaley, Ltd.
475 Cleveland Avenue North,
Suite 222
St. Paul, MN 55104 USA
276, 307

Gray Cat Design
920 N. Franklin, Suite 303
Chicago, IL 60610 USA
81, 86

The Great American Logo
Company
14800 NW Cornell Road #4C
Portland, OR 97229 USA
315

The Green House
64 High Street
Harrow-on-the-Hill
London HA1 3LL, UK
279

Greteman Group
142 North Mosley
Wichita, KS 67202 USA
133, 163, 164, 165, 166,
185, 203, 210, 238, 254

Hanson/Dodge Design
301 N. Water Street
Milwaukee, WI 53202 USA
127, 134

Harrisberger Creative
3635 Collins Lane
Virginia Beach, VA 23452
USA
207

Hartmann & Mehler Designers
GmbH
Corneliusstrasse 8
90325 Frankfurt-am-Main,
Germany
326, 341

Hawley & Armian
Marketing/Design
305 Newbury Street #22
Boston, MA 02115 USA
270

Held Diedrich
703 East 30th Street,
Suite 16
Indianapolis, IN 46205 USA
142

Peter Hermesmann
306 Bainbridge Street
Philadelphia, PA 19147 USA
298

Hieroglyphics Art & Design
602 E. Grove Street
Mishawaka, IN 46545 USA
97

Hornall Anderson Design
Works, Inc.
1008 Webster Avenue,
Suite 600
Seattle, WA 98104 USA
24, 83, 123, 125, 247,
271, 284, 292, 294, 299,
306, 334, 337

Icehouse Design
135 West Elm Street
New Haven, CT 06515 USA
33, 41

Image Group
25 Main Street, Suite 203
Chico, CA 95928 USA
301, 343

Imagine That, Inc.
1676 Oak Street
Washington, DC 20010 USA
13

Impress SAS
Via Galimberti 18
13051 Biella, Italy
150

Insight Design
Communications
322 South Mosley Street
Wichita, KS 67202 USA
44, 69, 122, 127, 148,
192, 238

Ivie & Associates Inc.
2322 East Kimberley Road,
Suite 150E
Davenport, IA 52807 USA
166, 185, 207, 212

James Clark Design Images
200 West Mercer Street
#102
Seattle, WA 98119 USA
336

Jeff Fisher Logomotives
P.O. Box 6631
Portland, OR 97228-6631
USA
44, 62, 105

Jenssen Design Pty. Limited
2A Glen Street
Milsons Point NSW 2061,
Australia
304

Jill Tanenbaum Graphic
Design & Advertising
4701 Sagamore Road, Suite
235 South
Bethesda, MD 20816 USA
202

Jim Ales Design
123 Townsend Street #480
San Francisco, CA 94107
USA
303

John Evans Design
2200 North Lamar #220
Dallas, TX 75202 USA
194, 221, 222, 236, 254

John Gambell Graphic Design
LLC
341 Crown Street
New Haven, CT 06511 USA
43

John Reynolds Design
10791 Ohio Avenue, Studio
#1A
Los Angeles, CA 90024 USA
250

Johns Hopkins University
Dept. of Art as Applied to
Medicine
1830 East Monument Street,
Suite 7000
Baltimore, MD 21250 USA
214

Jon Flaming Design
2200 North Lamar, Suite
222
Dallas, TX 75202 USA
154, 155, 156, 218

Jon Wells Associates
407 Jackson Street #206
San Francisco, CA 94111
USA
219

Juice Design
1572 Howard Street
San Francisco, CA 94103
USA
81, 111

The Kamber Group
1920 L Street NW, Suite 700
Washington, DC 20006 USA
230

Kan & Lau Design
Consultants
28/F Great Smart Tower
230 Wanchai Road
Hong Kong, China
63

Kanokwalee Design
10402 Yucca Drive
Austin, TX 78759 USA
88

Kelly O. Stanley Design
3205 North Medford Avenue,
Suite 240
St. Louis, MO 63112 USA
193

Kiku Obata & Company
5585 Pershing Avenue,
Suite 240
St. Louis, MO 63112 USA
99, 104, 109

Kirby Stephens Design, Inc.
219 Mount Vernon Street
Somerset, KY 42501 USA
100

Knut Hartmann Design
Zeppelinalle 77A
60487 Frankfurt, Germany
161

Lambert Design Studio
7007 Twin Hills Avenue,
Suite 213
Dallas, TX 75231 USA
194, 310

Larry Burke-Weiner Photo-
Illustration Design
832 South Woodlawn Avenue
Bloomington, IN 47401 USA
71

Laura Hermann Design
69 Atlantic Road
Gloucester, MA 01930 USA
268

Laurie Bish
405 Iris Road
Corona del Mar, CA 92625
USA
206

Leann Brook Design
P.O.Box 1788
Nevada City, CA 95959 USA
339

The Leonhardt Group
1218 Third Avenue #620
Seattle, WA 98101 USA
208

Let Her Press
1544 Westerly Terrace
Los Angeles, CA 90026 USA
320

Linnea Gruber Design
1775 Hancock Street #190
San Diego, CA 92110 USA
273

London Road Design
535 Ramona Street #33
Palo Alto, CA 94301 USA
161

Lorenz Advertising & Design
9320 Chesapeake Drive
#214
San Diego, CA 92123 USA
127

Lorna Stovall Design
1088 Queen Anne Place
Los Angeles, CA 90019 USA
277, 333

Love Packaging Group
410 E. 37th Street, North
Plant 2, Graphic Dept.
Wichita, KS 67219 USA
130, 145, 148, 175, 250

LSL Industries
910 NW Front Avenue I-23
Portland, OR 97209 USA
8

Lucy Walker Graphic Design
Level 5, 15-19 Boundary
Street
Rushcutters Bay
Sydney, NSW 2011 Australia
48

M. Renner Design
Weiherway 3
CH-4123 Australia

M Plus M Incorporated
17 Cornelia Street
New York, NY 10014 USA
347

MacVicar Design &
Communications
2615-A Shirlington Road
Arlington, VA 22206 USA
62, 228

Malik design
88 Merritt Avenue
South Amboy, NJ 08819 USA
81

Marca Registrada Diseno
Grafico LTDA
Calle 117 No. 7 83 of 506
Bogota, Colombia
641

Marise Mizrahi Design
74 Leonard Street
New York, NY 10013 USA
171

Mark Oldack Design
3525 N. Oakly Street
Chicago, IL 60614 USA
280

Mark Duebner Design
176 Horizon Circle
Carol Stream, IL 60188 USA
168

The Marketing & Design
Group
297 Garfield Avenue
Oakhurst, NJ 07755 USA
313

Martiny and Company
8150 Corporate Park Drive
Cincinnati, OH 45242 USA
152

Matsumoto Incorporated
17 Cornelia Street
New York, NY 10014 USA
213, 226

Maximum Marketing
430 West Erie, Suite 400
Chicago, IL 60610 USA
231

Randall McCafferty
305 Edgewood Road
Pittsburgh, PA 15221 USA
267

Melissa Passehl Design
1275 Lincoln Avenue #7
San Jose, CA 95125 USA
10, 30, 75, 227

[Metal]
1210 West Clay, Suite 13
Houston, TX 77019 USA
153

Metropolis Corp.
56 Broad Street
Milford, CT 06460 USA
181

Michael Stanard Design, Inc.
1000 Main Street
Evanston, IL 60202 USA
35, 52

Mike Salisbury
Communications, Inc.
2200 Amapola Court, Suite 202
Torrance, CA 90501 USA
145

Mind's Eye Design
620 East Main Street
New Albany, IN 47150 USA
238

Mires Design
2345 Kettner Boulevard
San Diego, CA 92101 USA
45, 52, 60, 112, 127, 129, 134, 194, 216, 224, 228

Misha Design Studio
1638 Commonwealth Avenue, Suite 24
Boston, MA 02135 USA
29, 216

Mohr: Design
Huettenweg 28A
D-14195 Berlin, Germany
203

Mortensen Design
416 Bush Street
Mountain View, CA 94041 USA
332

Mother Graphic Design
Level 5, 15-19 Boundary Street
Rushcutters Bay
Sydney, NSW 2011 Australia
79, 80

Mueller & Wister, Inc.
801 E. Germantown Pike
Building J-4
Norristown, PA 19401-2489 USA
145

Muller & Company
4739 Belleview
Kansas City, MO 64112 USA
263, 335

Multimedia Asia, Inc.
P.O. Box 1345 Ortigas Center
Pasig, Metro Manila 1653, Philippines

Musikar Design
7524 Indian Hills Drive
Rockville, MD 20855 USA
258, 287

Nesnadny + Schwartz
10803 Magnolia Drive
Cleveland, OH 44106 USA
55, 316

New Idea Design Inc.
3702 S. 16th Street
Omaha, NE 68107 USA
316

Oakley Design Studios
519 SE Park Avenue, Suite 521
Portland, OR 97205 USA
81

On the Edge
505 30th Street, Suite 211
Newport Beach, CA 92663 USA
119

Ortega Design Studio
1735 Spring Street
St. Helena, CA 94574 USA
324

Palmquist & Palmquist Design
P.O. Box 325
Bozeman, MT 59771 USA
183, 205, 216, 218

Patri-Keker Design
1859 Mason Street #1
San Francisco, CA 94133 USA
279

Pencil Neck Productions
2513 Lands End Road
Carrolton, TX 75006 USA
21

Peterson & Company
2200 North Lamar Street, Suite 310
Dallas, TX 75202 USA
176, 177, 179, 182

Phillips Design Group
25 Drydock Avenue
Boston, MA 02210 USA
101

Phoenix Creative
611 North 10th Street
St. Louis, MO 02210 USA
101

Pig Studios
41 Wooster Street
New York, NY 10013 USA
342

Pinto Design
4612 Simpson Ferry Road
New Cumberland, PA 17070 USA
166

Pizzeria Uno Corp. In-House Art Department
100 Charles Park Road
West Roxbury, MA 02132 USA
212

Plaid Cat Design
147 East Chestnut Street, Apt. 6
Asheville, NC 28801 USA
207, 242, 250

Price Learman Associates
737 Market Street
Kirkland, WA 98033 USA
189, 204, 242, 250

Proforma Rotterdam
Slepersvest 5-7
3011 MK Rotterdam, The Netherlands
256, 291

The Proven Edge
12616 D Springbrook Drive
San Diego, CA 92128 USA
108, 110

Puccinelli Design
114 E. De La Guerra #5
Santa Barbara, CA 93101 USA
267

Ramona Hutko Design
4712 South Chelsea Lane
Bethesda, MD 20814 USA
40, 315

Rappy & Company
150 West 22nd Street, 10th floor
New York, NY 10011 USA
184

Richard Danne & Associates Inc.
126 Fifth Avenue
New York, NY 10011 USA
315

Rick Eiber Design (RED)
31014 SE 58th Street
Preston, WA 98050 USA
16, 19, 147, 148, 151, 211

Rick Sealock
#2 217 10th Avenue SW
Calgary, AL T2R 0A4, Canada
90

Riley Design Associates
214 Main Street Suite A
San Mateo, CA 94401 USA
310, 331

Nora Robbins
19 Holden Road
Belmont, MA 02178 USA
279

Robert Bailey Incorporated
0121 SW Bancroft Street
Portland, OR 97201 USA
21, 140, 236, 238

Ron Kellum Inc.
151 First Avenue PH-1
New York, NY 10003 USA
257

Rousso+Associates Inc.
5881 Glenridge Drive, Suite 200
Atlanta, GA 30328 USA
234, 239

S.A. Design Group
1379 Bank Street
Ottawa, Ontario K1M 8N3, Canada
253

Sackett Design Associates
2103 Scott Street
San Francisco, CA 94115-2120 USA
196, 197, 198, 217, 230, 251

Sagmeister, Inc.
222 West 14th Street #15A
New York, NY 10011 USA
9, 22, 128, 135, 169, 188

S&N Design
121 North 8th Street
Manhattan, KS 66502 USA

Sayles Graphic Design
308 Eighth Street
Des Moines, IA 50309 USA
106, 112, 132, 141, 312, 329

Schmeltz & Warren
74 Sheffield Road
Columbus, OH 43214 USA
282, 297

Schowalter[2] Design
21 The Crescen
Short Hills, NJ 07078 USA
315

Segura Inc.
361 West Chestnut Street, 1st floor
Chicago, IL 60610 USA
229, 261, 275, 278, 296, 299

Jeff Shelly
300 Mercer Street, Apt. 28I
New York, NY 10003 USA
264

Shields Design
415 E. Olive Avenue
Fresno, CA 93728 USA
259

Shimokochi/Reeves
4465 Wilshire Boulevard, #305
Los Angeles, CA 90010 USA
8, 14, 136

JiWon Shin
1186 Broadway #1003
New York, NY 10001 USA
235

SHR Perceptual Management
8700 E. Via De Ventura, Suite 100
Scottsdale, AZ 85258 USA
300, 309

Sibley/Peteet Design
3232 McKinney, Suite 1200
Dallas, TX 75204 USA
92, 100, 210, 238

Smith Group Communications
614 SW 11th Street
Portland, OR 97205 USA
306, 314

Smith Korch Daly
51 Union Place
Worcester, MA 01608 USA
237

Sommese Design
481 Glenn Road
State College, PA 16803 USA
117, 325

Source/Inc.
116 South Michigan Avenue
Chicago, IL 60451 USA
306

Space Design International
Graphic Design Society, Inc.
444 North Front Street, Suite
211
Columbus, OH 43215 USA
69

Squadra Design Studio
Eleodoro Yanez 156B
Providencia, Santiago, Chile
186

Stefan Dziallas Design
Olbersstrasse 9
D-28307 Bremen, Germany
31

Steven Gulla Graphic Design
65 Sullivan Street, Suite 8A
New York, NY 10012 USA
338

Stewart Monderer Design,
Inc.
10 Thatcher Street,
Suite 112
Boston, MA 02113 USA
69

Storm Design & Advertising
Consultancy
174 Albert Street
Prahran 3181, Victoria,
Australia
11, 78, 103

Studio Michael
1775 Hancock #190
San Diego, CA 92110 USA
266

Sullivan Perkins
2811 McKinney, Suite 320
LBIII
Dallas, TX 75204 USA
46

Sweiter Design U.S.
3227 McKinney Avenue,
Suite 201
Dallas, TX 75204 USA
200, 214, 218, 219, 232,
243, 247, 254

Tanagram
855 West Blackhawk Street
Chicago, IL 60622 USA

Tangram Strategic Design
Via Negroni 2
28100 Novara, Italy
15, 32

Teikna
366 Adelaide Street East,
Suite 541
Toronto, ON M5A 3X9,
Canada
91

THARP DID IT
50 University Avenue,
Suite 21
Los Gatos, CA 95030 USA
104, 125, 126, 223, 225,
252, 262, 293, 317

That's Cadiz! Originals
2601 Elliott Avenue, Suite
3175
Seattle, WA 98121 USA
120

"That's Nice"
235 East 13th Street,
Penthouse 6L
New York, NY 10003-5650
USA
170

13TH FLOOR
3309 Pine Avenue
Manhattan Beach, CA 90266
USA
180

38 North
2001 South Hanley,
Suite 200
St. Louis, MO 63144 USA
258

Thomas Hillman Design
193 Middle Street
Portland, ME 04107 USA
188, 269, 303

Tim Noonan Design
410 NW 18th Avenue
Portland, OR 97209 USA

Toni Schowalter Design
1133 Broadway, Suite 1610
New York, NY 10010 USA
120, 157, 158, 185, 221,
222

José Torres
R. Saladura Cabral, 119, 3
Esq.
2765 S. Joõa Estoril,
Portugal
15

Tower of Babel
24 Arden Road
Asheville, NC 28803 USA
100

Tracy Sabin
13476 Ridley Road
San Diego, CA 92129 USA
47, 92

Transparent Office
Overgarden Oven Vandet
54A2
SK-1415 Copenhagen,
Denmark
47, 54

Turner Design
6609 Woodshed Circle
Charlotte, NC 28270 USA
104

TW Design
3490 Piedmont Road,
Suite 1200
Atlanta, GA 30305 USA
310

246 Fifth Design
1379 Bank Street
Ottawa, Ontario K1N 8N3,
Canada
190

Vaughn Wedeen Creative
407 Rio Grande NW
Albuquerque, NM 87104
USA
215

Voss Design
Witteringstrasse 33
D-95130 Essen, Germany
44, 56, 92, 139

Vrontikis Design Office
2021 Pontius Avenue
Los Angeles, CA 90025 USA
77, 106, 113, 117, 118,
318, 319, 321

Walsh and Associates Inc.
4464 Fremont North,
Suite 310
Seattle, WA 98103 USA
241, 247, 303, 322

Watts Graphic Design
79-81 Palmerston Crescent
South Melbourne 3205
Australia
17, 18, 143

WDG Communications
3011 Johnson Avenue NW
Cedar Rapids, IA 52405 USA
160

Webster Design Associates
5060 Dodge Street,
Suite 2000
Omaha, NE 68132 USA
8, 57, 69

The Weller Institute
P.O. Box 518
Oakley, UT 84055 USA
136

Werk-Haus
22-2, Plaza Damansara
Medan Setia 2, Bukt
Damansara
Kuala Lumpur, Malaysia
98

Whitney Edwards Design
14 W. Dover Street,
P.O. Box 2425
Easton, MD 21601 USA
144

Widmeyer Design
911 Western Avenue #305
Seattle, WA 98104 USA
82, 131

William Field Design
355 East Palace Avenue
Santa Fe, NM 87501 USA
287

Athena Windelev
Baxmann & Harnickell
Grossebleichen 35
20435 Hamburg, Germany
39

Witherspoon Advertising
1000 West Weatherford
Fort Worth, TX 76102 USA
136, 224

Wood/Brod Design
2401 Ingleside Avenue
Cincinatti, OH 45206 USA
84, 94, 146

The Wyatt Group
5220 Spring Valley Road,
Suite 120
Dallas, TX 75240 USA
184

XSNRG Illustration and
Design
5635 Yonge Street,
Suite 213
North York, ON M2M 359,
Canada
24, 39

Zappata Designers
Lafayette 143
Anzures C.P. 11590
Mexico City, Mexico
38

Zauhar Design
510 1st Avenue
Minneapolis, MN 55403 USA
27, 189

ZGraphics, Ltd.
322 North River Street
East Dundee, IL 60611 USA
248